HIDDEN
JOHANNESBURG

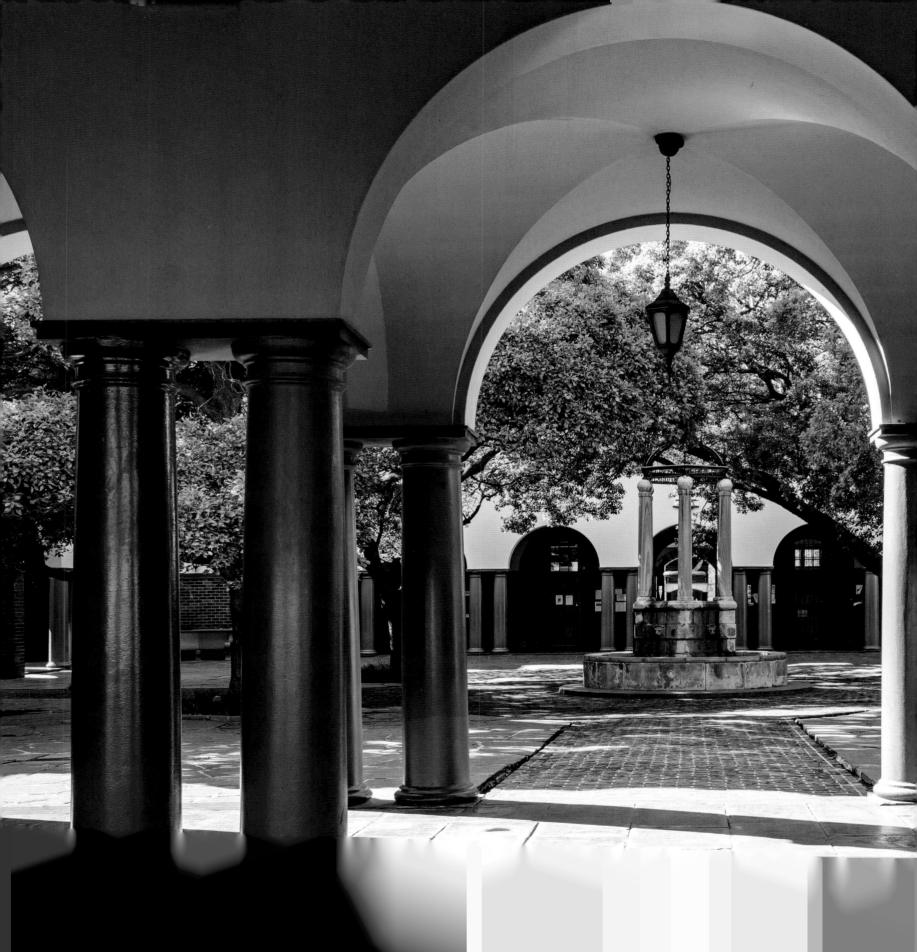

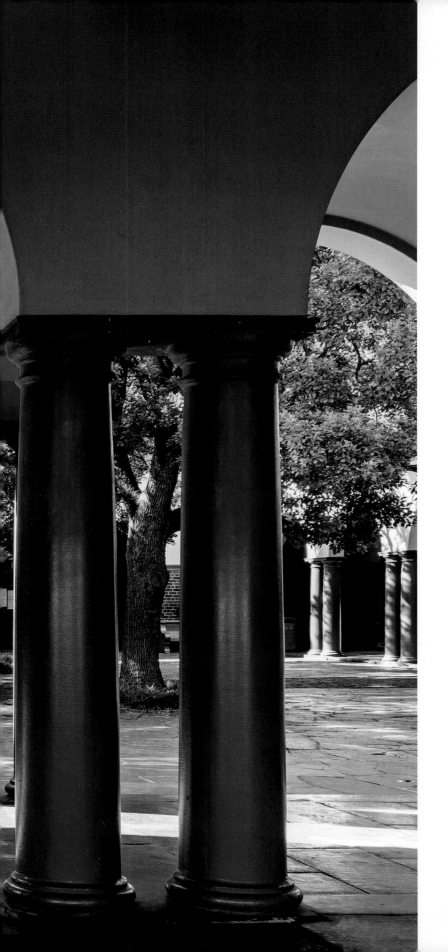

HIDDEN
JOHANNESBURG

PAUL DUNCAN

ALAIN PROUST

Published in 2016 by Struik Lifestyle
(an imprint of Penguin Random House South Africa (Pty) Ltd)
Company Reg. No 1953/000441/07
The Estuaries, 4 Oxbow Crescent, Century Avenue, Century City 7441
PO Box 1144, Cape Town, 8000, South Africa

www.penguinrandomhouse.co.za

Reprinted in 2017, 2018

ISBN 978 177007 992 2

Publisher: Linda de Villiers
Managing editor: Cecilia Barfield
Design manager: Beverley Dodd
Designer: Helen Henn
Editor: Gill Gordon
Proofreader: Cecilia Barfield

Reproduction: Hirt & Carter Cape (Pty) Ltd
Printing and binding: RR Donnelley Asia Printing Solutions Ltd, China

ACKNOWLEDGEMENTS

Mary Armour, Imam Ibrahim Atasoy, James Ball, Flo Bird, Father George Coconas, Duan Coetzee, Michael Collins, Puneet Dhamija,
Dominique Enthoven, Dick Glanville, Susan Greig, David Hart, Rabbi Ilan Hermann, Eric Itzkin, Craig Kaplan, Russell Kaplan,
Skye Korck, Ruth Kuper, Reshma Lakha-Singh, Robert Long, Saleh Mayet, Barbara McGregor, Gavin McInnes, Brian McKechnie,
Gussie Nourse, Phetsile Nxumalo, Catherine Page, David Pickard, Jo-Marie Rabe, Kalim Rajab, Alayne Reesberg, Warren Siebrits,
Beverley Smith, Michael Spicer, Jacques Stoltz, Ernst Swanepoel, Sim Tshabalala, Julia Twigg, Neil Viljoen, Sarah Welham.

FRONT COVER Park Station; PAGES 2–3 St John's College; PAGE 5 Park Station;
BACK COVER Villa Arcadia; ENDPAPERS The View

South African Railways

JOHANNESBURG TO CAPE TOWN

◇

Regular trains between South, East and West city areas.

Trains to all provinces and Cities. Excursions during the Holiday Season to South West Africa and Rhodesia.

For further information apply to any of the Railways Stations.

SOUTH AFRICAN RAILWAYS COMPANY LIMITED

CONTENTS

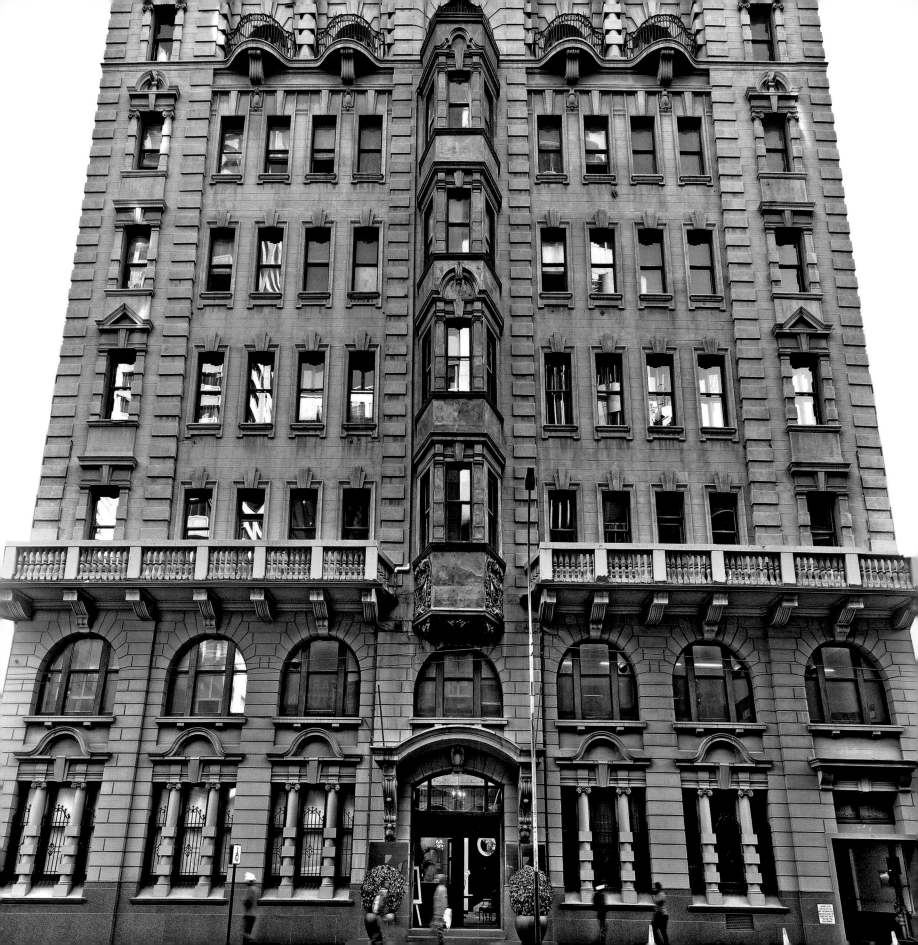

INTRODUCTION

There is always way more to see when you explore a city on foot, keeping to the pavements, crossing its streets from side to side, and making detours to catch a glimpse of something overlooked previously, or to take a short cut. Suddenly, you become aware of looming façades, their adornments, the detail, door cases and windows, roofscapes, symmetry, scale, monumentality, light and shade – in fact, all those things that give buildings their presence and underpin their contexts and their place in the world. And there's that constant question asked more out of curiosity than from any particular concern: what does the inside look like? If there's an interesting façade there's probably an even more fascinating interior. And if the exterior is intact, what's happened inside? What's the story behind how this particular building came to stand here and play a role in a city plonked down and grown like some hybrid maverick in the hot African veld?

Johannesburg – old Johannesburg – is no exception to any of this. It may be difficult now to be a pedestrian (try it though; I did) in the CBD and the old suburbs nearby, like Hillbrow or Doornfontein, other than on an organized tour, but in other places – Newtown for example, and lately, Braamfontein – there's been a revival of cultural and mercantile life leading to a revitalizing of neighbourhoods and an almost dizzying injection of activity that's woken them from near-death experiences.

But Johannesburg is a city that only truly reveals itself when you look upwards – on the outside anyway. Not only are there plenty of magisterial façades festooned with a wealth of detail, much of it preserved because it's out of reach, but also there, writ large, is a plausible visual microcosm of Western architecture between the two last decades of the nineteenth century and those at the middle of the twentieth. Much of it apes its peers in sophisticated, fashionable European metropolises like London or Berlin or Paris, or American cities like New York or Chicago. That such a new city was able to do this so quickly hints at its resources both financial and physical. They had the cash to do it, and the spacious land. Look at the Rand Club: a puffed-up building with three different street façades, on a site where, not 20 years before it was built, there had been just open veld. Much of early Johannesburg, including the Rand Club, went through successive waves of building construction as the earliest wooden shacks and corrugated iron-roofed shanties were transformed into more permanent, two- or three-storey brick-and-mortar structures with cast-iron verandahs templated out of a catalogue in the Victorian style, only to be replaced by statelier buildings that, indicating a mature city at full throttle, ran the gamut of late nineteenth century and early twentieth century architectural styles from *fin de siècle* to beaux arts, Arts and Crafts to neoclassical, designed by architects who had distinguished themselves either in Cape Town or in the offices of well-known, even famous, British practices.

Most often, and from the close of the Anglo-Boer War, Johannesburg's buildings are an architectural representation of British imperial hegemony; City Hall for example, or the buildings of Herbert Baker that today seem to be extraordinarily non-indigenous white elephants in territories far from home. Baker's picturesque 'country houses', like Northwards and Glenshiel, spring to mind, until you look closely and notice that they respond to their environments both functionally and respectfully. And sometimes, here and there, you stumble on a building that's transitional; not yet distanced enough from that 'old world' and still tentatively embracing a new global language, like Gordon Leith's Freemason's Hall. Now and again there are buildings that are in tune with, even herald, a brave new world and are revolutionary; Leck & Emley's Corner House is the best example of this. Most often, they just ape the fashion of the day and are first-class examples of sparkling new styles

OPPOSITE The entrance façade of Leck & Emley's Corner House is characterized by a copper-clad projecting central bay.

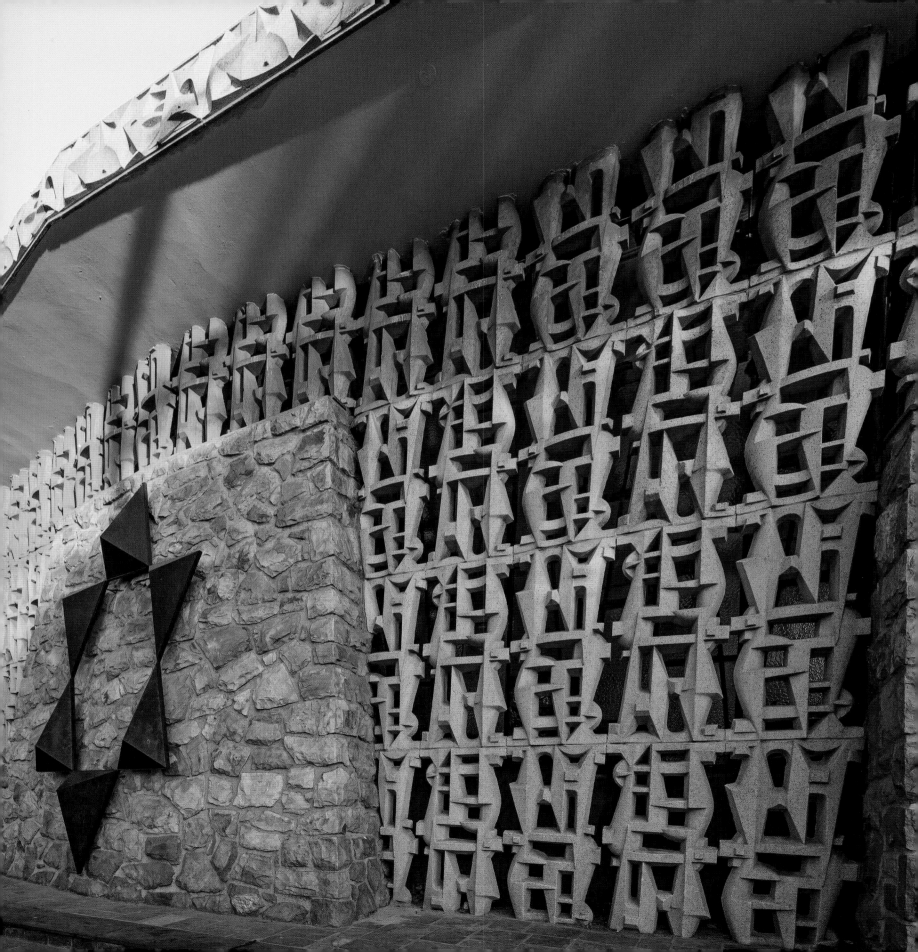

of design, interpreting international optimism with attention to local needs or bullishness. Johannesburg's Art Deco buildings fall into this category and there are some remarkable survivors of the period, like Gleneagles apartment block in Killarney, and Anstey's Building, on the corner of Jeppe and Joubert Streets in the CBD. Sometimes they're part of an attempt to inculcate into the cityscape a national architectural style – as in the building boom of the 1930s. Leith, again, is a key protagonist, along with Gerard Moerdijk, their opus in this respect being their work in association as the architects of Park Station.

I'm making very broad sweeps here. But a walk around the CBD is like finding yourself in a labyrinthine textbook discovering or uncovering signs and symbols and, learning to read them, being enabled to understand ever more the contexts of the city and its history. It's an uplifting experience simply because so much of early Johannesburg is still there, even though business has mostly moved on to places like Sandton, leaving these old neighbourhoods and their monuments in decline. The CBD is key in this respect, as are Hillbrow and Doornfontein. And while *Hidden Johannesburg* looks at a variety of buildings in those areas, it also reaches into Parktown, Westcliff and further afield, into Killarney, Kew, Orange Grove, Linksfield Ridge, Victory Park and Orchards. Names barely able to do justice to the evolution of these streets and suburbs.

This book, however, isn't a crusade for the restoration and revitalization of Johannesburg's old buildings. Indeed much of its content doesn't need any of that. In fact, only one building featured, Park Station, is derelict and in need of attention. Yes, I could have put in more of the latter sort as there are plenty of them, but public access is difficult and anyway the whole point of this book is to provide a list of 'hidden' places for people to visit and celebrate – places perhaps known only to a few but which tell a story that brings the city's contexts to life. Further afield still, *Hidden Johannesburg* heads out to Bedfordview and Midrand, Boksburg and Soweto, everything in it in some way a contributing feature of Johannesburg's multifaceted story. I know there's way more to see than the list of buildings pulled together here, but it's a start and with any luck all those tantalizing suggestions and further recommendations made by everybody who helped me with the contents can be given a starring role in a future publication. This book only scratches the surface.

Maybe it's just me, but I love the idea of finding myself in Midrand, or Wolmarans Street in grubby, historic Hillbrow, examining buildings and finding links that connect them across time with important structures of another, distant age. Who would have thought that the Nizamiye Masjid in unbeautiful Midrand is a close facsimile of the ancient Ottoman Selimiye Mosque in Edirne in Turkey, or that the Holy Cathedral of Saints Constantine and Helen in Hillbrow, along with the Great Synagogue further up the road, derives its domed form directly from Hagia Sophia in Istanbul, as did the Selimiye Mosque? So the Midrand mosque and Hillbrow cathedral and synagogue are linked inextricably, their provenances virtually interchangeable.

These kinds of connections make up a single stratum amongst diverse others that give every building its provenance. They enrich the buildings and the neighbourhoods they're in. I find it uplifting to be able to connect Bergamasco, Duncan & James's St Charles Borromeo Catholic Church in Victory Park with Oscar Niemeyer's Brasilia Cathedral in Brazil and Frederick Gibberd's Liverpool Metropolitan Cathedral of Christ the King in England. Who was influencing whom? What's the subtext here? Imagine my surprise when I discovered, after weeks of research, that the architect of St Charles Borromeo was none other than my own father, who also designed Disa Towers in Cape Town. A super-charged novelty unites these buildings, their language that of innovative church practice but also one of stylistic experimentation in the heady aftermath of Vatican II. Similarly, parallel Modernist preoccupations unite the architects of Doornfontein's Catholic Cathedral of Christ the King and Coventry's Anglican Cathedral, the former by father-and-son practice P & B Gregory, the latter by Basil Spence, pushing them into a sphere that speaks a global language.

I look up at Corner House and see not just a handsome, ornate building that was a local manifestation of a ground-breaking innovation in construction and design, but also a location from which the world's richest gold mines were controlled. This building was the engine room that underpinned the whole point of a fledgling Johannesburg, in turn creating an instant city at a distant outpost of the British Empire. And when you visit Nelson Mandela's house museum in Orlando West, Soweto, look beyond the orange-yellow bricks and the simple rooms and direct your attention to the ebb and flow of historic events that, with the house at their vortex, changed the course of the history of South Africa. Buildings are more than just the sum of the materials used to construct them.

Any indepth exploration of Johannesburg turns up the unexpected, not just the architecture of iconic buildings but the personalities behind them. Who knew that the founder of the Church of Scientology, that eccentric adventurer L Ron Hubbard, once lived in Linksfield Ridge in what turns out to be a rather exceptional post-war Modernist building? His portrait bust by Coert Steynberg in a back bedroom is the original that was copied and disseminated around Scientology's global empire. And who knew that Mohandas Gandhi lived with the aesthete and body-builder, Hermann Kallenbach, in an intimate gay partnership in a couple of rondavels in Orchards called The Kraal? Kallenbach designed The Kraal and today it's part of a simple guesthouse and museum to Gandhi's *satyagraha*, his policy of passive political resistance. Later, Kallenbach would go on to become the architect of many of early Johannesburg's buildings, including the Greek Orthodox Cathedral,

In the tumult of Johannesburg's rapid social change, there were undeniable losses and wanton destruction. The discovery that there are two whole rooms of Ceramic Studio tiles in Park Station was a stomach-churning high point. The work of the studio is an endangered species and there needs to be a rallying cry to save it at Park Station, *in situ*. The station itself is a marvel – if you're one of those driven types who, like me, loves to find the hole in the fence, squeeze through, and spend time clambering about ancient ruins on the hunt for tangible remains of the past. Some years ago, I squeezed between the hoardings surrounding the remains of the ancient, bombed-out Palazzo Lampedusa in Palermo and found, in the remains of his library, mangled letters written to the Prince of Lampedusa, who wrote *The Leopard*, and I was left virtually weeping at the sight of them. I mention this because although there's an undeniable romance in ruins, the picturesque dereliction and decay, Sicily's history, like Johannesburg's, is overburdened by a past for which it has little respect. But Park Station, on its last legs but not yet in ruins, conjures up all the ghosts of past lives, and is an important surviving reminder of the historical contexts of a city that became the nexus of a country enriched by its mineral wealth. The station tantalizes us with more presence than, say, the Great Zimbabwe Ruins or the ruins of Pompeii, if only because there are many people alive today who used it and who have a very clear memory of how it functioned and what it looked like. Its social context has not yet been forgotten.

Another fascinating relic of a forgotten age is Lady Phillips's sunken bath at Herbert Baker's Villa Arcadia. Here bathed the woman who tried virtually single-handedly to coax into being a national identity for the arts, architecture and craft in this country, and who was instrumental in establishing the Johannesburg Art Gallery (and getting Lutyens to design it) and much more besides. How did it manage to survive the institution that subsequently made it a home for orphans? And why did the schoolmistresses who took over Herbert Baker's Bedford Court, transforming it into St Andrew's School for Girls, keep Lady Farrar's bathroom intact? Like the Villa Arcadia bathroom, it also has Delft-style wall tiles. Sadly, it looks as if it hasn't been used for years and is concealed from view as a storeroom. But there it is, hidden away on an upper floor, attached to what had been her ladyship's bedroom. A tour of discovery at Bedford Court is an eye-opener, because everything in this huge house has been preserved and is waiting until the right occasion presents itself at which to begin a programme of restoration.

OPPOSITE The living room, Hannaben Street, Linksfield Ridge. A perfectly recreated period interior has restored the mid-century magnificence of the former home of Scientology's founder, L Ron Hubbard. The Rhodesian teak floors are original, as are the slasto walls and ceiling lights. The clerestory windows are lit by concealed uplighters, better dramatizing the enforced perspective of the ceiling beams.

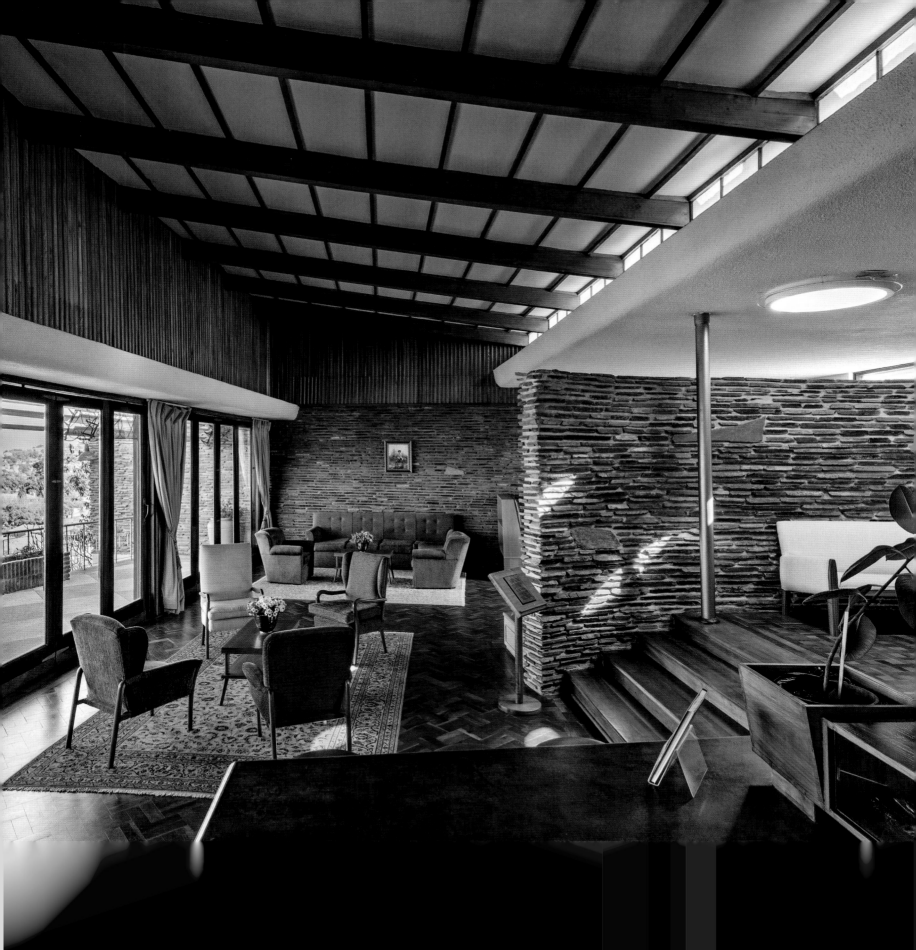

This kind of research was hit and miss. I would have included the Chassidic Synagogue on the corner of Yeo Street and Harrow Road, with its stone and terrazzo sheath by Edoardo Villa, but I couldn't get inside it. Nor could I tell whether or not Villa's Holy Ark was still *in situ*. I couldn't get into the SARS building at 5 Rissik Street either, where the main hall features panels by Alexis Preller, or so I'm told. Or is that an urban legend? I attempted some research into this but was stonewalled from virtually every angle. All attempts to get in were in the end foiled by overzealous security guards so I gave up. And what about the space inside the Johannesburg Magistrate's Court that features panels by Pierneef? We should have photographed those too, but again access was an issue. And I'm still waiting for replies to a lengthy series of emails asking for permission to photograph inside the Johannesburg Public Library. I wonder if they'll ever come? It's such a pity that the library isn't included in this book because there's a lot to look at in there and much to record.

One wet afternoon, I let myself into the City Hall through a side door and had a free run of the interior all alone. Not a soul challenged me as I wandered about from room to room and up circuitous staircases with porthole windows to the attics. While much of it is what you'd expect of a civic palace that popped up virtually overnight, and which has seen better days, there were some genuine surprises, like two Louis XV-style 'salons' lined with painted panelling and looking-glass on either side of an oval, mosaic-floor atrium linked to the foyer. How beautiful they were, even in their slightly dog-eared state. And how unexpected, even though they had been painted an unpleasant municipal green. And what about the foyer itself! Roughly decorated with colourful tesserae on the floor, its squat arches and shallow coffered vaults gave the impression that the builders were in a hurry to get it up. I would have included the spectacularly domed Great Synagogue in Wolmarans Street but a prophet of the Zionist Church was preaching from the *bimah* to his congregation in a language I didn't understand and photographs weren't allowed. All the ancient Jewish symbolic inscriptions are still inside the building which occupies a site that, not 28 years before it was built, was stony open veld with wild animals roaming at large.

Johannesburg has been in a constant state of reinvention as long as it's been in existence. And that's the odd, mesmerizing, infuriating thing about it. Frustrating and heartening in equal measure, from mining camp to instantaneous city in less than 20 years, it's always pretended to be cosmopolitan. And while money and business have migrated out of the CBD, transforming yet more chunks of veld into suburbs and satellite cities, there's much that has survived here and is waiting to be rediscovered. To take on a second life, to start over.

OPPOSITE Deep within the now-derelict Park Station one finds the remains of the Dutch-inspired tea room. Its hand-painted blue and white Delft-style tiles incorporate Dutch text, depictions of animals and plants, scenes from South African history and highlights from the worlds of diamond and gold mining. The Great Zimbabwe Ruins are depicted, as are scenes from the Great Trek and little replicas of San rock art, some of them copied from old books and manuscripts. They came from the Ceramic Studio – a slightly startling find, especially now that the Studio's output is so highly collectable following its sale and renaming in 1942 as Linnware.

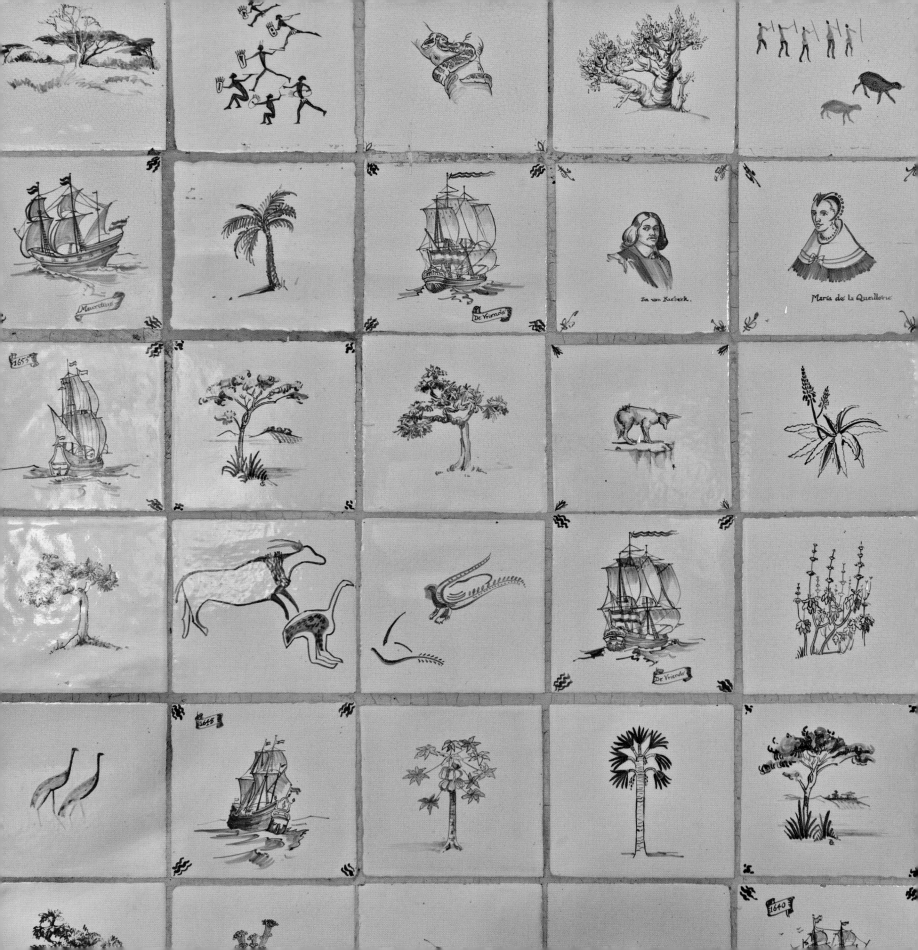

ST JOHN'S COLLEGE
St David Road, Houghton

St John's College is another of those Herbert Baker buildings that, true to the architect's principle of using local materials wherever possible, was built initially using rock quarried on site, 32 acres of which were purchased from the Houghton Estate with the help of £5000 donated by mining magnate Sir Thomas Cullinan.

St John's College, an Anglican private school for boys, was founded in 1898 by an Irish priest called the Reverend John Darragh. It began life 12 years after the founding of Johannesburg, and in its earliest incarnation had just two desks and seven pupils. One hundred and eighteen years later, it has over 1000 pupils installed in some very English-looking collegiate buildings arranged around a number of cloistered quads designed by Baker and his partner Frank Fleming (although the latter, Baker's partner after 1910, is credited with the lion's portion of the work).

Construction began in 1907 and continued for some years after Baker left South Africa in 1912 and after the Baker-Fleming partnership was dissolved in 1920. While Baker was probably responsible for the basic concept of this magnificent group of buildings, it is Fleming who brought it to life. All the 'Bakerisms' are there though – the *genius loci*, for example, of the siting of the college on the ridge, its monumental, rough stone bulk supported by buttresses and high retaining stone walls, and the grouping and massing of its constituent buildings, their proportion and their detail. The influence on Baker and Fleming of the English vernacular, expressed through the style and handwork of the Arts and Crafts Movement, is given almost free rein; if it wasn't for the blue sky, the palm trees and the rich colour of the quartzite rock from which St John's is mostly built, why wouldn't you believe that you had been suddenly and swiftly transported to old England?

Fleming went on adding to the college up until 1934. The Crypt Chapel was begun in 1915 and, over it, the simple, barrel-vaulted War Memorial Chapel, completed in 1925 and dedicated a year later to all those who fell in World War I. Says Clive Chipkin in *Johannesburg Style*, 'Clearly it is time that Frank Fleming should be rescued from Baker's shadow, since his work at St John's surpasses that of his mentor'. We would all agree.

OPPOSITE A cloister in which the play of dark, vaulted spaces against bright, sunny quads is, spectacularly, one of the memorable features of St John's College, here the work of Frank Fleming, who had entered Herbert Baker's office in 1904 as an assistant.

RIGHT The Arts and Crafts vernacular of some of the collegiate buildings is just one of an eclectic range of architectural styles that characterizes St John's College.

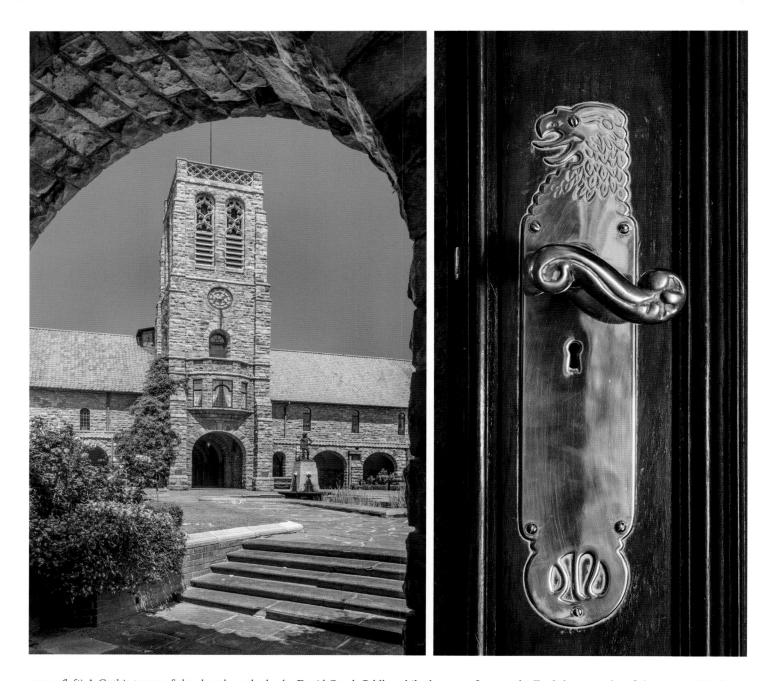

ABOVE (left) A Gothic tower of the chapel overlooks the David Quad. Oddly, while the tower features the English vernacular of the Arts and Crafts, its interior is Renaissance. The quad is named after a copy of the Renaissance sculptor Verrocchio's statue of David that stands on a plinth at its centre.

ABOVE (right) As with a great many buildings associated with Herbert Baker and his architectural practice, many of the interior details – such as door handles – are in harmony with the exterior because they, too, have high standards of craftsmanship.

OPPOSITE The north façade is perhaps the portion of the college that indicates the satisfying combination of building materials used by the architects – including the rough stone walling and the pantile roofs. The massing of the buildings, the heights of the chimneys and the rhythm of the fenestration, as well as the terraces falling away beneath the buildings on their ridge to the gardens below, add up to a unique combination. Here, the *genius loci* which Baker was so adept at conjuring up is much in evidence.

PAGES 20–21 One wonders how many generations have, over the years, passed through this extraordinary room at a school that was founded when Johannesburg was just 12 years old?

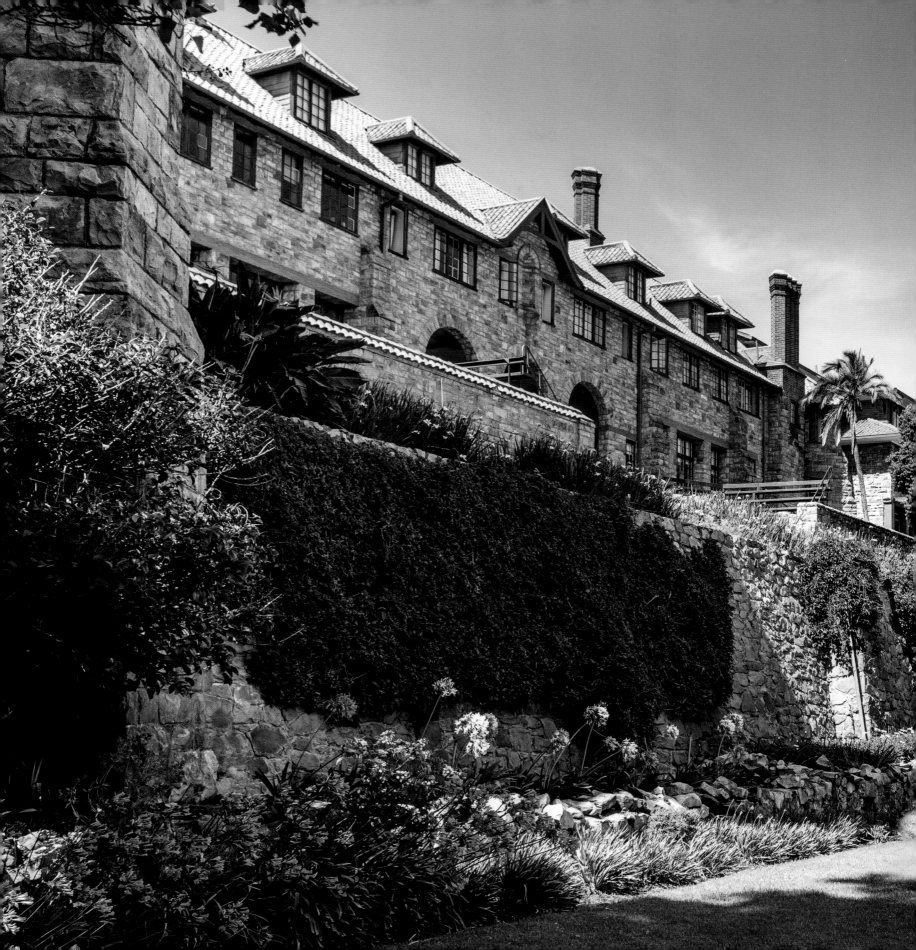

THE VIEW
Ridge Road, Parktown

The View could be any of a number of rambling Victorian piles that survive in the suburbs of South Africa's older cities. Typically, it has burnt red brick walls and imported wooden fretworked verandah balustrade detail and friezes, deep bay windows, keystones picked out in white, and twin-timbered gables, and there's an ornate roofline. It's actually rather ugly on the outside. It's also a house that sports building materials that were either novel at the time, or of the very best quality, or both. But it's not all that remarkable a building — particularly in comparison with its rather grander neighbour, Hazeldene Hall.

The View, however, is different from the others. The former home of Sir Thomas Cullinan, a bricklayer-turned-prospector and owner of the Premier Diamond Mine, its interiors are, for this country, incomparably opulent and have survived, one imagines, partly because Lady Cullinan, who lived in the house until the 1960s, never changed anything. The house has been occupied since 1976 as the headquarters of the Transvaal Scottish Regiment, known familiarly as The Jocks, but the interiors of what is now their clubhouse had become blackened with the smoke of thousands of cigars, and what was once a splendid display of exuberant colour was hidden and forgotten. But they'd survived, and Skye Korck restored them, spending hundreds of hours on a scaffold, like Michelangelo, recolouring and revitalizing friezes, cornices and the ceilings themselves. Brought cleverly back to life, they're significant in that they're the remaining evidence of the once-prestigious backdrop to lives enriched by huge new fortunes in a fledgling city: 'dusty in winter and a quagmire in summer', wrote Flora Shaw in *The Times* in 1892.

The View's interiors, preserved with help from the Lottery Commission, have been restored and are as magnificent now as they must have been when they were first decorated for Lady Cullinan and her husband, the man after whom was named the Cullinan Diamond which came out of the Premier Mine in 1905. Renowned as the largest diamond ever found, Cullinan's gem was presented to King Edward VII and today a portion of it, The Great Star of Africa, forms part of the Sovereign's Sceptre, while the Lesser Star of Africa is in the Imperial State Crown of the British Crown Jewels. These kinds of links are breathtaking, more so because the tangible evidence of their existence is still around for all to examine.

The View was built in 1896, designed by Johannesburg's city engineer, Charles Aburrow who, in partnership with Philip Treeby, extended it in 1903 to accommodate Thomas and Annie Cullinan's 10 children. Like Hazeldene Hall (also the work of Aburrow & Treeby), The View once had incomparable views over rolling veld north to the Magaliesberg and Pretoria. This was the countryside, and at the time Parktown was chosen for development as a respite from the gritty clamour of the rapidly developing city on the other side of the rocky ridge, replacing dusty Doornfontein as the suburb of the elite. But it wasn't only the distant Magaliesberg that excited its plutocratically prodigal resident Randlords and magnates who, slightly later, went on to employ Herbert Baker, Frank Emley and James Cope Christie to design their stately homes in this dramatic setting. In fact, it looked out over the dense acres of young firs and blue and red gums of the Sachsenwald, planted to supply the mines with props. There was green forest down there where, not long before, it had been only rocky veld and scrubby growth. Who wouldn't want to enjoy the view over what has developed into the largest man-made urban forest in existence?

OPPOSITE Period interiors have been meticulously brought back to life. Flowers decorate the entrance hall's wainscot, while the painted frieze above the arches depicts exotic birds.

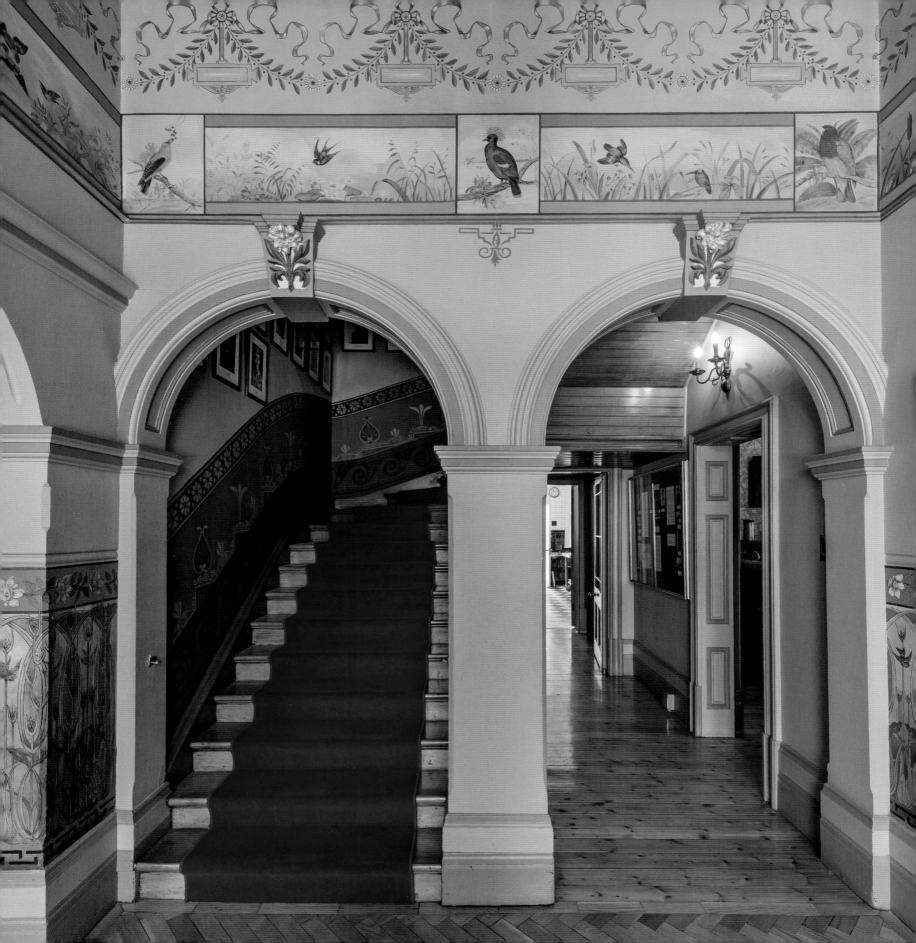

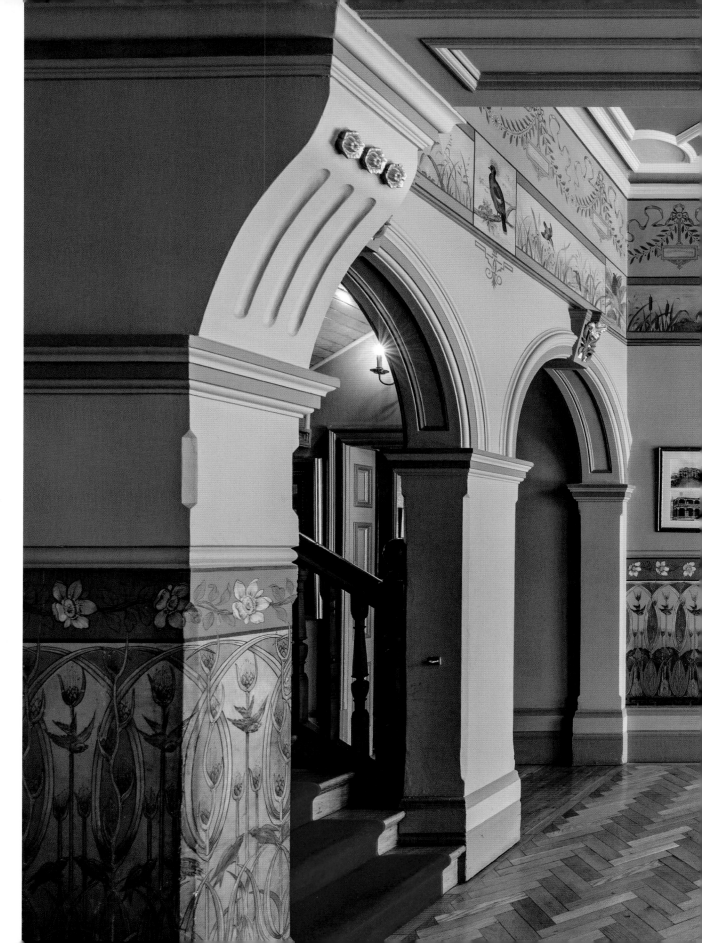

RIGHT The View is one of Johannesburg's oldest surviving houses (built only a decade or so after the city was proclaimed in 1886) and the only pre-Anglo-Boer War survivor still intact. This is the entrance hall, beyond which is Sir Thomas's study.

PAGE 26 The interiors at The View were restored by Skye Korck, who painstakingly removed the effects of decades of cigar smoke that was obscuring the decorative detail.

PAGE 27 Many of the Cullinans' original rooms have survived, their heavy Victorian opulence exaggerated by the intrusion of memorabilia of the resident Transvaal Scottish Regiment.

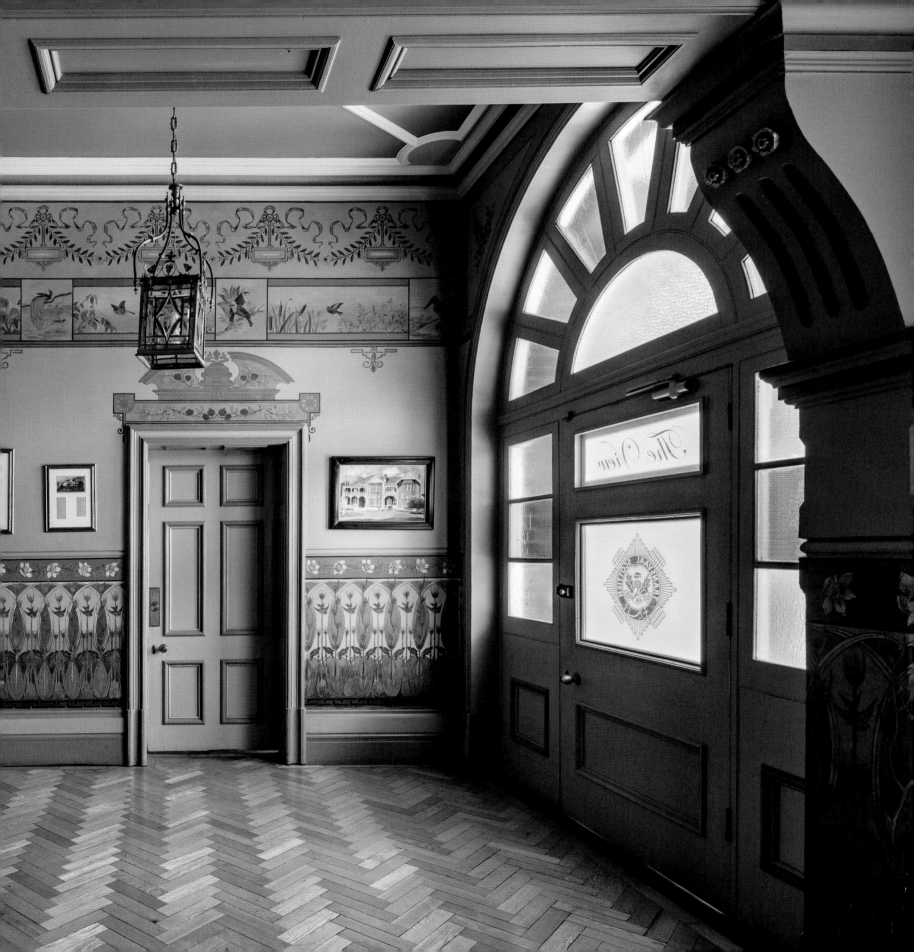

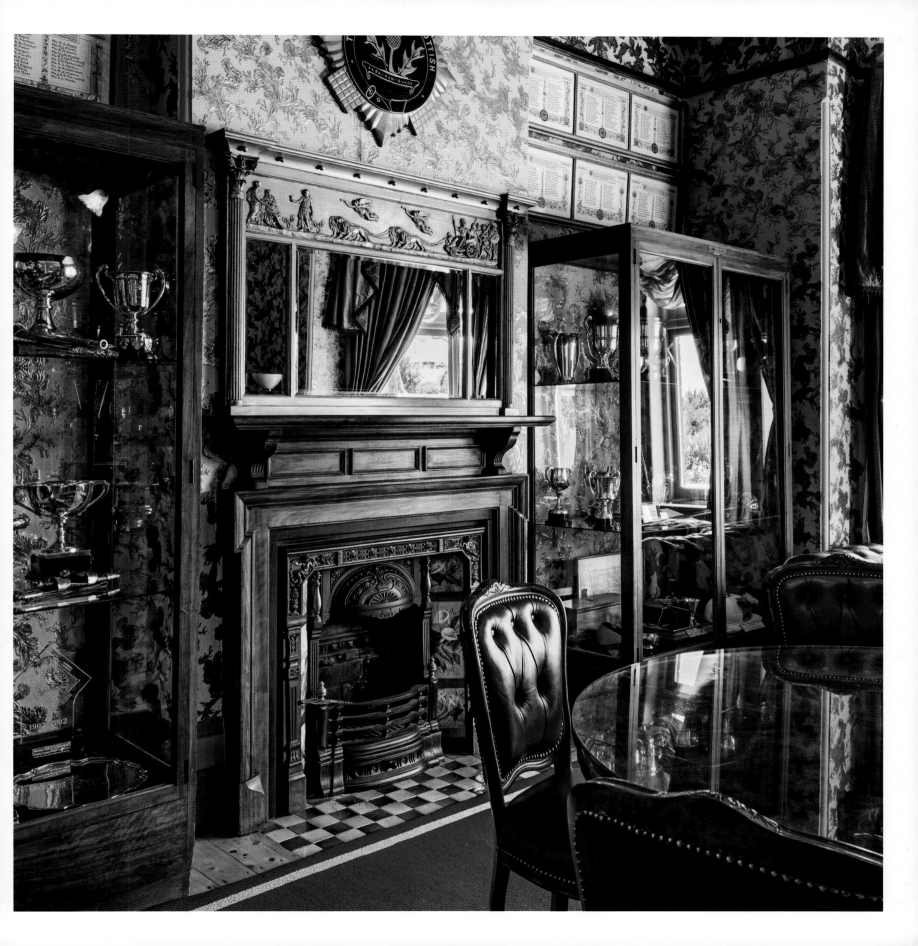

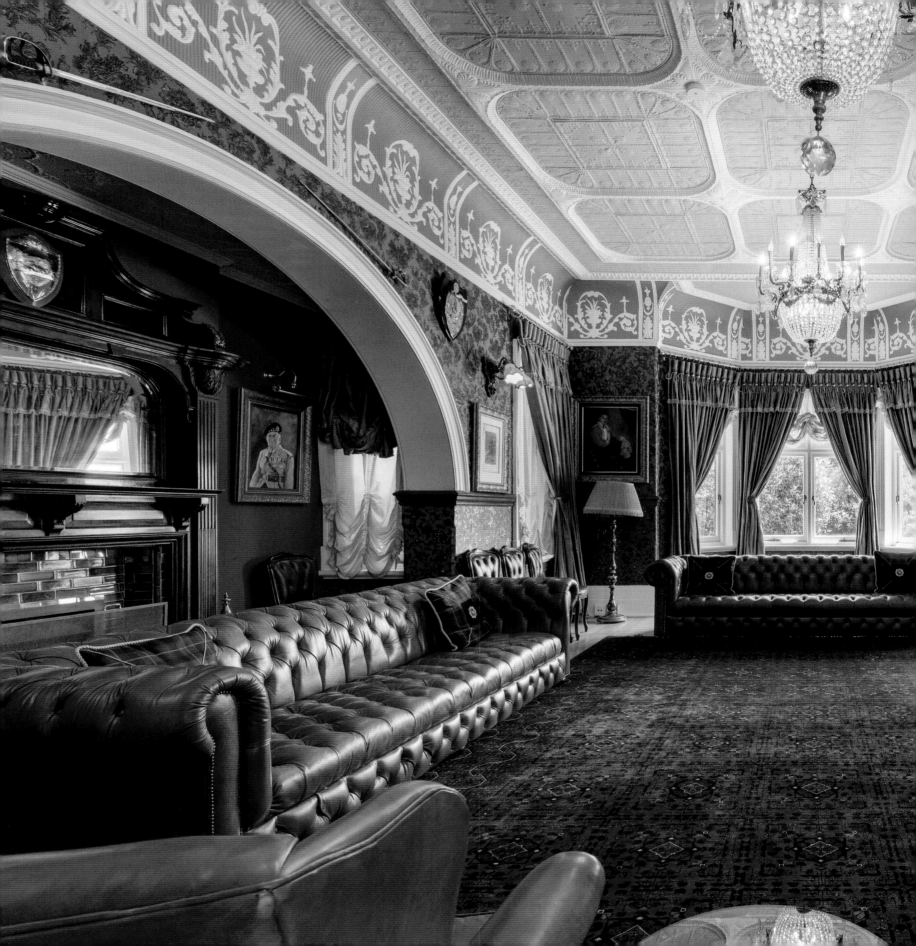

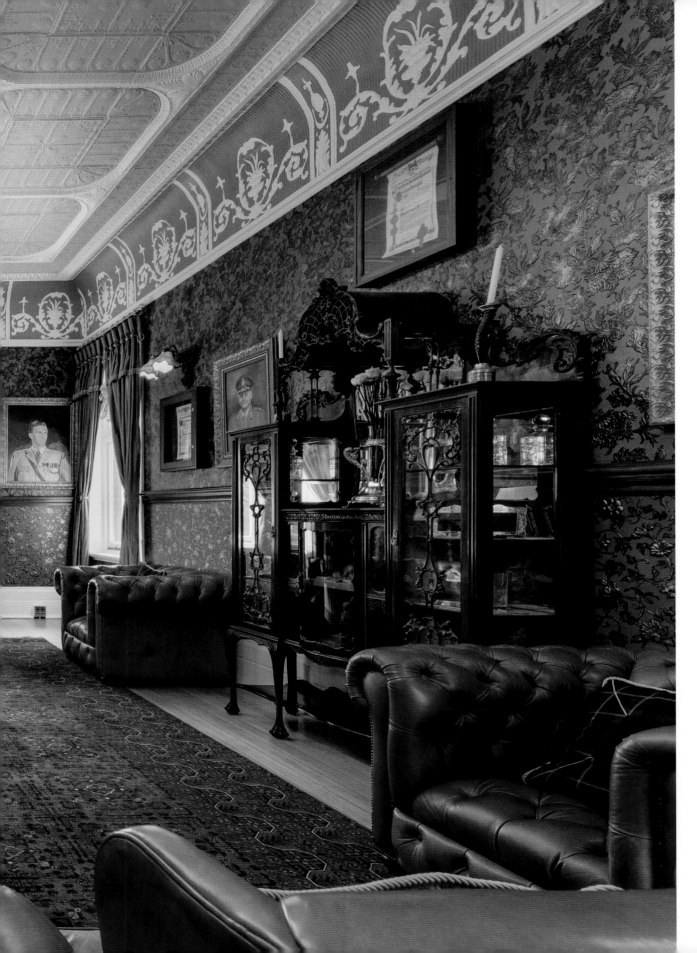

LEFT In the 1960s, more than 50 of Parktown's stately homes were demolished for a variety of reasons, including the construction of the M1. That The View has even survived is a remarkable feat of endurance. This is the former billiard room, its fireplace situated in an arched inglenook.

PAGE 30 Nowadays, views from The View are mostly obscured by the lumpen buildings of the Wits university campus. Even as you approach Cullinan's mansion from its stone gates, its silhouette is indistinguishable from, and has been compromised by, the hideous twentieth-century mass of inappropriate hospital development behind it.

PAGE 31 From the hall to the first floor, the staircase is flanked on one side by a heavy timber balustrade and on the other by a decorated wainscot.

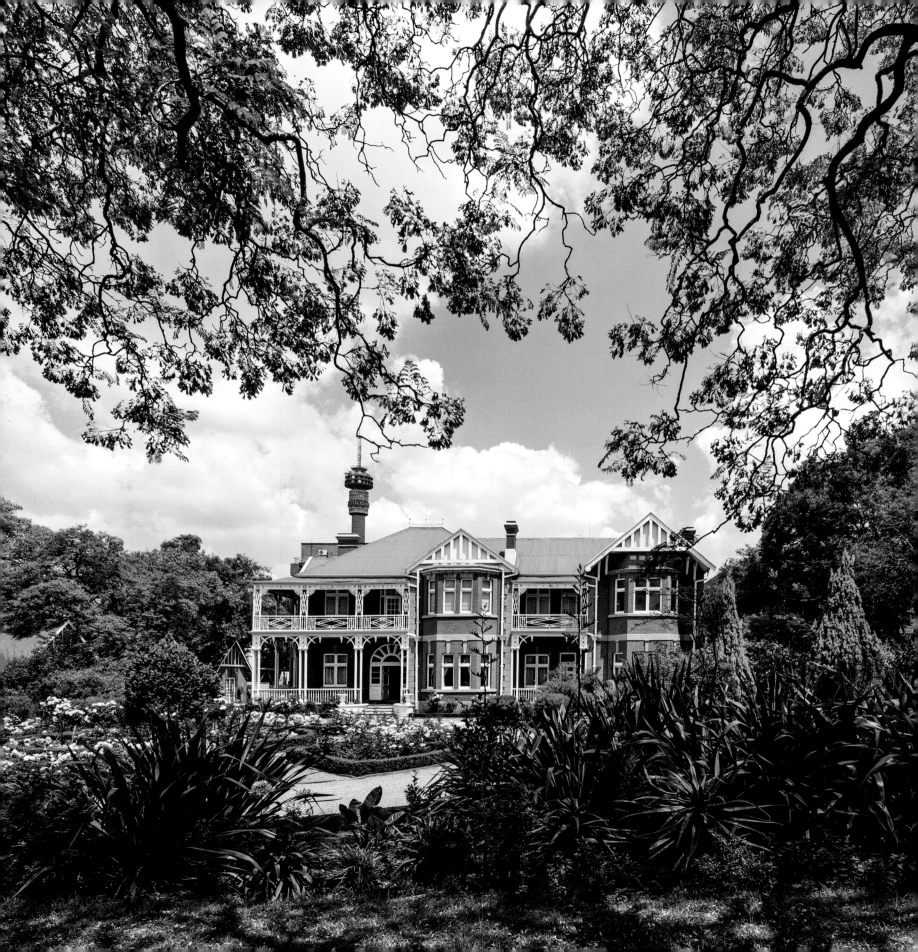

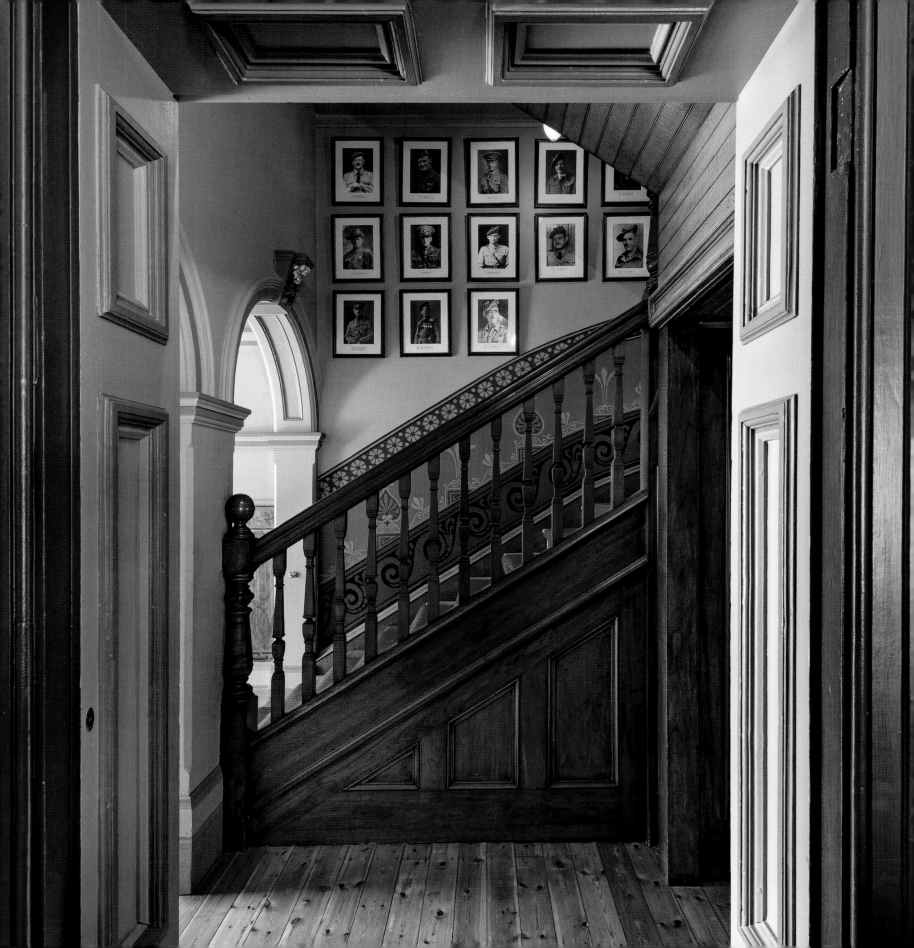

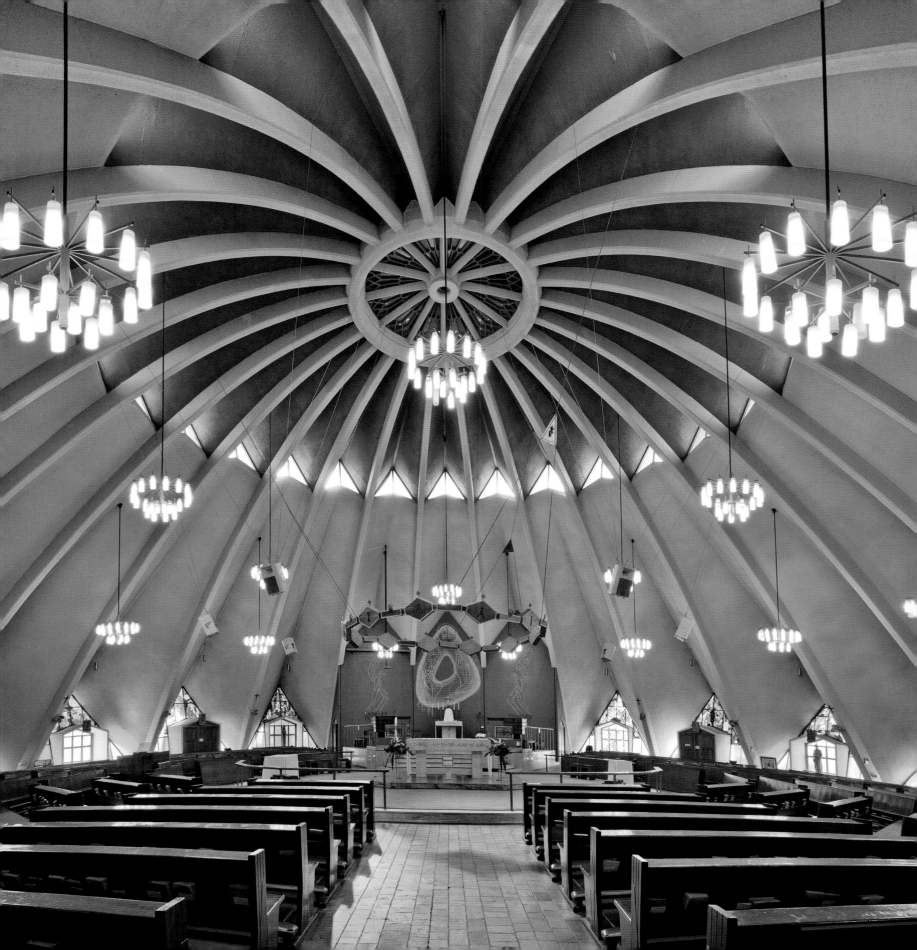

ST CHARLES BORROMEO
Road No. 3, Victory Park

At first impression, the circular church of St Charles Borromeo in Victory Park, built in 1966, is ugly, even brutal in the unexpected crispness of its presentation, its unusual interior and the sheer novelty of its spiky silhouette. That it looks like a giant lemon squeezer never passes without comment – as it happens, not unlike its inspiration, Frederick Gibberd's Metropolitan Cathedral completed in 1967 for the Archdiocese of Liverpool and its population of Irish Catholics, the much jeered-at Paddy's Wigwam. Popular disdain didn't stop bolder architects in South Africa or Latin America from pushing the envelope on ecclesiastical architecture: Oscar Niemeyer's similarly iconic kitchen utensil, the Cathedral of Brasilia in Brazil dates from 1960 – even before the modernization of the Catholic Church got underway with Vatican II. St Charles Borromeo was designed and built by Bergamasco, Duncan & James, the same firm of architects who built the Catholic Cathedral of St Saviour's in Oudtshoorn, consecrated in 1967, two of South Africa's more controversial, if striking, churches.

As the ritual and liturgy changed, so architecture reshaped worship spaces for a fan-shaped congregation. Although centrally planned, when the designs for St Charles Borromeo were first submitted, an initial proposal presented an octagonal building while another had a cruciform plan. In the end though, St Charles Borromeo would be circular and the cruciform shape was kept for St Saviour's. The circular plan would become a leitmotif of the practice's work, its most prominent manifestation being the triple columns of Disa Towers, in Vredehoek in Cape Town, at the foot of Table Mountain.

Attending a service in any of these centrally planned churches is a little like experiencing theatre in an auditorium under lofty parabolic ceilings with optimized acoustics. St Charles Borromeo, with its central altar, has the priest facing the congregation in the pews on three sides, and around the perimeter wall of the building, between the 24 precast concrete portals, are the confessionals, and the shrines and statues without which no Catholic church is complete – even one as rigorously modern as this. In defiance of the original design's 'undecorated' minimalism, stained-glass windows replaced the original plain glass in 2004.

At Victory Park, a tower constructed of 12 precast concrete beams soars 15–24 metres above floor level, its upper reaches filled with timber-frame windows. The ribs – one for the each of the Twelve Apostles – merge and burst heavenward as a sort of modern-day Crown of Thorns at the church's highest point. Beneath it, around its base, a zigzag of clerestory windows tops a series of 24 precast concrete portal arches that support the entire construction, their feet set in a concrete foundation and their top ends embedded in a concrete ring beam 15 metres above the floor. The altars and the surrounding floor are of Carrara and Namib marble respectively.

Iconic or something of an eyesore? You choose. Today the spiky crown remains an imposing landmark in Victory Park, regarded with affection by parishioners and locals.

OPPOSITE The interior of St Charles Borromeo is a virtuoso performance of theatrical ingenuity, its circular plan dominated by 24 precast concrete arches. The altar stands on a raised predella of rose-pink marble from Portugal.

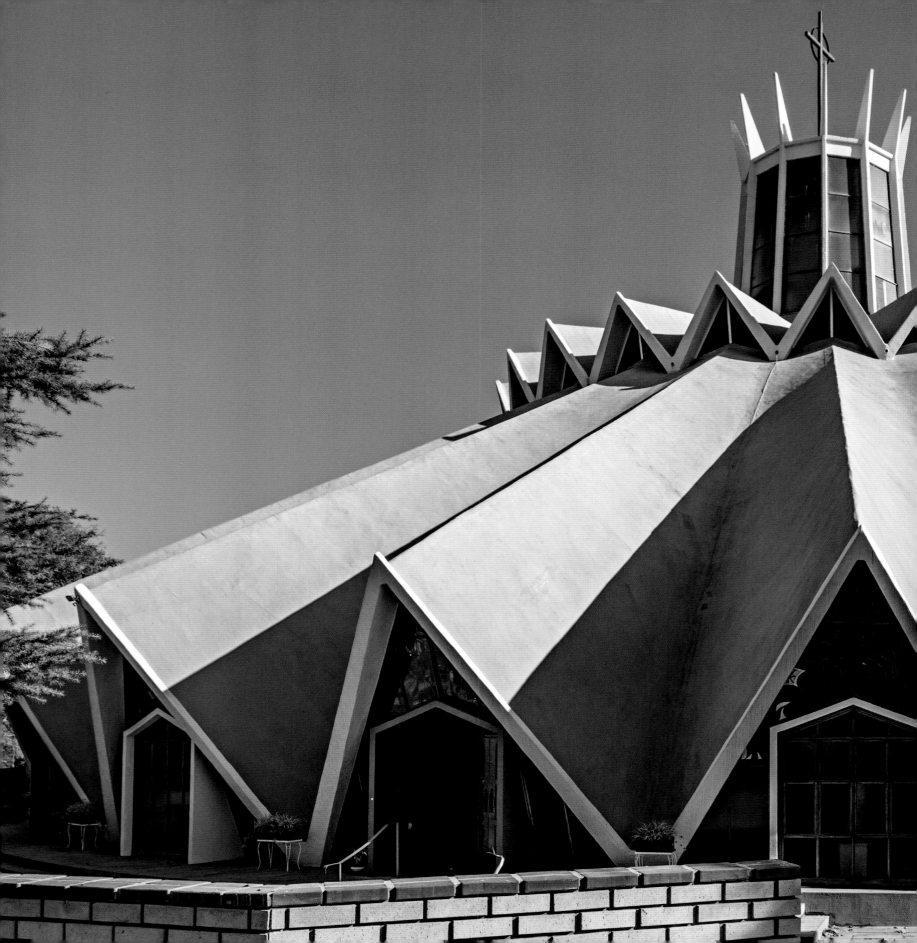

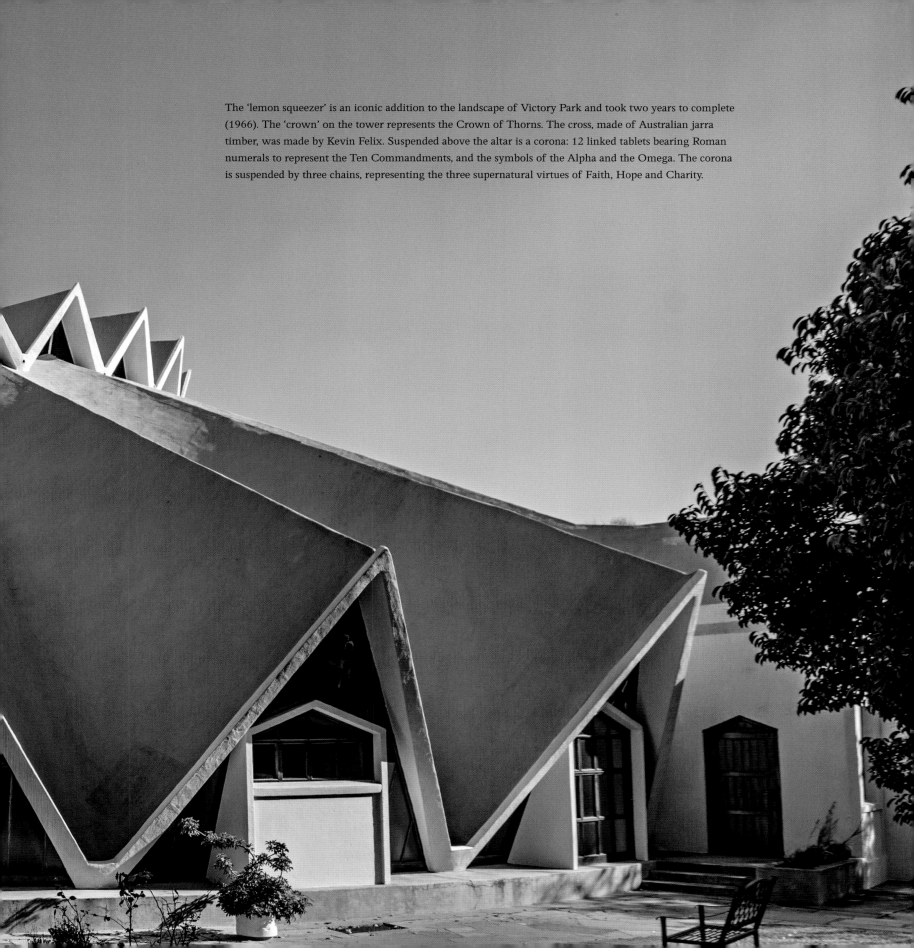

The 'lemon squeezer' is an iconic addition to the landscape of Victory Park and took two years to complete (1966). The 'crown' on the tower represents the Crown of Thorns. The cross, made of Australian jarra timber, was made by Kevin Felix. Suspended above the altar is a corona: 12 linked tablets bearing Roman numerals to represent the Ten Commandments, and the symbols of the Alpha and the Omega. The corona is suspended by three chains, representing the three supernatural virtues of Faith, Hope and Charity.

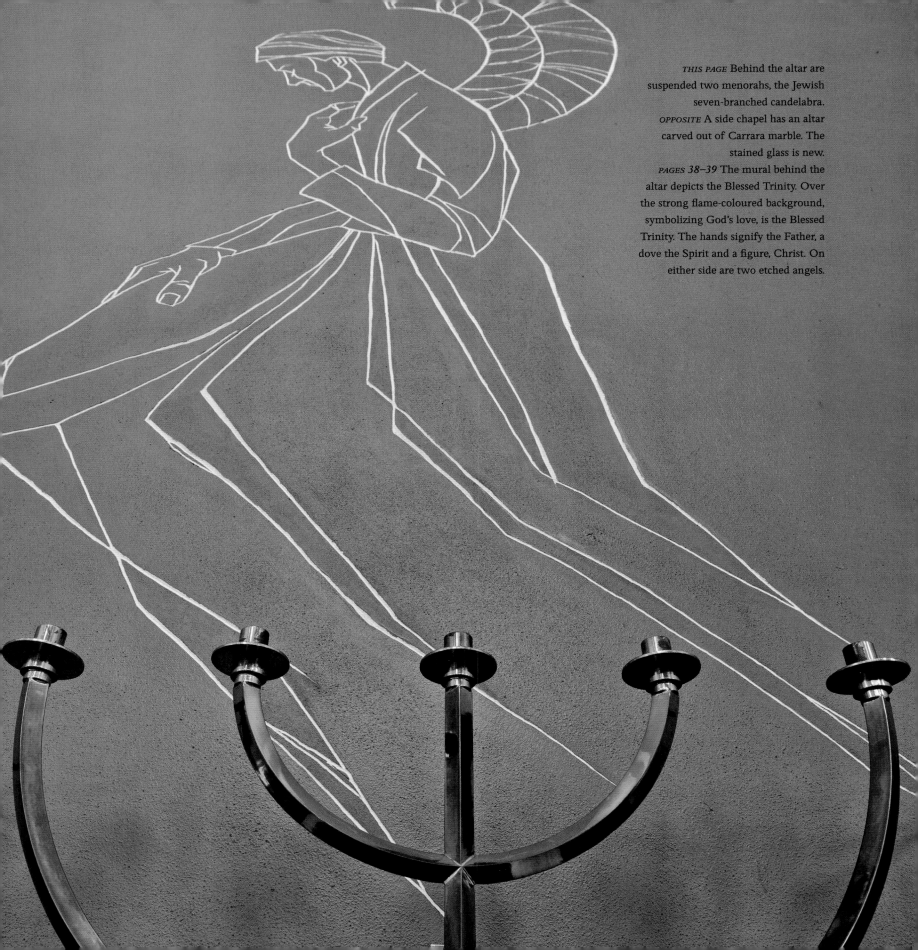

THIS PAGE Behind the altar are
suspended two menorahs, the Jewish
seven-branched candelabra.
OPPOSITE A side chapel has an altar
carved out of Carrara marble. The
stained glass is new.
PAGES 38–39 The mural behind the
altar depicts the Blessed Trinity. Over
the strong flame-coloured background,
symbolizing God's love, is the Blessed
Trinity. The hands signify the Father, a
dove the Spirit and a figure, Christ. On
either side are two etched angels.

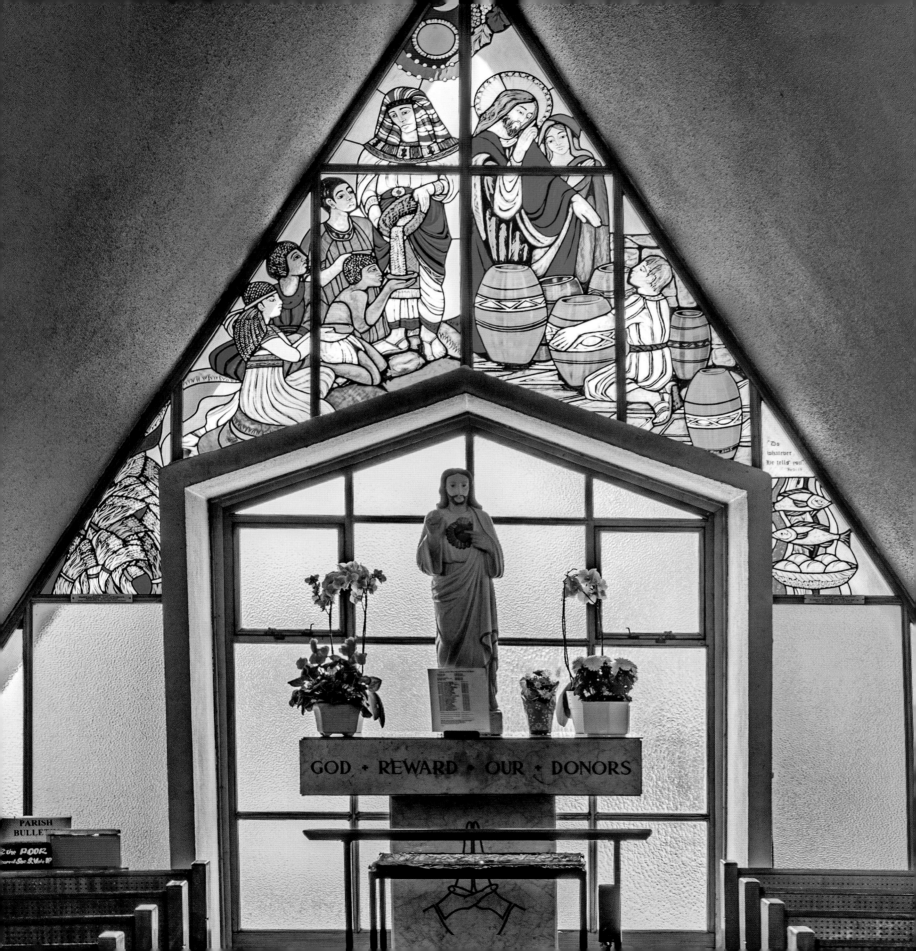

"Do whatever He tells you"

GOD ∗ REWARD ∗ OUR ∗ DONORS

PARISH
BULLE

2 the POOR

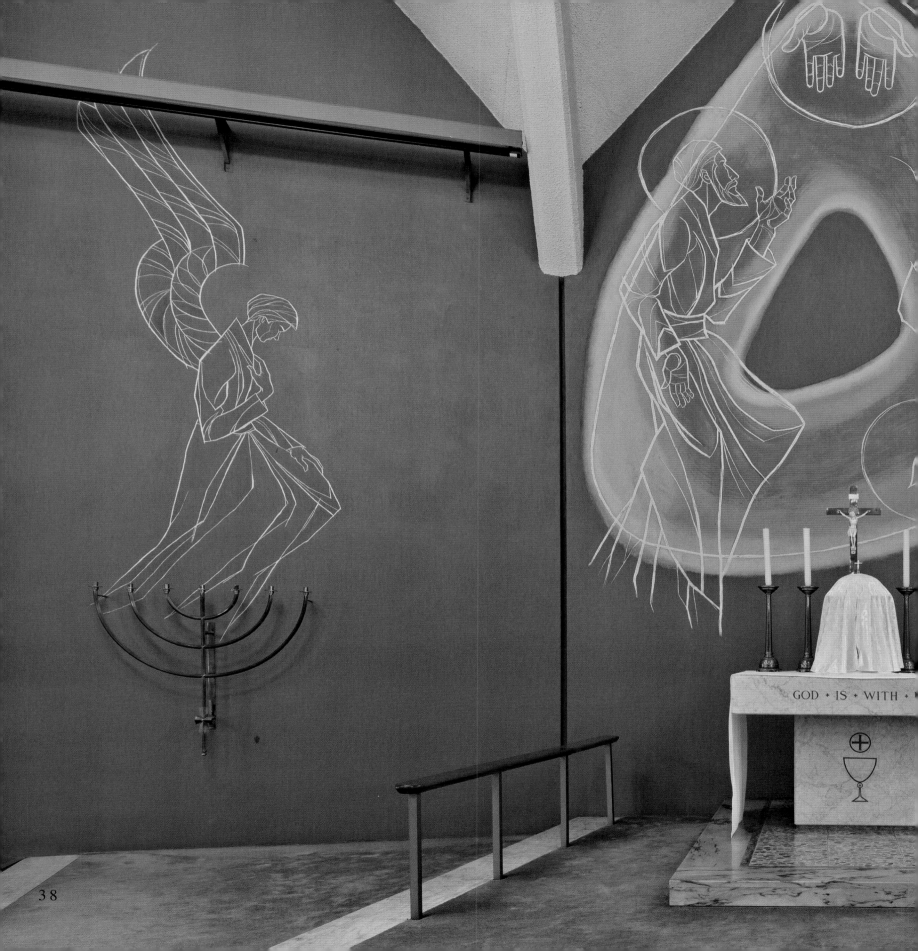

GOD · IS · WITH ·

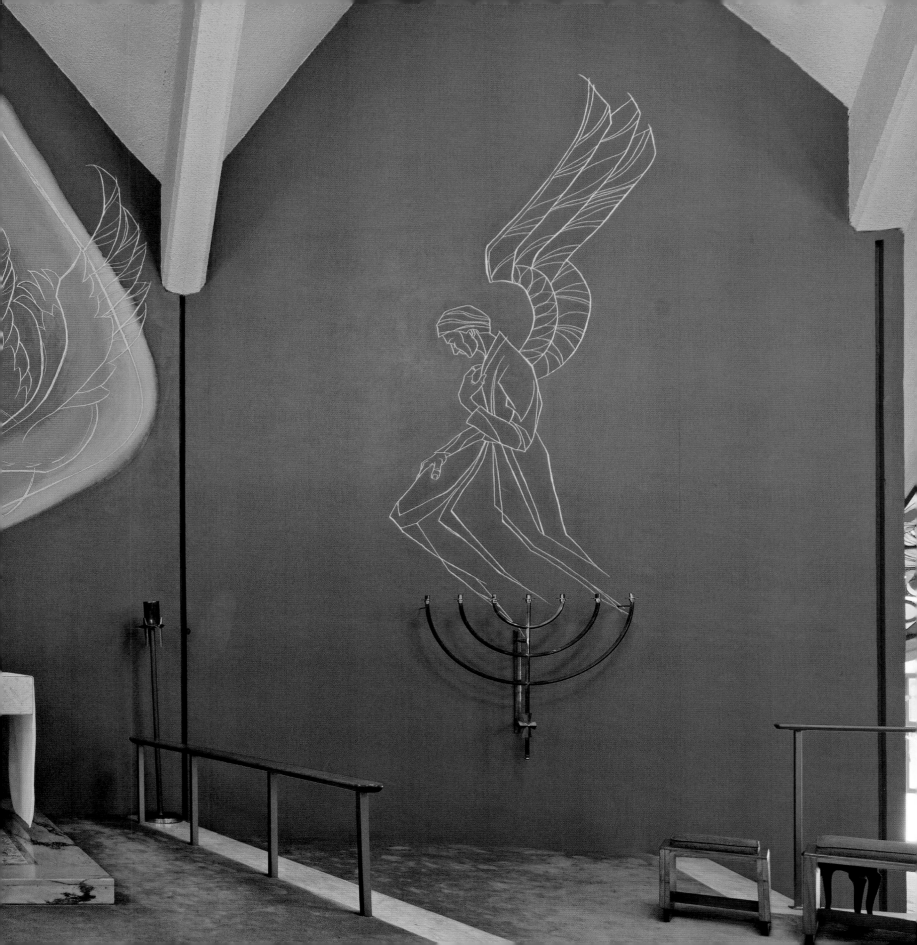

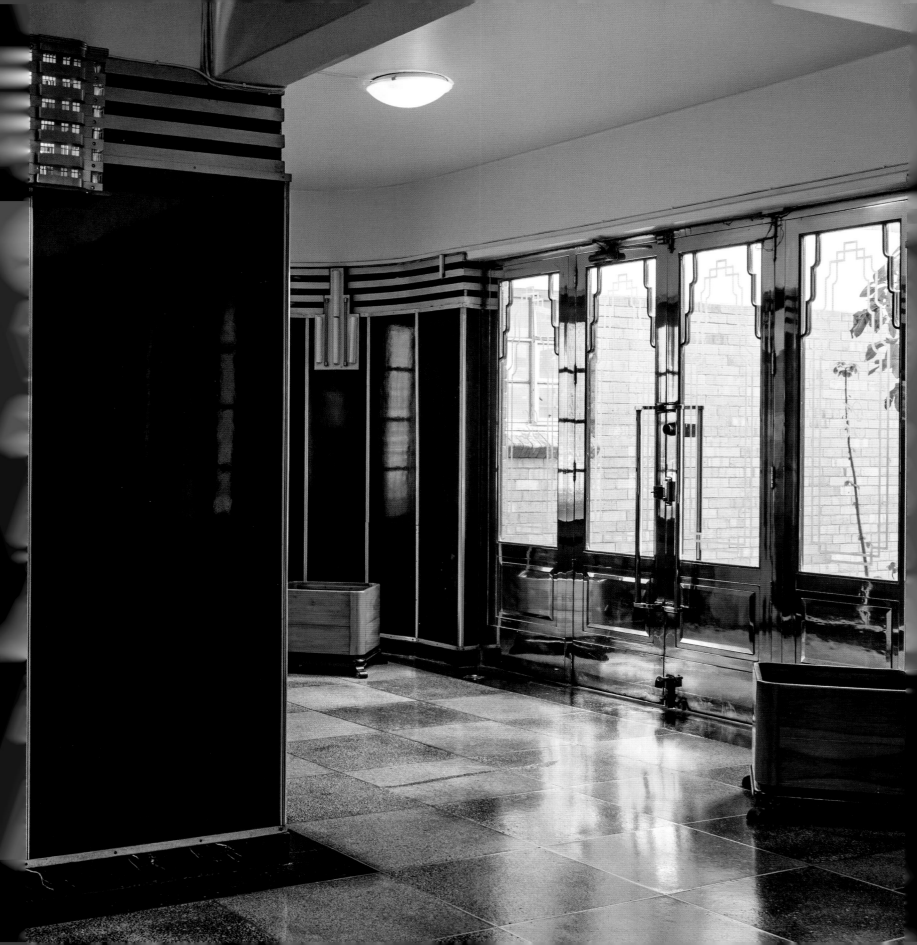

GLENEAGLES
1st Street, Killarney

In his book, *Lost and Found in Johannesburg*, Mark Gevisser describes a visit in 2012 to Killarney and his former apartment there, 'built in the mid-twentieth century for the more-comfortable elderly Jews who came to be associated with Killarney and who are still to be seen, perhaps less comfortable now, amid the gay people, students and large multi-generational families who now call the suburb home'. Mention Gleneagles, that Art Deco-ish, facebrick and stucco apartment block – the one with the pilasters framing the entrance with its gleaming brass doors – at the heart of this densely packed, leafy flatland and it seems that everyone knows somebody who lives, or has lived, there. Such is life in Killarney.

With well-planned, functional, generous accommodation, much of it still intact, Gleneagles was designed by JC Cook & Cowen and completed in 1937, just as Johannesburg was booming and apartment blocks were blossoming in a quasi-emulation of what was fashionable and modern in places like New York at the time. It's still a sought-after place to live. Daventry Court, a bit further away, is another – its 1934 Art Deco-inspired bulk sprawling along Riviera Road like a beached ship. There are others, too, here and in the old CBD, and their attraction today, provided you're not resident in one or other of them, is always the surviving entrance lobby, lifts and stairwells that, by and large, feature ornamentation that embodies the style of the period.

At Gleneagles, there's a magnificent Art Deco entrance to a lobby that displays everything that was novel, even innovative, in many buildings of the 1930s: panelling with aluminium trim, concealed tube lighting behind ribbed cast glass, and a black marble dado. Even the furniture seems to have survived remarkably intact, the hard Modernist chairs, tables and planters symmetrically arranged around the walls on either side of the handsome, gleaming brass entrance doors. It's an extraordinary thing to see, more so because it is polished to a gleam you could see your face in.

OPPOSITE The lifts are tucked away at the rear of the entrance lobby. As you approach them, a perfectly scaled aluminium model of the bulding's north façade greets you from its position on the wall (top left).

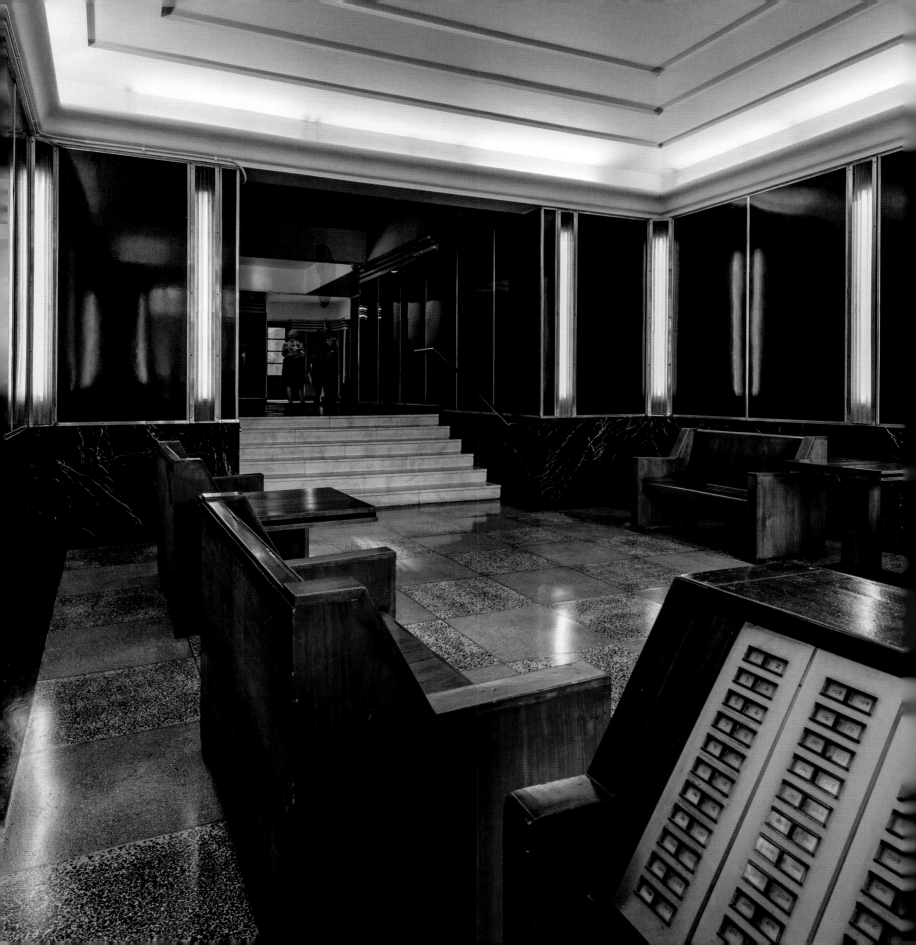

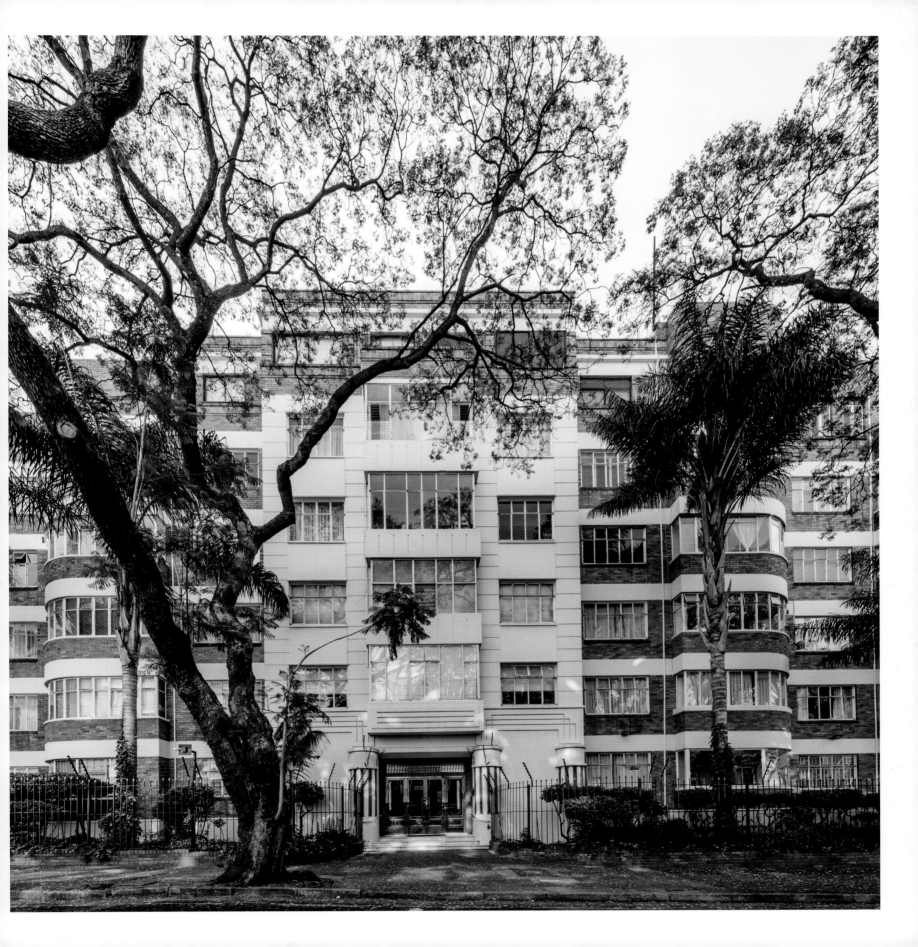

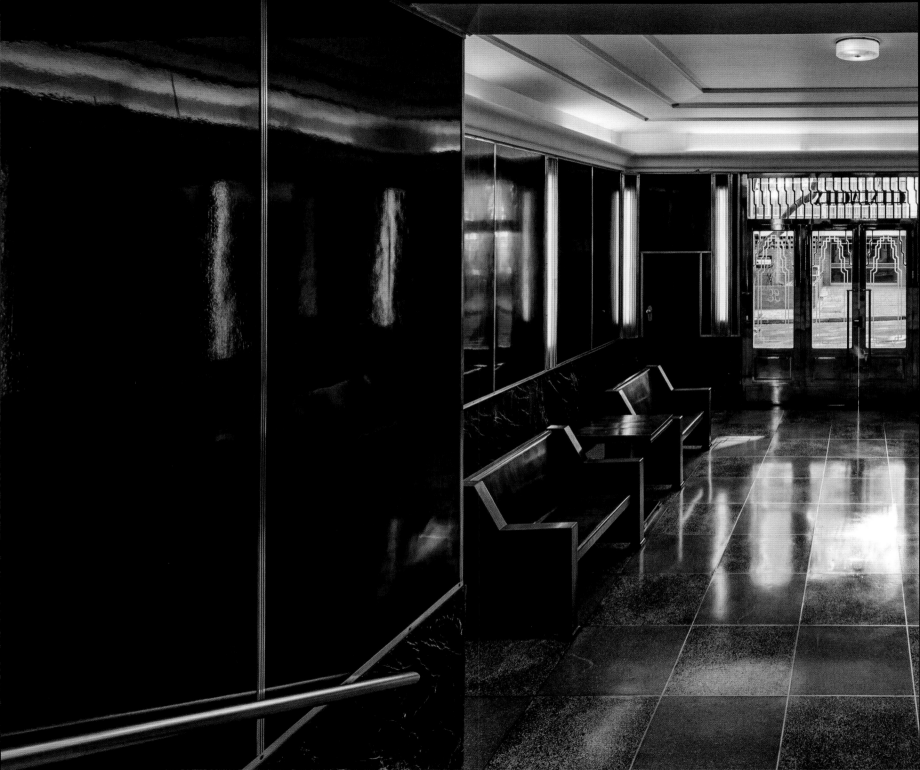

LEFT The building, its façade, the entrance lobby, and the apartments above, exude a lavish sense of luxury that attracted upper middle-class society to Killarney between the wars. *PAGE 42* Gleneagles' entrance lobby is a *tour de force* of Art Deco interior decoration. *PAGE 43* JC Cook & Cowen's huge north façade of Gleneagles is almost palace-like in the majesty of its design and symmetry of its layout.

PARK STATION

De Villiers Street, Johannesburg

At one time, all roads led to Rome, just as in South Africa all railway lines converged on Park Station, at the centre of the Witwatersrand's gold wealth, and in turn connected it with the rest of the country, in particular the coastal ports. A monument to transportation, in its design and execution Park Station was at the pinnacle of passenger transport in Africa. And while it's been extended and refashioned in the decades since the then Minister of Railways handed Gordon Leith the commission to construct (in association with Gerard Moerdijk) the new terminus in De Villiers Street, the discovery that the original structure has survived at all – its extraordinary vaulted concourses and crumbling green and grey marble-decorated Blue Room hidden behind locked doors – comes as something of a revelation to the many travellers who used it in the past and haven't given it a thought since. Completed in 1932, it's a monument to the aggressive potential of a prosperous, growing city, but it's also a reminder of a vanished urban culture. Travel by train was romanced in the years between the wars in line with the belief that this was the future of travel, whether by the Orient Express or Rhodes's dream of a Cape to Cairo route that would carry well-heeled expatriates and gold bullion right across a continent.

Park Station in its original incarnation was called Park Halt or The Halt. There was to have been a park nearby and it was where passengers alighted on their way to shop in fashionable Eloff Street. It subsequently became Johannesburg's primary station and, like the city itself, has gone through a number of reinventions, growing as quickly as its surroundings. In 1897, a steel and glass structure arrived from Holland and was in use until the late 1920s – in fact you can see its remains marooned on a derelict site west of the Nelson Mandela Bridge on the edge of Newtown. Leith's station opened in 1932 with eight platforms and four approach tracks, the contemporary of Milan's majestic railway terminus, Milano Centrale, completed in 1930 by Mussolini as a mirror of his aspirations for state power.

The foundation stone records that Gordon Leith was the architect in charge. His task was enormous, given that he had to come up with a building that promoted Johannesburg as a prosperous world-class metropolis on a site that not 60 years previously saw little action other than from the wild animals that roamed across it. The vaulted concourses are silent now, their lanterns covered in a film of mining dust, their fish ponds empty and the marble stairs leading down to them chipped and broken. And although the 32 painted panels that JH Pierneef supplied to South African Railways in 1929 – the Station Panels – have been removed to the Rupert Museum in Stellenbosch, their setting is still remarkably intact. *In situ*, they were a reminder of the fact that the Railways were responsible for the promotion of tourism both nationally and internationally.

Leith's entrance also remains intact, the disembodied elephant heads with their huge flapping ears still in position above the sealed-off entrances – along with the frieze and the row of coupled Tuscan columns holding up the roof. The exterior does nothing to herald an extraordinary interior that seems to look back with longing to the buildings of ancient Rome; a preoccupation of Leith's possibly since the time in Rome in 1911 when he surveyed the Flavian palace on the Palatine. But the ruins of Pompeii or the Baths of Caracalla in Rome have nothing on Park Station.

OPPOSITE After 1994, racial segregation ended, but so did the glamour of travel by rail as airports were expansively restructured. Urban decay took its toll on many once-busy train stations, but the elegance and style of Park Station persist.

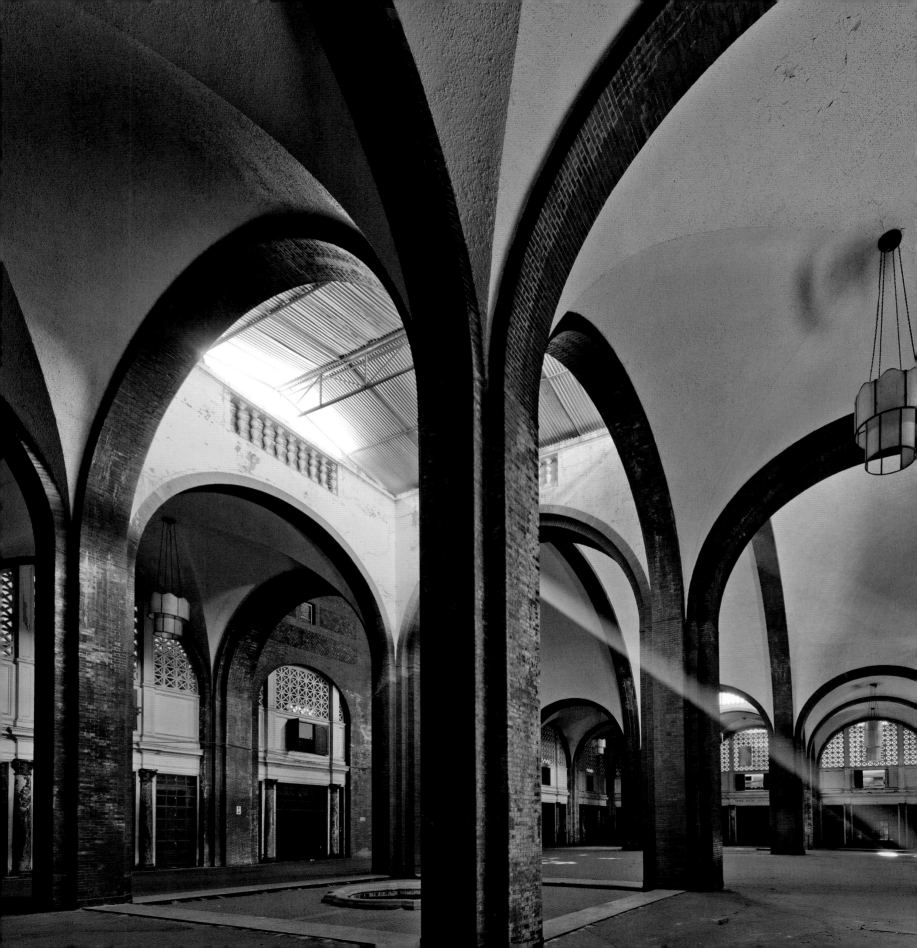

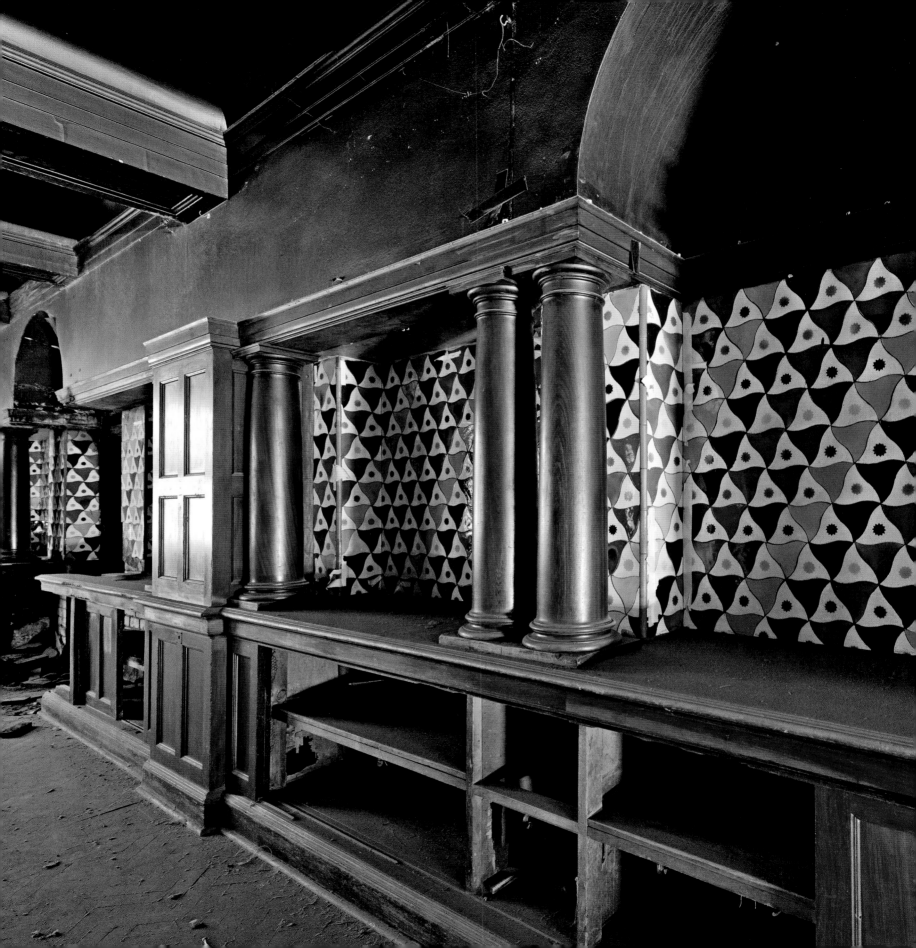

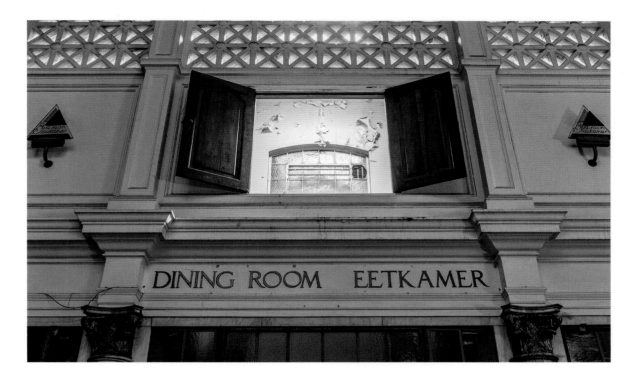

ABOVE Rather dismal signage from a different era survives to remind us that the restaurant at Park Station was once a glamorous dining venue.

OPPOSITE Established in 1926 in the defunct workshops of the Transvaal Potteries, founded in 1909 by Sir Thomas Cullinan at Olifantsfontein, the quality of the Ceramic Studio's work was favoured by architects; at Park Station it was promoted by Gerard Moerdijk. Gladys Short and Joan Methley were responsible for the geometric patterned tiles in the Ladies Bar that recall the decoration of the Alhambra in Granada, Spain. In fact, 'Miss Short specifically went to Spain to study the designs', said *The Star* on May 26, 1930. Spanish styles for architectural faïence were popular in the 1920s and 1930s and here at Park Station there survives a whole room of them. 'We dream tiles', said Miss Short. We do too, and wish these abandoned rooms had a secured future.

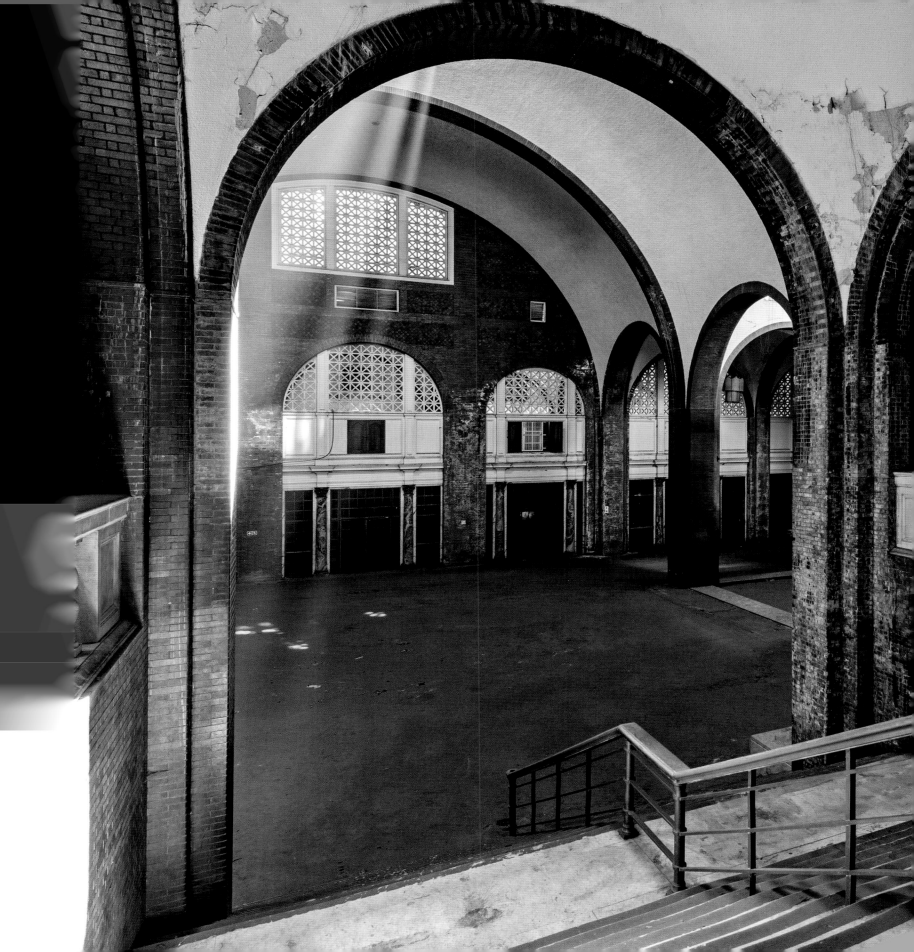

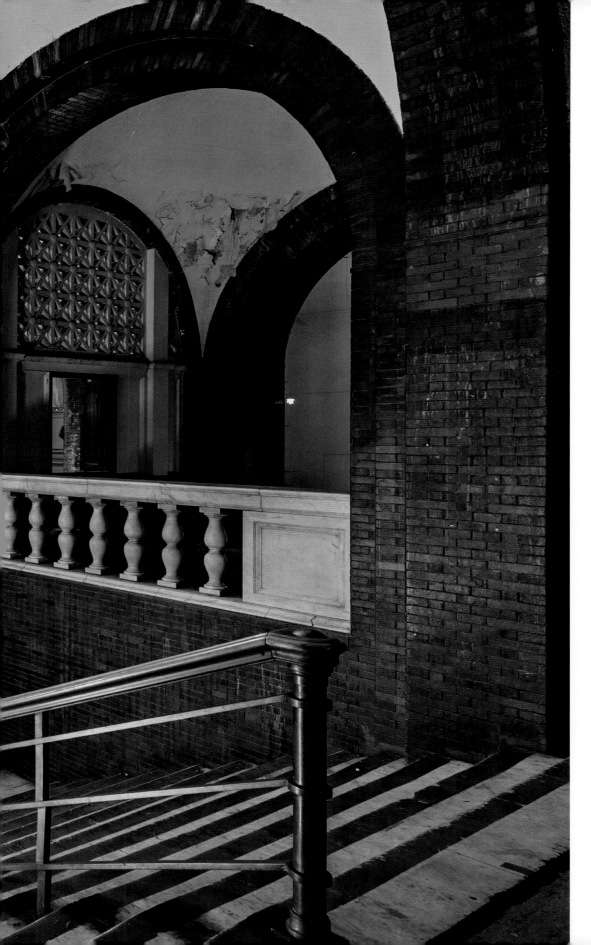

LEFT As a central terminus, Park Station had a certain predictable appeal: its proximity to Joubert Park and off-duty soldiers back from North Africa or Egypt during World War II made it a popular cruising venue nicknamed the *Via Ferra* (iron way). Like most railway and bus stations or airports around the world, cottaging flourished even in the grimmest days of Calvinist repression and grand apartheid. Later, in 1964, John Harris of the African Resistance Movement placed a bomb on a whites-only platform of Park Station in protest against apartheid. The bomb exploded, killing one person and injuring others, and Harris was eventually given the death sentence.

PAGES 52–53 The Blue Room, the 'whites only' restaurant, is still there. In a period when Johannesburg was almost devoid of public entertaining venues, the railway station assumed a certain importance as a social focus, and the Blue Room was, for a time, its glamorous epicentre. Here you'd come for New Year's Eve dinner, with white-gloved waiters serving you at tables dwarfed by monumental marble columns whose bronze caps and bases supported a coffered ceiling.

PARK STATION 51

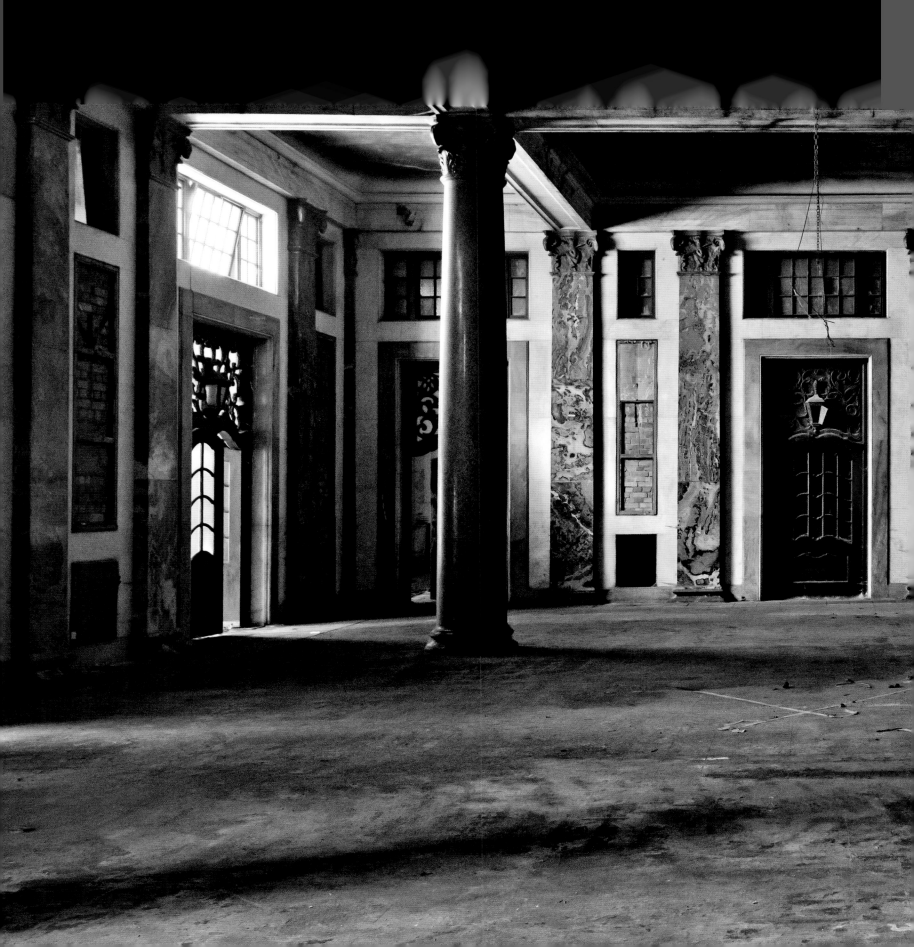

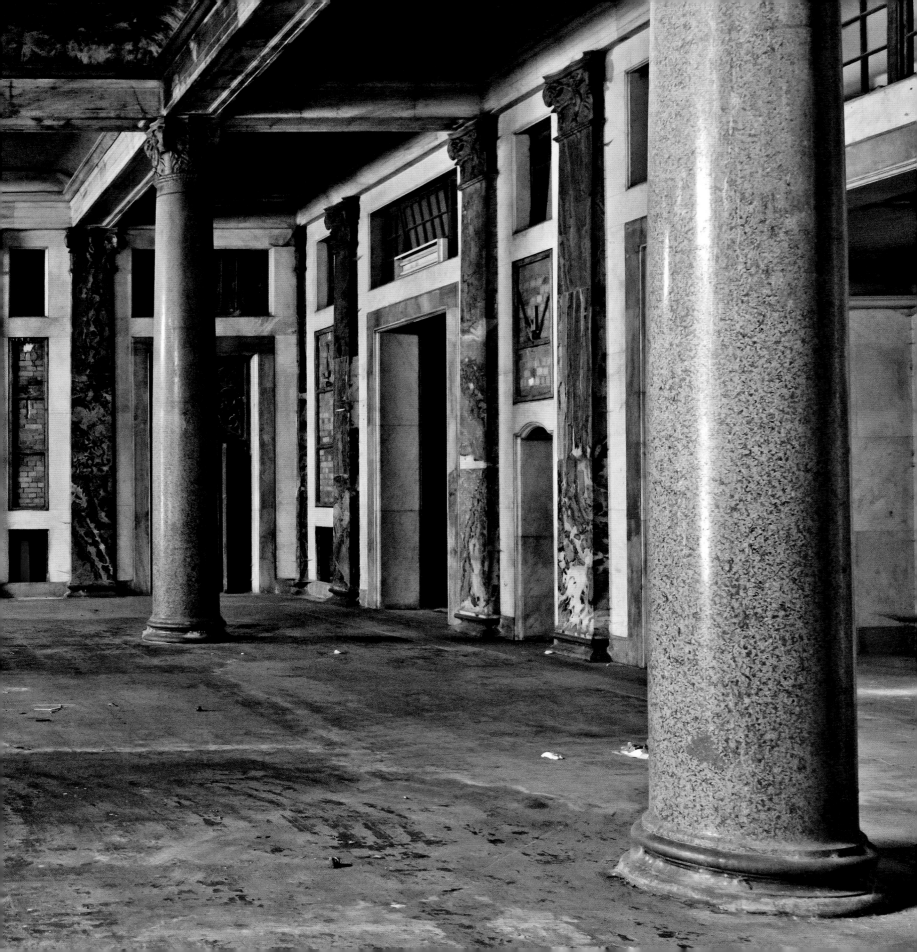

VISIT THE

Orange Free State

S.A. RAILWAYS

LEFT Johannesburg's railway station was, in its day, the main point of embarkation for visitors, whether tourists or businessmen, as the age of air transport had yet to arrive. The proof can still be found in a locked warren of dark passages in which still hang, incredibly, posters from the 1940s and 1950s promoting rail travel across the country.

OPPOSITE Ceramic tiles, and their exotic colours and designs, were the work of the women of the Ceramic Studio – the precursor of Linnware. 'They stand out because of the depth and complexity they achieved with the glazes', notes Jo-Marie Rabe of Piér Rabe Antiques in Stellenbosch.

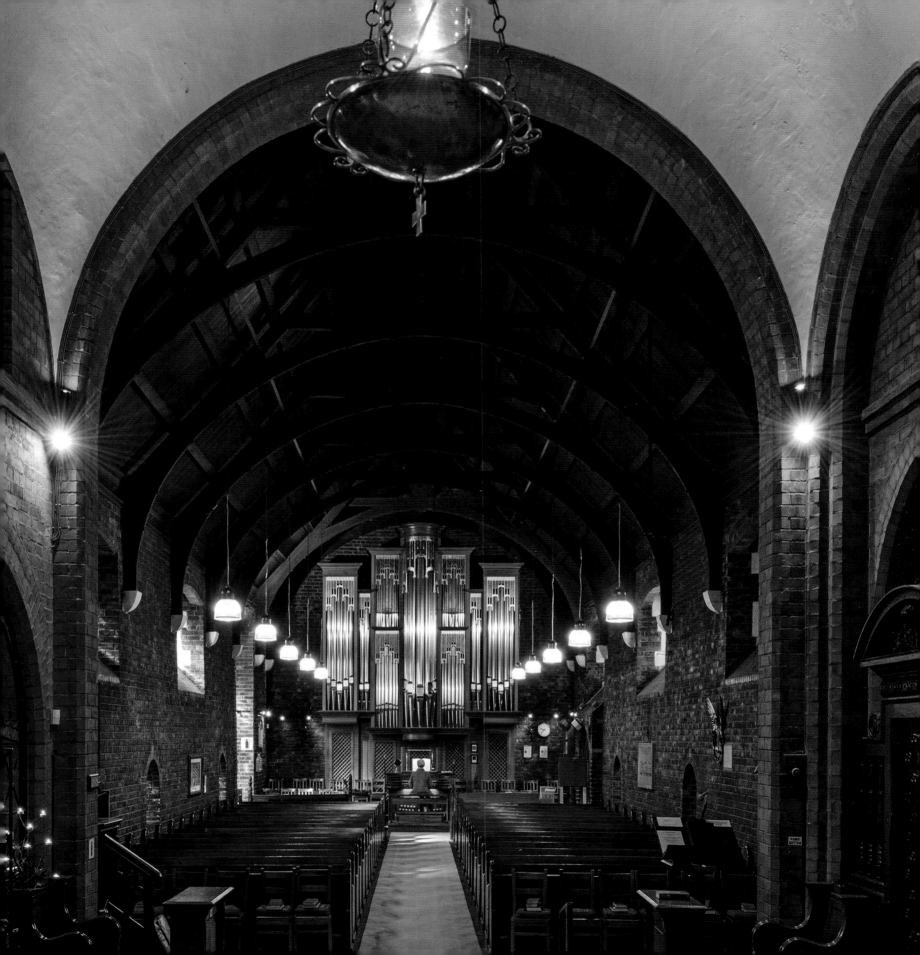

ST GEORGE'S ANGLICAN CHURCH
Sherborne Road, Parktown

There is no denying that Anglican churches of the colonial period in South Africa have had their cultural baggage – the flags and bunting, plaques and gravestones celebrating Empire, wars and misplaced missionary endeavours – but these days the Anglican Church of Southern Africa is undoubtedly the organization's most liberal province as regards same-sex marriage and the ordination of women. In addition, the architecture itself is a solid and beautiful legacy, from Sophia Gray's neogothic parish churches in the Cape and the Karoo to the Arts and Crafts churches of Herbert Baker.

St George's was the first of the many Anglican parish churches that Herbert Baker's firm was to design in the Transvaal. The main structure of the church dates from 1904, but the choir and tower date from 1910 when the building was re-orientated. While Baker himself is supposed to have conceived of the building at the beginning, his partners, Francis Masey and Frank Fleming, variously had a hand in taking it to completion. Using hard stone cut from the surrounding koppie indicates Baker's commitment to the Arts and Crafts philosophy of using local material as far as possible. This, combined with an authentic, high standard of traditional methods of craftsmanship, established a picturesque style of building – almost otherworldly on the Highveld – that became popular in Parktown, in particular in the designs of Northwards and Stonehouse, and Glenshiel in Westcliff.

But this little rough-hewn parish church of the Randlords, with its rounded apse, pitched red-tiled roof, and a shadowy, ascetic interior relieved only by coloured light from the stained glass, has a primitiveness about it that's perhaps a mirror of the world it inhabited. It was built as a sanctuary and refuge in an uncertain time. As with the brutish little fortress-like Norman churches built by the Christian pioneers of the early Middle Ages in England which it apes, St George's is a severe reminder that the world outside – in this case a rough, every-man-for-himself, early twentieth-century Johannesburg, at the time a scant two decades old – was harsh for all those who, quite literally, were breaking new ground daily on the Witwatersrand. For these pioneers, St George's was their rock.

OPPOSITE The only thing 'local' about this traditional English-looking church, with its solid-beamed roof and stained-glass windows, standing on a koppie in Africa, is the stone from which it's been built.

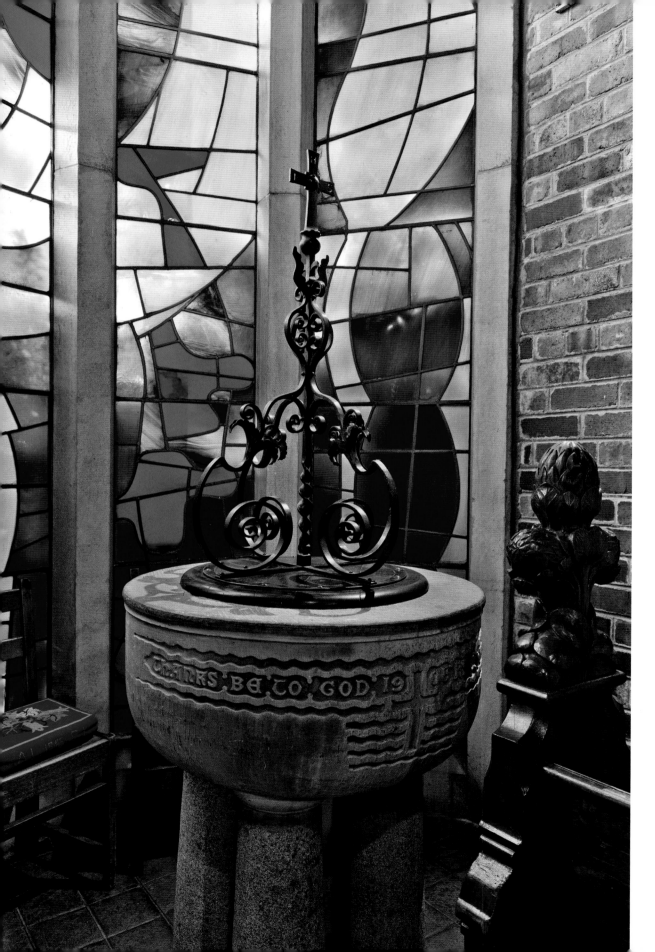

LEFT AND OPPOSITE The new with
the old: stained glass adorning the
windows features prominently in
St George's interior. In the modern
window (*left*), the blue is purely
symbolic, indicating heaven, hope
and piety. The traditional windows
(*right*) depict biblical events in
representational form, as was done
in medieval times to enable the
illiterate to understand the Bible.
PAGE 60 A little corner of medieval
England is perfectly conjured up
by the architects for whom the
Arts and Crafts philosophy of
mentoring traditional methods of
craftsmanship was key.
PAGE 61 A new addition, in 2012,
to St George's, the Rieger organ
ensures that this church has a
healthy future as a music venue.

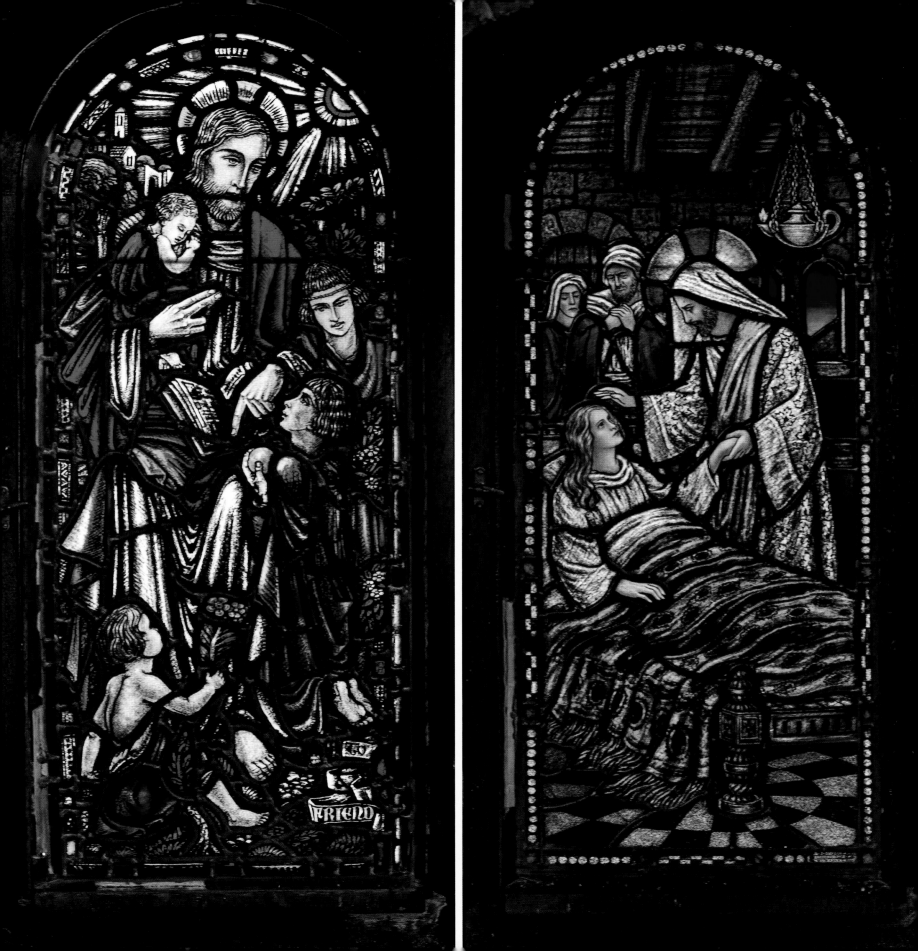

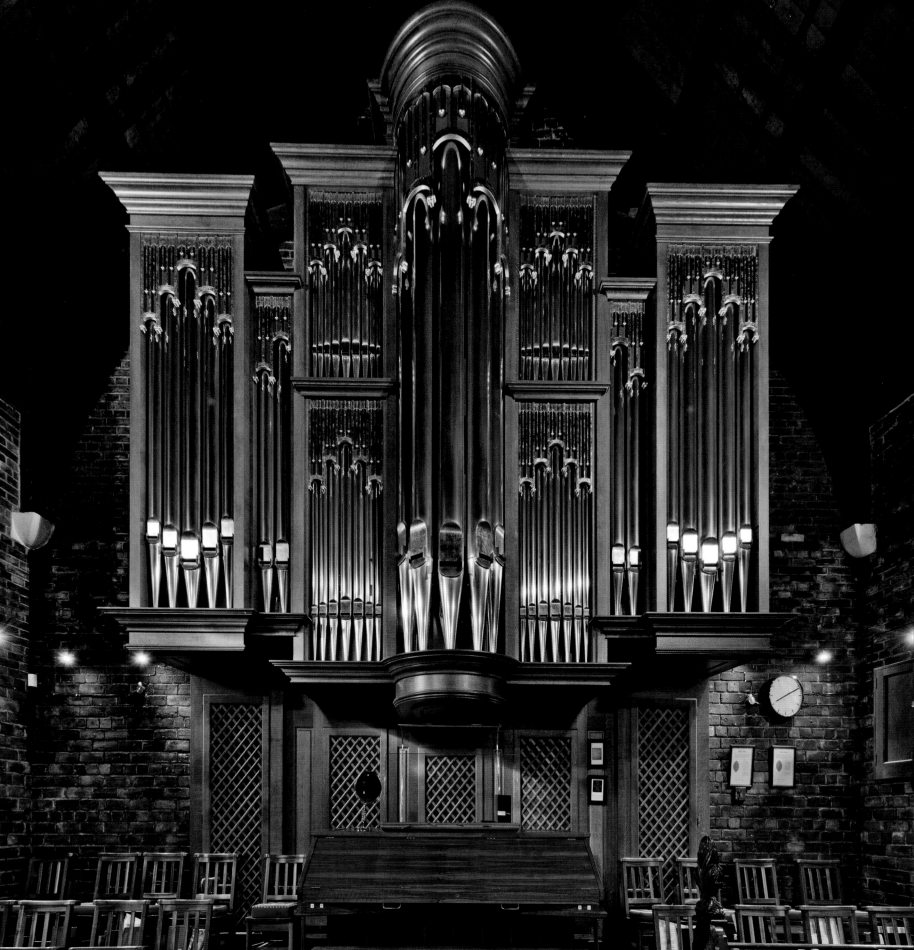

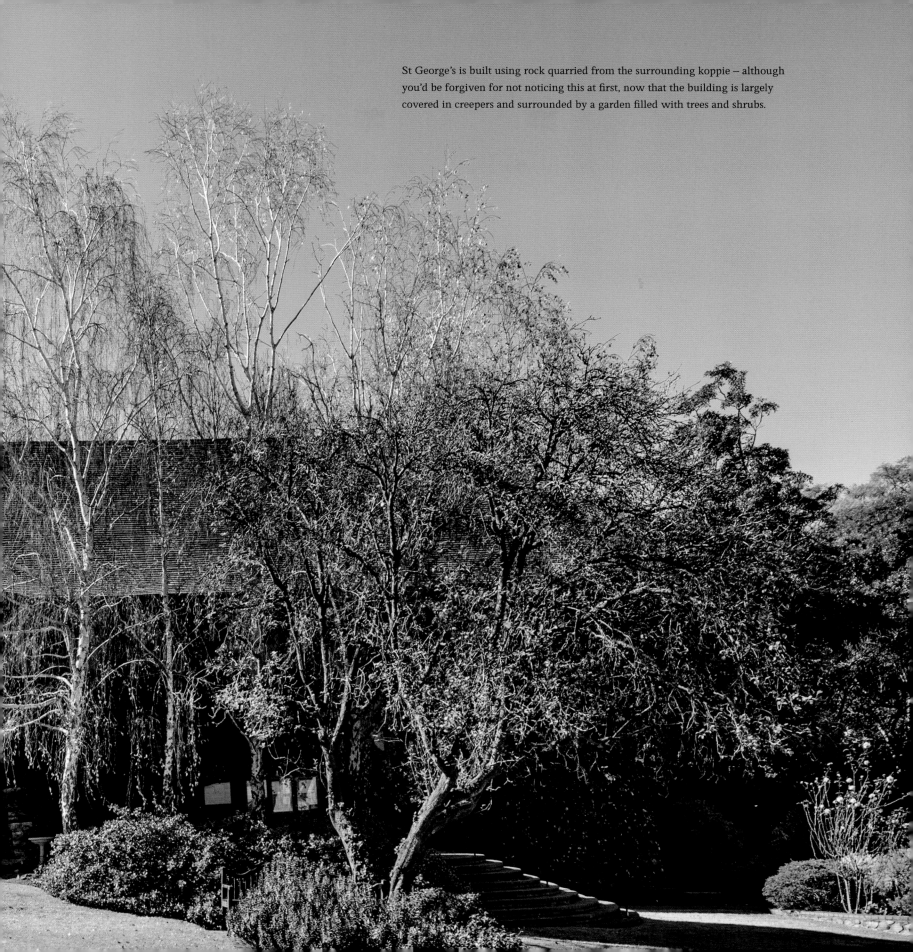

St George's is built using rock quarried from the surrounding koppie — although you'd be forgiven for not noticing this at first, now that the building is largely covered in creepers and surrounded by a garden filled with trees and shrubs.

L RON HUBBARD HOUSE
Hannaben Street, Linksfield Ridge

Who was L Ron Hubbard (1911–1986) and what was he doing living in Linksfield Ridge? In *L Ron Hubbard, A Profile*, the founder of the Church of Scientology is described as 'an adventurer, explorer, author, philosopher… a man who lived no cloistered life…' Lafayette Ronald Hubbard was, in fact, an American pulp science fiction writer who developed a system of Dianetics ('The Modern Science of Mental Health') as a way of healing the self, spreading his message through the Church of Scientology, the controversial and secretive religious movement that he founded in the 1950s. Everyone's heard of the Scientologists, not least because numerous Hollywood celebrities, including John Travolta and Tom Cruise, are involved with the worldwide organization. The house in Hannaben Street is where Hubbard lived during his South African sojourn and it's been meticulously restored to reflect the period he lived there.

In 1957, an office of the Hubbard Association of Scientologists International opened in Johannesburg and this marked the formal beginning of the expansion into South Africa by the Church of Scientology. While he was here for only six months in 1960–61, Hubbard developed much of the structural and organizational aspects of Scientology. He also taught the state security services how to use E-meters to detect subversive terrorists in interrogation, expressing support for HF Verwoerd, the architect of grand apartheid. Later, it was claimed that in 1960 Hubbard authored a gradual 'one man, one vote' constitution for 'apartheid-shackled South Africa' that would allow whites to retain power, but this remains unproven.

The house is only one of a number of places connected with the Scientology founder. There are others, in London, East Grinstead (UK), Washington DC, New Jersey and Phoenix, Arizona. The Johannesburg house has been painstakingly restored to its 1960s state, as captured by Hubbard in photographs and film footage. His life and achievements are laid out in the upstairs rooms as a sort of homage, well documented with photos, letters and artefacts depicting him as a Boy Scout, seaman, glider pilot, and writer of more than 300 science fiction titles. Here, in his South African home, announces *Walk in Ron's Footsteps*, 'he championed rights on behalf of Black Africa…' There's an aura of hagiography about the place. Hubbard would later describe his time here as instrumental to Scientology's development. The brochure you get when you visit deems it a 'landmark site', and a place of 'supreme significance'. Following its restoration, 'visitors are effectively teleported back in time to pivotal moments of discovery and thus revelation' – via a 1960s-era fridge and an Oregon pine accent wall amongst a range of other well-chosen mid-twentieth-century modern collectables.

Shrine or museum, the house on Hannaben Street is an exceptional post-war Modernist building, designed in 1951 by Frank L Jarrett for a Greek timber merchant called Manos Broulidakis who spared no expense in using the richest of timbers for its interiors. Jarrett is also remembered for having designed Chancellor House in the late 1940s, the three-storey building in Ferreirastown that housed, from 1952–1960, South Africa's first black law firm, Mandela & Tambo Attorneys. Flo Bird, when 'opening' the restored house, mentioned that it was the first 1950s house in Johannesburg to attain heritage status.

OPPOSITE The kitchen is a masterful recreation of what the room might have looked like in Hubbard's time. The red leather banquette is new, as is the blue lino, the original of which was removed in the 1990s. The restorers managed to track down a supply of the original material in the USA and it's been used here and in the bathrooms.

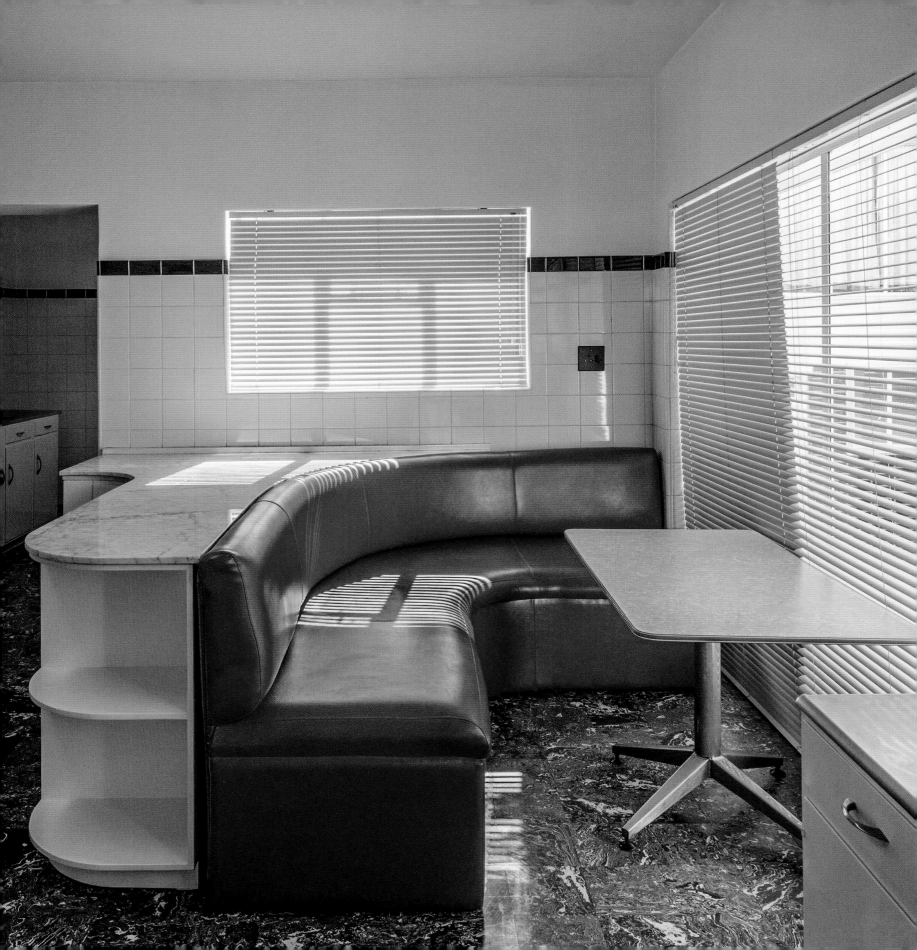

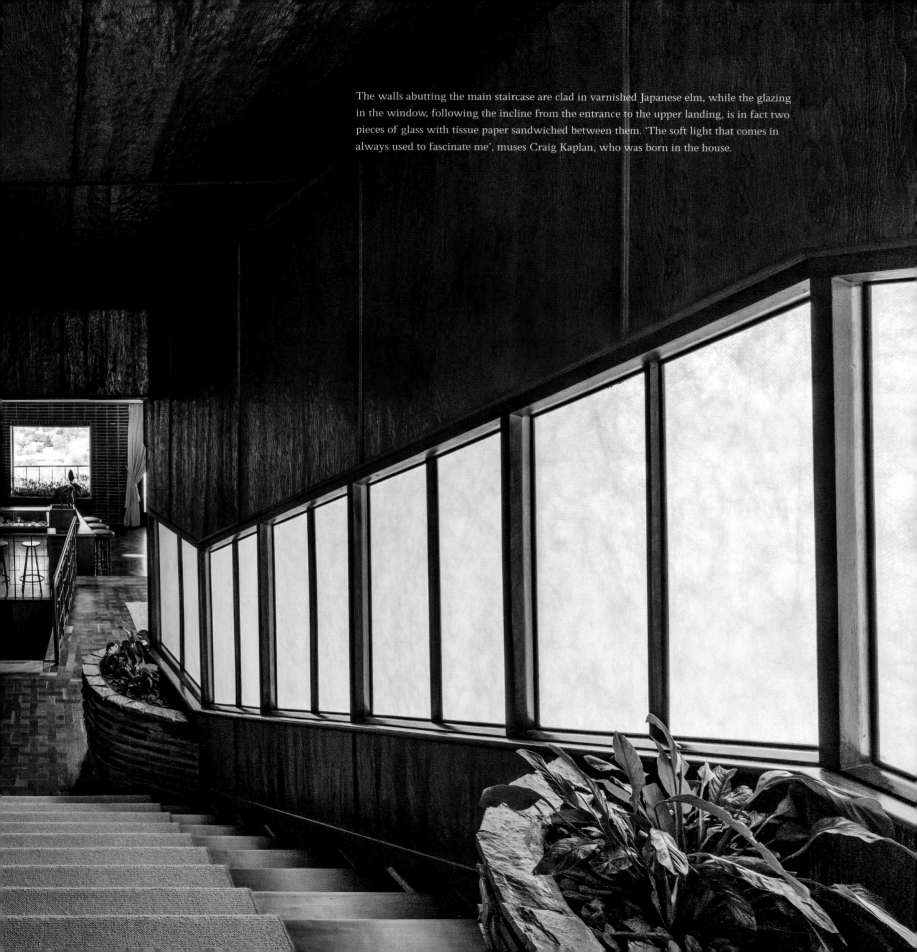

The walls abutting the main staircase are clad in varnished Japanese elm, while the glazing in the window, following the incline from the entrance to the upper landing, is in fact two pieces of glass with tissue paper sandwiched between them. 'The soft light that comes in always used to fascinate me', muses Craig Kaplan, who was born in the house.

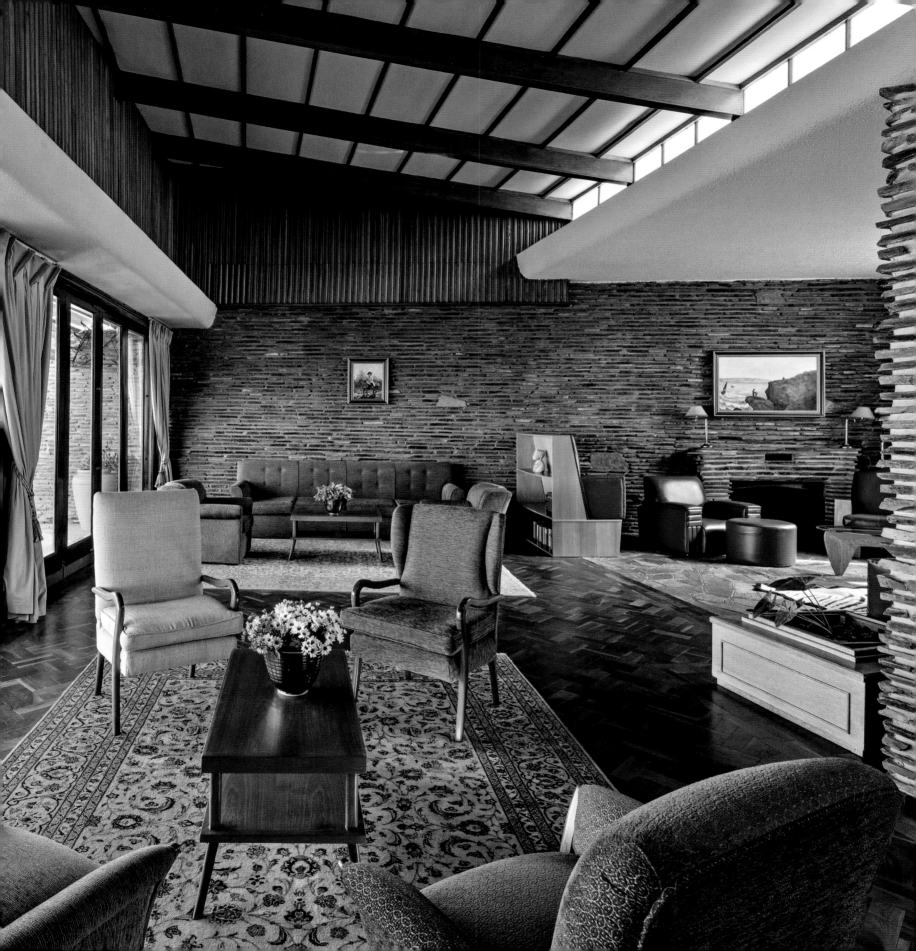

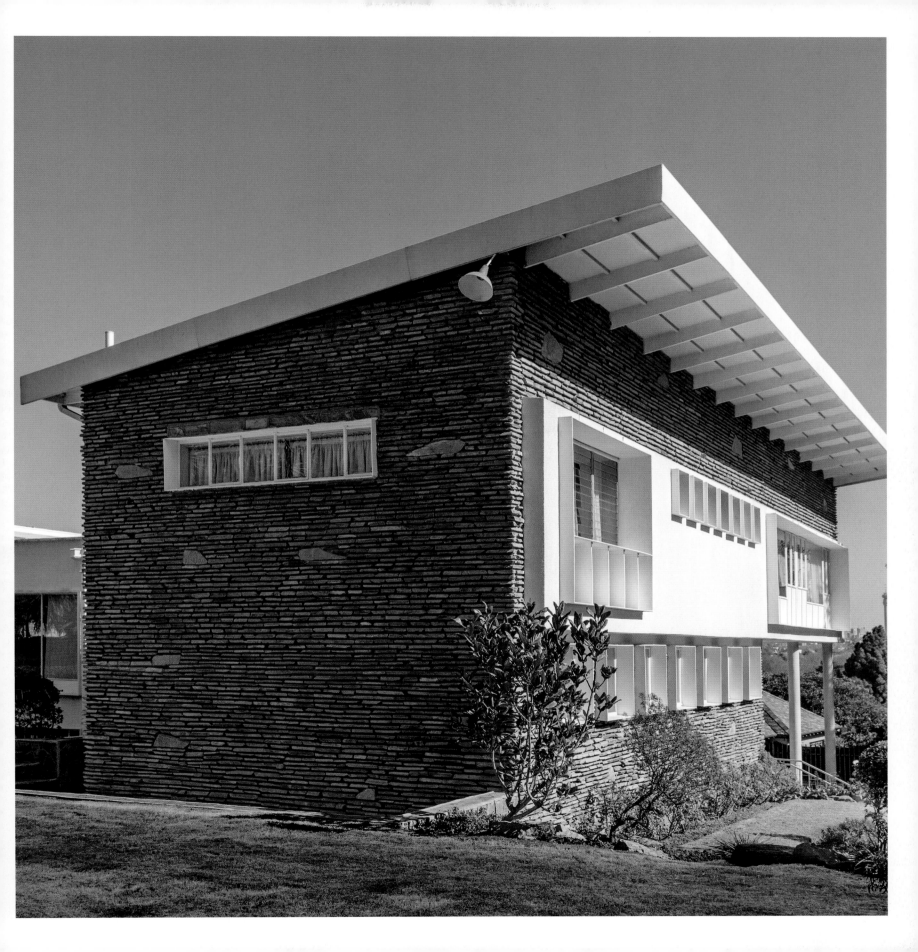

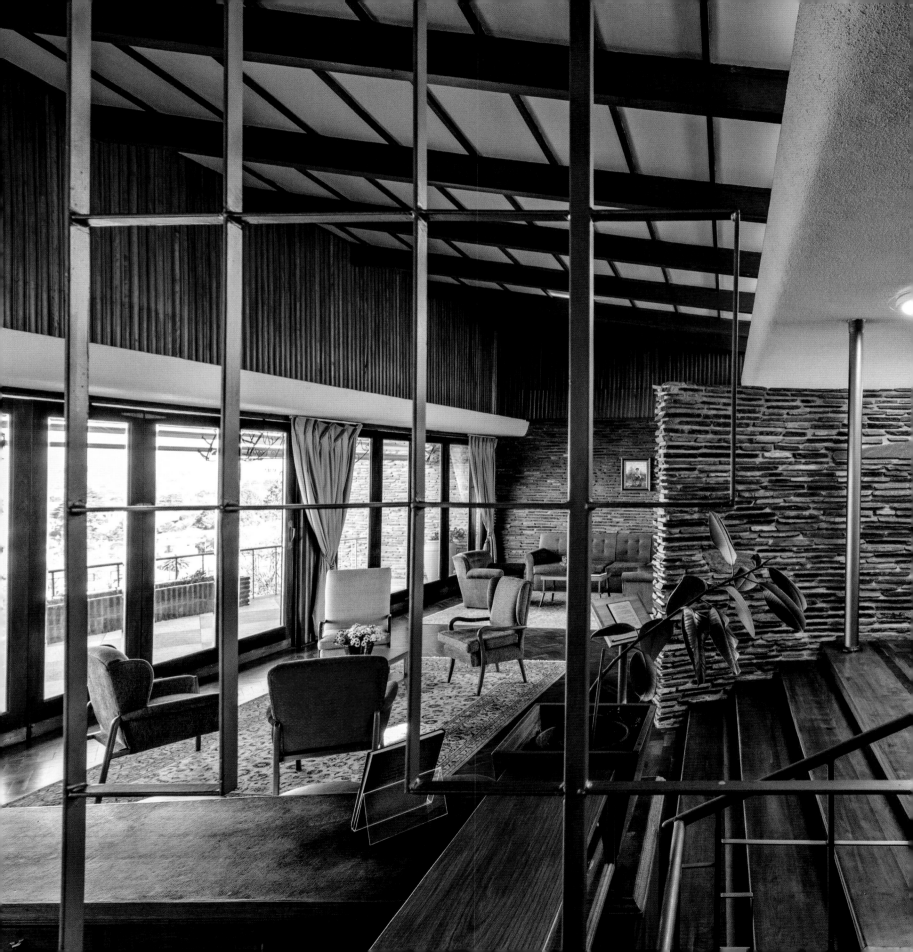

LEFT The view from the dining room across the entrance hall to the sitting room through the original burnished metal screen. The play of multi-levels is an important feature of the interior of the building; the drama they incite reaches a crescendo on the terrace, with its vertiginous drop to the view beyond.

PAGE 68 Essentially a single room, the sitting portion of this living space is separated from the study area on the right by a change in floor materials, the transition between the two marked by teak parquet in the former and slasto in the latter. A change in ceiling heights confers physical definition. 'The fireplace never heated anything', says Craig Kaplan. 'This is an unimaginably cold house in the winter months'.

PAGE 69 The house, designed by Frank L Jarrett, is an exceptional post-war Modernist building and, according to Craig Kaplan, was very avant-garde even when it was built. 'When my mother bought it from Hubbard, it was the antithesis of the conventional family home'.

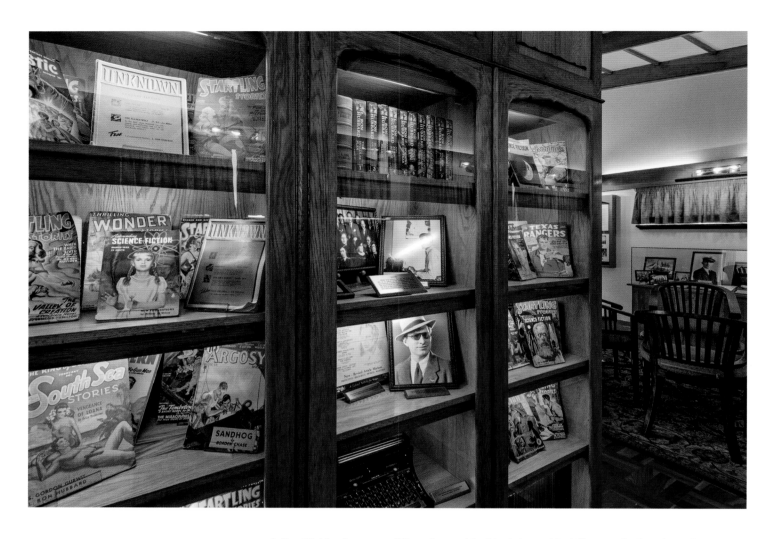

ABOVE L Ron Hubbard was a prolific writer, and in this shrine to his skills are to be found novels spanning all popular genres, including mystery, romance, adventure, fantasy, Westerns and science fiction.
OPPOSITE Original two-tone chequerboard terrazzo lines the surface of the terrace that's cantilevered above the pool deck. Beyond, there are views over Johannesburg's eastern suburbs.

CORNER HOUSE
Corner Commissioner and Simmonds Streets, Johannesburg

The Corner House has always been a part of Johannesburg lore. It began life as Beit's Building, a wooden shack with an iron roof, and was transformed into something more solid in 1889, later to become the home of Hermann Eckstein & Company, which was a branch of Wernher, Beit & Co. The names of Julius Wernher and Alfred Beit are synonymous with diamonds and Kimberley. With the discovery in 1886 of gold on the Witwatersrand, they added gold mining to their interests, appointing Hermann Eckstein as their representative in Johannesburg. From the Corner House, Eckstein was instrumental in establishing the Chamber of Mines, and formalizing production so that what were, at the time, just random mine workings, became a structured industry. On the other side of the street was the Stock Exchange and much of the dealing was done out-of-doors in a chained-off area between the two buildings. Corner House was famous then – and is famous now – if only because it was the seat of a company that once controlled the world's richest gold mines; the Corner House acted as a holding finance company for the mines its occupants floated, and had control over appointments and major decisions. The Corner House partners kept one-fifth of the profits and were free to invest on their own account.

Eckstein's old three-storey building was demolished in 1902. Its replacement, the building you see there today, is the work of Leck & Emley. Built in 1903, and the third Corner House on the site, it had, and still has, a copper-clad projecting central bay that's just one of an array of characteristic features.

At 10 storeys high, the Corner House was Johannesburg's first 'skyscraper'. Structurally, it comprised a steel frame, over which a skin of red-brown cut stone from Warmbaths was layered. The steel frame is arguably the building's most important characteristic because, at that time, it pushed the boundaries of construction technology in the way that American architect Louis Sullivan's buildings in early Chicago had done, changing the rules around a building's height through the insertion of steel girders as a skeleton that could support tall, slender buildings. The rest of the building – walls, floors, ceilings and windows – would be suspended from the skeleton, which carried the weight. The blockish Corner House even resembles a Sullivan building; as does the addition, to so simple a structural element, of heavily wrought surface decoration. Clearly the Corner House, like the buildings of Sullivan, indicates a moment of transition in construction and design. The idea that form should follow function was born.

OPPOSITE At 10 storeys high, and surmounted by a cupola and corner 'turrets', this magnifient edifice was South Africa's first skyscraper. Alongside it, to the left, is what was the National Bank, which architects Leck & Emley designed, along with Corner House, as though they were a single massive building.

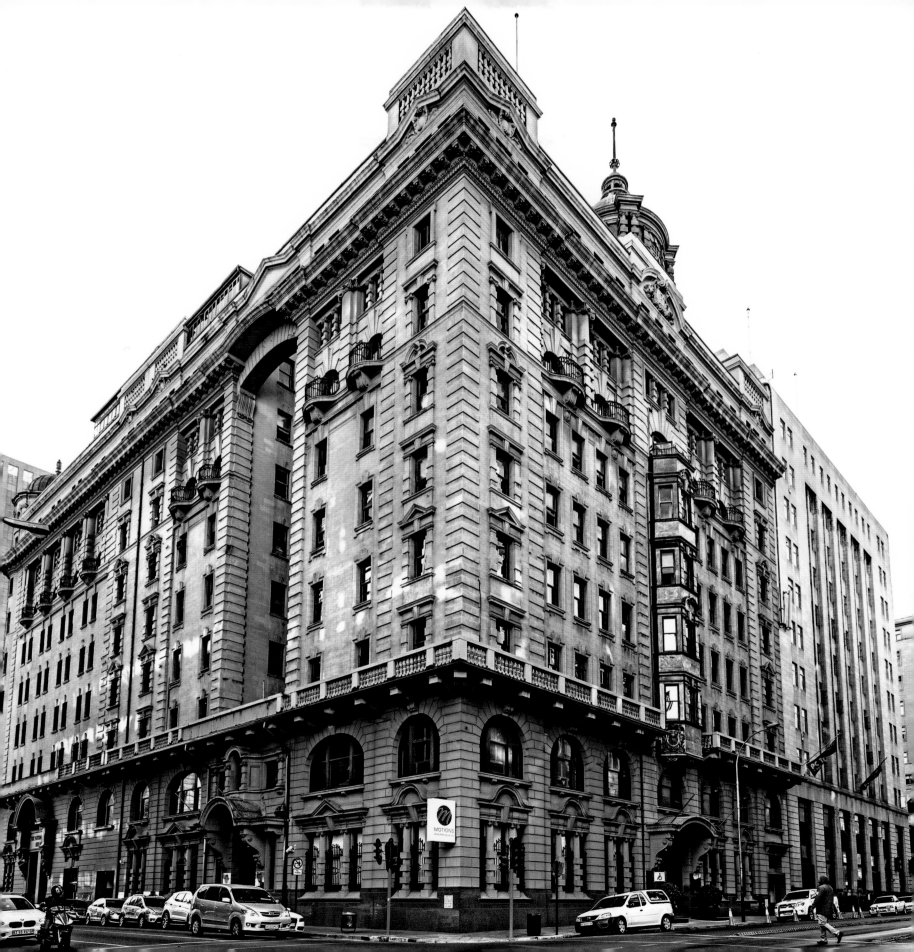

RIGHT Corner House is an opulent building and the attention to detail paid by its architects on its appearance is nowhere more apparent than on the staircase. Its occupants benefitted from the latest in modern comforts, and were provided with water-borne sewerage and central heating.

76

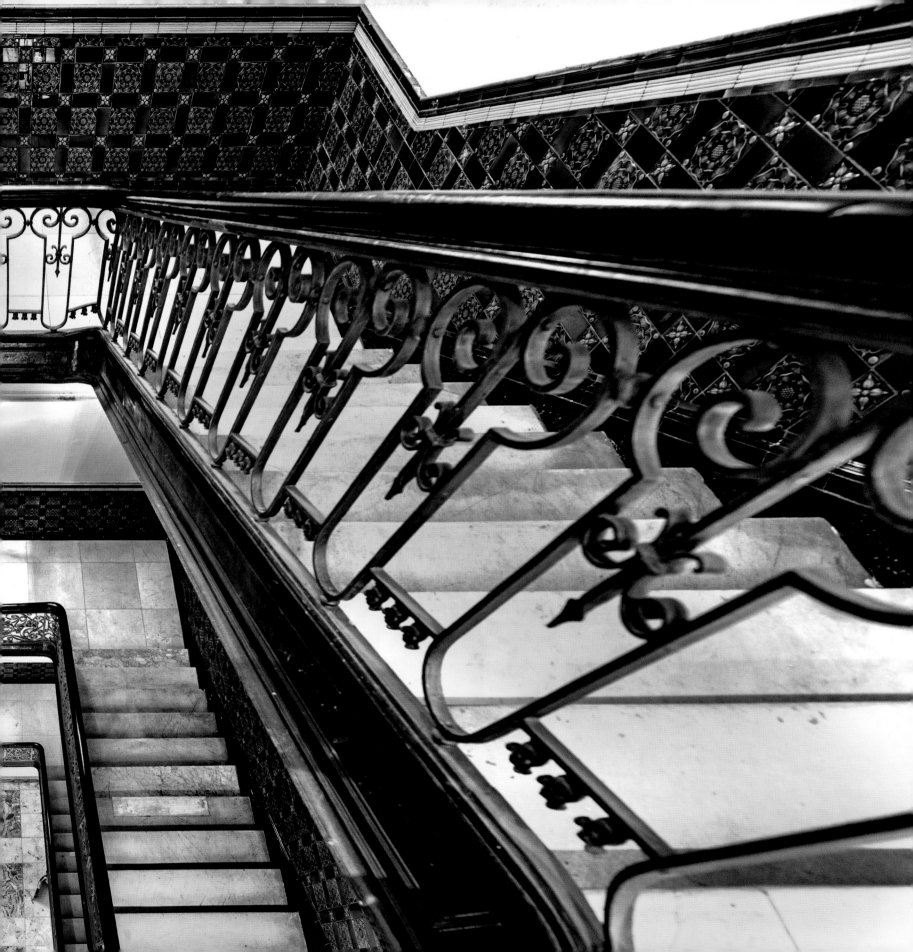

ABOVE If you study its façade closely, you can pick out that eclectic mixture of styles the Edwardians were so fond of —
here ranging from Continental Beaux Arts to Arts and Crafts and Art Nouveau.
OPPOSITE The Corner House was given a new lease on life in 2003 when, following the flight of business to the
northern suburbs, it was purchased by a property development company and converted into workspaces for legal
professionals, start-up entrepreneurs and creative companies. It also houses a luxury penthouse.

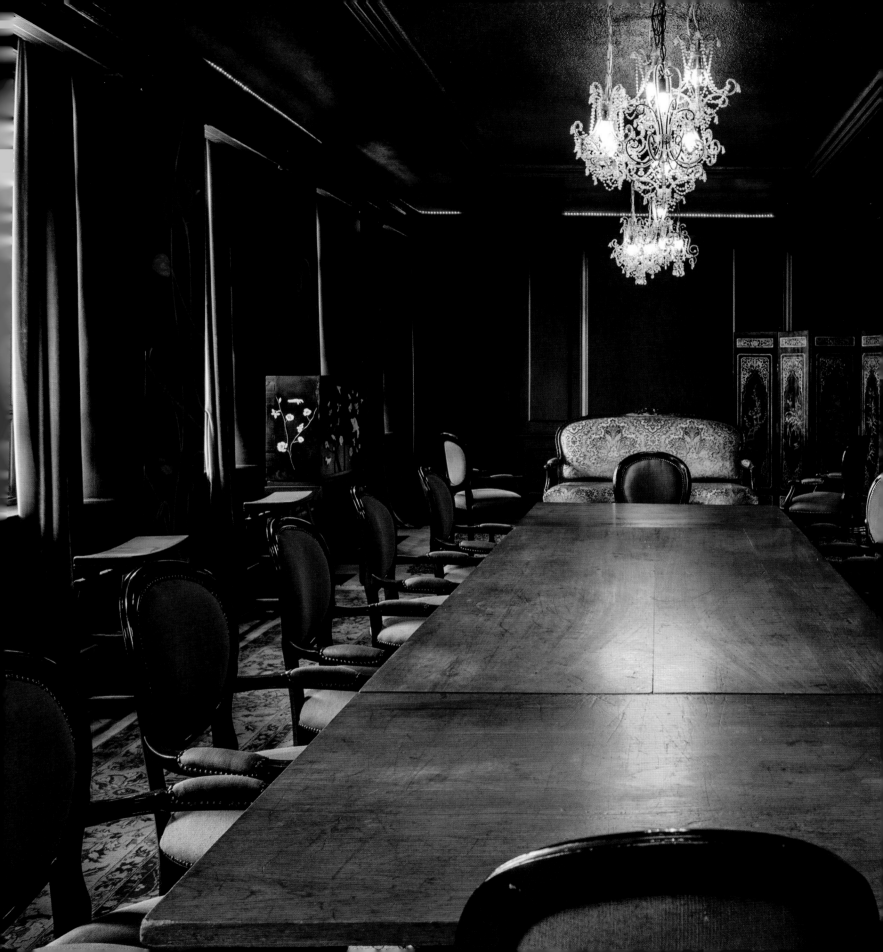

HOUSE EDOARDO VILLA

4th Street, Kew

Not many deceased artists' homes have survived in South Africa with their contents even partially intact. One or two notable exceptions spring to mind: Irma Stern's rather sterile home and studio in Rosebank, Cape Town, now a museum, and the painter Christo Coetzee's madly theatrical home in Tulbagh. Now there is the home of Edoardo Villa, probably the most important South African sculptor of the twentieth century.

The house, in the Johannesburg suburb of Kew, is on a property that he bought from the painter Douglas Portway, and onto which he moved with his new wife, Claire Zafirakou, when they were married in 1965, living first in Portway's old homestead at the damp bottom of the garden – subsequently the studio where Villa worked with Lucas Legodi, his longtime studio assistant – before building their own house in 1968 higher up the site. Then, as now, the building stands out amongst the suburban villas that surround it; an extraordinary, rough-cast, even brutal, structure designed by Villa's friend, the little-known but charismatic architect Ian McLennan.

Today it's owned by Warren Siebrits, curator, writer and art collector who, with his partner Lunetta Bartz, bought it in the years following Villa's death, at 95, in 2011. Siebrits is happy to take visitors on a tour of its interior and show them what has survived of its original content and fittings. Siebrits, whose own home in Illovo is by Michael Sutton and David Walker, will also discuss his plans for a reinvention of the private sculpture court that once characterized Villa's garden and saw it filled with the sculptor's own work. A passionate Villa fan and maverick collector of his work, Siebrits envisions a museum here that, in time, will be open to the public. Having been friendly with Villa for years, he visited the Kew house many times and consequently understands how the sculptor lived and worked there. In addition to works by Villa himself and by artists from within his circle, Siebrits has added contemporary works by, for example, Michael McGarry and Belinda Blignaut.

But the real importance of this building in the hands of its new owner-curators is that they understand the contexts for Villa's life and work. The house sits on a secluded site on an anonymous road, surrounded by indigenous and sculptural plants and trees. Both the house and garden were once a haven for friends, relatives and fellow artists who came to see the sculpture and stayed to share in lively debates and meals around a dining room table designed by McLennan and still *in situ*.

As Siebrits himself has written, 'Villa's prolific output was aided by the fact that he lived no more than a few paces from his studio for 50 years, which meant he encountered few of the everyday frustrations of spending time commuting to and from his place of work. This decision to work from home not only saved him enormous amounts of time and money, but also kept his creative energy distilled and focused'. We've all seen those massive works by Villa. Virtually every one of them emerged from the small studio that survives at the bottom of his garden.

OPPOSITE Today, the villa houses Warren Siebrits's collection of art by people in the Villas' circle, for example Sydney Kumalo and Cecil Skotnes. And of course there are a number of works by Villa himself, from Siebrits's own collection. At one time, the house was filled with Villa's own art collection. He used to swap works with friends. 'All the greats were his friends', says Siebrits.

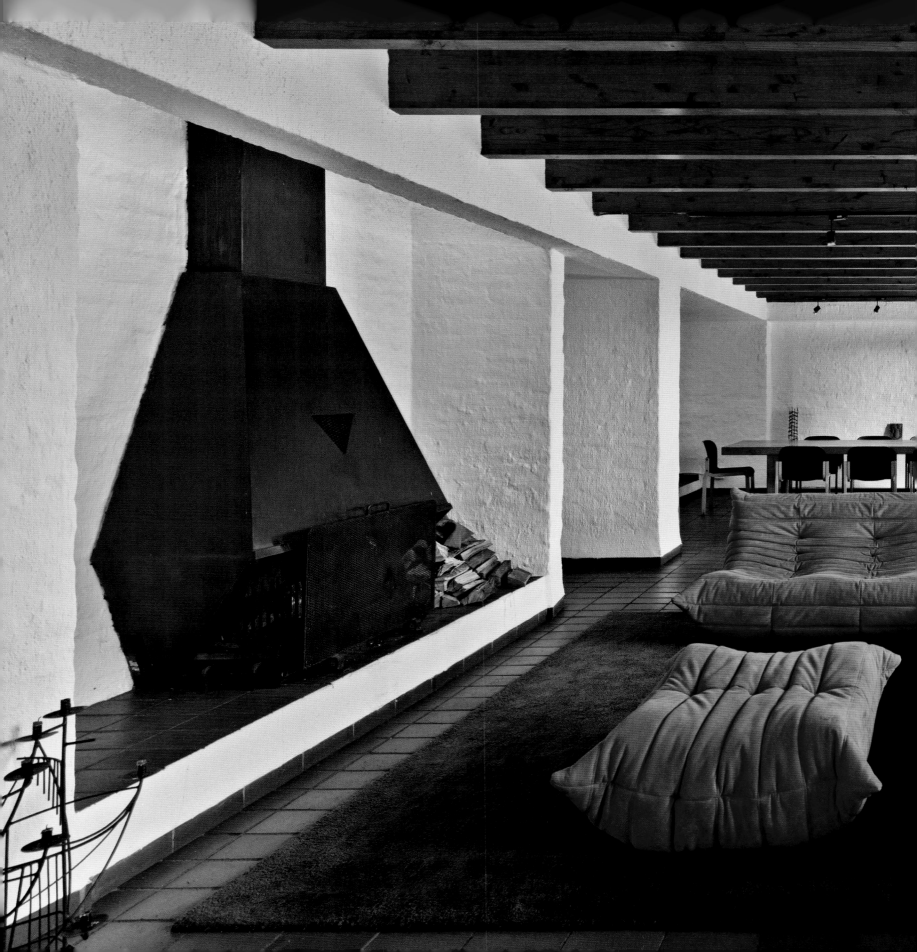

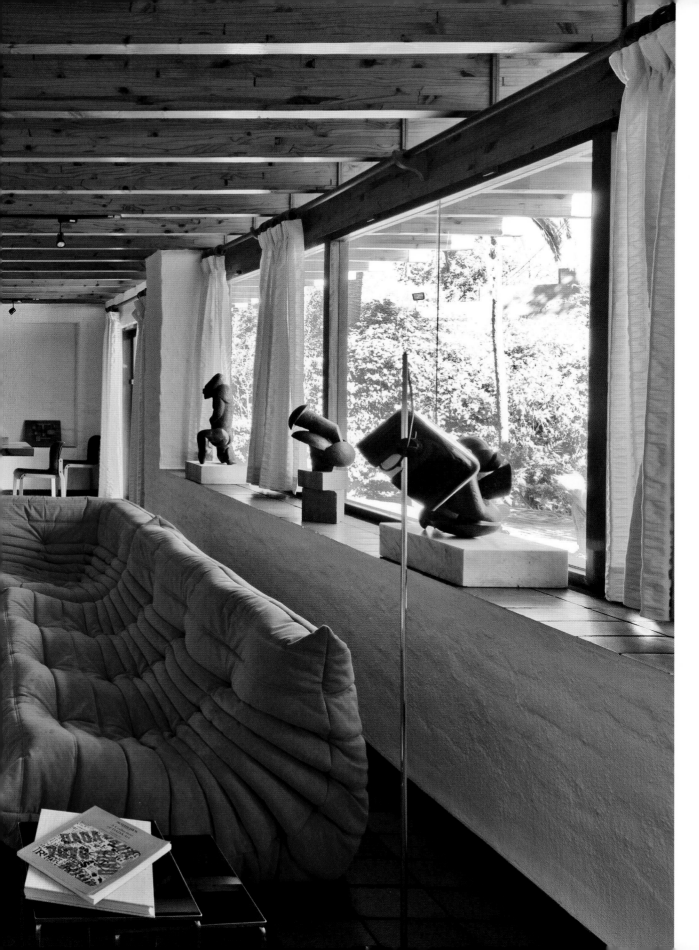

LEFT 'The house was always furnished simply, the only real luxury', said *Habitat* in 1974, 'the olive green leather suite in the living room', now gone but replaced with a 1972 sofa that Villa himself may well have considered right for the room.

ABOVE The house is small, but so ingeniously constructed that the ebb and flow of the internal spaces provide unexpected views of the sculptor's work, housed there as you turn a corner or approach from behind or from the side. The volumes and dimensions increase and diminish as you move around the building, so you get a real sense of an elastic space that's neither too timid nor too overblown to house the sculptures – sometimes spiky, often monumental and always multifaceted.

OPPOSITE There's an almost sepulchral feel to the hefty, but small, rooms in the Villa house.

PAGES 86–87 The house is like a piece of sculpture, or perhaps a stage set to receive and animate Villa's work. It's small, 'based on the minimum requirements for the artist and his wife', said *Artlook* in December 1970. A geometric structure set inside a paved courtyard, the house, in the architect's own words (*Habitat*, No. 9, 1974, in an article called 'Villa's Villa'), '… had to overcome that most common failing of all things small, which is how to stop falling out of them! This was in this case a circulatory problem and it was decided that the longest route between the limited number of spaces would create an impression of more house than there was. Furthermore it was decided to impede these routes with obstacles such as narrow openings and steps…'

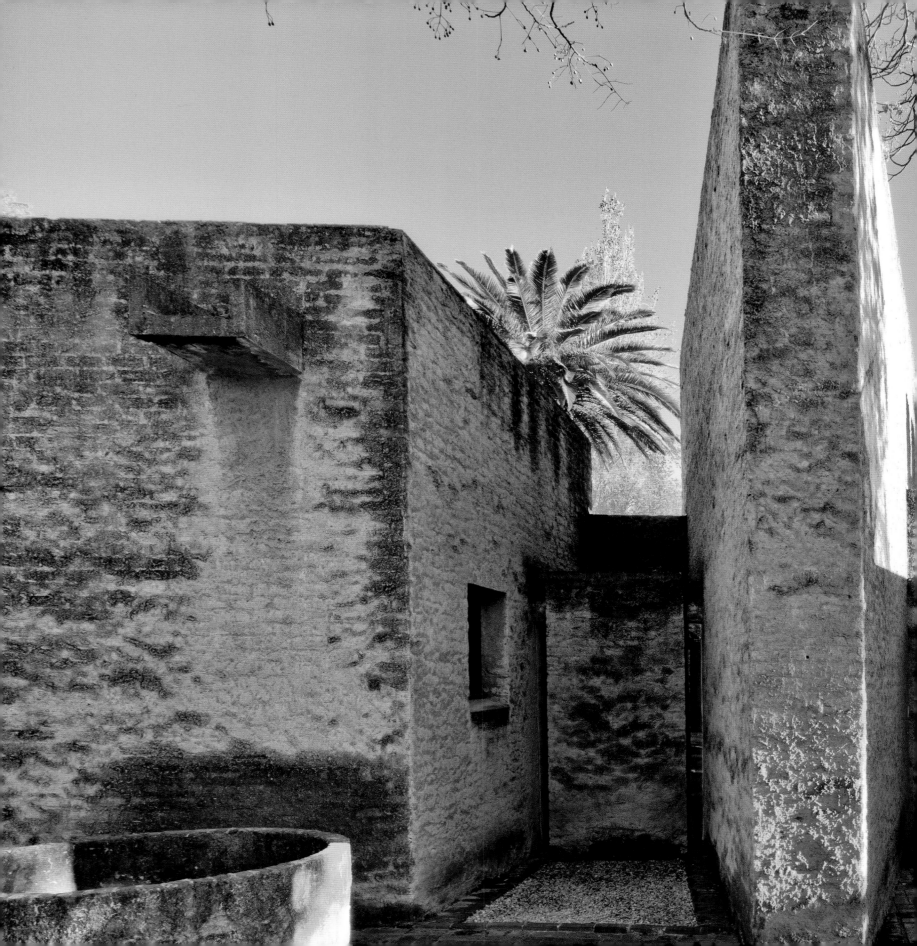

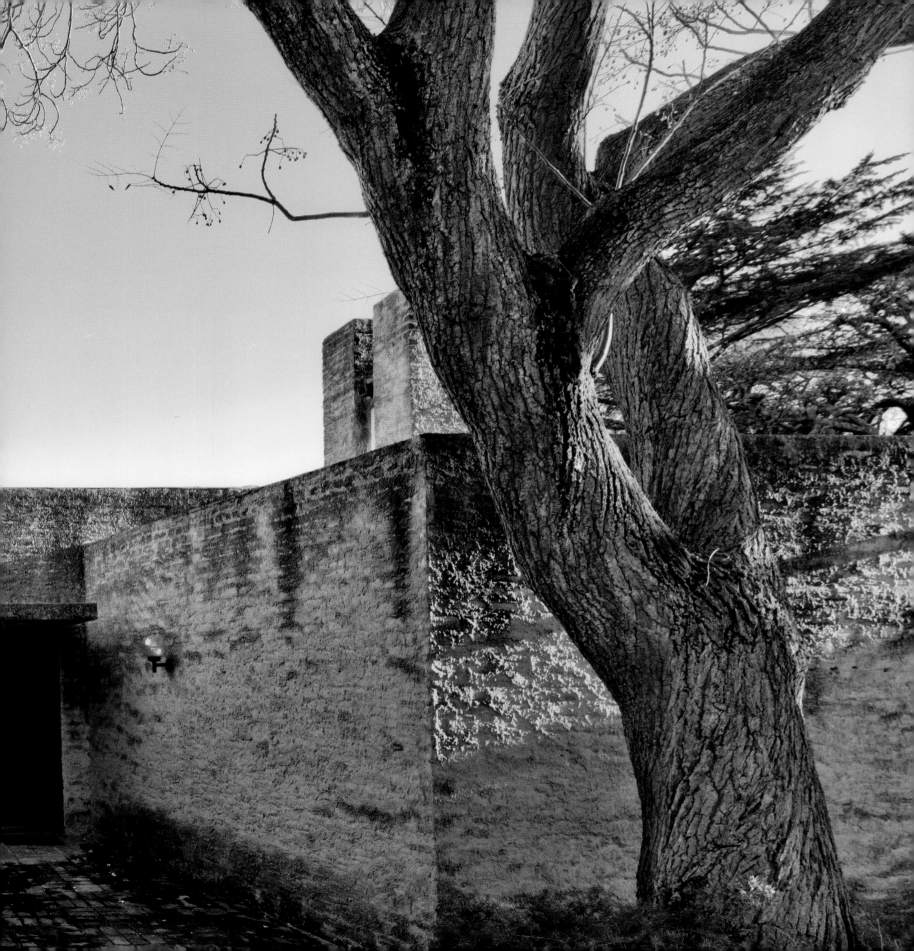

FREEMASONS' HALL
Park Lane, Parktown

One of the least known of Johannesburg's heritage buildings is also one of its most handsome: the Freemasons' Hall, with a stupendous neoclassical, columned façade that faces onto Park Lane. Most people simply pass by, never noticing it. Still in use today, it was designed by Gordon Leith in the early 1950s (the foundation stone was laid in 1954). Hemmed in by the Brenthurst Fertility Clinic, and not far from the wonderfully named St Mary on the Limpopo, it sits impassively in a neighbourhood that's neither quite Parktown nor yet Hillbrow. Today, access to the building is via a large car park. A magnificent bronze double front door opens into a lobby from which a handsome staircase rises crisply to a gallery giving access to meeting rooms and dining rooms. When it was built, the approach was from the front, from Park Lane, the building's columned façade facing the street across an open court, flanked by low wings that rise another storey on either side of the main block which juts out in front of them. There's no pediment, just an architrave supported by Corinthian columns standing on a low platform. An ambulatory separates the columns from the double-storey wall of the building with its meticulously orchestrated rows of windows. If anything, it looks more Greek than Roman, but it exhibits a streamlined, almost austere classicism that's clever in execution but utterly cold in demeanour – even in the Highveld sunshine. Leith, remembered for his prolific work in Johannesburg – Park Station for example – became good at that.

'The foundation stone for the new building was laid on 14 February 1954 by the Assistant Grand Master, Rt. Wor. Bro. Major-General Sir Allan Adair, Bart., C.B., D.S.O., M.C.', said the brochure commemorating the event. 'Before the Foundation Stone was lowered, two phials were placed in a cavity in the lower stone … containing copies of the English and Afrikaans newspapers of the day, a copy of the latest issue of the *Masonic Journal*, a full set (from a farthing to a sovereign) of the Union's coinage, and a copy of the plans of the building. To the Glory of God…' Cement was laid on the lower stone, which the Assistant Grand Master adjusted with a trowel passed to him by the architect also, it seems, a Freemason. And on went the ceremony, its solemn ritual 'a moving spectacle'. The 'brethren, bearing silver vessels containing corn, wine, oil and salt, perambulated the Stone. Each in turn handed his vessel to the Assistant Grand Master who, with pronouncements of fine clarity, scattered corn on the Stone as a symbol of Plenty and Abundance; poured wine, the symbol of Joy and Cheerfulness; poured oil, the symbol of Peace and Unanimity; and sprinkled salt, the emblem of Hospitality and Friendship'. Gordon Leith, wearing his Masonic apron, is shown presenting the building's plans to Sir Allan.

OPPOSITE The grand staircase. The 'foundation stone … was laid on 14 February 1954 by the Assistant Grand Master, Rt. Wor. Bro. Major-General Sir Allan Adair, Bart., C.B., D.S.O., M.C.', said the brochure commemorating the event. Architecturally its design is rather restrained – as if in deference to ('if not in sympathy with', said Bernard Cooke) the Modern Movement.

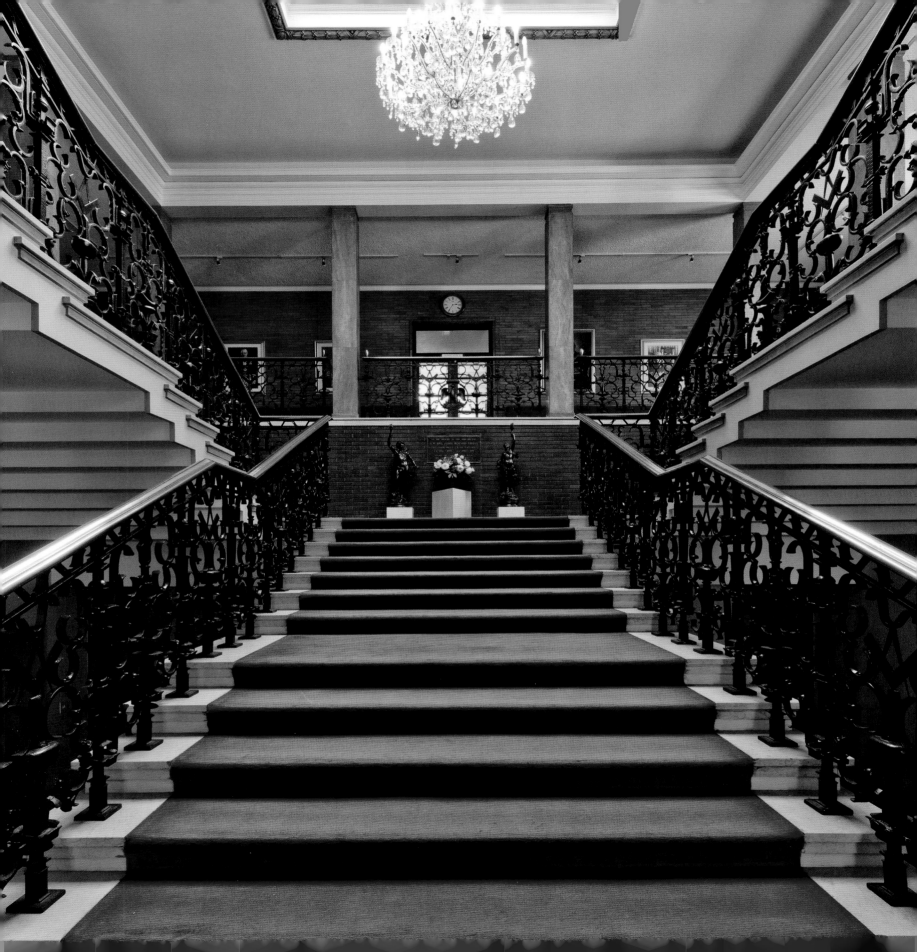

ABOVE On the façade, the relief carvings of the cornucopia (*top*), the symbol of abundance, and the double-headed phoenix (*bottom*), the symbol for immortality and resurrection, are two of the most widely recognizable Masonic symbols in the world.

RIGHT The entrance hall: to the left the grand stair, and to the right the main entrance prefaced by a columned entrance façade.

PAGES 91–92 The entrance façade: Freemasons' Hall is a particularly refined example of a classical style of architecture that emerged in South Africa with Herbert Baker, with whom Gordon Leith had worked on the designs for the Union Buildings in Pretoria. Leith was the first winner of the Herbert Baker Scholarship to the British School in Rome (1911–13), where he spent time measuring some of the ruins of the ancient city. Some 40 years later, the Freemasons' Hall is the sophisticated outcome of that training.

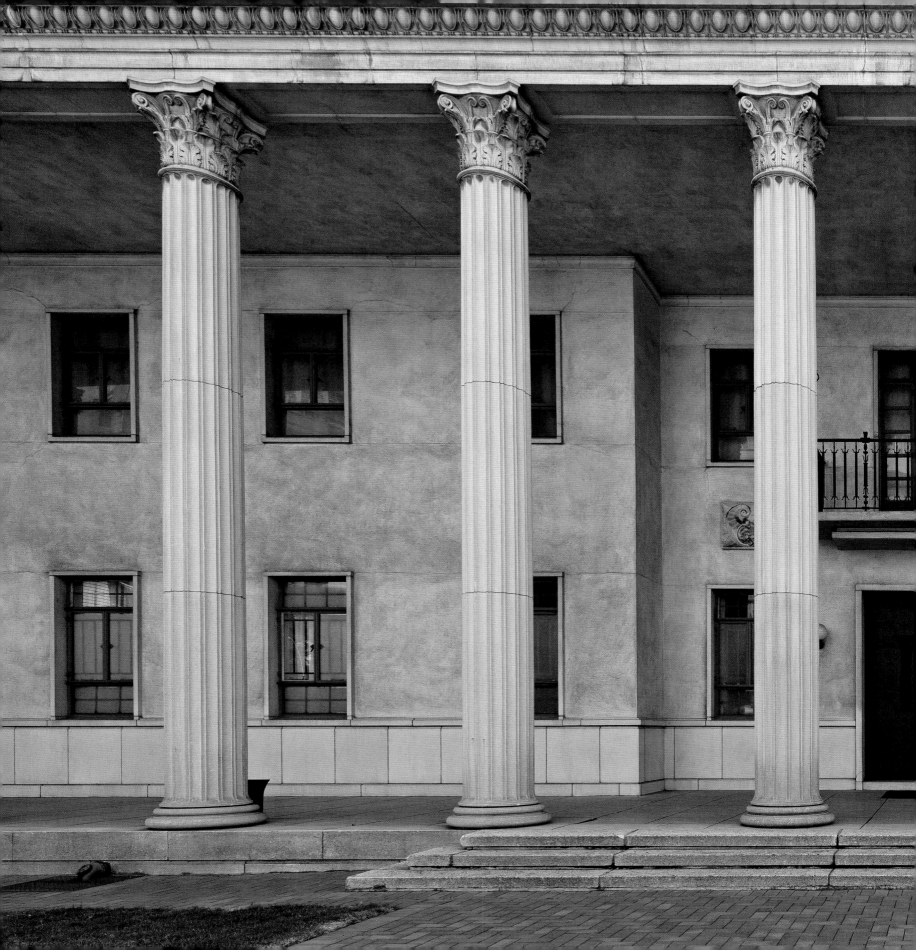

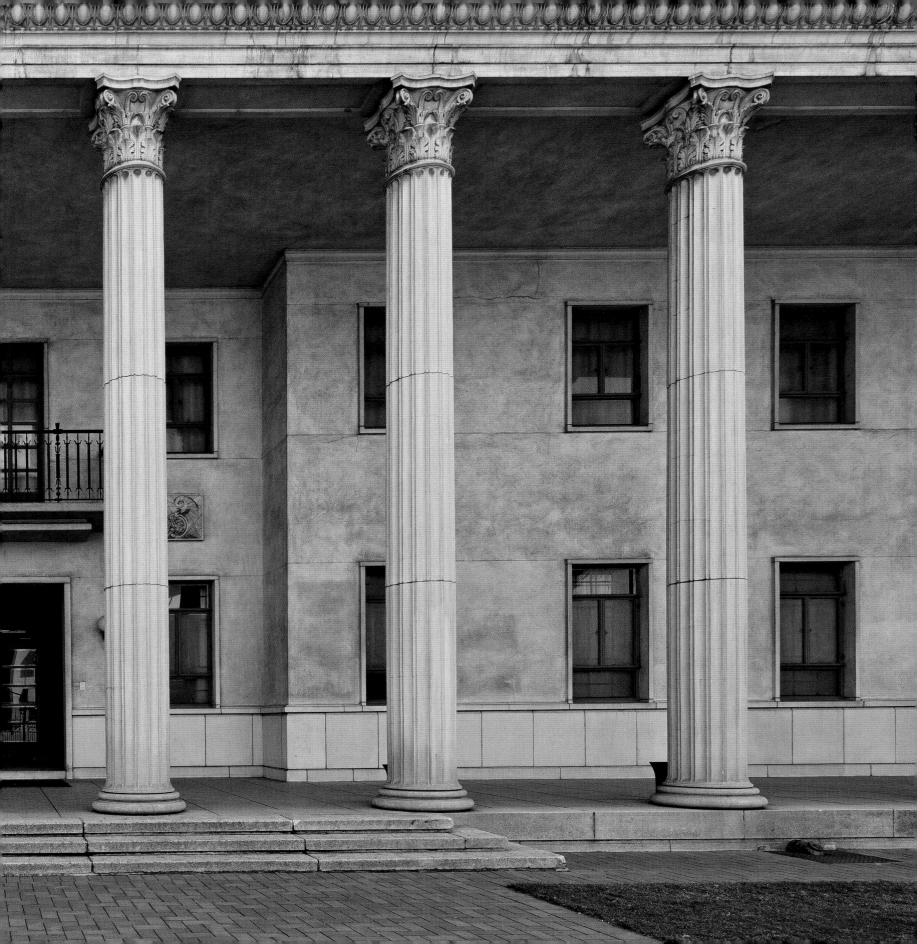

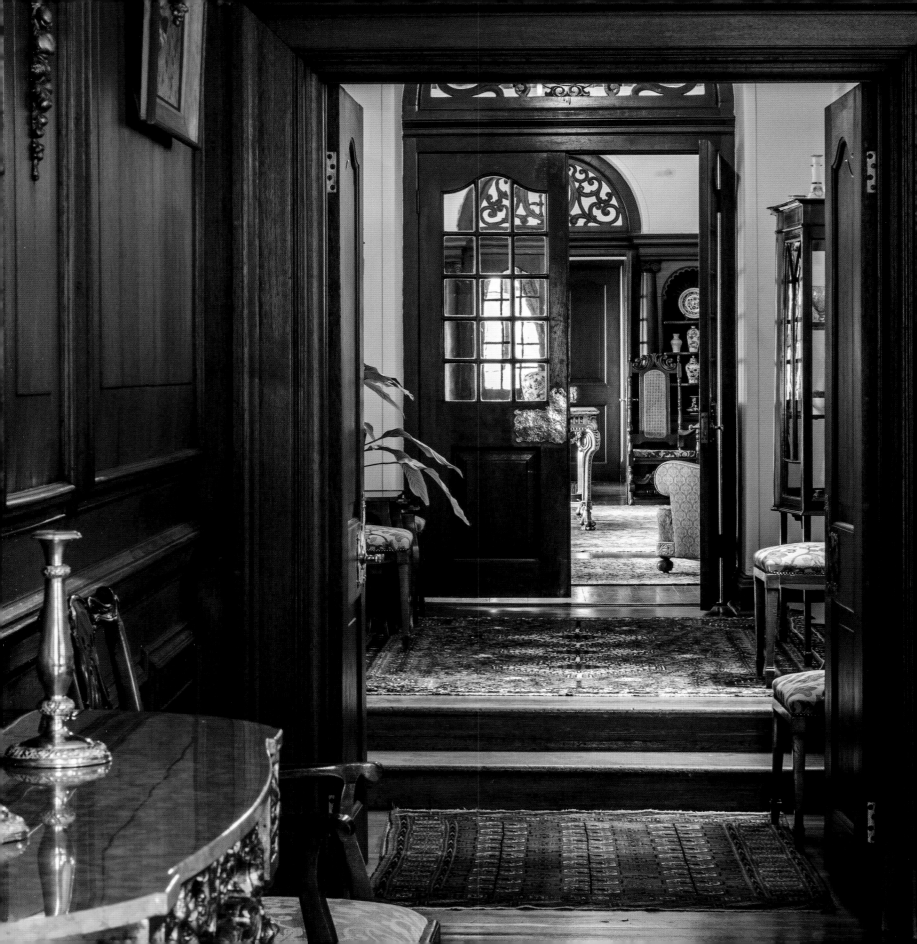

What must it have been like on the rocky Parktown ridge just north of Doornfontein at the dawn of the twentieth century, when José Dale Lace stepped out of her zebra-drawn four-in-hand coach and into the magnificent new 40-room mansion, Northwards, for the first time? Did she really have a zebra-drawn carriage, or is that the same urban legend that insists she had been a royal mistress to King Edward VII and that her son, Lance, was the King's? Does it matter now? That the legends persist is a measure of the glamour of the former Josephine Brink from the Karoo who became one of the most glittering of early Johannesburg's stars. Her most noteworthy accomplishment was her skill as a rider. In fact, she was a superb horsewoman and the star attraction of the Rand Show in its earliest incarnation as the Witwatersrand Agricultural Society Show. To her and her long-suffering husband, John, we owe the fabulous Northwards, on the front steps of which, when she departed in one of her carriages, a bugle would be blown, allowing the neighbours to rush out to watch her pass.

Northwards, designed by Herbert Baker, faced away from the gritty shantytown and fortune-seeker's paradise that comprised early Johannesburg, and north across the African landscape towards the distant, shimmering Magaliesberg. Not only were the views exceptionally gorgeous – particularly from the great oriel window on the northwest front – so were its contents, particularly those in the Great Hall which, with its minstrel's gallery, Baker thought would do well as a ballroom. There was the Louis XV furniture and there were white servants, including footmen to serve lunch and tea to guests. And there was enough space on the nine-acre property for a gate house, a serpentine drive, elaborate Cape Dutch-style gabled stables with teak fittings, orchards, park-like gardens – all of it enough to satisfy the needs of a flamboyant socialite who liked to bathe twice a week, it's said, in the fresh milk that kept her skin supple.

It was all terrifically showy, but that Northwards, built in 1904 from quartzite quarried from the surrounding ridge, survives at all is nothing short of miraculous. If you stand on the north terrace and half shut your eyes and put your fists over your ears, you won't see or hear the traffic on the M1 motorway that dramatically interrupts the extraordinary *genius loci* selected for this William Morris-style Arts and Crafts mansion by Baker, whose first Johannesburg commission of significance it was. 'The 1960s were marked by unsympathetic change, innovation and development in the spirit of modernism', writes Dr Neil Viljoen, curator of Northwards, now owned by the Northwards Trust. 'The new motorway cut through the koppie, and the old gatehouse and gate "had to be" demolished. It was a time when conservationists often fought a losing battle to save heritage sites for as long as was needed to change the views of decision makers. The Parktown and Westcliff Heritage Trust (now the Johannesburg Heritage Foundation), led by Flo Bird, campaigner for preserving old Johannesburg, needs to be mentioned here. It was due to their efforts that the building was saved. But it was not yet preserved. It was to go through the mill of being adapted for use as a boarding house and later as an office block, all of which left grave scars. The beautiful stables were demolished...' Subsequent owners wrought their own special versions of havoc, until a restoration by Gencor, now BHP Billiton, brought it back to life.

In 1911, the west wing of Northwards burned down. Not long after that, José and her Randlord husband Colonel John Dale Lace departed, the latter having got into crippling financial difficulties exacerbated, no doubt, by José's extravagant ways.

OPPOSITE Northwards was the first house Herbert Baker designed and built in Johannesburg.
PAGES 96–97 When Sir George Albu rebuilt Northwards after the 1911 fire he extended it, retaining Baker's interiors where he could, along with all those eclectic building styles that characterize the house.

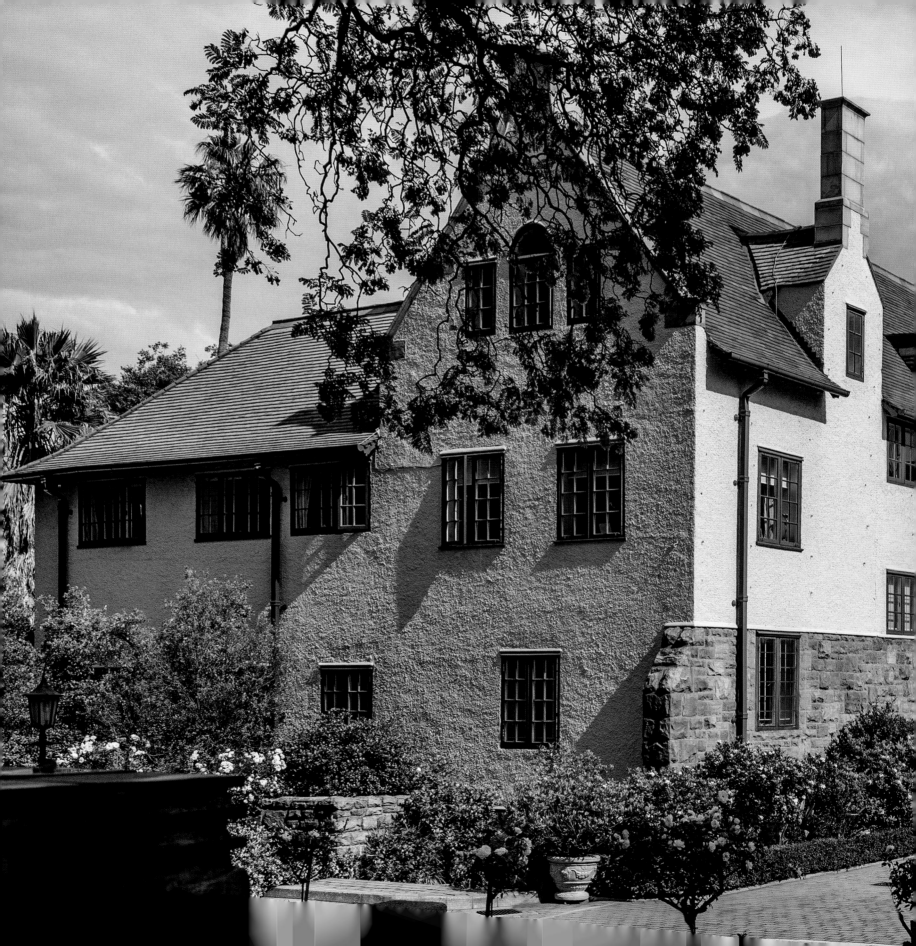

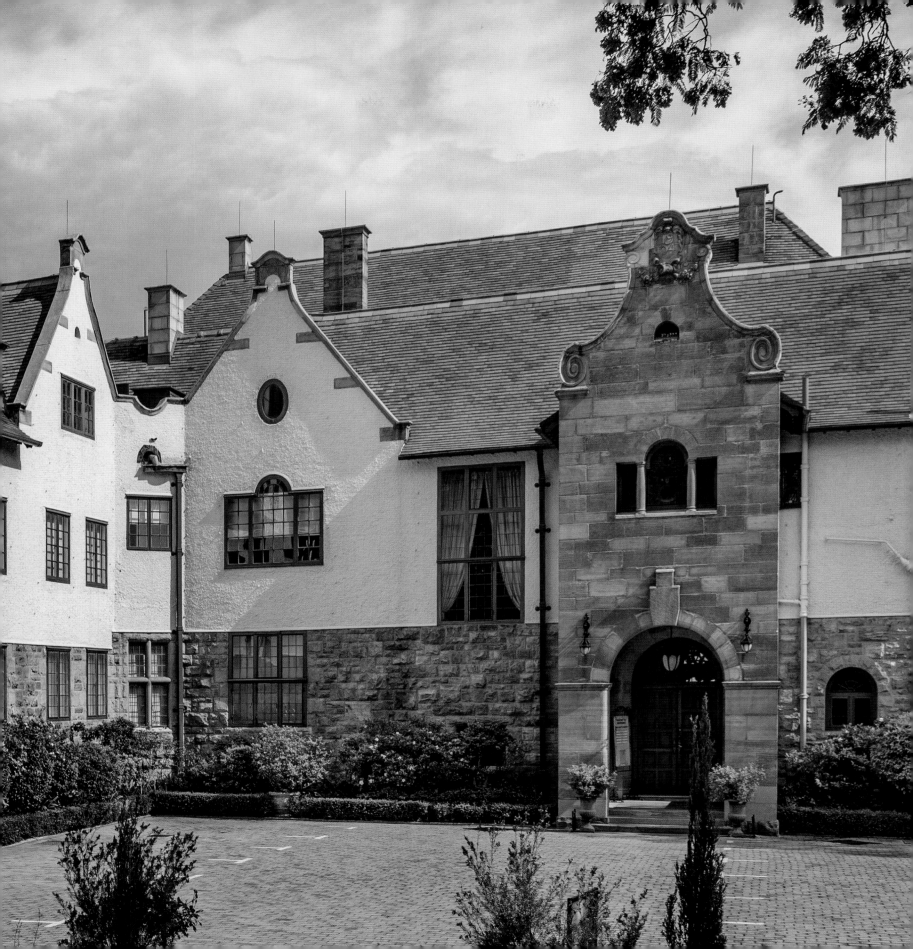

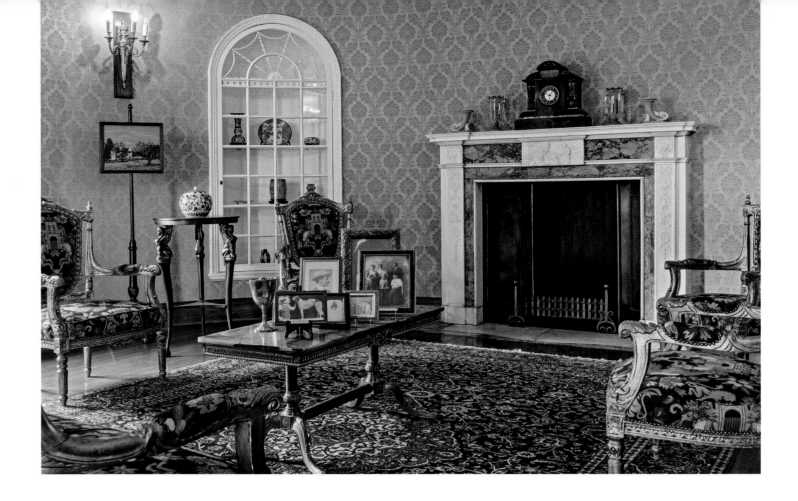

Not even Sir Lionel Phillips would bail them out. By 1922 José was running a dress shop in Eloff Street, where she took particular pleasure in charging the highest prices to the Johannesburg ladies who came to buy from her and gloat over her fall. She was last recorded living in Rondebosch, in Cape Town, in greatly reduced circumstances where she was known as 'the rag woman'. The Dale Laces never returned, and Northwards was bought by George Albu, the founder of General Mining (later Gencor) who restored it and whose family lived in it until 1951 after which it was sold to the SABC who planned to knock it down and replace it with a television tower. Albu, later Sir George Albu, with the Swiss architect Theophile Schaerer, also extended the house, retaining much of Baker's interiors where he could and all of those eclectic building styles that run the full gamut of the English vernacular with a dose of Cape Dutch harmonious in the mix. And yet, in spite of its vaults and arches, grand forecourt and elaborate gables, Palladian windows and double-height ballroom, this extraordinary place is oddly cosy, even picturesque. Perhaps this derives from the homely wood panelling and quaint minstrel's gallery, the window seats and beamed ceilings, and the brass window fittings and door handles with which Baker kitted out Northwards' interior. It was, and still is, a *tour de force* in a brash environment.

ABOVE The drawing room, a fairly small room in comparison with the vast great hall. 'You should have a large Hall for dancing instead of using your Drawing or Dining Room', wrote Baker.
OPPOSITE In the great hall, an oriel window looks north to the view. While it soars practically to the heavens, it provides an intimate sitting place at its base; somewhere to retreat from the vastness of the hall.
PAGE 100 In spite of its architectural idiosyncracies, the house is oddly cosy. Perhaps this derives from the wood panelling, window seats and brass fittings with which Baker kitted out Northwards' interior.
PAGE 101 The north façade overlooks the terraced garden and the view of the Magaliesberg in the distance.
PAGE 102 A portrait of José Dale Lace in her heyday.
PAGE 103 The entrance to the great hall with the minstrel's gallery above. None of the furniture is original.

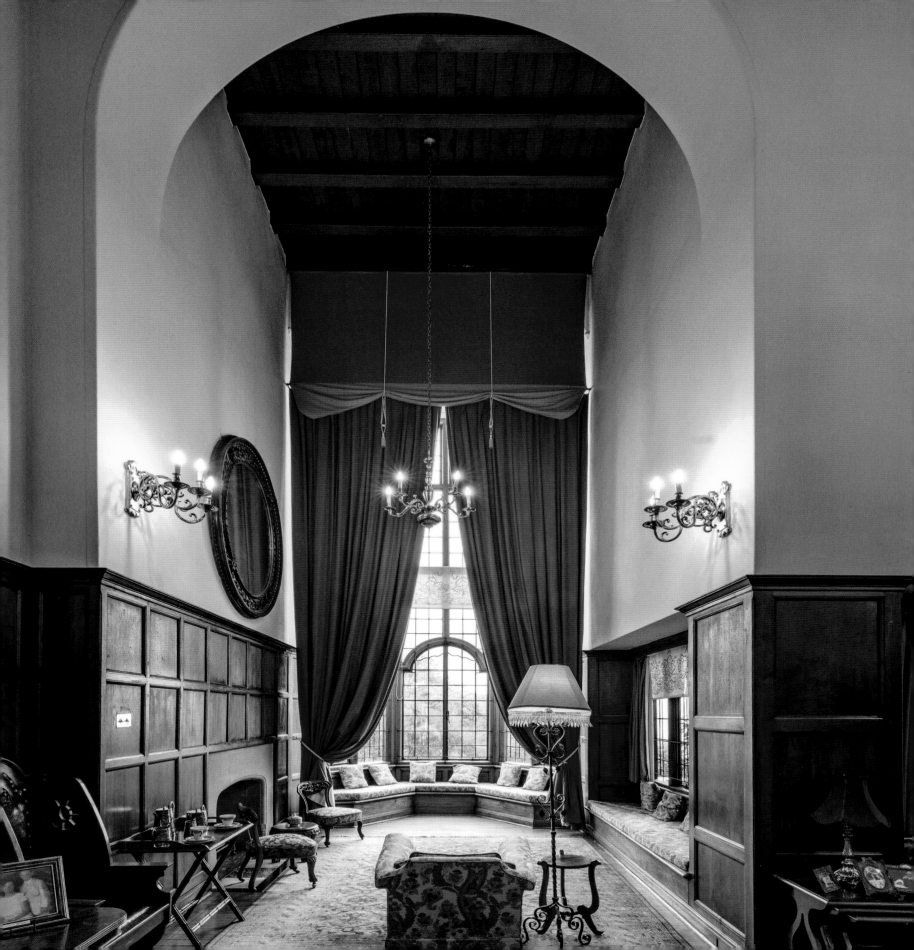

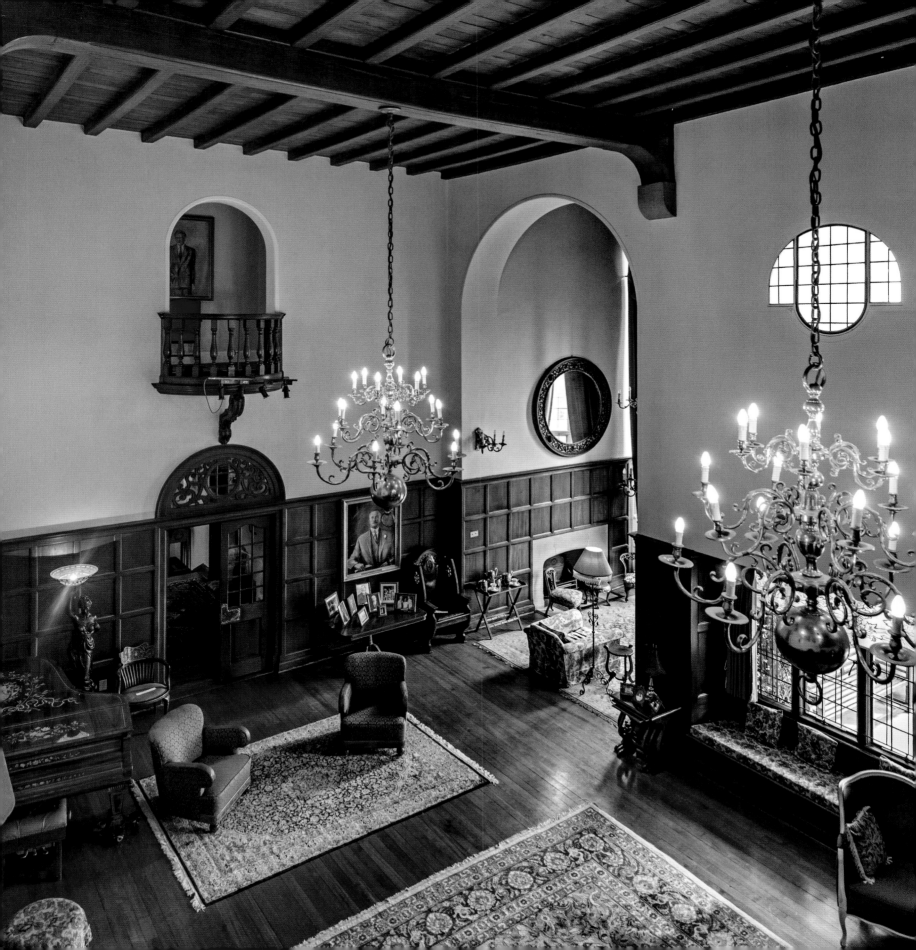

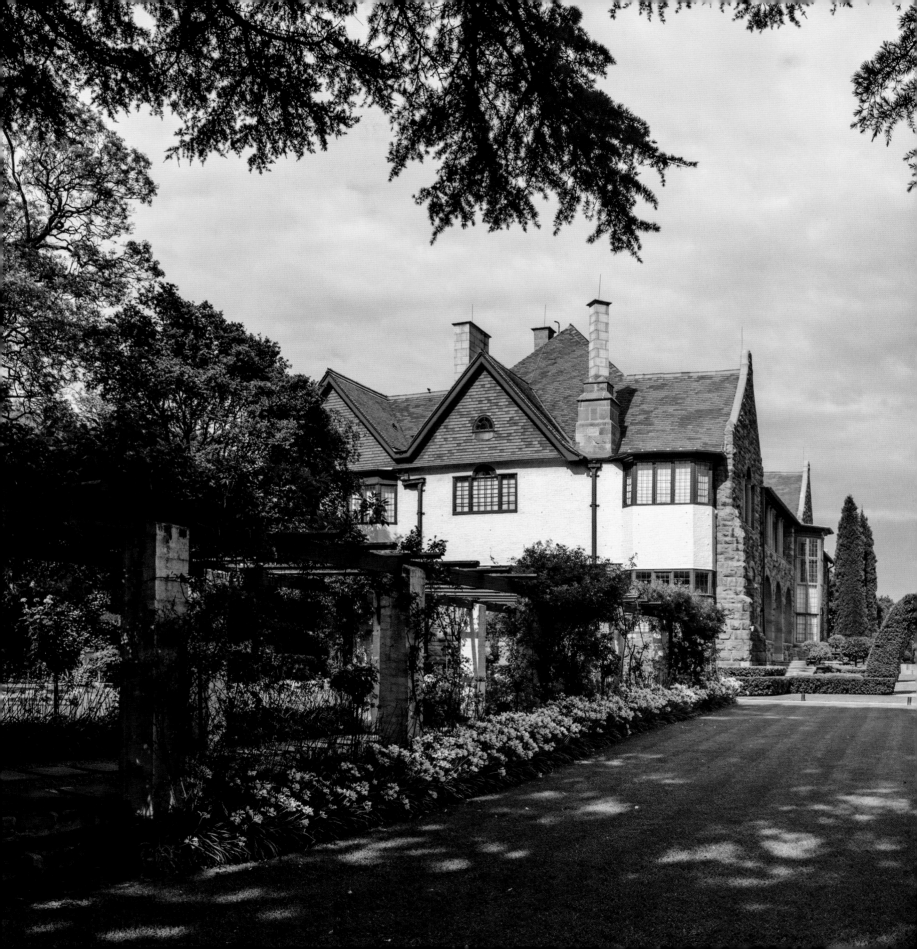

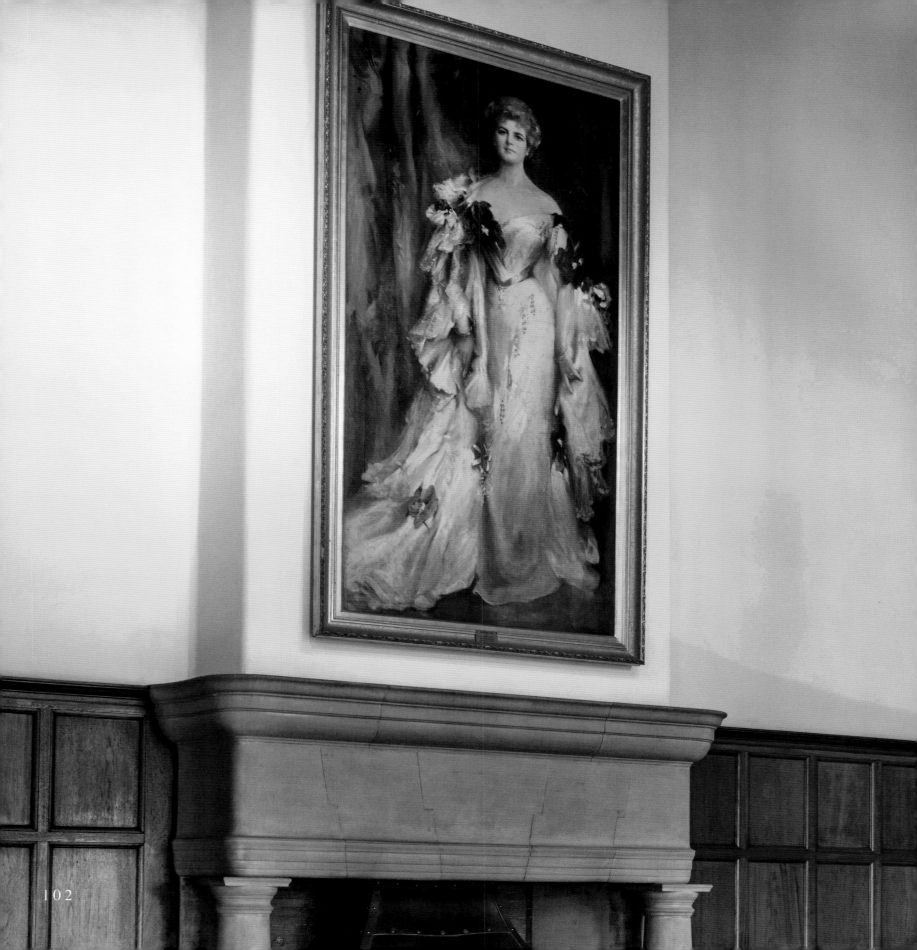

NELSON MANDELA HOUSE
Vilakazi Street, Orlando West, Soweto

The Nelson Mandela National Museum is the house in which Mandela lived from 1946 until his arrest and imprisonment in 1962, initially with his first wife Evelyn and their son Thembikile, then from 1958 with Winnie Madikizela, his second wife. Not that he lived here much, as his growing role in the anti-apartheid struggle, and his increasing prominence in the ANC, drove him underground, moving around the country after his acquittal in the first Treason Trial, until his arrest in 1962. His next home, following his sentence in 1964, charged with sabotage and attempting to overthrow the state violently, was prison – first on Robben Island, then Pollsmoor followed by Victor Verster. If you're interested in tracing Mandela's life journey, Vilakazi Street is a good place to start.

The house is an unprepossessing place, now a museum crammed with memorabilia. What is perhaps most interesting about it is that it lets us look back at the Johannesburg that Mandela knew as a young man: a rough-edged, often violent place crammed with hopefuls from rural areas trying to survive in a city undergoing one transition after another.

Back in 1941, the 23-year-old Mandela arrived in Johannesburg, having been expelled from Fort Hare University for leading a student protest. He was offered a job as a night watchman at Crown Mines, taking it while planning to continue his law studies at the University of the Witwatersrand. Mandela stayed first in a backroom in Alexandra township, without electricity or running water. His first habitable and real home, one for which he always expressed great nostalgia and affection, was the small house on Vilakazi Street. The cramped living room was where his comrades met to plan defiance campaigns for the ANC and the Youth League. This is where the decision to adopt the Freedom Charter of 1955 was made.

In portraying the importance of this building both to Mandela and to the national psyche, it seems appropriate to simply quote from Nelson Mandela's *The Long Walk to Freedom*. 'That night I returned with Winnie to No. 8115 in Orlando West', he writes about his release from jail. 'It was only then that I knew in my heart I had left prison. For me No. 8115 was the centre point of my world, the place marked with an X in my mental geography'. The house he'd left 28 years before had been built in 1945 and, like hundreds of others around it, and in other townships in other cities countrywide, it was a simple, three-roomed, rust-red facebrick-built structure with a tin roof. It had 'a narrow kitchen, and a bucket toilet at the back. Although there were street lamps outside we used paraffin lamps as the homes were not yet electrified. The bedroom was so small that a double bed took up almost the entire floor space'. It had a coal stove and there was a small stoep finished in shiny red polish. But, like many of the homes in Johannesburg's developing townships back then, it was a foothold in an emerging city.

Johannesburg before the Nationalists was a sprawling mining town dominated by mine dumps and tall mine shafts on every horizon. A snappy dresser, keen dancer and party-lover, Mandela knew the night life of black Johannesburg: the shebeens and dance halls, along with the lecture theatres of the university and the boxing gym at the Donaldson Orlando Community Centre where he worked out on week nights. At weekends, singers like Miriam Makeba would perform at the community centre. There were parties in Sophiatown, where white liberals such as Nadine Gordimer, Anthony Sampson and Uys Krige would socialize with the young activists, including Mandela. After meeting Walter Sisulu, an estate agent, Mandela

OPPOSITE The former home of Nelson Mandela on Vilakazi Street – famously, and uniquely, the only street in the world to have had two Nobel Peace Prize winners living on it, Archbishop Desmond Tutu being the other.

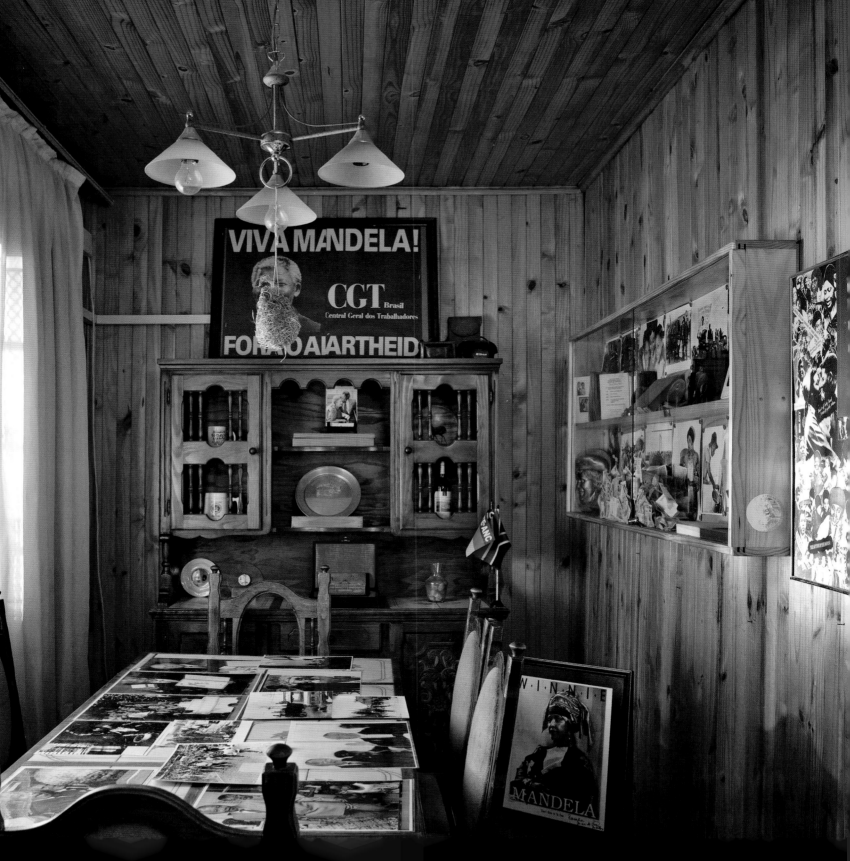

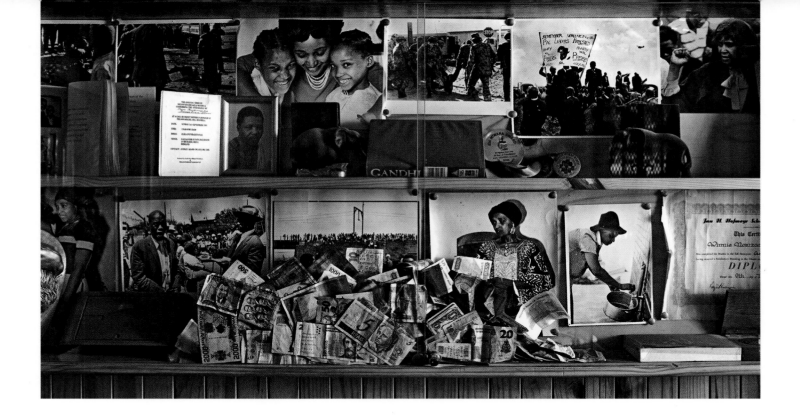

was introduced to Lazar Sidelsky and did his articles through a firm of attorneys, Witkin, Eidelman & Sidelsky. He went on to open a law office with Oliver Tambo, on the corner of Fox and Gerard Sekoto Streets in Ferreirastown, in a new building designed by architect Frank L Jarrett, Chancellor House, one of the few buildings that would rent space to black clients. Hardly a block or two away was Kapitan's, the Indian curry restaurant that remained multiracial throughout the nine decades of its existence. Mandela regularly ate there, and often took Winnie there when they were courting. Across town stood Anstey's Building, the home of Cecil Williams, theatre director, and a member of Umkhonto we Sizwe, the armed wing of the ANC, now headed by the young Mandela. Visitors to Anstey's Building included actors, activists, artists and writers, including Amalia Cachalia, Leonard Bernstein and Sir Laurence Olivier. The young Mandela had friends in high places.

Mandela was banned first in 1952: as a restricted person he was only permitted to watch in secret as the Freedom Charter, planned in his living room, was adopted in Kliptown on 26 June 1955. He was arrested in a countrywide police swoop in December 1955, which led to the 1956 Treason Trial, a marathon trial that only ended when the last 28 accused, including Mandela, were acquitted in 1961.

As his home came under increasing police surveillance, Mandela took the name David Motsamayi and secretly left South Africa. On his return, he went underground. The press referred to him as the 'Black Pimpernel' but his freedom was short-lived. While pretending to be Cecil Williams's chauffeur, Mandela was arrested in KwaZulu-Natal. He would not see No. 8115 Vilakazi Street again for nearly three decades, until he returned to his former home for 11 days following his release from prison in 1990.

ABOVE AND OPPOSITE Memorabilia of a life of struggle. During the course of its life as the Mandelas' home, No. 8115 was raided and petrol bombed a number of times, so many of its original features have been lost.

RIGHT AND OPPOSITE The house sits in an area where the students from nearby Orlando West High School and the police confronted one another in 1976, leading to the death of Hector Pieterson. It burned down in 1988 during a fight between the local community and Winnie Madikizela-Mandela's United Football Club, after which it was restored. No. 8115 Vilakazi Street remains pivotal to any understanding of not just the life of Mandela, but the history of how apartheid was overcome.

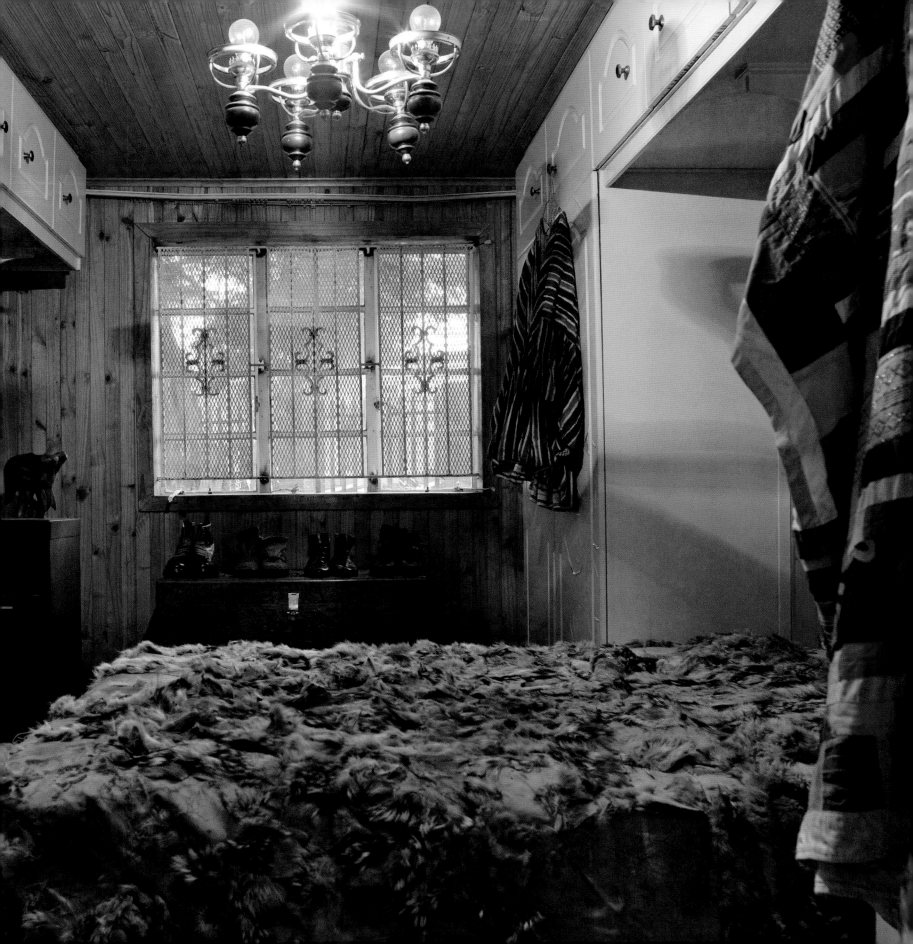

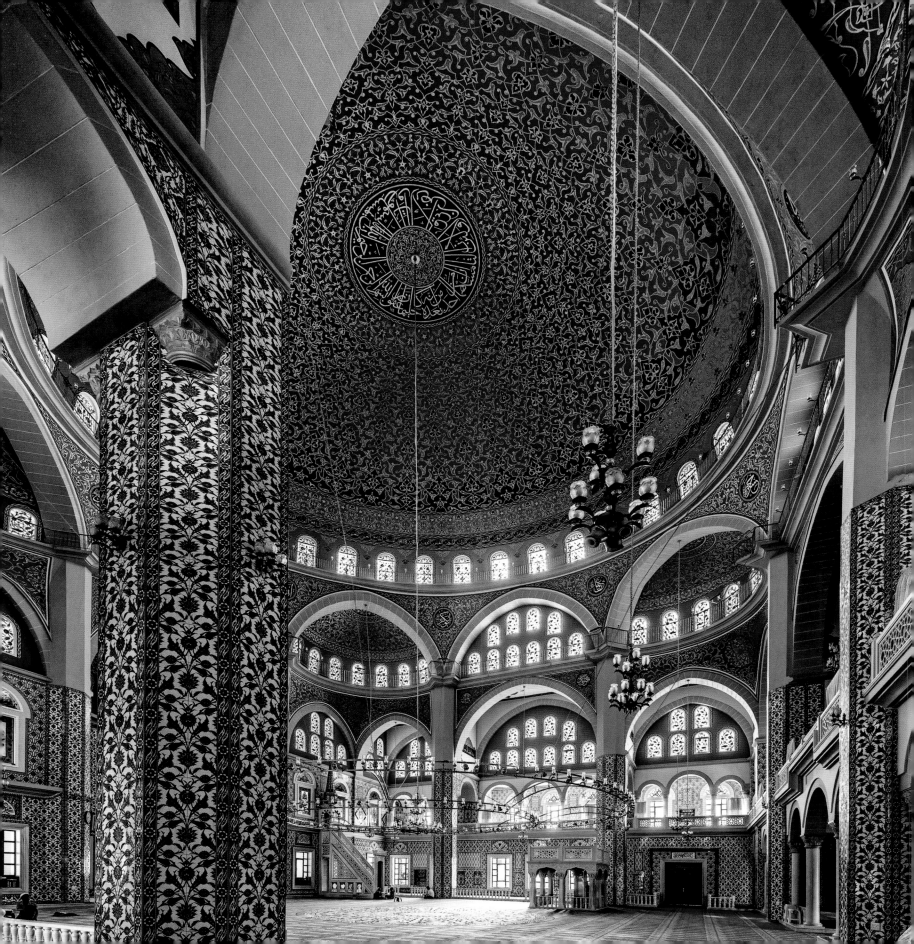

NIZAMIYE MASJID
Old Pretoria Road, Midrand

In Midrand, covering a site of nearly a hectare, is a monumental, richly decorated mosque that holds nearly 3000 people in worship. It's called the Nizamiye Masjid, and it's an unexpected – even extraordinary – sight, not least because it's virtually a replica of the Selimiye Mosque in Edirne in Turkey, itself a masterpiece of Ottoman architecture commissioned from Mimar Sinan in 1569 by Sultan Selim II and opened in 1574. Mimar Sinan, a contemporary of Michelangelo, lived and worked during the zenith of the Ottoman Empire (his apprentices would later be involved in the building of other major Islamic landmarks, most notably the Blue Mosque in Istanbul and the Taj Mahal at Agra in India). At the time, there was the desire to match the epic dome design of Hagia Sophia ('Holy Wisdom') in Constantinople (Istanbul), built as a Christian church in 537 but converted to a mosque after the fall of the Byzantine empire in 1453. The Selimiye Mosque in Edirne more than accomplishes this. And in scale, silhouette and layout, the similarities with the Nizamiye Masjid are legion, and intentional.

The Nizamiye Mosque stands, like its Edirne predecessor, at the centre of an educational and community complex that houses a university, a school, a dormitory, a clinic, a restaurant and a bazaar, all managed as a single institution – the traditional *külliye* that gives so much Turkish religious architecture its unique character. In the past, there would have been baths, too, as there are at the Selimiye Mosque.

The Nizamiye Masjid opened in 2012, given the blessing of Mandela and Tutu. Designed in Turkey, it was paid for by Turkish business tycoon Ali Katricioglu, who had originally planned its construction in the USA but couldn't find a suitable site. South Africa was a second choice. The mosque's establishment here was at the behest of Fethullah Gülen, a Turkish preacher, imam and writer actively involved in the societal debate concerning Islam in the modern world. He leads the Gülenist movement, whose characterization as a moderate blend of Islam is actively involved with interfaith dialogue.

Out there on its African plain, the huge central, lead-covered dome – the Nizamiye Masjid's most visible feature from the highway – is at the heart of the plan, while tall minarets occupy each of its four corners. The centrality of a circular dome to predicate the entire layout of the complex is a Byzantine feature highlighted at Hagia Sophia and subsequently adopted by the Ottomans as a feature for religious architecture that evoked Divine perfection. A series of buttresses, smaller domes and half domes cascade down around the drum supporting the central vault. A forecourt flanks the entrance, and the additional spaces of the complex are axially aligned and topped by 21 even smaller domes, each of them covered in lead. The exterior, like its Islamic forerunners and their Byzantine predecessors, is sheathed in marble, ceramic tiles, stucco and frescoed decoration.

OPPOSITE You'd be forgiven for imagining you'd been transported to ancient Istanbul where the gigantic, soaring domes of early Christian churches, now mosques, are a distinctive characteristic of the old city. Here, in Midrand, the Nizamiye Masjid is quite new, but it's been meticulously detailed to re-imagine the exquisite craftsmanship of those antique edifices.

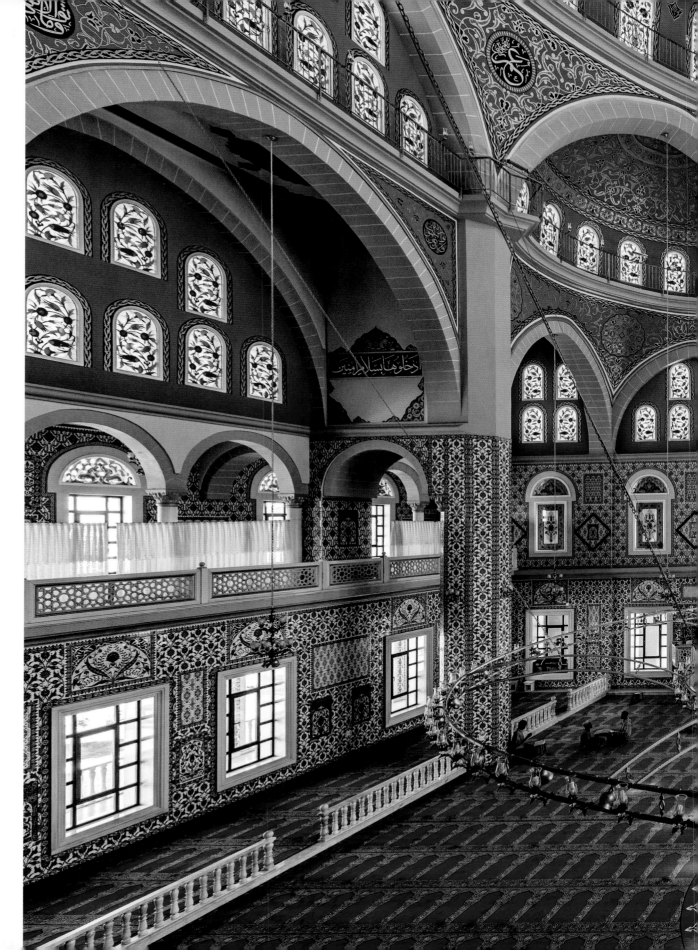

RIGHT The first Ottoman-style mosque in the southern hemisphere is only slightly smaller than the original on which it was modelled – the sixteenth-century Selimiye Mosque in Edirne, Turkey. The rich Oriental carpet, custom-made in Turkey, is a reflection of the dome above that soars to 31 metres at its highest point.

PAGE 114 The mosque is at the heart of a complex, or *külliye*, that serves the community. The pure, simple lines of the Ottoman-style architecture, with its extravagant symmetry (provided as illustration of God's perfection), astonish visitors at Midrand today – just as they did then, and still do, at Edirne.

PAGE 115 Hand-painted decoration is a feature of the dome.

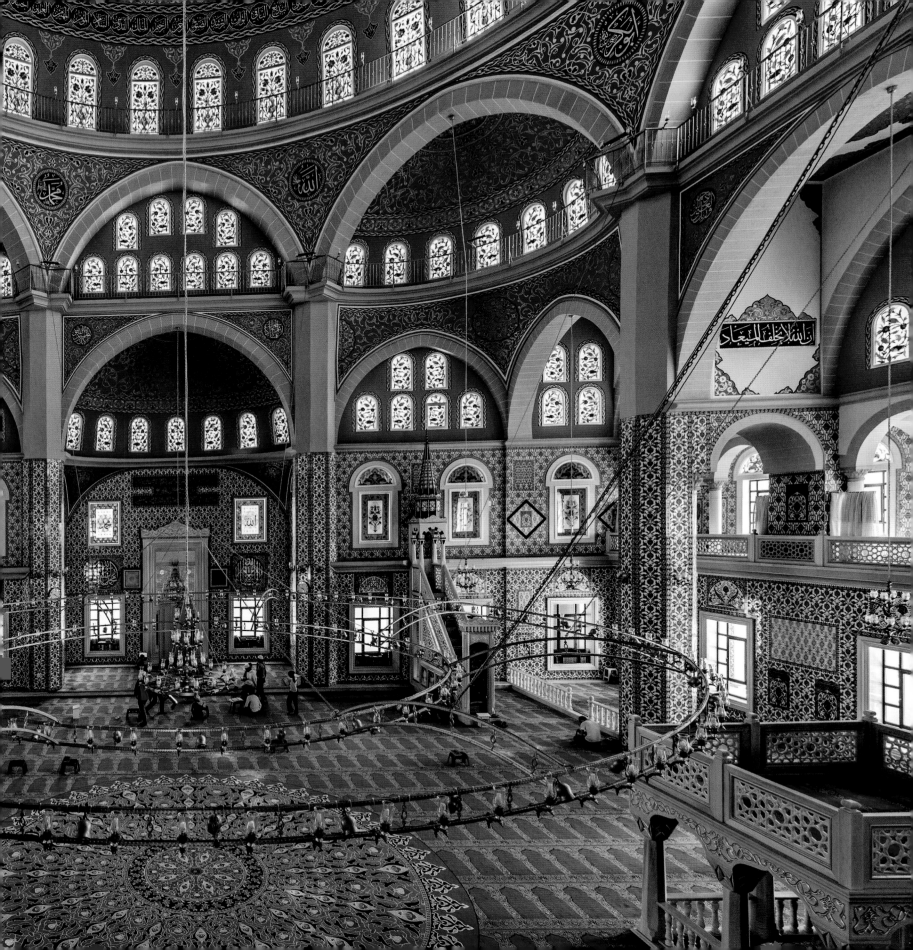

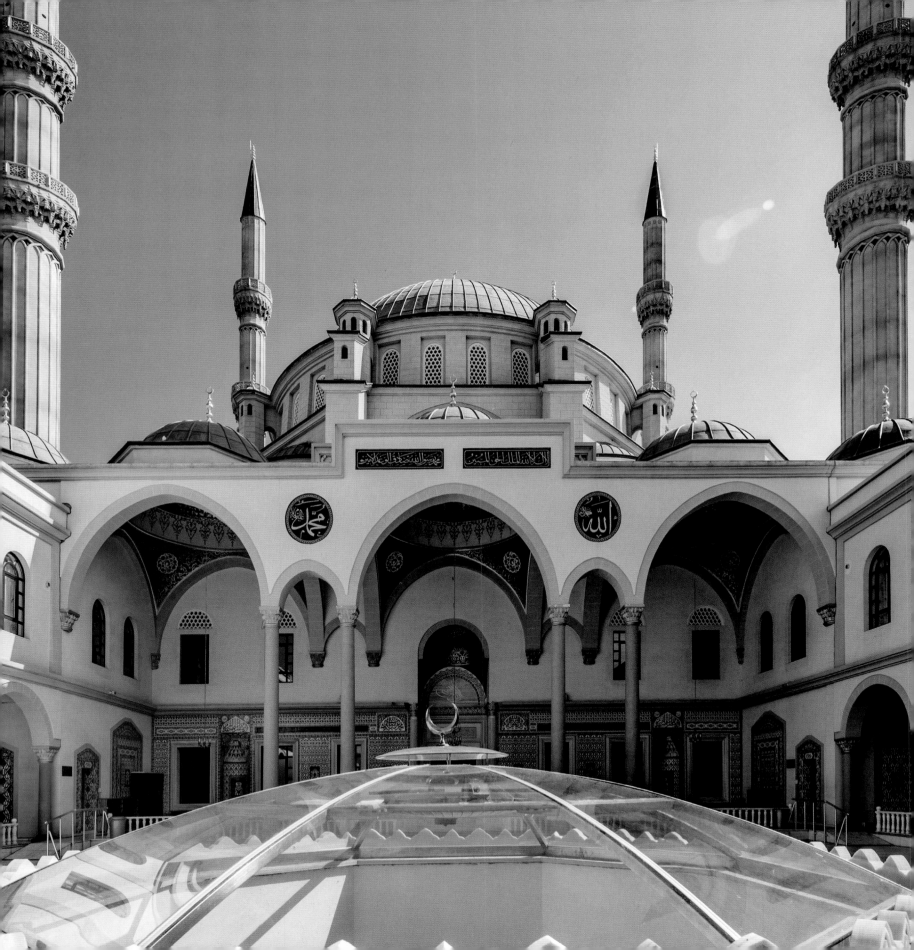

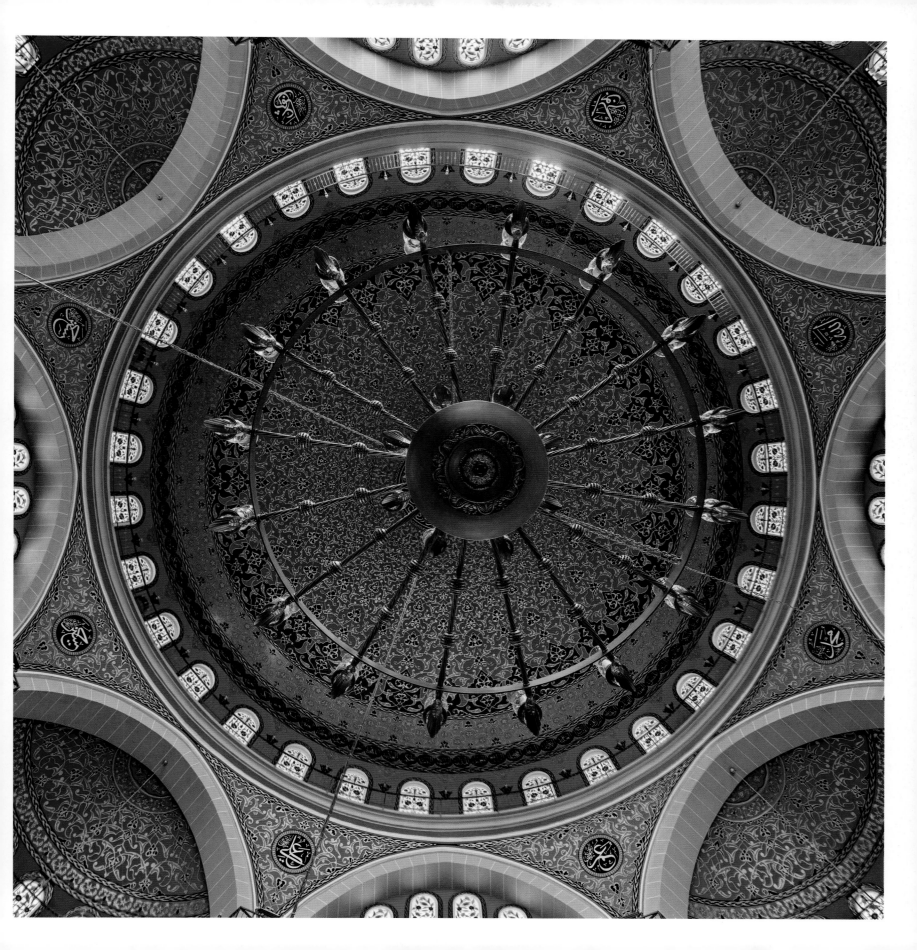

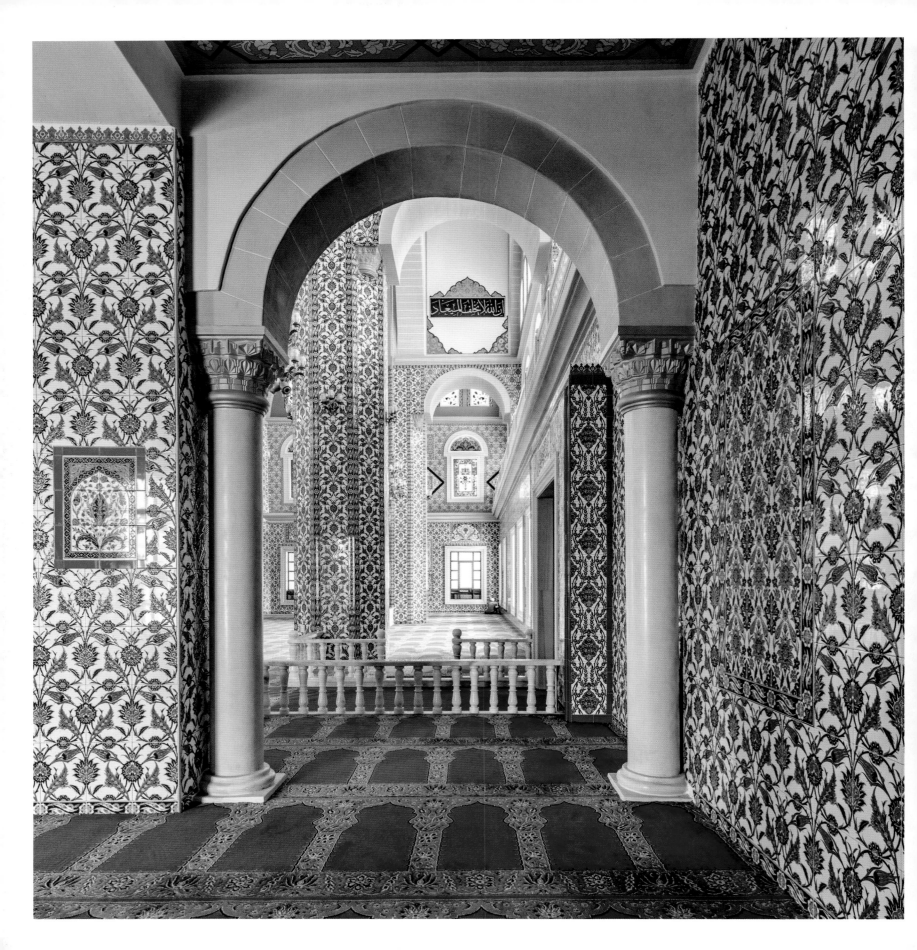

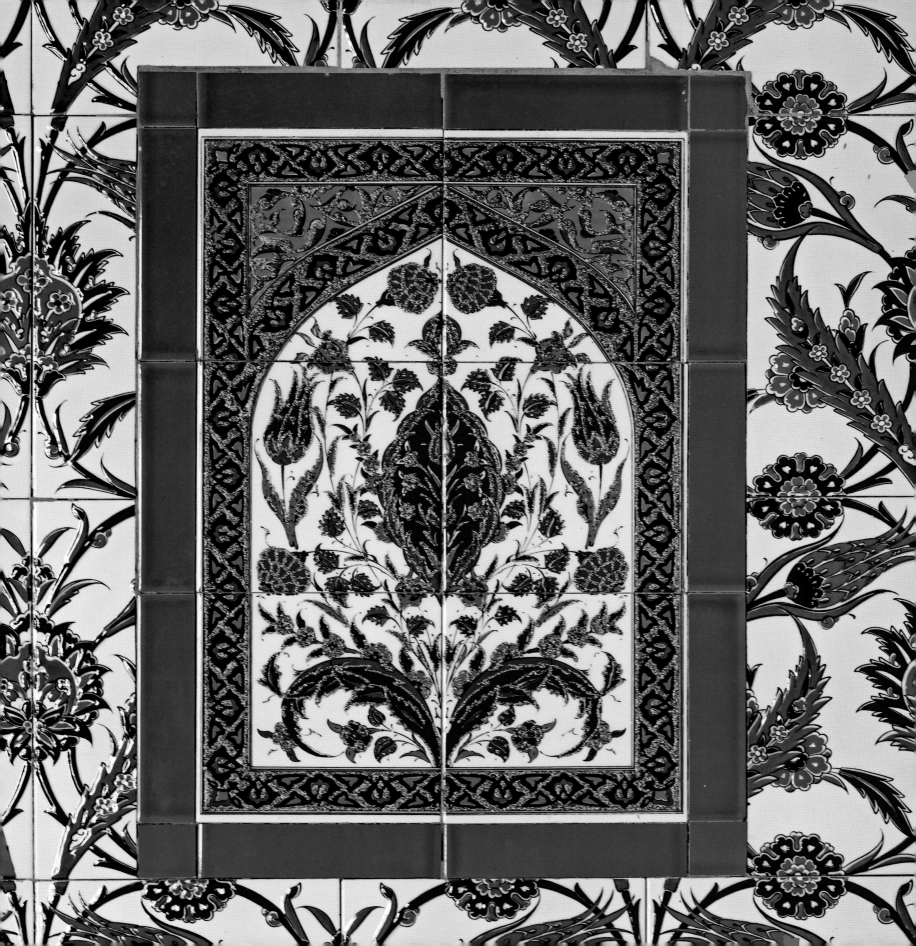

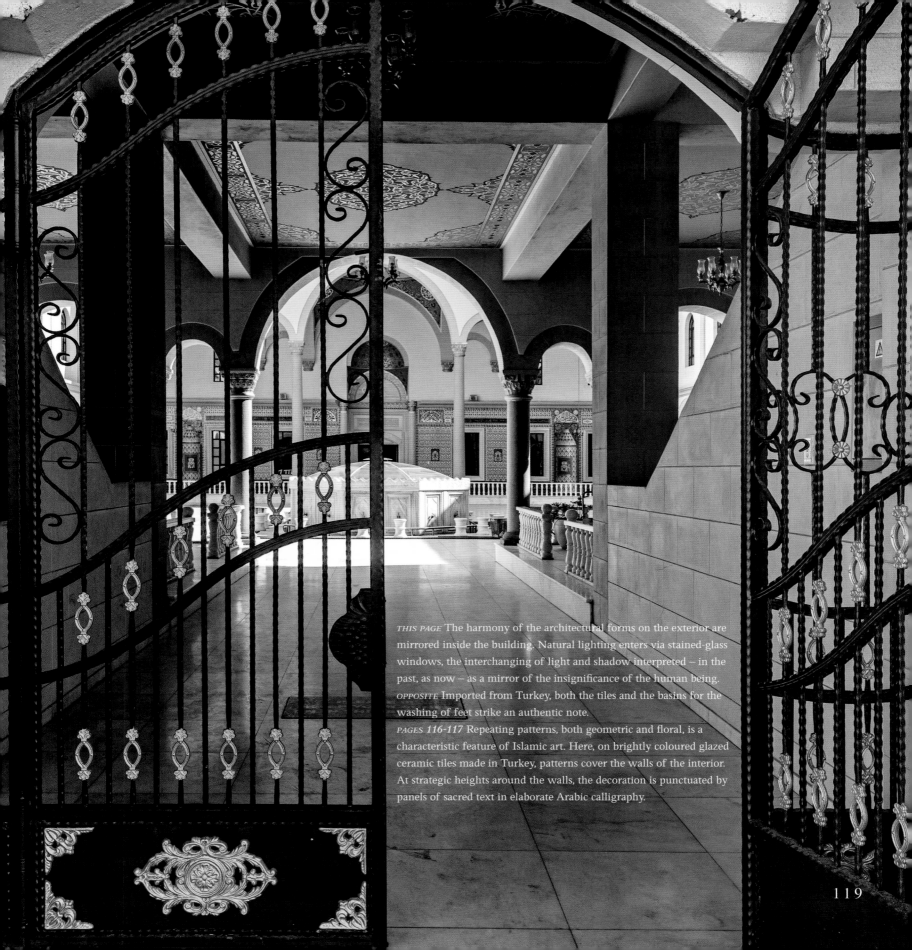

THIS PAGE The harmony of the architectural forms on the exterior are mirrored inside the building. Natural lighting enters via stained-glass windows, the interchanging of light and shadow interpreted – in the past, as now – as a mirror of the insignificance of the human being.

OPPOSITE Imported from Turkey, both the tiles and the basins for the washing of feet strike an authentic note.

PAGES 116-117 Repeating patterns, both geometric and floral, is a characteristic feature of Islamic art. Here, on brightly coloured glazed ceramic tiles made in Turkey, patterns cover the walls of the interior. At strategic heights around the walls, the decoration is punctuated by panels of sacred text in elaborate Arabic calligraphy.

ST MICHAEL & ALL ANGELS
Plein Street, Boksburg

Marooned in what was the commercial centre of Boksburg, is Herbert Baker's fiercely Romanesque-style Anglican church of St Michael & All Angels. Built in 1910, it's one of his most important church buildings. Oddly, the East Rand is not noted for Herbert Baker architecture, although it turns out that there are probably 'more Baker-designed structures in Boksburg than in Parktown', writes Peter Wood of the Boksburg and East Rand Historical Association. Most of the surviving structures are industrial or commercial buildings; many that survive were mine structures designed for mining magnate Sir George Farrar of Bedford Court.

Herbert Baker was the most important church architect working at the beginning of the twentieth century in South Africa. He was also the architect of choice for the Anglican diocese in the Transvaal after the Anglo-Boer War. His work – inspired by English medieval church building, which favoured the use of stone and wood – influenced the course of church design in South Africa until at least the 1930s. At its heart, Baker's work was done in the spirit of the English Arts and Crafts Revival which had found its inspiration in the teachings of Pugin, Ruskin and later, William Morris, and it manifested in buildings that might seem more at home in the shires of England than on the African veld. St George's Cathedral, in Cape Town, is an obvious example in the Gothic style, but here in Boksburg is another, this time in the Romanesque style redolent of the Norman period.

St Michael & All Angels is a typical example of a small Anglican parish church designed by Baker's office. Simple and sturdy, with an apse, a campanile and arched windows, it's a no-nonsense, honest design which seems odd in its African setting. It has a red-tiled roof, a hefty tower, and is built of pale-coloured, locally quarried, heavily rusticated freestone. Apart from a series of stained-glass windows, it's practically devoid of any interior decoration – which only highlights the utter simplicity of a nave topped by a sturdy, dark-stained wooden ceiling supported by a wooden superstructure.

OPPOSITE A little bit of Romanesque England transported to Boksburg. Herbert Baker's church replaces an earlier wood-and-iron structure, and was constructed after a fundraising effort supported by Sir George Farrar, the mining magnate, and a leading figure in the mining sector on the East Rand.

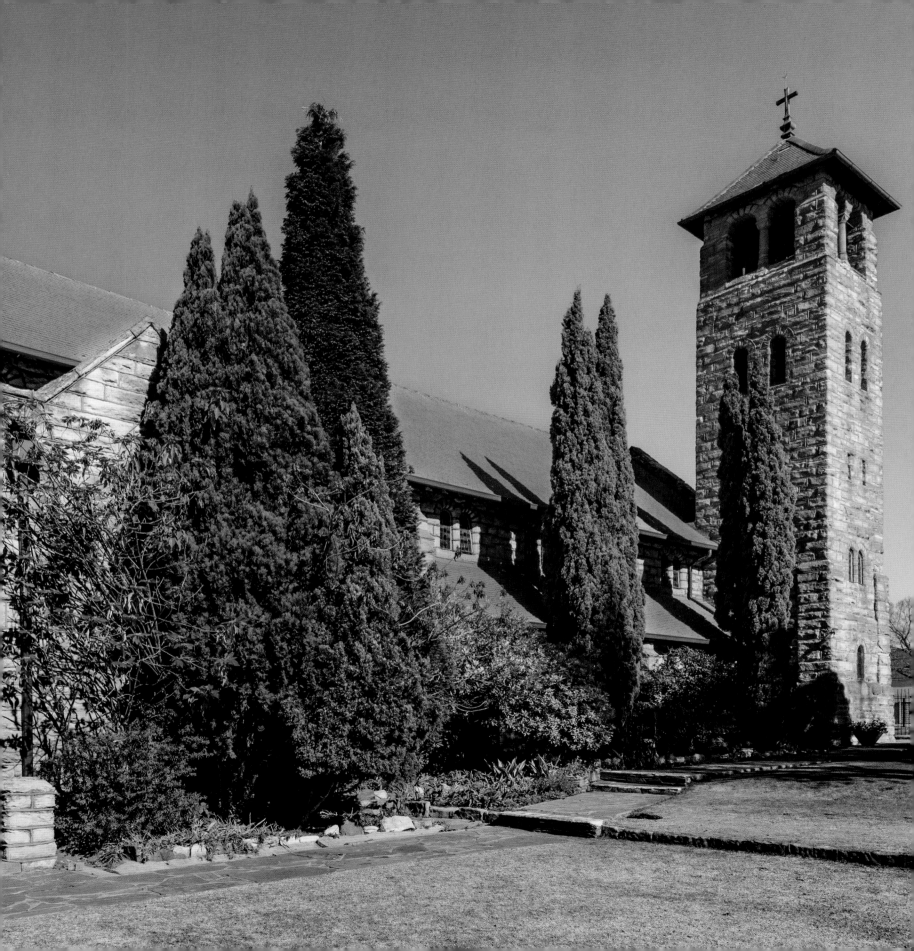

RIGHT The only source of decoration in an otherwise severely plain interior are the period stained-glass windows.

OPPOSITE Simple, even humble, these semicircular arches characterize the architectural style of medieval Europe. In England, they typify the Norman style of architecture, which Baker's office was particularly good at bringing back to life, nowhere more heroically than here, in Africa.

PAGES 124–125 Norman-style architecture is underpinned by massive structural devices, blockish stonework, sturdy pillars and semicircular arches. The general appearance is one of simplicity – in comparison to the Gothic that was to follow. Here, the nave, aisles and apse behind the altar all point freely to the building's stylistic origins.

✦ GENERAL GORDON ✦

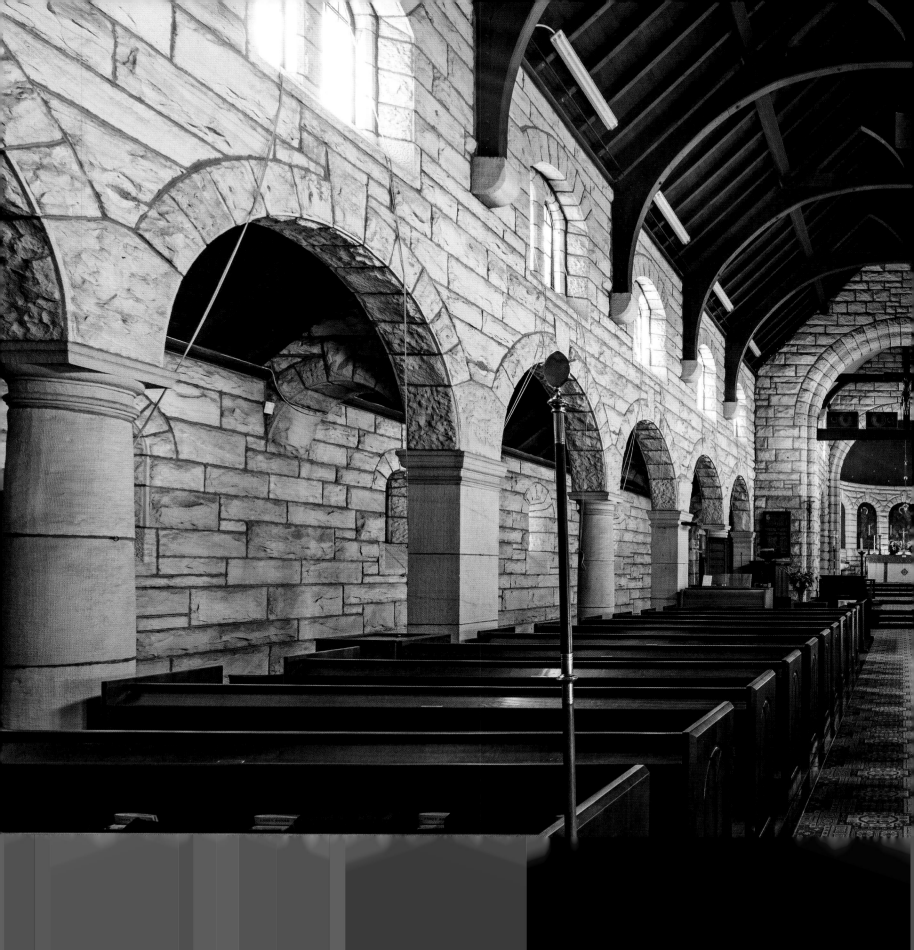

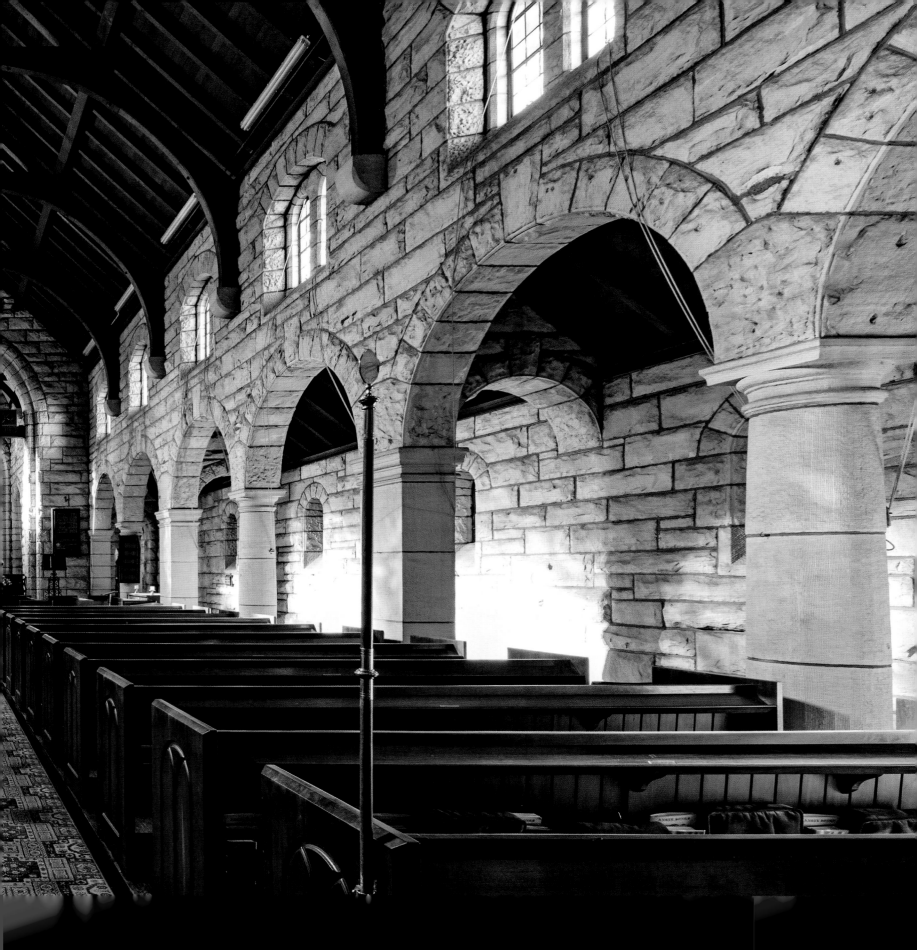

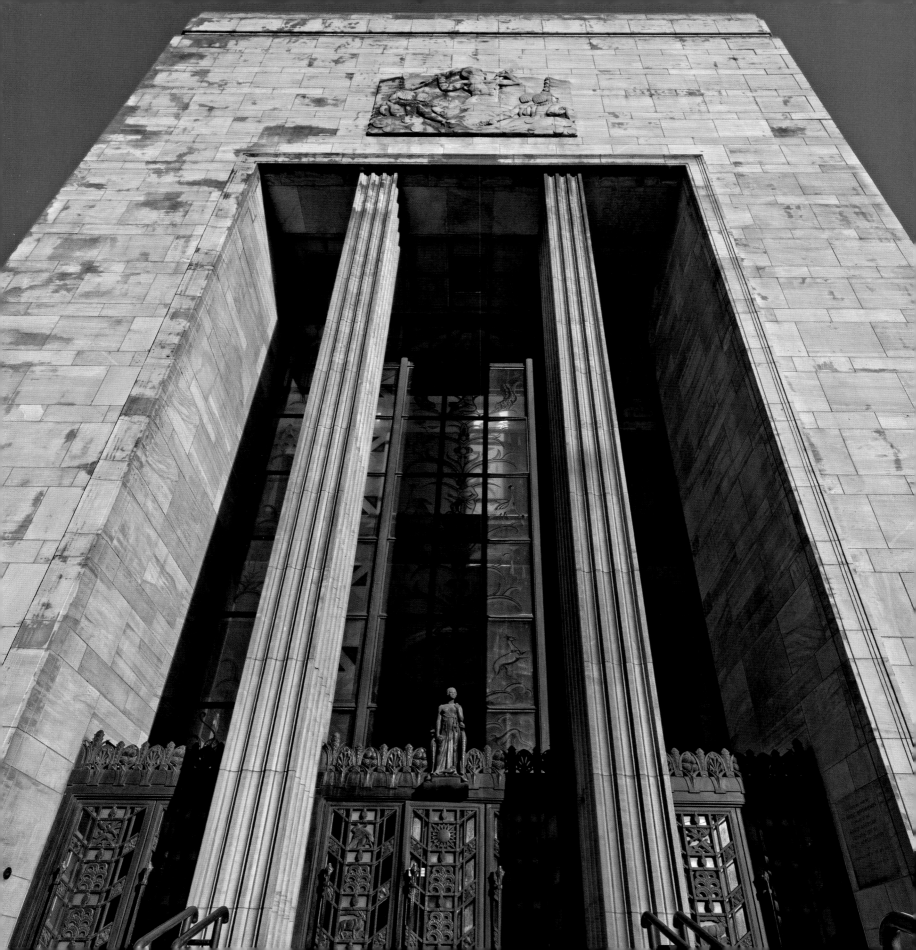

ANGLO AMERICAN HEAD OFFICE
44 Main Street, Marshalltown

I f you want to look for the stylistic antecedents for the handsome Anglo American building on Main Street, you need to go back to 1930s London and Val Myer's Broadcasting House for the BBC (1932) in Portland Place; its near neighbour the RIBA headquarters designed by George Wornum (1934); and the monolithic Senate House designed by Charles Holden for the University of London, completed in 1937. The massive League of Nations building in Geneva, completed in 1937, its forecourt situated between two wings on either side of a central building, is perhaps the precursor of the much smaller Anglo American building, at a time when the 'skyscrapers' in Johannesburg were rather more high-rise than layered, as this one is.

Even the massive buildings of Mussolini's Rome, with their pared-down classicism, or Albert Speer and Gerdy Troost's grimly elegant buildings in 1930s Germany, can be referenced here, their monumental scale used as an instrument of state propaganda; their 'simplified but traditional classicism', wrote William JR Curtis, expressive of 'the Führer's aspirations towards a monumental "community" architecture extolling the discipline, order and strength of the new state'. Monumental architecture has always been used to embody the values of dominant groups or ideologies. That Anglo American felt the need to do the same isn't surprising; they too felt the need 'for a certain type of impressive external appearance', writes Clive Chipkin in *Johannesburg Style*.

The architects – commissioned in 1935 by Sir Ernest Oppenheimer for the new headquarters into which the Anglo staff moved in 1939 – were the London firm of Burnet, Tait & Lorne whose principal, Sir John Burnet, had been heavily involved in the competition to find a winning design for the League of Nations building. Burnet, who had also designed the Edward VII Galleries at the British Museum and the completion of the eponymous Oxford Street store for Gordon Selfridge, died in 1938. It was his partner in the firm, Francis Lorne, who carried out the work, with Sir John only appearing at periodic meetings in a chauffeur-driven Rolls Royce.

Today, the building at 44 Main Street, still Anglo American's HQ in Africa, is a Johannesburg landmark. It occupies an entire city block, on a site that was, in fact, where gold was found in one of Johannesburg's original claims. Even now, there's a timelessness to Burnet, Tait & Lorne's design, its monumental bulk shorn of all ornament except for specific sculpted panels placed strategically over entrances or on pylons flanking the entrance stairway.

OPPOSITE The monolithic, stone-faced central block is one of the most characteristic buildings of old Johannesburg. Anglo American was founded in 1917 by Sir Ernest Oppenheimer and today is still headquartered in the Main Street building.

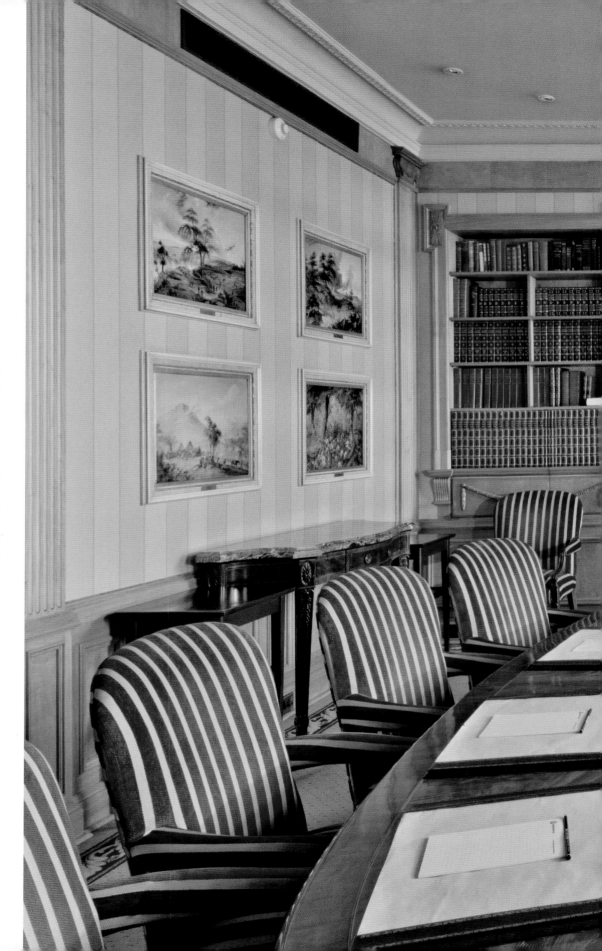

RIGHT One of the glories of the Anglo American interior is the hoard of old furniture and art, both historic and contemporary, that it contains. In a meeting room, is part of a fine collection of Thomas Baines paintings.

PAGE 130 At the entrance, Jan Juta's etched and glazed screen follows the direction of architect Francis Lorne to adorn the building with depictions of South African flora and fauna. Juta's work can also be seen adorning the Florence Hall at the RIBA building in London.

PAGE 131 Harry Oppenheimer, in a portrait in the boardroom, was chairman of Anglo American Corporation for 25 years and chairman of De Beers Consolidated Mines for 27 years. He succeeded his father, Sir Ernest Oppenheimer, who founded the Anglo American Corporation and was responsible for commissioning this building.

PAGE 132 The ornament on the entrance doors, the work of Walter Gilbert, was developed from a study of South African birds, animals and flowers; at the time they were planned, it was deemed inappropriate to use ornament belonging to Europe.

PAGE 133 The foundation stone of 44 Main Street.

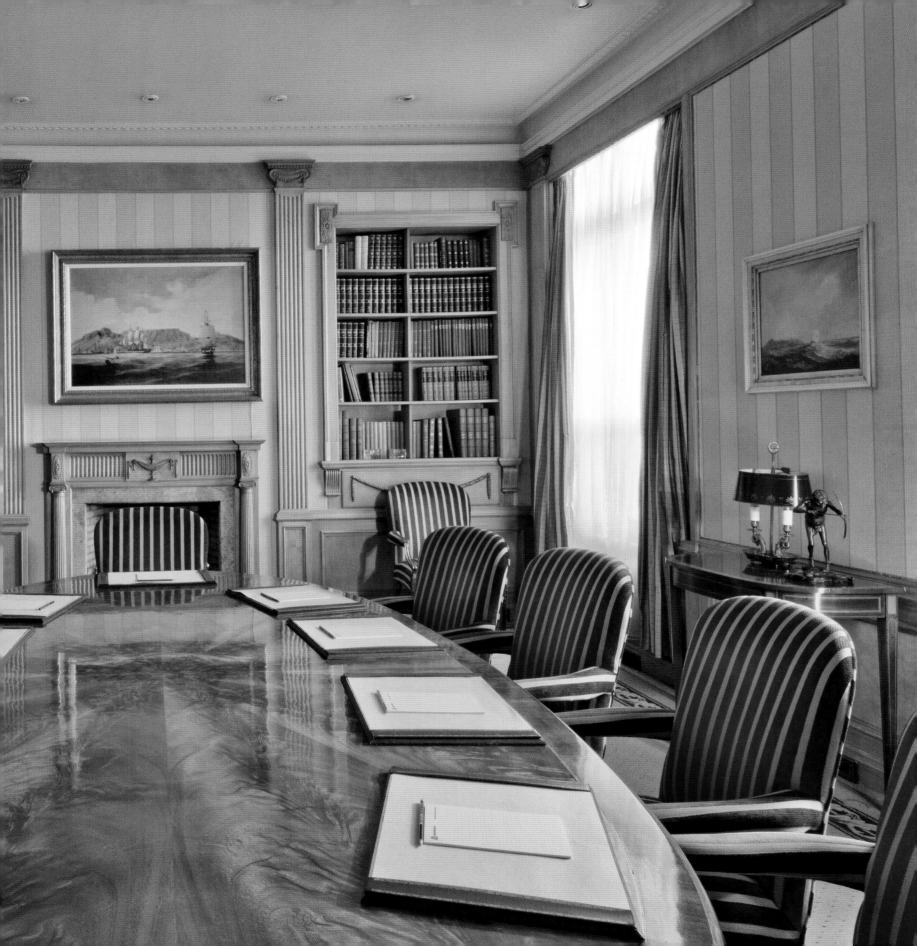

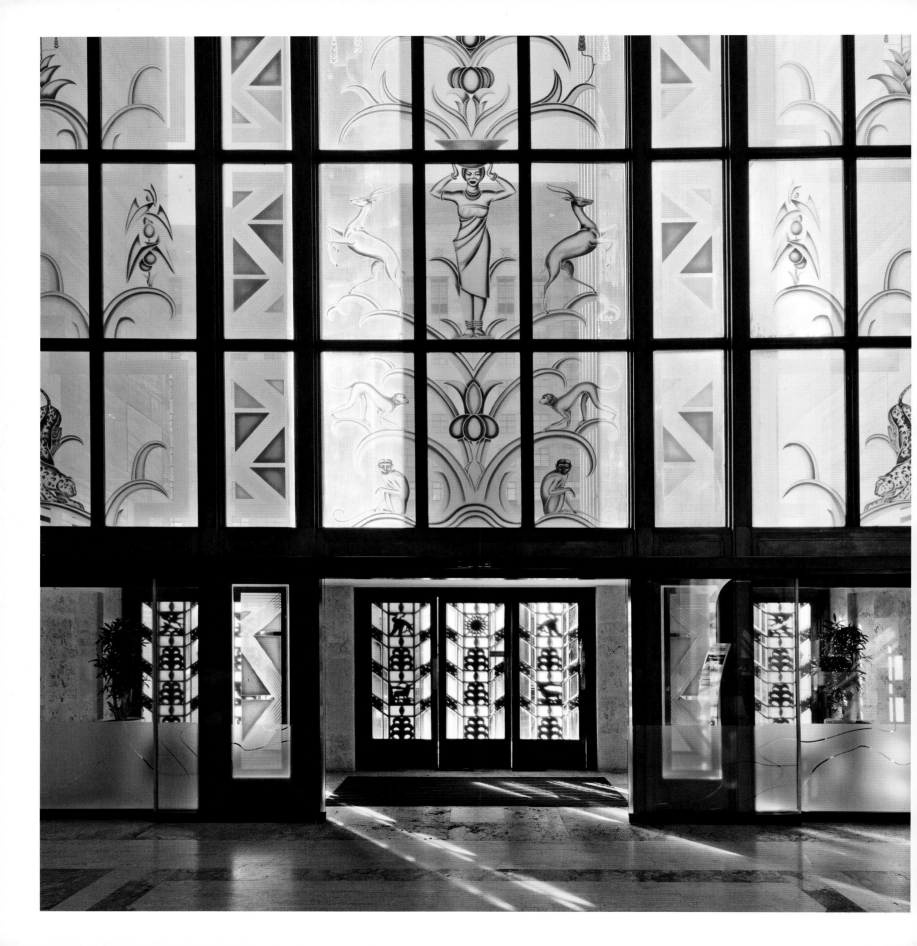

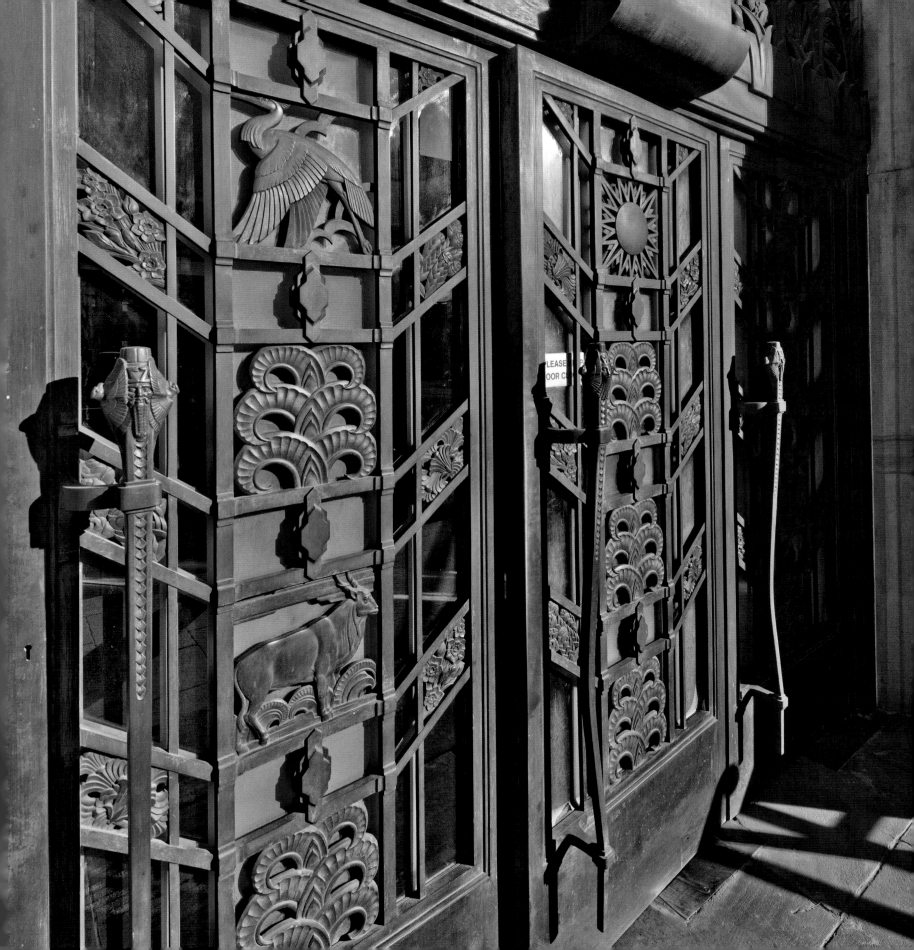

THIS STONE WAS LAID BY

SIR ERNEST OPPENHEIMER

CHAIRMAN OF THE

ANGLO AMERICAN
CORPORATION OF
SOUTH AFRICA LIMITED

ON

WEDNESDAY THE 15TH OF JUNE 1938

SIR JOHN BURNET, TAIT AND LORNE.
ARCHITECTS

SATYAGRAHA HOUSE
Pine Road, Orchards

In a deeply suburban but bucolic corner of northern Johannesburg, is Orchards, a neighbourhood where the streets are lined with trees and the gardens are large and leafy. When Mahatma Gandhi lived here, in two simple thatched rondavels called The Kraal, this was countryside and the house had a stable, a tennis court and a well for water.

Satyagraha is the Sanskrit word used by Gandhi to describe the struggle of nonviolent passive resistance, in this particular instance for Indian rights in South Africa. Satyagraha – initially called the passive resistance (struggle) – galvanized around two pieces of discriminatory legislation: the Asiatic Registration Act and the Transvaal Immigration Act. The first required all Indian males living in the Transvaal to register and have thumbprints taken. The second restricted the entry of Indians into the province. Until then, Indian grievances had been dealt with via petitions, memoranda and public speeches. Gandhi realized that new radical methods of struggle had to be devised. He formed an alliance with South Africa's Chinese community who faced the same discrimination under the anti-Asiatic laws. Satyagraha was born.

Today, The Kraal is called Satyagraha House and is a part of a guesthouse whose seven rooms are decorated in the spirit of Gandhi's asceticism and temperance and his disregard for material wealth. The original buildings have been augmented with contemporary accommodation, designed by Rocco Bosman, and throughout, the furniture and objects come mostly from Gujurat, Gandhi's native region. There is also an interesting small museum. While not exactly austere, the guesthouse does exhibit a pared-down simplicity that was the essence of Gandhi's daily life – and that of Hermann Kallenbach, the German body-builder architect who designed The Kraal and lived in it with Gandhi between 1908 and the end of 1909. In Gandhi's words, the two men were 'soul mates', a voluntary simplicity the essence of their daily lives here and for the five years, until 1913, that they lived together, subsequently under canvas at The Tents in Mountain View and, finally, at Tolstoy Farm, the property Kallenbach bought for Gandhi at Lenasia in southwest Johannesburg. 'Your portrait (the only one) stands on the mantelpiece in my bedroom', Gandhi wrote to Kallenbach, fuelling speculation about the nature of their friendship, 'the mantelpiece is opposite the bed'. In turn Kallenbach, wealthy from land speculation and township development, renounced his luxurious lifestyle and its extravagances, and went on to become Gandhi's disciple, accepting that being a *satyagrahi* meant a way of life rather than simply a political struggle.

Extraordinarily, this modest cluster of buildings in a forgotten corner of suburban Johannesburg, is seminal as one of the backdrops to a fundamental transformative aspect of South African social history. Today, restored and a heritage monument, it nonetheless retains its scrubbed authenticity.

OPPOSITE A French company, Voyageurs du Monde, that specializes in exotic travel destinations, purchased Gandhi's former home. Now a museum and guesthouse, it is simply furnished, in keeping with the asceticism of its illustrious occupant.

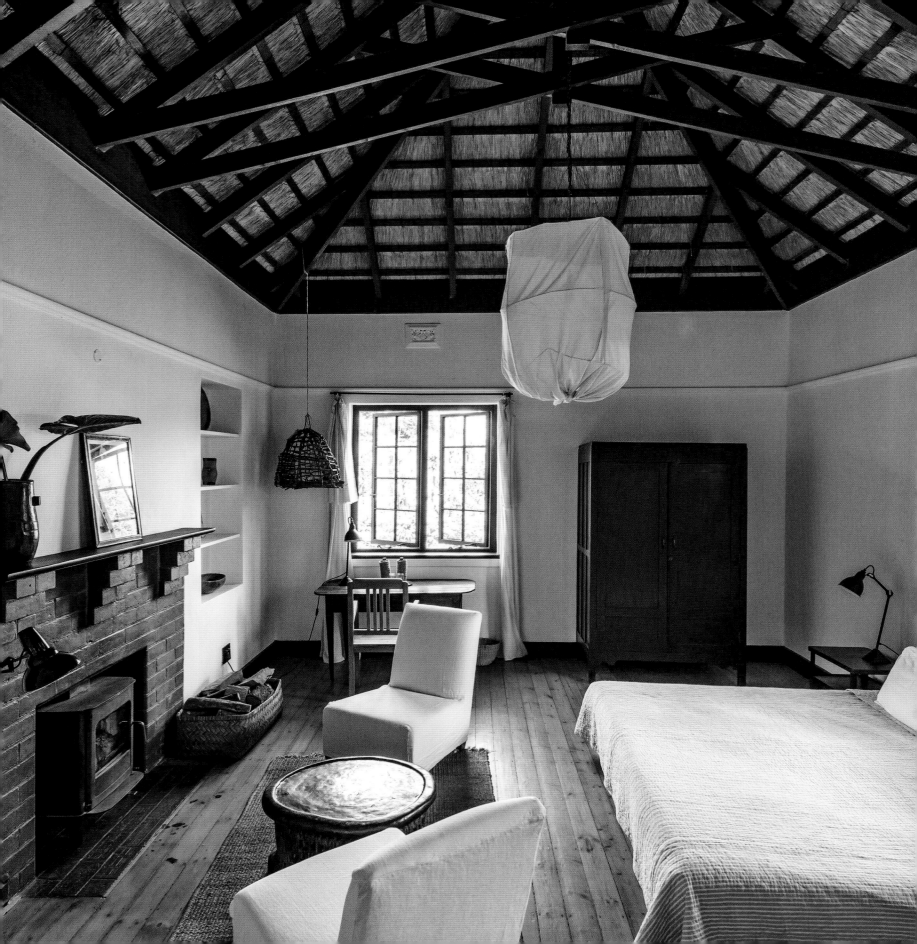

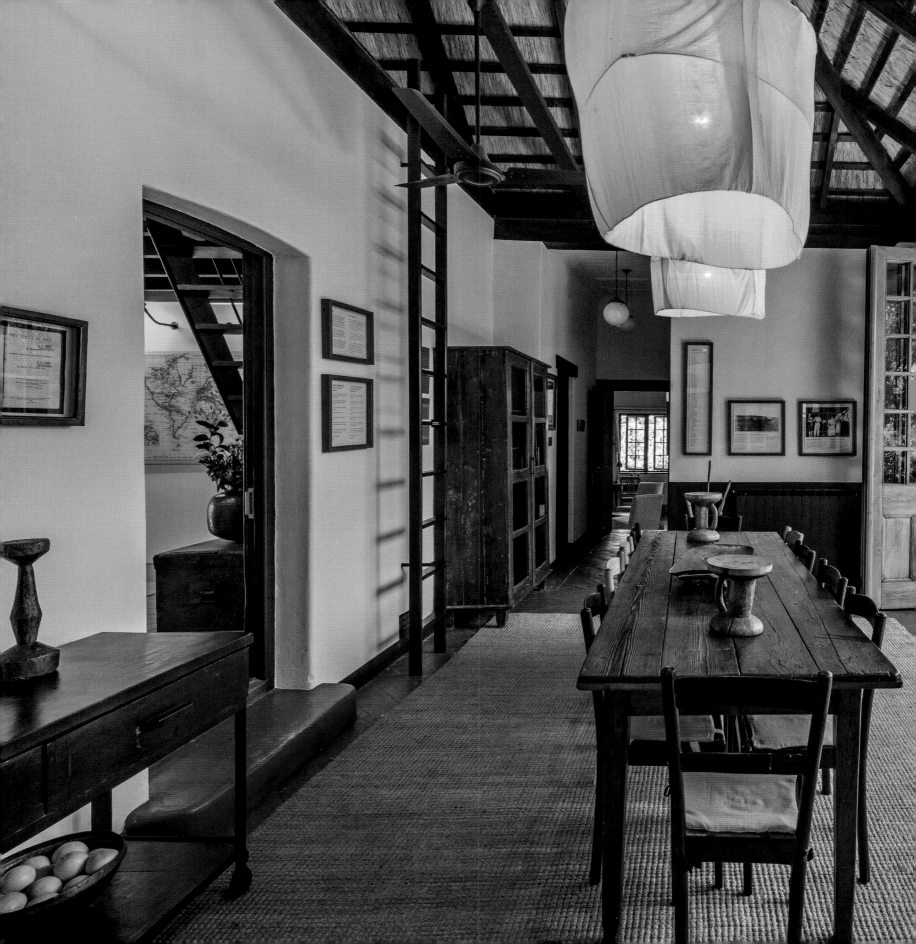

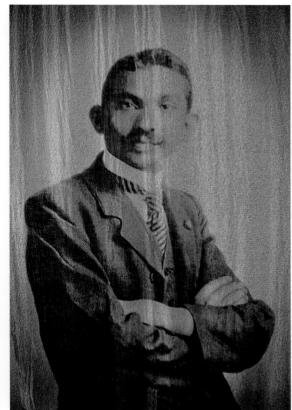

ABOVE Gandhi lived at The Kraal for no more than five years. He shared it with a body-builder called Hermann Kallenbach, whose name pops up frequently in the history of early twentieth-century Johannesburg, principally because he was a prolific architect, many of whose buildings survive to this day.

LEFT The interiors of Satyagraha House today are the work of Christine Puech and Amit Zadok who sourced much of its content in India and South Africa. The hanging lights were constructed by Mark Schooley using cotton khadis (handwoven cloth from India, Pakistan and Bangladesh) over a wire frame. The khadi was made famous in India in the 1920s by Gandhi, who promoted the idea of Indians using khadi fabric for clothing instead of wearing imported British clothes.

PAGE 138 More of a shrine to Gandhi than a room to use, an attic room invites quiet contemplation.

PAGE 139 Portraits of Gandhi and Kallenbach hang on a stoep that links the two thatched rondavels whose future is secured through their heritage status.

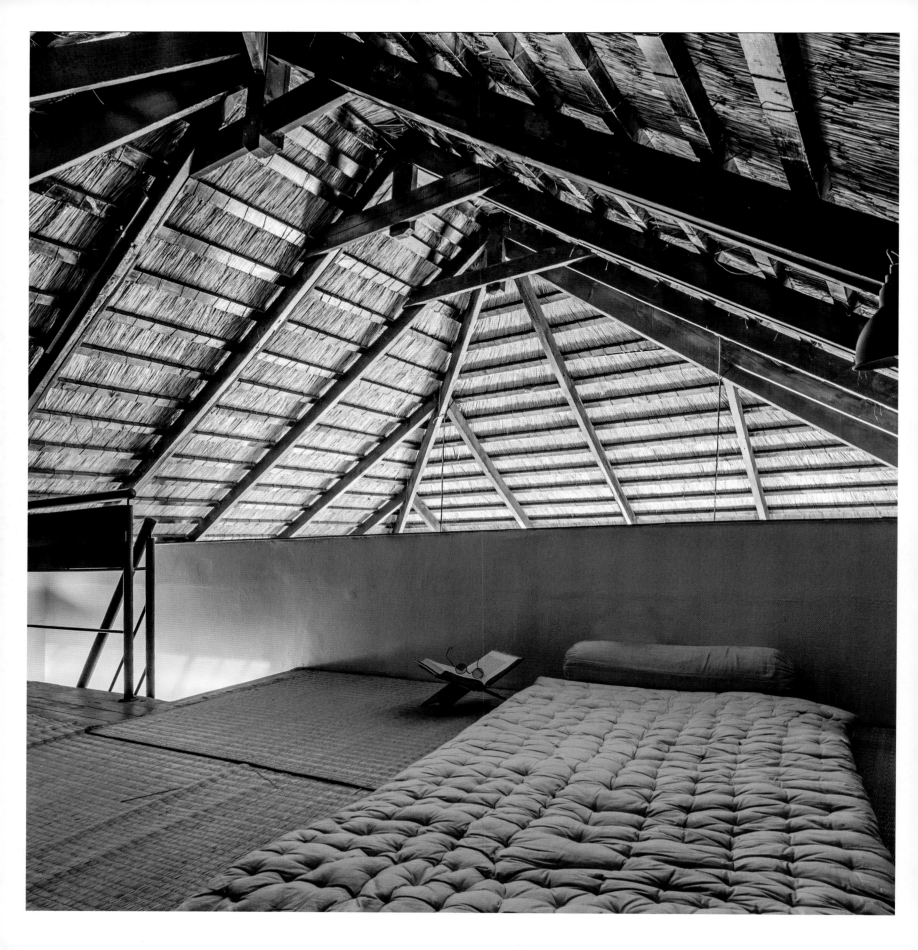

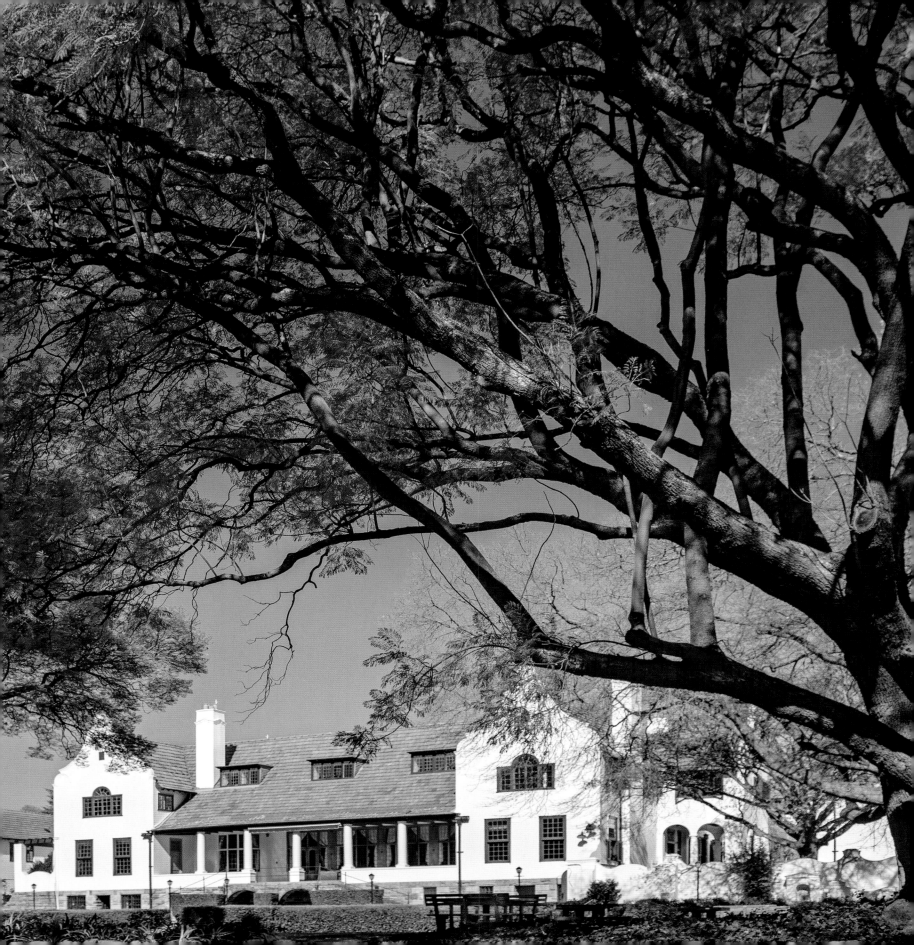

BEDFORD COURT
St Andrew's School for Girls, St Andrew's Avenue, Bedfordview

Bedford Court, the handsome Cape Dutch-style mansion that Herbert Baker designed for the Randlord George (later Sir George) Farrar at his farm Bedford, is today at the heart of an old Johannesburg institution, St Andrew's School for Girls. 'Lord Milner', says the handcut letters on the stone plaque by the garden gate, to the left of the main entrance, 'laid the foundation stone in 1903'. It's one of Baker's most beautiful houses, externally at least, and while its *genius loci* is diminished somewhat by the development on what was once Sir George's farm, it faces Lady Farrar's gardens that are still filled with their trees and parterres, avenues and walks. Situated to the east of Johannesburg, the Bedford farm wasn't far from Sir George's mining claims in Boksburg – where many of the mine structures that Baker designed for him still survive. Farrar would ride to work, mounting his horse under the jacarandas at the bottom of the garden and reaching the mines after just an hour's canter. Sir George was the leading figure in the mining sector on the East Rand, the main source of his wealth the East Rand Proprietary Mines he'd established in 1893. He had a busy, involved life, which saw him become a conspirator in the Jameson Raid, a member of the first Parliament of the Union Government, and chairman of the Chamber of Mines. It led, ultimately, to his death during World War I from injuries sustained in an accident on a railway in German South West Africa (Namibia).

His house survives, though for most of its existence it's been a school. After Sir George was killed, the Farrar family lingered on there for a while before selling a chunk of the estate and the house in 1920 to Jean Fletcher who, with Jessie Johnston, had been one of the founders of St Andrew's School for Girls. The school began life on Hospital Hill in Johannesburg in 1902, and as it outgrew the double-storey, semidetached house it occupied, went through a variety of other premises until the decision was made to install it in the enormous Farrar mansion which, with its seven indoor bathrooms, water and electricity, was more than ideal. For nearly a century now, Bedford Court has been a school and not a private home, and today the school uses the building as offices and as a venue for functions.

While it's quite a formal, even grand, house – particularly when viewed from the garden – it is also an expression of Baker's interest in the English vernacular of the Arts and Crafts Movement and the idea of authentic, even traditional, craftsmanship. It evokes the picturesque English country house with its forecourt, off-centre entrance gable, tall chimneys, dormer windows and rusticated basement. It has its eclectic antecedents: the panelled 'medieval' Great Hall with its open-beamed ceiling, and the Morning Room with its stone fireplace shaped like a perpendicular arch of the Tudor period. It has the massing and silhouette of its near contemporary, Northwards, in Parktown, and the monumentality of Groote Schuur, Cecil John Rhodes's house in Cape Town, built for him by Baker in 1893. All the 'Bakerisms' are here, confidently presented as though this was the new dawn of South African architecture. Bedford Court is actually the best evidence, along with Villa Arcadia in Parktown, of the eclectic knowledge and preferences that Herbert Baker had gathered en route to South Africa – see the white, plastered Cape Dutch-style gables, those on the entrance front exhibiting that stylized, elongated shape that seems more Flemish than Cape. And the house contains one or two surprises, not least a 'Turkish' bathroom with Delft-style tiles lining its walls and, in former bedrooms, niches for use as washstands, featuring ornate tiles for both practical and decorative purposes. And then there are the fireplace openings with more tiles, the look sometimes Islamic, sometimes Portuguese, occasionally Spanish. Elsewhere, carved newel posts and balusters have survived, along with light fittings and original door handles.

OPPOSITE The garden façade, viewed from the Tea Lawn, showcases the magnifence of the mansion. The dormer windows of the Farrar girls' former nursery and schoolroom are on the upper level, the drawing room and stoep on the middle level and the storage rooms, or dungeons, as the St Andrew's girls like to call them, are below.

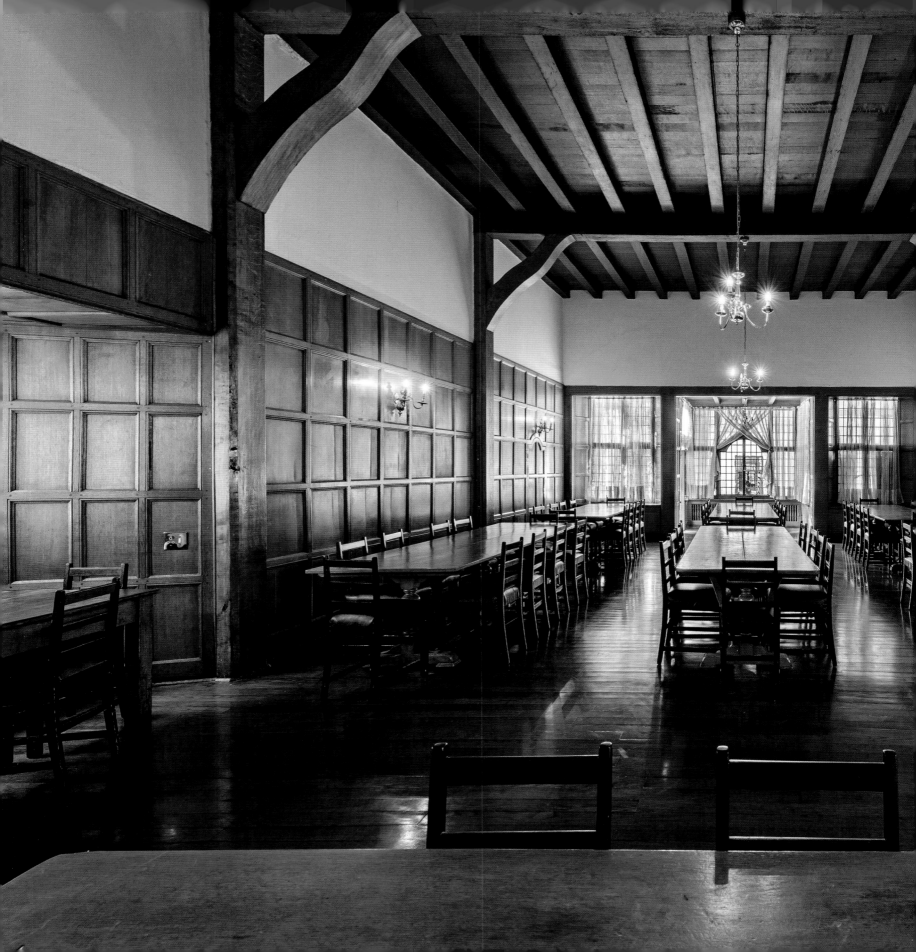

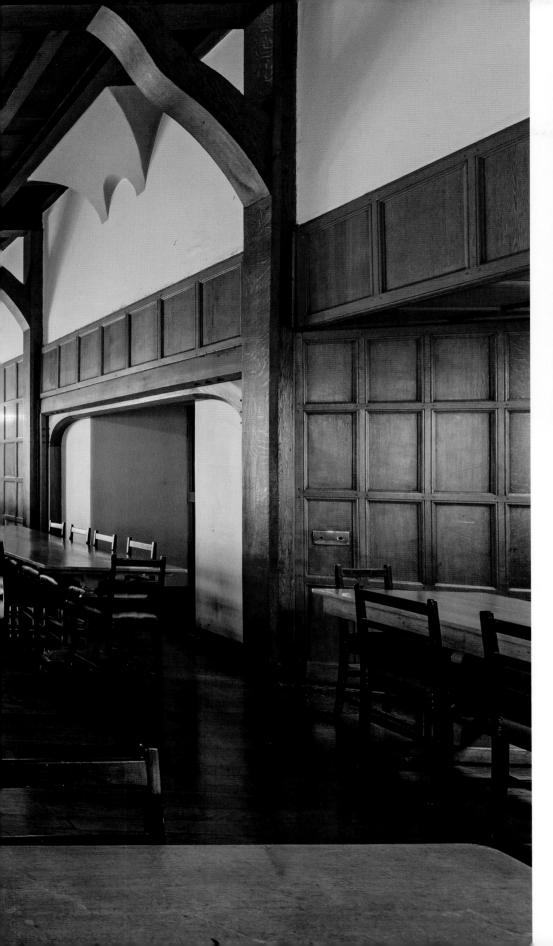

ABOVE The original brass knocker on the front door of Bedford Court.

LEFT The beautiful wood-panelled dining room with its beams and arches accommodates the boarders.

PAGES 144–145 The approach to Bedford Court from the main drive.

PAGE 146 A fireplace in one of the former Farrar girls' bedrooms. Today this room is the office of one of the deputy heads of St Andrew's School for Girls.

PAGE 147 The fireplace surround in the executive head's study – at one time also a bedroom of one of the Farrar girls. Later it became a common room for boarders.

PAGE 148 A view over the rooftops of Bedford Court.

PAGE 149 The former drawing room leads out onto the front stoep. Guests of the Farrar family were entertained here. To this day, it is used by the school for smaller functions and cocktail parties.

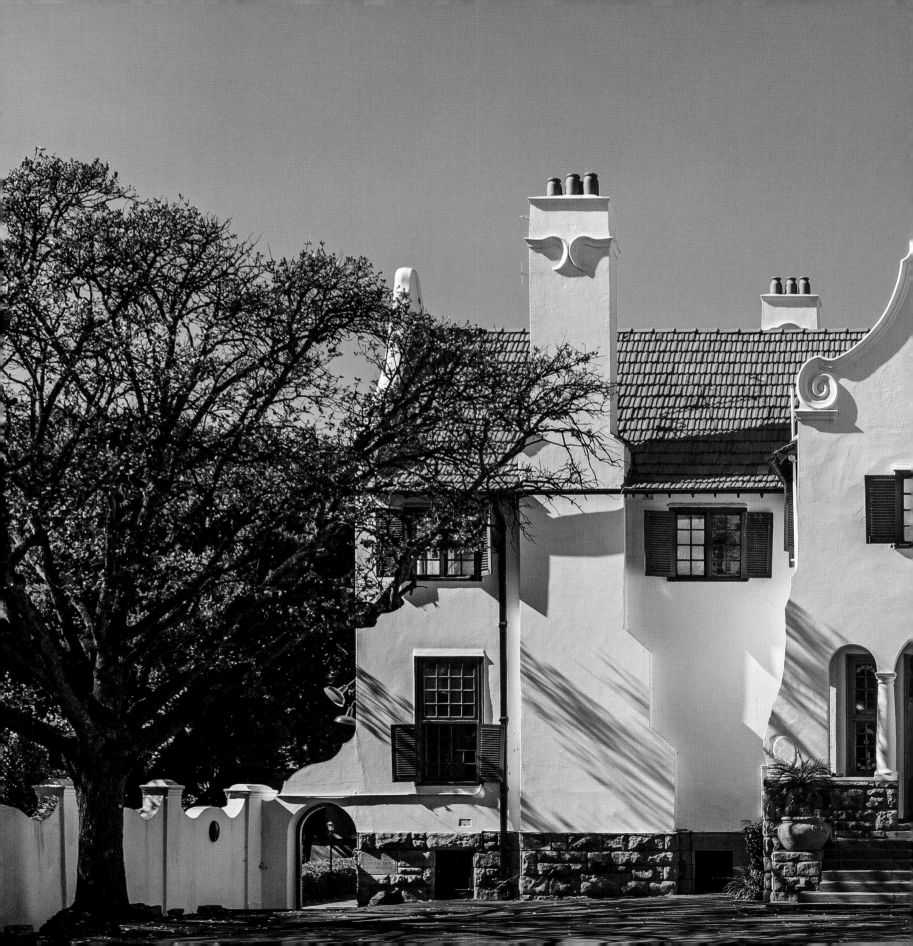

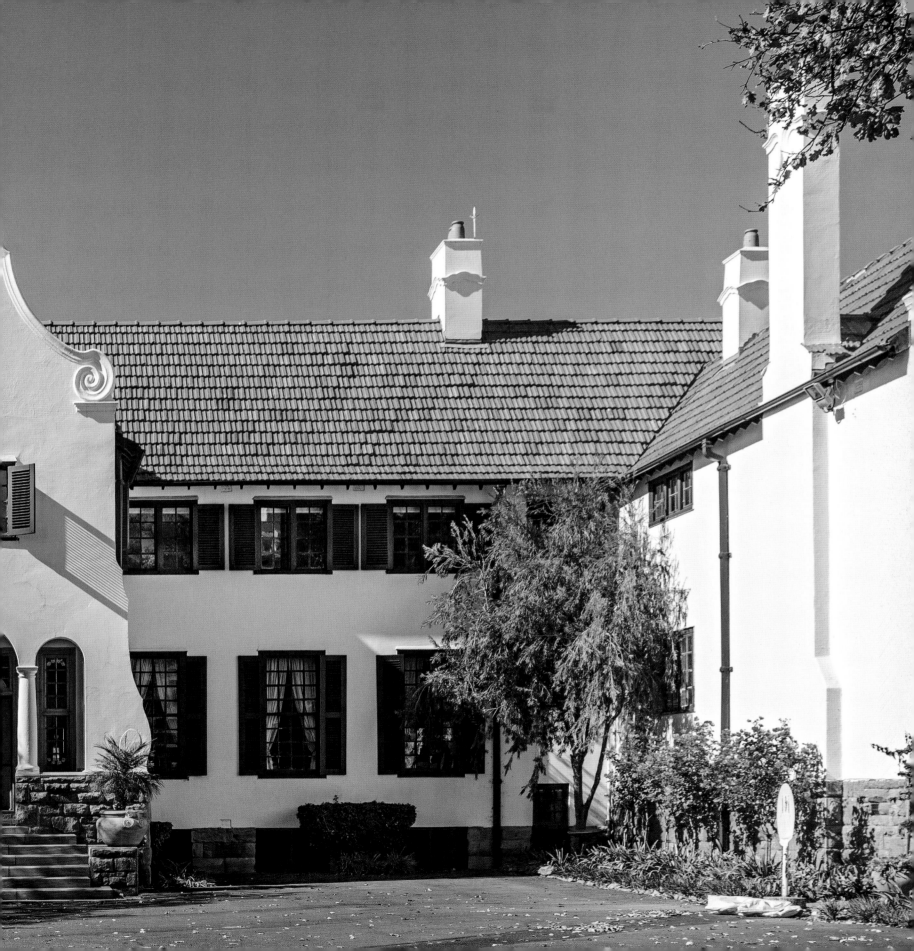

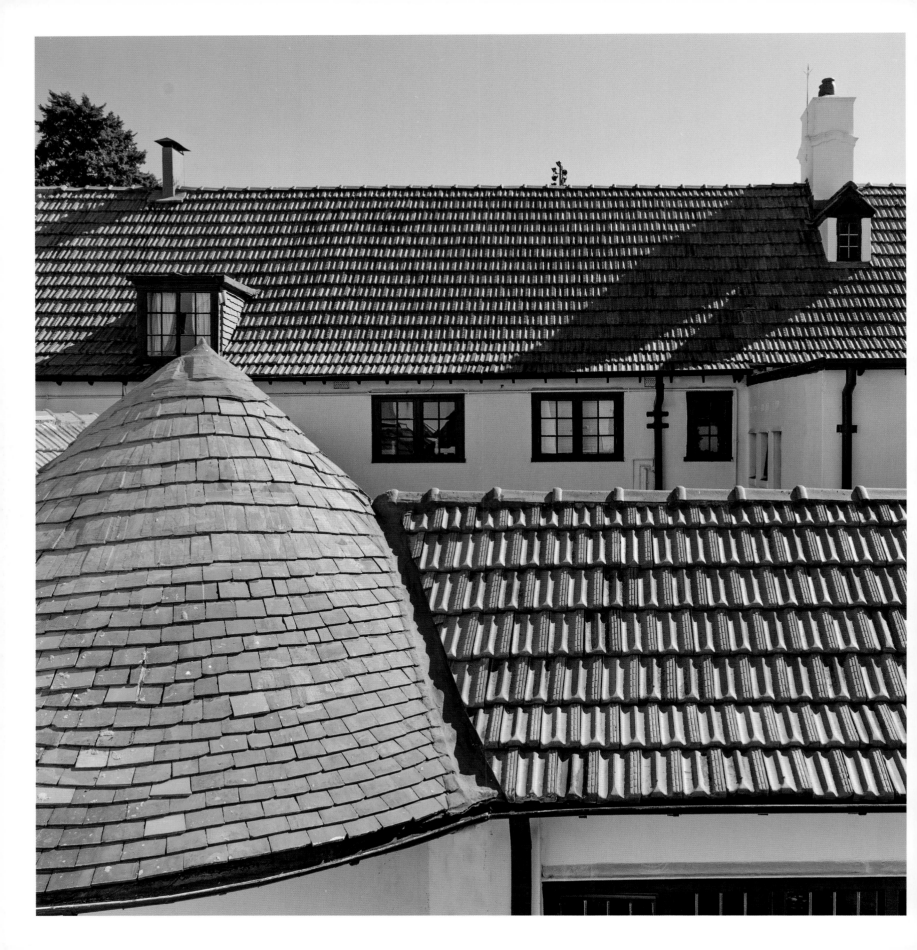

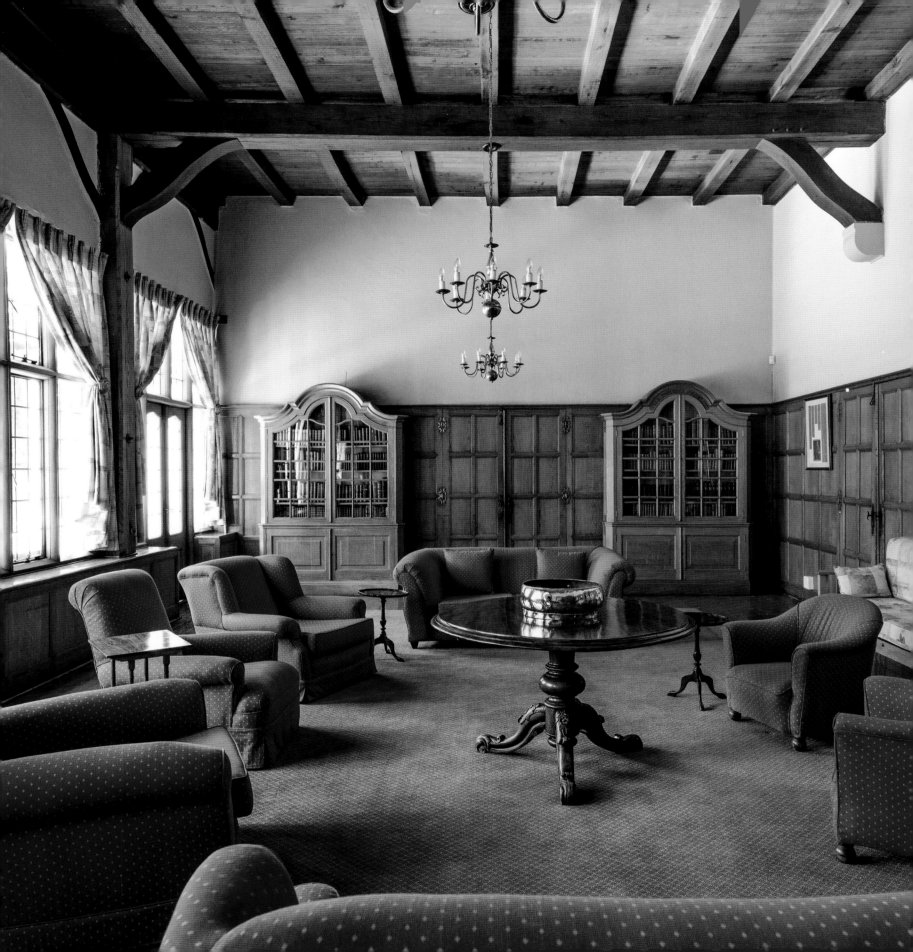

THE OLD FORT
Kotze Street, Braamfontein

At one time, the Old Fort prison complex housed South Africa's most prominent political prisoners. Its construction was completed in 1896 by the South African Republic and the intention was that it would 'command Johannesburg' following the Jameson Raid, but after the British took occupation of Johannesburg in 1900, the fort became a prison.

There's something fantastical about The Fort's whitewashed, crenellated entrance and bastions with their armorial bearings, buttresses and gun emplacements. They seem more Hollywood than a serious deterrent against any threat of invasion, their bird's-eye view of the fledgling town a strategic necessity in Paul Kruger's view, given that Johannesburg, at the time, was filled with *uitlanders* ('outsiders'). In the event, no shot in anger was ever fired from the Fort.

Absurd it may look, but the Fort was to become a notorious prison that has earned a place as a beacon for human rights in South Africa. Over the decades, it's housed a range of prisoners, many thousands of them incarcerated simply for contravening petty colonial or apartheid legislation. But it's also where common criminals and notorious murderers were brought – people like Daisy de Melker who was hanged in 1932 for killing two of her husbands and a son. Gandhi was imprisoned here in 1908, along with many Indian protestors, for refusing to carry a pass; so were striking mineworkers in 1913 and again in 1922 following the Rand Revolt.

During the Struggle years, many hundreds, if not thousands, of South Africans were held here: following the 1952 Defiance Campaign, the 1956 Treason Trial, Sharpeville (1960), the 1976 Soweto uprising, and the clampdowns of the mid-1980s State of Emergency. Over the years, the inmates have included not only Nelson Mandela but Albert Luthuli, Joe Slovo, Oliver Tambo, Walter Sisulu, Helen Joseph, Moses Kotane, Ruth First, Lillian Ngoyi, Albertina Sisulu and Winnie Mandela. Suspected communists, activists and students all did time here, in conditions that were notoriously unlovely. The complex was divided into various sections, including the Natives' Section; isolation cells, known as Sections Four and Five, where black male prisoners were held; a Women's Gaol, and the Awaiting Trial block, the latter a place to hold high-risk prisoners, like the treason trialists in 1956.

The prison was shut down in 1987 but the complex was revived in the 1990s when the site was chosen for South Africa's new Constitutional Court, established after the country's first democratic elections in 1994 and the adoption of a new constitution in 1996. The entire complex is now known as Constitution Hill and the Old Fort is a museum.

OPPOSITE The old prison complex was – and still is – a harrowing place, notorious for the brutal treatment of its inmates.

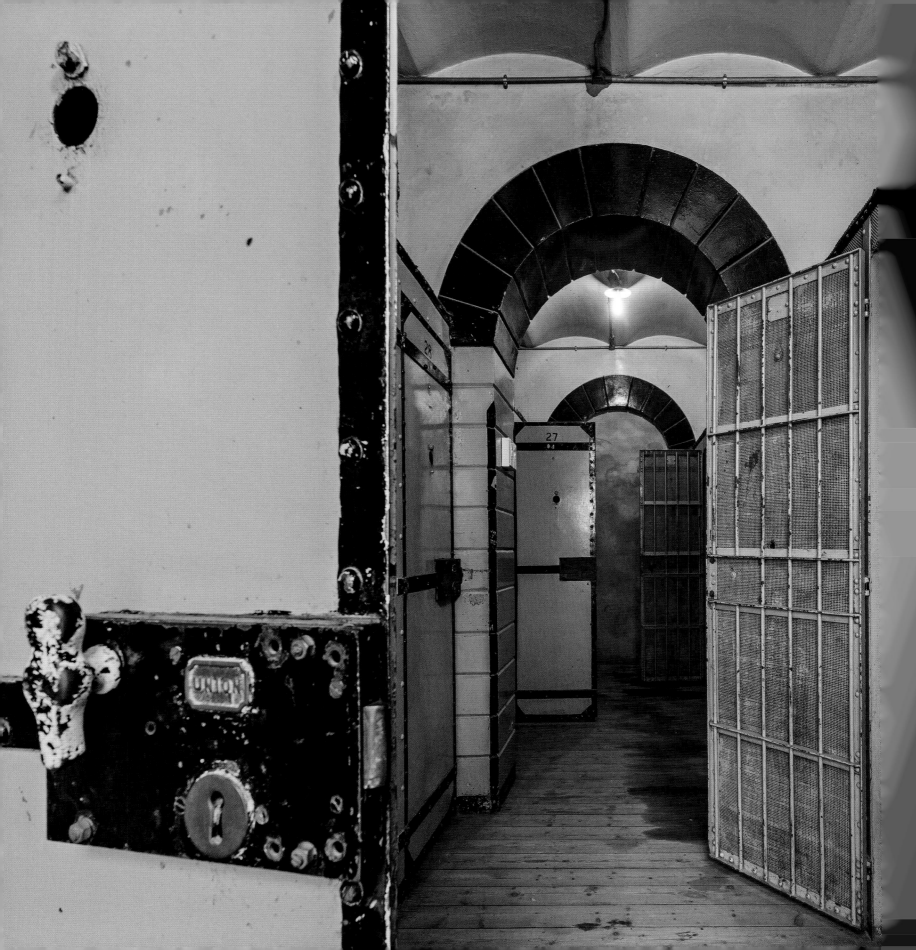

THIS PAGE The horrible conditions in this ghastly place have been preserved simply because they bolster the stories of the many famous, and infamous, prisoners held here – from rebel Boer leaders to Mahatma Gandhi, Nelson Mandela and serial murderer Daisy de Melker, to the many ordinary people held under the inhumane pass laws.

OPPOSITE Sections of the prison complex, comprising the Awaiting Trial block, Section Four, the Old Fort itself, and the Women's Gaol, have been preserved and transformed into museum and exhibition spaces.

PAGE 152–153 Common criminals were housed 60 to a cell, while political prisoners, who were housed separately, were packed as many as 120 to a cell. Rations were strictly defined along racial lines, and showers were provided once a month.

PAGE 156–157 The isolation cells: a walk around the complex brings the visitor into disturbingly real contact with the prison's dark history.

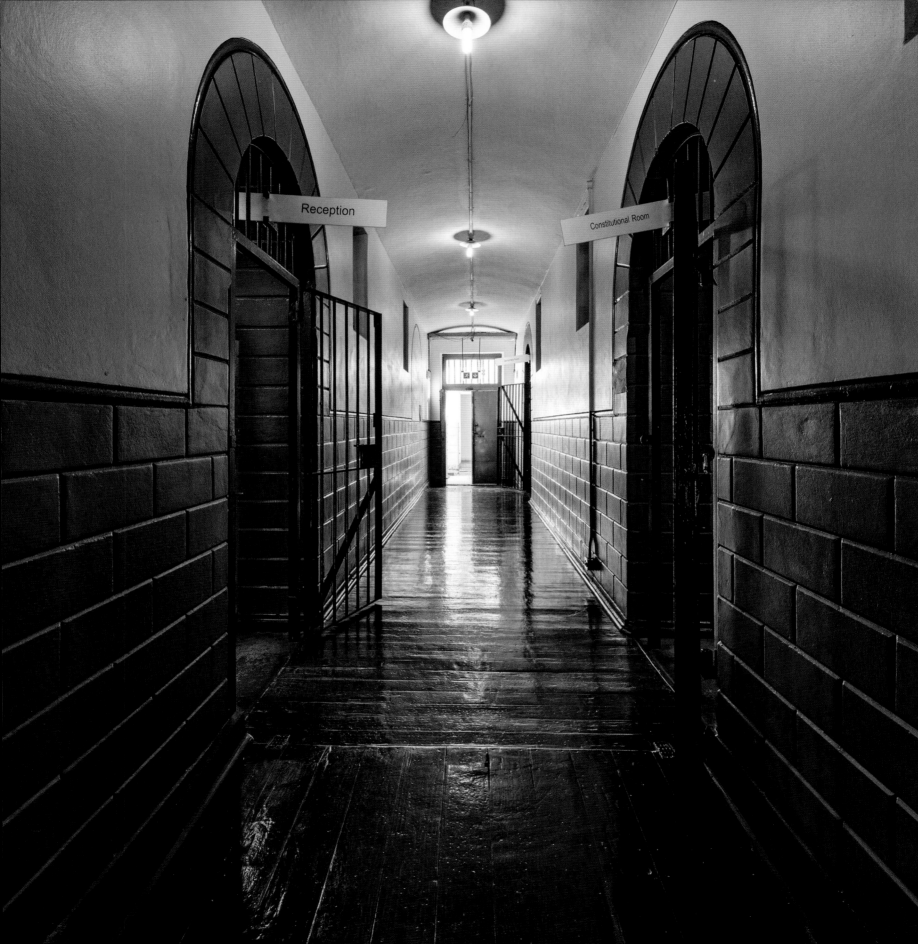

Reception

Constitutional Room

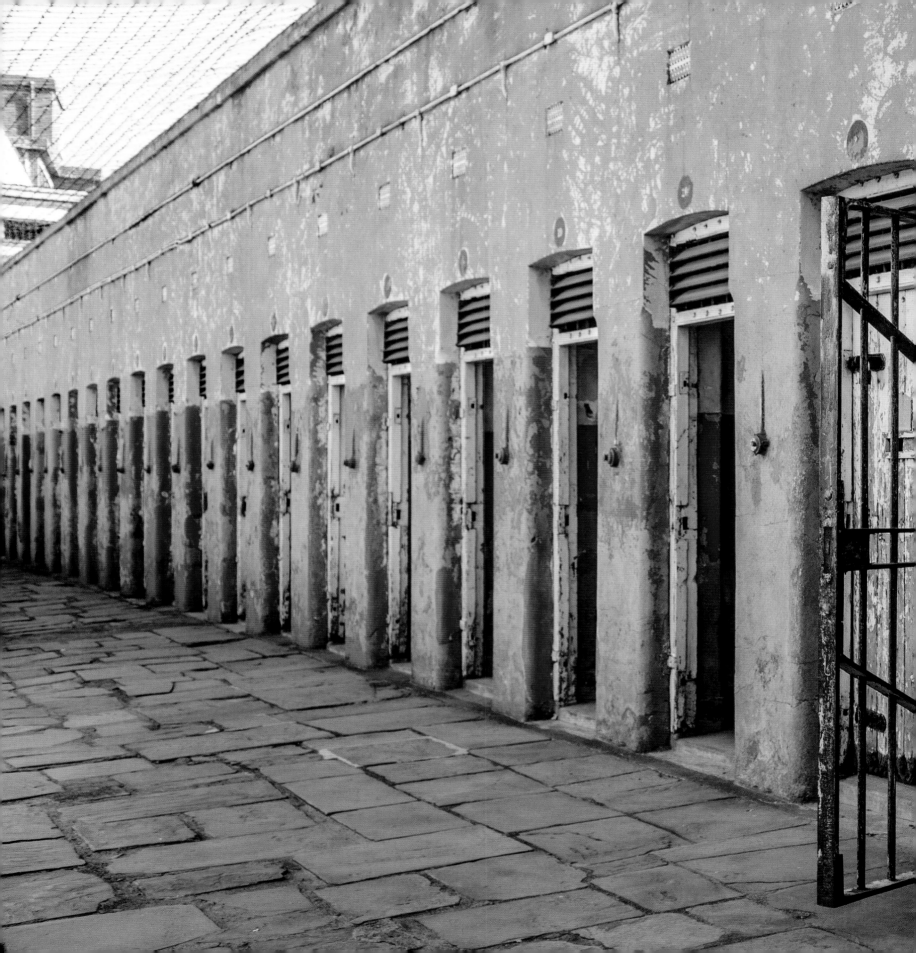

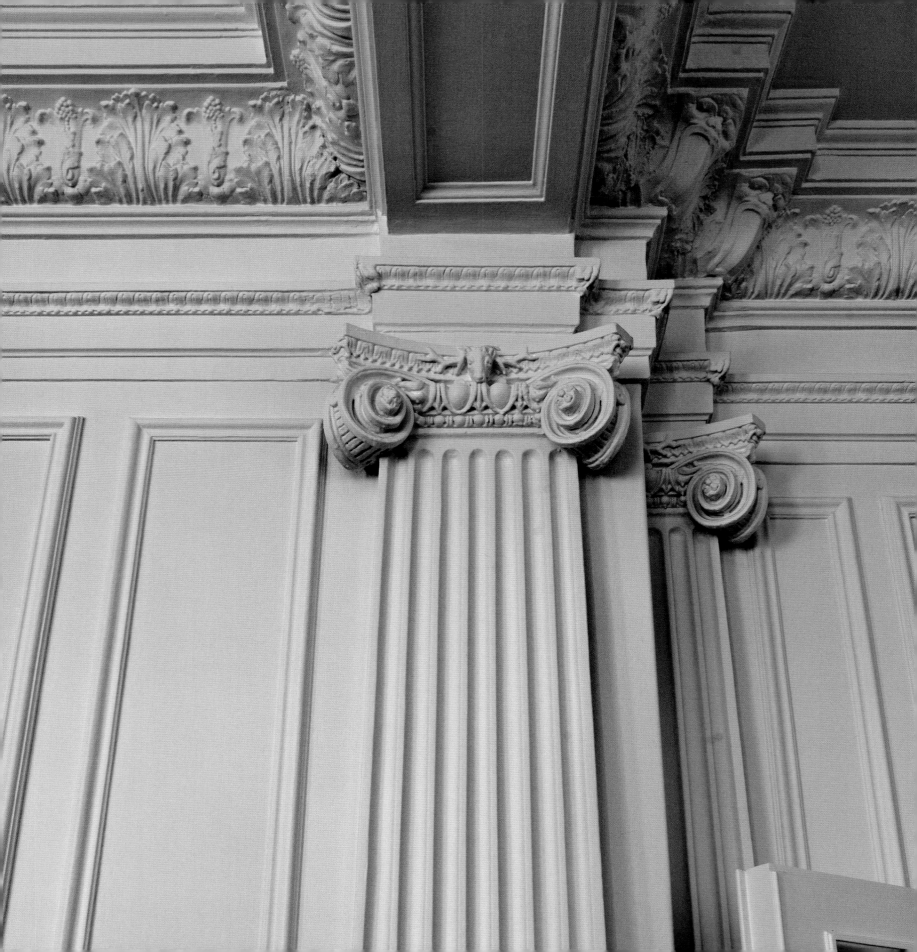

WHITEHALL COURT
Corner 2nd Avenue and 4th Street, Killarney

When it was built in 1924 for the charismatic American entrepreneur, Isidore William Schlesinger, in a bucolic corner of what was once a portion of what was called Cook's Farm, Whitehall Court exemplified the *ne plus ultra* of contemporary American living standards. Said the *South African Builder* in 1926, 'The building is situated in grounds adjacent to the Automobile Club, enjoying an uninterrupted view along the valley looking northwards toward Pretoria, and is perhaps the most up to date of its kind in South Africa'. Schlesinger had acquired the farm in 1905, establishing there the Killarney Golf Course and Transvaal Automobile Club, both of which welcomed Jews. This encouraged many to move to the neighbourhood, especially after the Oxford Shul was established, not far away, after World War II.

Originally Schlesinger lived on the second floor of Whitehall Court, the rest of the building in use as his offices. Only later was it converted into residential apartments and today, at just three storeys high, the apartments arranged around an inner courtyard filled with trees and plants, its style is a gently pared-down neoclassicism. Like an Italian palazzo, it has a rooftop belvedere at each of its four corners, while the bronze and glass double entrance doors create a great sense of arrival. Paparazzi lurking behind the jacarandas wouldn't be out of place here; there's a movie star glamour about its white stuccoed appearance which would have pleased Schlesinger who, amongst other activities, produced early sound films (on his death his son sold his company, African Films, to 20th Century Fox) and was responsible for the popular newsreel *African Mirror*. He was also the owner of the Killarney Film Studios, which once occupied the site of nearby Killarney Mall, as well as theatres, cinemas, hotels and other city-centre properties.

But hats off to Whitehall Court's architect, John Moffat (he was of sufficient significance in the annals of Johannesburg architecture that the School of Architecture and Planning building at the University of the Witwatersrand is named after him) who, at a cost of about £60,000 conjured up some really beautiful classical interiors. Throughout, the residential apartments (each comprising two- or three-bedroom suites, hall, kitchen and spacious living rooms), are adorned with perfectly executed cornices and capitals, niches and fireplaces; a sense of symmetry and proportion always key. Even the parquet floors are beautiful. Schlesinger himself lived here in a lavish apartment, subsequently the home of interior decorator Stephen Falcke.

Whitehall Court is just one of many landmark buildings associated with Schlesinger. The Carlton Hotel, into which he moved in 1903, is possibly the most famous, but there was also the Polana in Lourenço Marques (now Maputo), which he built, the Edward on Marine Parade in Durban, and the Riviera on the Vaal at Vereeniging – all of them, in their day, bywords for impeccable service and luxury or, as Jean d'Ormesson has written in *Grand Hotel*, '... places whose architecture mirrors that of palaces fit for kings and queens'.

OPPOSITE Architect John Moffat was responsible for the interior detail of the apartments at Whitehall Court, which is one of only two of his buildings still standing.

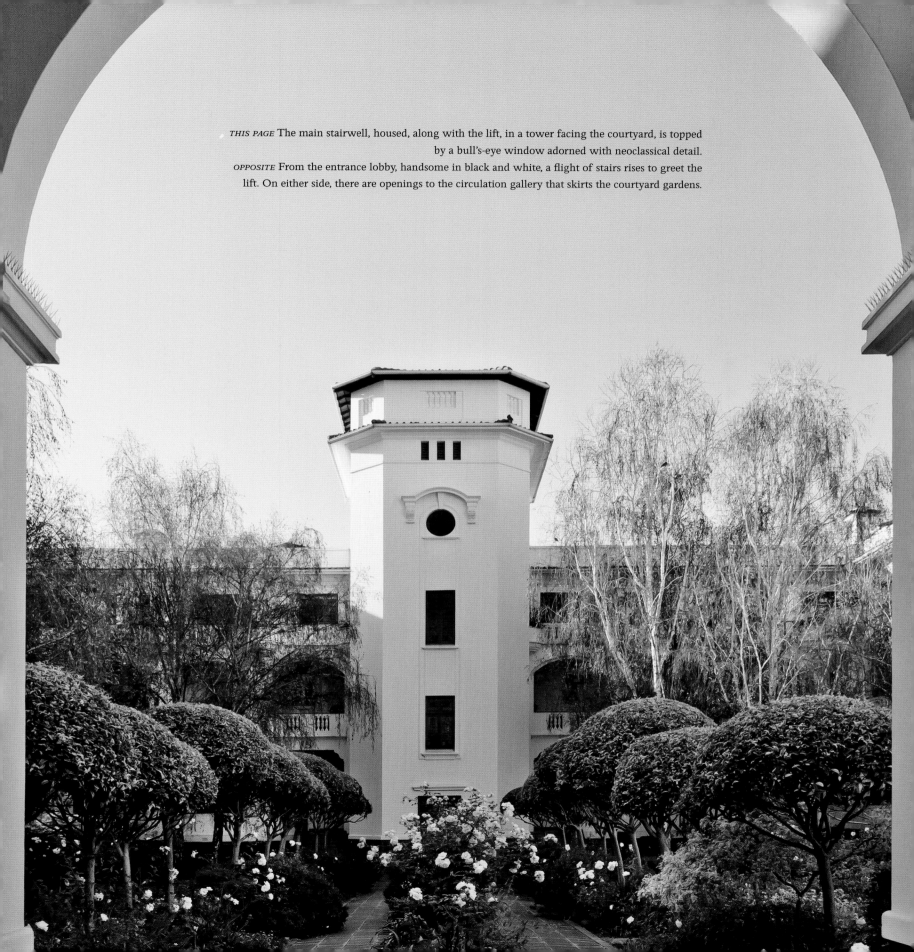

THIS PAGE The main stairwell, housed, along with the lift, in a tower facing the courtyard, is topped by a bull's-eye window adorned with neoclassical detail.

OPPOSITE From the entrance lobby, handsome in black and white, a flight of stairs rises to greet the lift. On either side, there are openings to the circulation gallery that skirts the courtyard gardens.

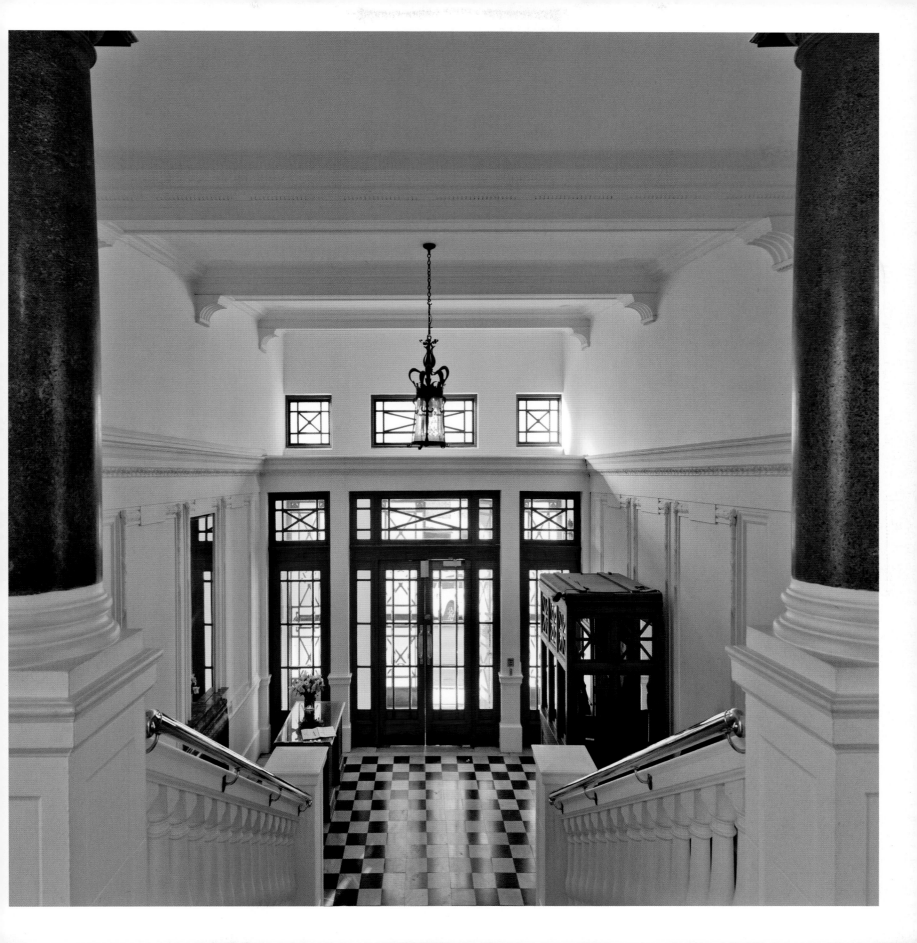

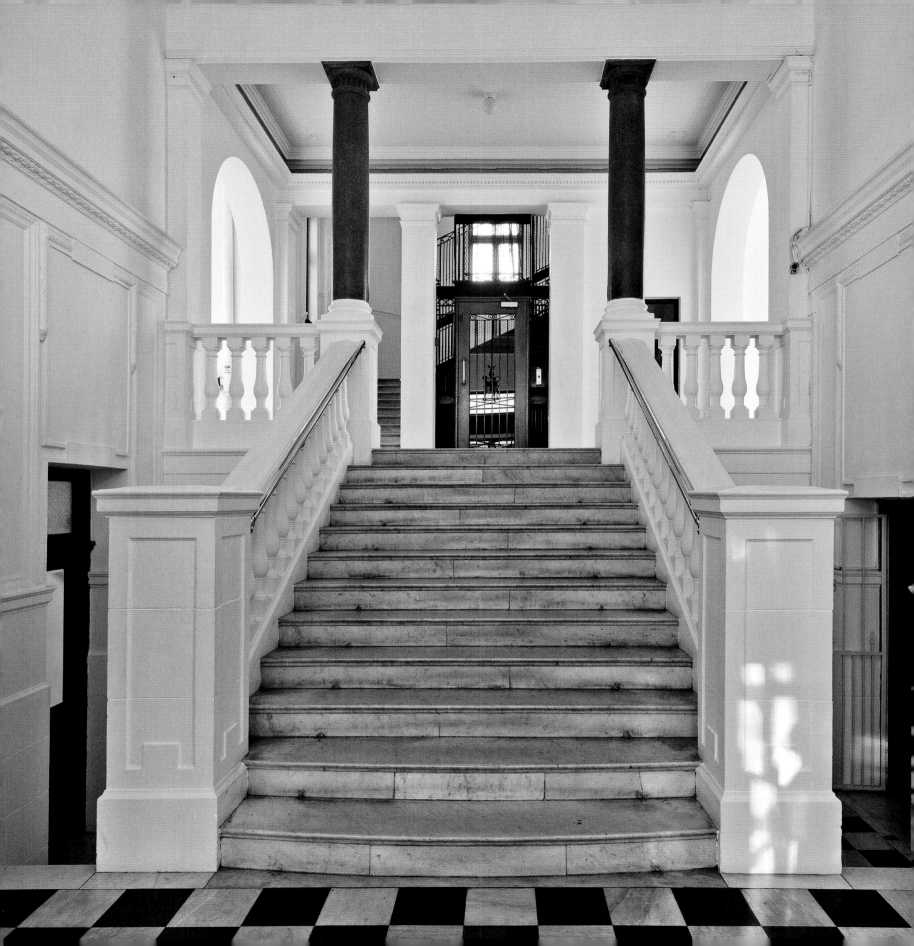

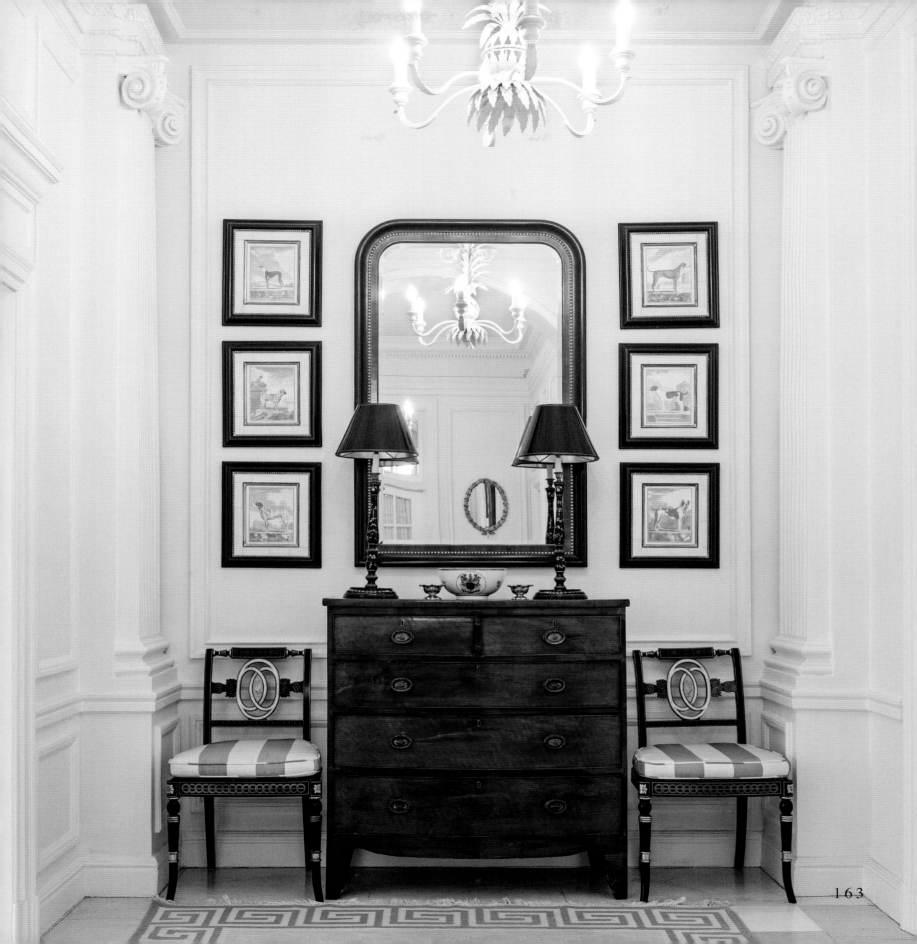

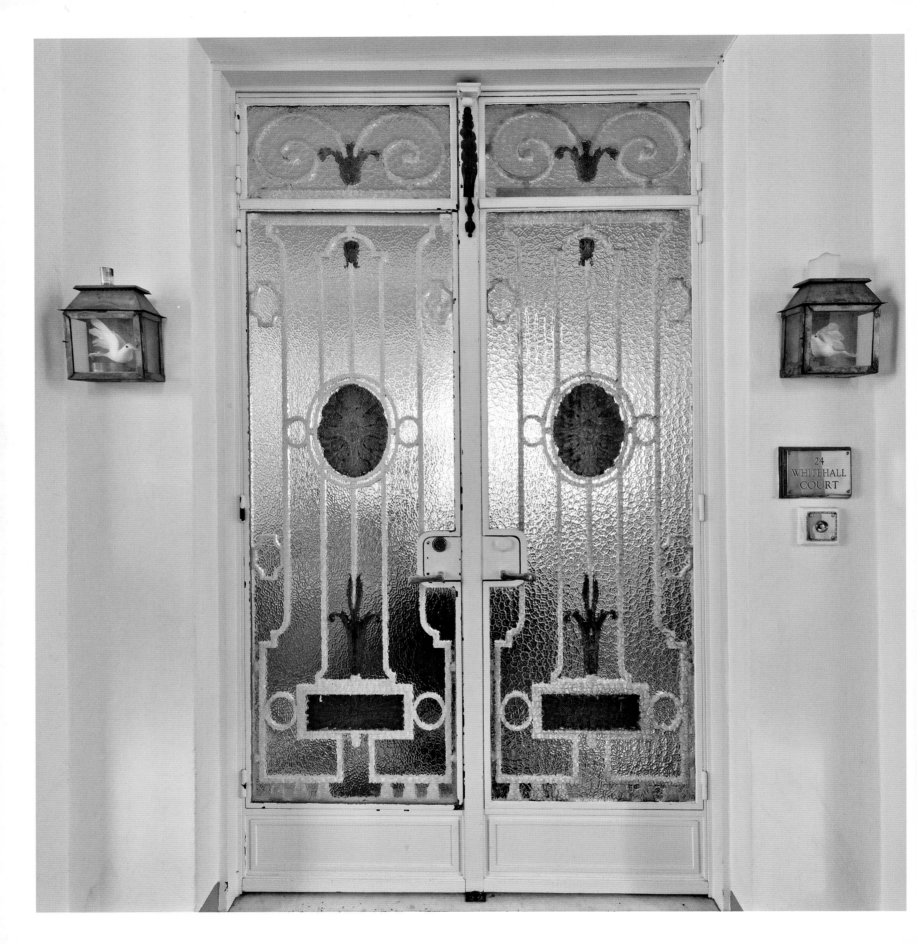

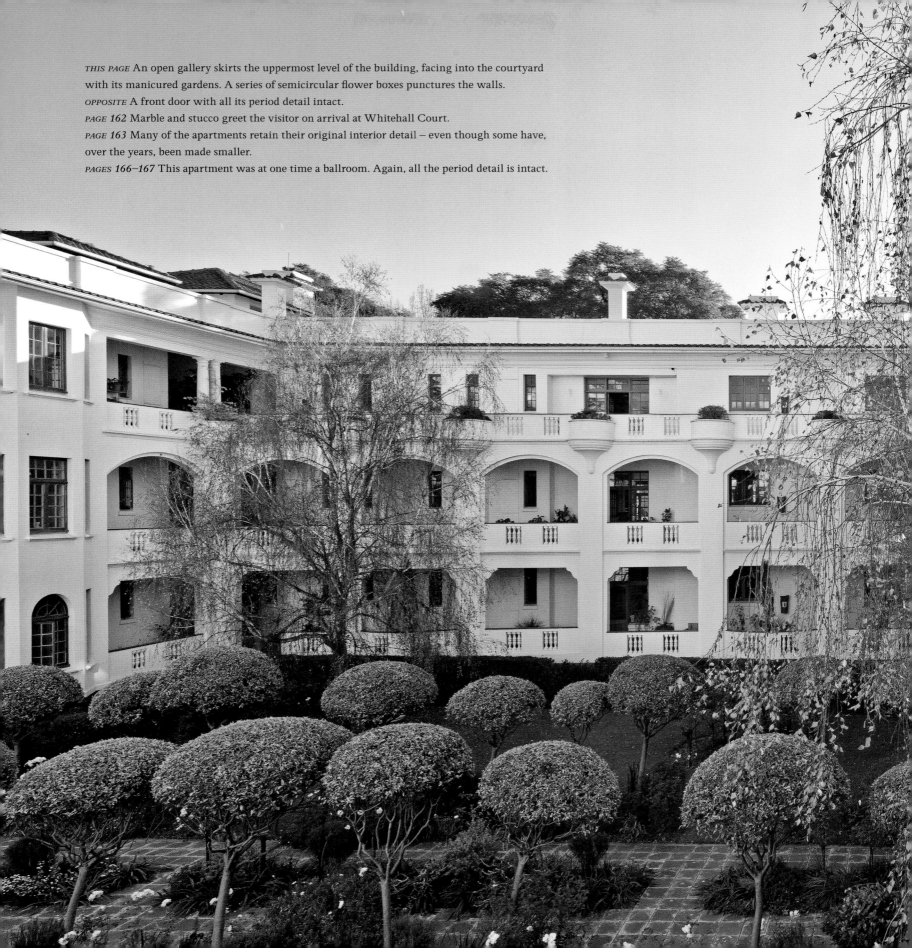

THIS PAGE An open gallery skirts the uppermost level of the building, facing into the courtyard with its manicured gardens. A series of semicircular flower boxes punctures the walls.

OPPOSITE A front door with all its period detail intact.

PAGE 162 Marble and stucco greet the visitor on arrival at Whitehall Court.

PAGE 163 Many of the apartments retain their original interior detail – even though some have, over the years, been made smaller.

PAGES 166–167 This apartment was at one time a ballroom. Again, all the period detail is intact.

LION'S SHUL

Harrow Road, Doornfontein

T he Doornfontein Synagogue takes its popular name from a pair of gold-painted cast-iron lions – the Lions of Judah – that crouch on either side of a short flight of four steps that lead from the pavement past four squat Doric columns to the great doors that open onto its handsome interior, a paw of each lion supporting a standing lantern.

Designed by Jacob Harris, built in 1906 then rebuilt in 1932 after a fire, the shul was at the heart of a district that was popular initially with European Jews, the professional co-pioneers of the city of Johannesburg and its goldfields, and then quite distinctly by a second wave of Jewish immigrants fleeing religious persecution and social instability in Tsarist Russia – the artisans, craftsmen and wholesalers. Rabbi Ilan Hermann still opens the Lion's Shul doors every Saturday to worshippers, calling a dwindling band of the faithful back to the places that once defined them. It's the only remaining shul in Doornfontein. 'Walking along the cracked sidewalks near Rabbi Hermann's shul, past the sour-smelling taverns and the men turning over chicken feet on tiny charcoal grills, it is difficult to imagine that until the 1950s this neighbourhood was packed with kosher butcheries and Yiddish cultural societies', writes journalist Ryan Lenora Brown in *Haaretz*. This was once a bustling, dynamic Jewish quarter but, ultimately, prosperity oversaw the migration from Doornfontein to other parts of the city. The Lion's Shul is a lone survivor.

Engineer-architect Theophile Schaerer's huge domed Great Synagogue in Wolmarans Street, just along the way, looking like something out of old Constantinople, is now used by the African Healing Church; the congregants, from all corners of the African continent, are anything but Jewish. Today the *bimah* is occupied by a large plastic seat covered with a leopard skin, the proclamation that 'Jesus is Lord' incongruously emblazoned above the curtain that once shielded the Holy Ark containing the Torah scrolls. On the plastic seat, exorcising demons, sits the self-proclaimed prophet and pastor of the congregation. This extraordinarily handsome building was built in 1914 on a site chosen by Hermann Kallenbach. Many of the original Jewish symbols are still present as features of an interior that can house up to 1400 people. Its reinforced concrete saucer dome, on which perches a rusting Star of David, was the first of its type in South Africa. Until 1994, this was Johannesburg's largest and most powerful synagogue. But the congregation is gone. What's left goes to the Lion's Shul, but even that's dwindling now.

But isn't history repeating itself? All those new members of the African Healing Church have come here to build a better life for themselves and their families, working modestly as shopkeepers, clerks, domestic workers and taxi drivers, and making their home in Hillbrow and the inner city districts vacated by other diasporas who have moved on to better lives. 'Their demons', continues Ryan Lenora Brown, 'are those of South Africa's young democracy writ large: unemployment, xenophobia and poor social services. A century ago, many of those facing the same struggles were immigrants from Latvia, Lithuania and other parts of Tsarist Russia'.

OPPOSITE Guarding the entrance are the two great cast-iron Lions of Judah from which this venerable synagogue takes its name.

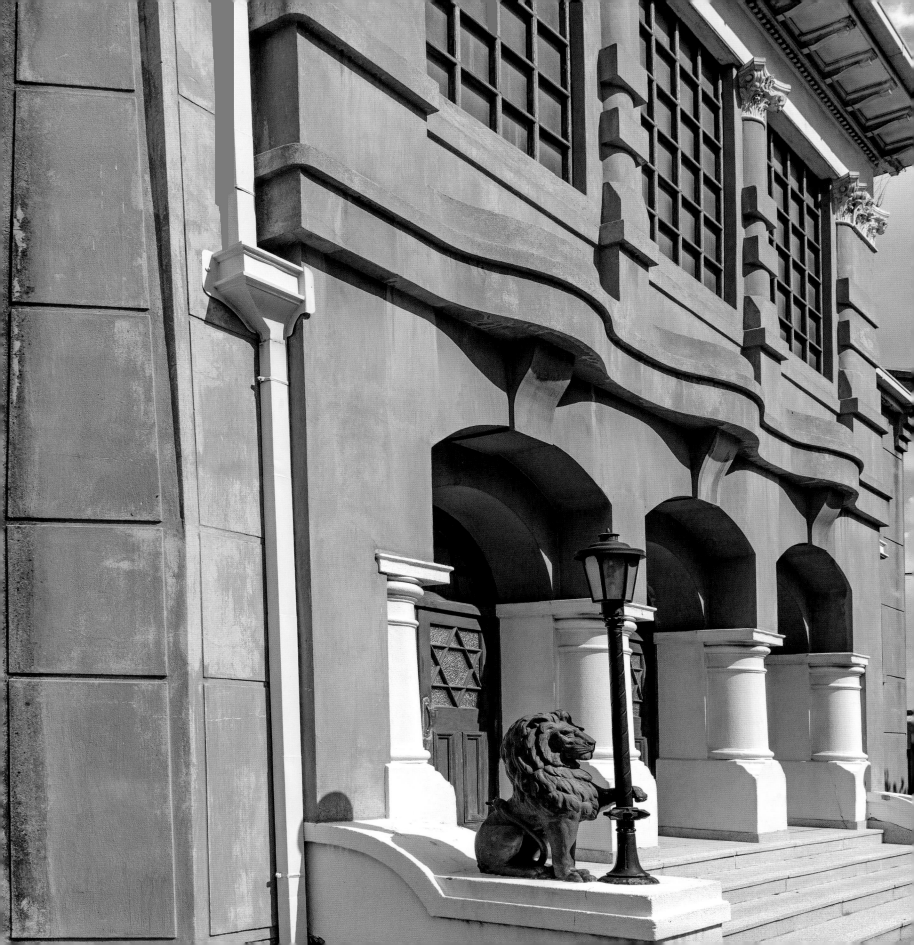

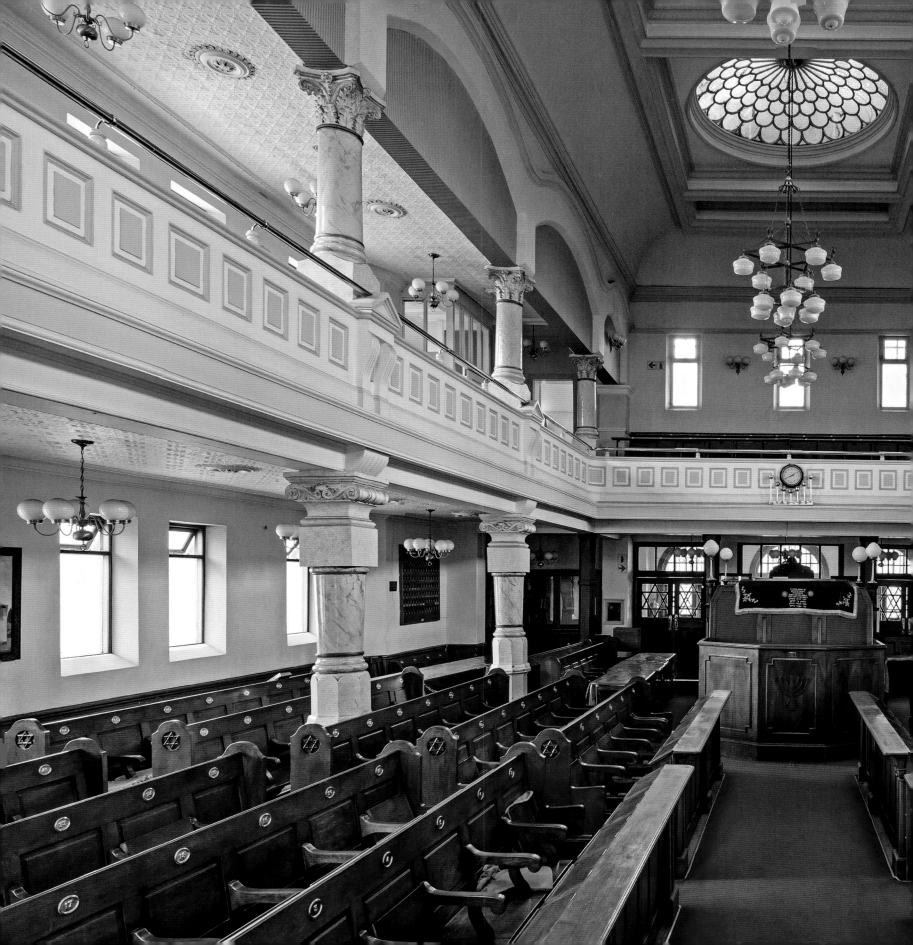

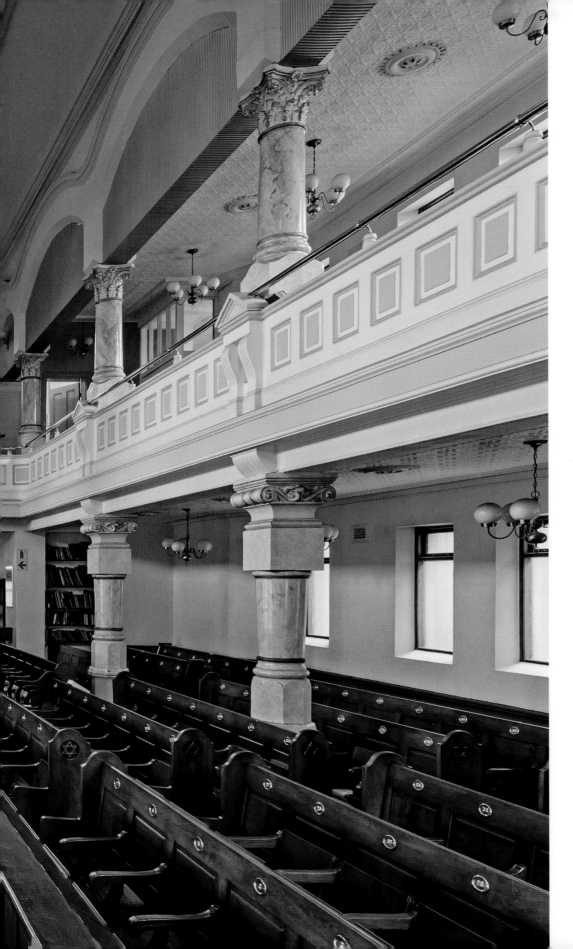

THIS PAGE More formally known as the Doornfontein Synagogue, this is the oldest synagogue in South Africa still maintaining a vibrant congregation. It's the last remnant of a once-thriving Jewish community in the area.

PAGE 172 Writes Rabbi Ilan Hermann in the *SA Jewish Report* (August 2006), 'If every edifice has a story to tell, the Lion's Shul has an epic novel: of how immigrant strangers in a land not their own, amid social and economic hardships, established a community and, at its centre, a home for God and a proud anchor of Jewish identity for these new citizens from war-torn Europe'.

PAGE 173 Sybil Gecelter, a past congregant and daughter of Morris Win, former chairman of the Doornfontein Hebrew Congregation (1968–1970) writes: 'Dad did everything for the shul. I remember, aged four or five, sitting on my mom's lap in our seats, which we still have to this day; numbers four to seven in the front row. Seats one and two, next to the Oren Kodesh (Torah Ark), belonged to dad'.

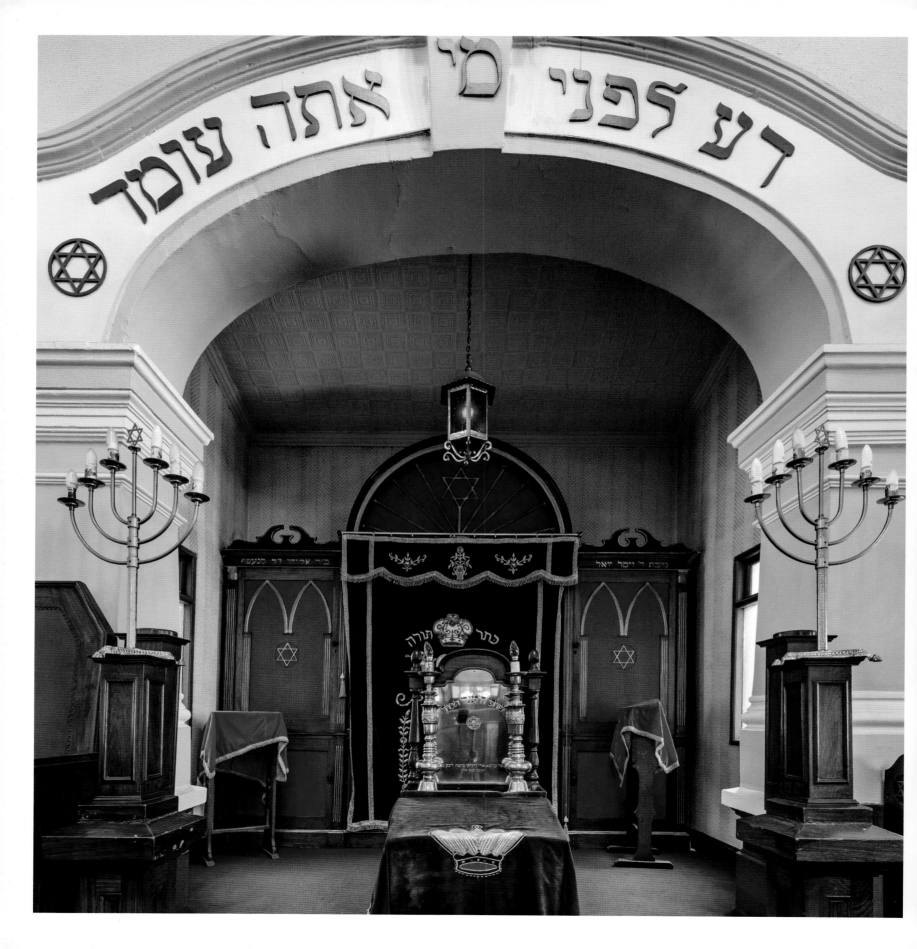

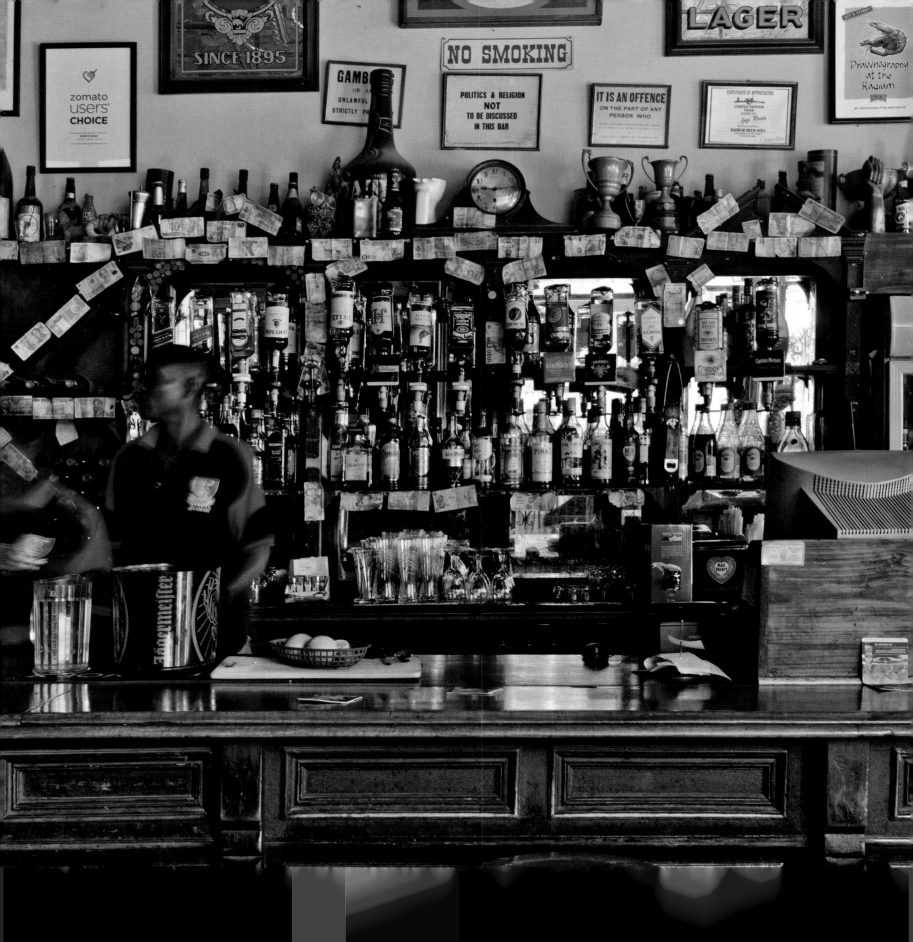

RADIUM BEER HALL

Louis Botha Avenue, Orange Grove

In 1929, in Orange Grove, what is now Johannesburg's oldest surviving public bar, the rather tatty Radium Beer Hall, opened its doors as the Radium Tearoom. A decade or so later it was given a new, male-dominated, spit-and-sawdust persona the minute it got its wine and malt licence. And, no doubt encouraged by the coincidental arrival of the original bar counter from the old Ferreirastown Hotel – the very one from the top of which 'Pickhandle Mary' is said to have inflamed the rebels during the 1922 Rand Revolt by brandishing a pickhandle – the Radium Beer Hall has never looked back. Ferreirastown incidentally, or Ferriera's Camp as it was originally known, was the oldest part of Johannesburg and it's where the first gold diggings started. The original El Dorado, it's also where Johannesburg's first bar was, and where its first pub, first brothel and first school were situated. It quickly became a slum of broken wood-and-iron dwellings, and after 1897 was a densely packed squatter settlement filled with the poor, the unskilled and the unemployed.

'Pickhandle Mary's' bar counter is a relic of Johannesburg's earliest days, and it's a survivor of a seminal event in a youthful South Africa's history, now largely forgotten. During the Rand Revolt, striking white miners clashed with the military and the police, and violence swept across the Rand, engulfing the mines, the railways, shops and other private property. Deaths occurred in Brixton, Ferreirastown and Vrededorp. Benoni was bombed, and there was fierce fighting in Ellis Park as Prime Minister Jan Smuts proclaimed martial law. Guns in Empire Road and Jan Smuts Avenue battered Mayfair. Why? Following a dramatic drop in the world price of gold, mine owners tried to cut operating costs by diminishing wages and by weakening the colour bar to enable the promotion of cheaper black mine labour. What began as a strike, ended as armed rebellion, the outcome of which, broadly, was the recognition of white trade unions and reinforcement of the colour bar. The young Communist Party of South Africa took an active part in the uprising on the grounds of class struggle while opposing the racist aspects of the revolt. Mary FitzGerald, or 'Pickhandle Mary', an Irish immigrant and prominent labour activist who became the first female to hold public office in Johannesburg, took up the cause. Whether she actually got up on the bar of the Ferreirastown Hotel is a moot point, but the district would have been fertile ground for inciting unrest. That she promoted the pickhandle as a symbol of oppression and free speech is uncontested. It was her weapon of choice as she and her 'pickhandle brigade' broke up anti-labour meetings and when, allegedly, she led the mob that burned down Park Station in the 1913 miners' strike.

In the 1940s, a soccer player called Joe Barbarovich took ownership of the Radium Beer Hall and a special variety of raucousness overtook the place as its legend began to grow. Portuguese ownership in the 1980s led to the billiard room being turned into a restaurant with a Portuguese menu. Women were finally allowed into the bar, and blacks – a seminal moment that anticipated the new South Africa by a few years. In *101 Beloved Bars of Southern Africa*, authors Chris Marais and Pat Hopkins recount that jazz journalist Don Albert, writing in *The Star*, observed that the 'staunch patrons decided to bury the past (literally!). On hand to make sure the coffin was given a good send-off were members of the Fat Sound jazz band, who marched along Louis Botha Avenue in the tradition of a New Orleans jazz funeral'. And thus the Radium Beer Hall entered the second half of the twentieth century. Today the Radium Beer Hall is a place of weekly live jazz performances, with a particular focus on the Radium Jazz band's regular gig on Friday nights.

OPPOSITE 'Pickhandle Mary's' bar counter, still intact, is a feature of the grungy Radium Beer Hall, a relic of Johannesburg's earliest days.

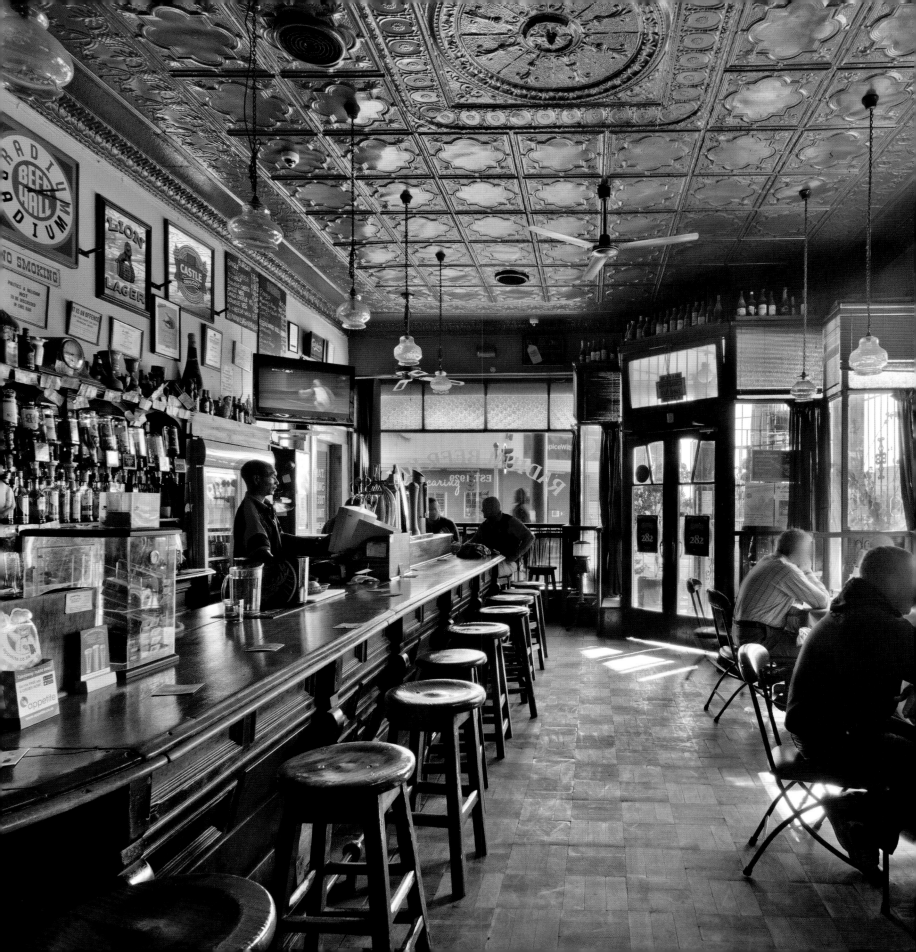

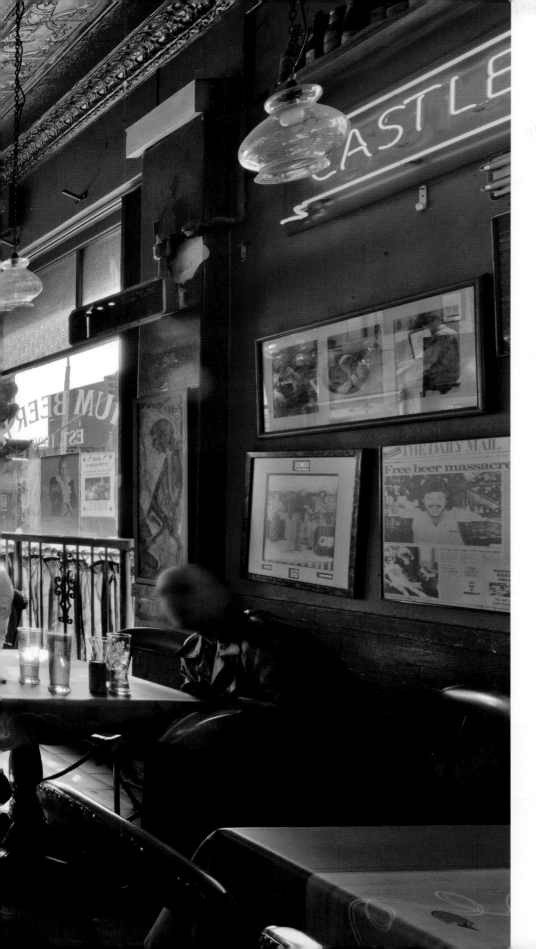

THIS PAGE Still raucous, and with a touch of tatty grandeur, but loved by everybody who frequents it, the Radium Beer Hall began life as a tearoom.

PAGES 178 & 179 The restaurant area, which serves a mean peri-peri chicken and succulent 'LM' prawns, is adorned with all kinds of memorabilia – from photos of pre-war soccer teams to vintage posters.

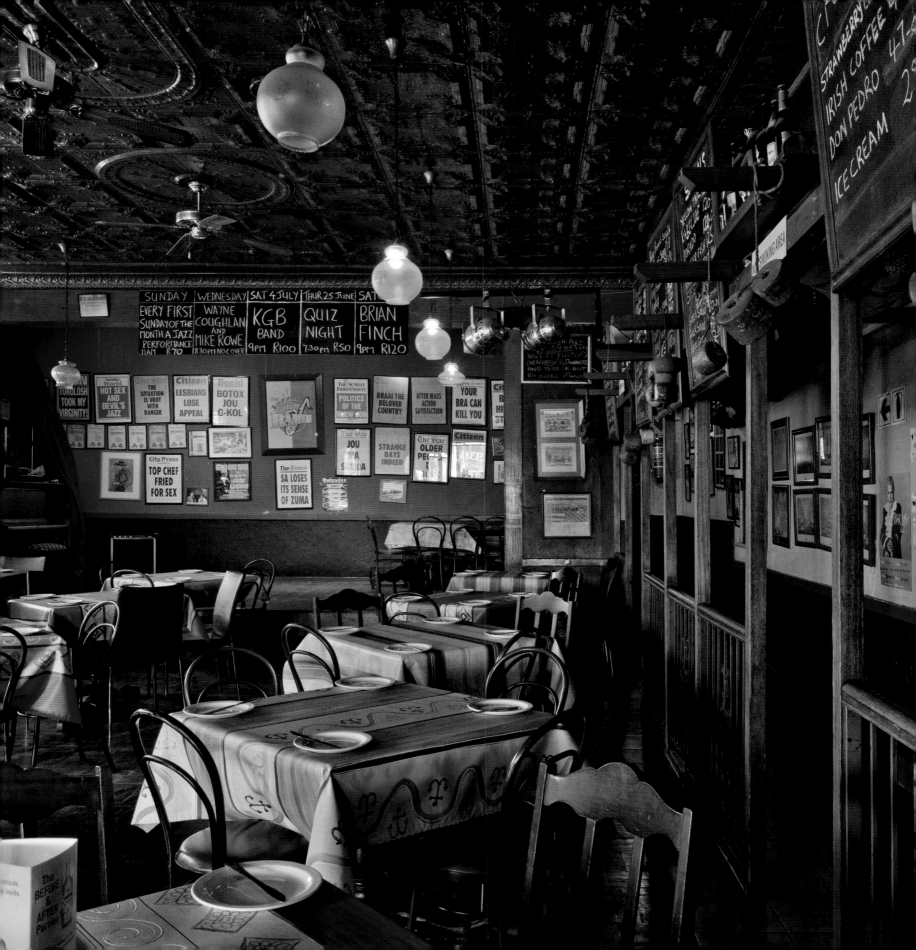

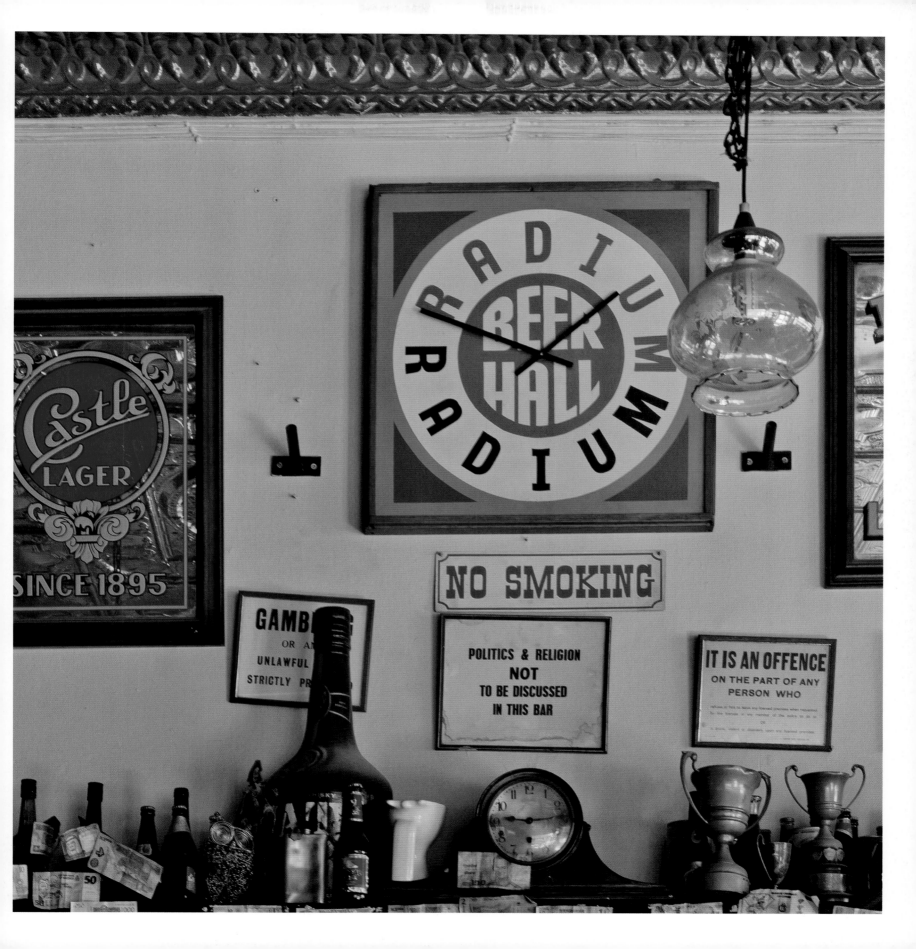

VILLA ARCADIA
Oxford Road, Parktown

Villa Arcadia was built in 1909 by Herbert Baker on a high shelf of the Parktown Ridge, overlooking the Sachsenwald's trees. Facing north, it had huge views out to the Magaliesberg in the distance and was one of the earliest houses in the new district of Parktown – situated well away from the prevailing tsunamis of dust emerging from the mines on the other side of the ridge. A 'vociferous little virago' supervised its construction, says Thelma Gutsche in her biography of Florence Phillips, *No Ordinary Woman*. This was Florence, Mrs Lionel Phillips, a woman remembered as the uncrowned Queen of Johannesburg, whose husband's vast wealth enabled her to make an indelible mark on the emerging cultural life of the newly unified South Africa at the dawn of the twentieth century.

Wife of Lionel (later Sir Lionel) Phillips, plutocrat, mining magnate and politician, she insisted on making absolutely certain that her instructions for the design of her new house were followed. She would emerge to direct operations from Hohenheim, the house Frank Emley built for her in 1892 (Parktown's first, replaced by the horrible Johannesburg General Hospital, now Charlotte Maxeke Academic Hospital) further up the ridge behind Villa Arcadia estate, which had been taken over by Sir Percy Fitzpatrick, and which the Phillipses had rented for the duration of the construction of their new house. Baker wasn't used to this kind of interference although, for his part, he found both Phillipses passionate advocates of his work.

The Villa Arcadia took nearly 18 months to build, and what emerged was an Italianate mansion with tall, exotic barley-sugar chimneys, green shutters and arcaded stoeps that Florence thought, agreeing with Baker, would better suit the rocky ridge than the architect's usual gabled Cape Dutch-style houses. It's a monument to this tireless patron of the arts who founded the Johannesburg Art Gallery – and got Edwin Lutyens to design it – and spent much of her life furthering her husband's career, 'spending his money and bullying other mining magnates to do likewise in the general cause of cultural improvement in South Africa,' says Graham Viney in *Colonial Houses of South Africa*.

'Florrie' Phillips's appreciation of and passion for Arts and Crafts is manifest quite clearly at Villa Arcadia. Indigenous construction materials were used as often as they could be but, more than that, Florence insisted that everything possible about the house should be of local design and manufacture. Even the gardens should contain as far as possible plants from the veld and the bush. This would have far-reaching impact on building practice for the next 30 years. Baker erred when he installed Dutch tiles in Florence's bathroom and teak panelling in the dining room, but George Ness, master craftsman and art metalworker, was responsible for the metalwork throughout the house – the wrought-iron railings on the staircase, the monogrammed doorplates, and the locks and hinges on the doors and windows. Dutch sculptor Anton van Wouw (subsequently regarded as the 'father' of the western tradition of South African sculpture) carved the fanlights above the doors and other mouldings in a sort of imitation of the work of Grinling Gibbons a few centuries previously in the grander stately homes of England. Ness was a hugely talented craftsman who moved on to the Union Buildings that Baker had begun just as the Villa Arcadia was nearing completion. His workmanship can also be seen at Northwards and St George's Anglican Church, in Parktown.

Lady Phillips's discerning eye, led perhaps by Baker, was abundantly in evidence at Villa Arcadia. Much of the furniture the house contained was manufactured locally, like the dining-room suite orchestrated by Baker in a Charles II style and made from stinkwood; Lady Phillips stood by her principles, and so did Baker. Many of the original interior fittings remain, this

OPPOSITE Her ladyship's bathroom with its sunken bath, marble floor and walls adorned with Delft tiles.

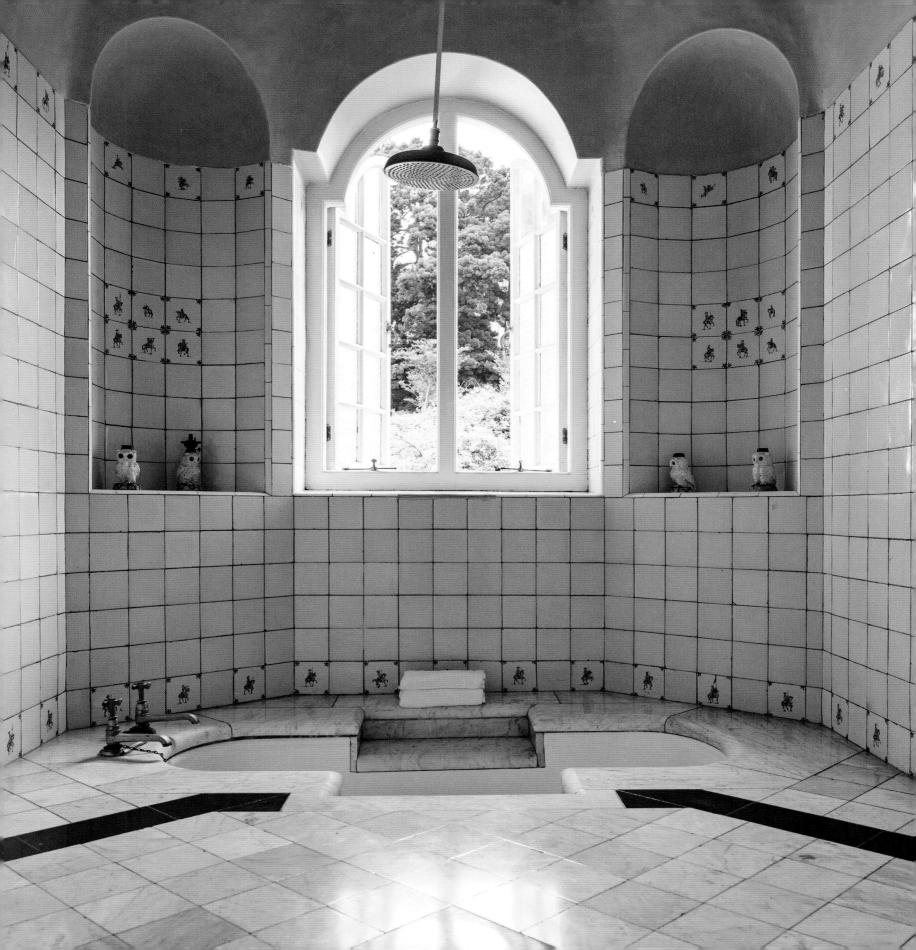

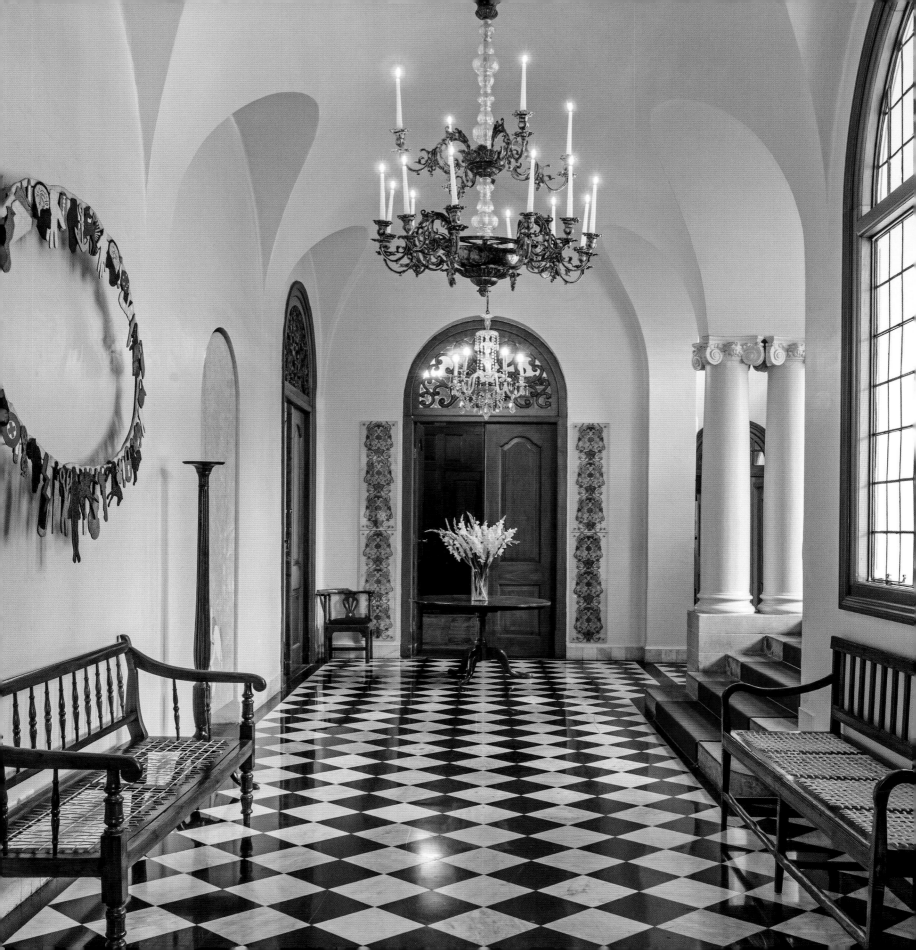

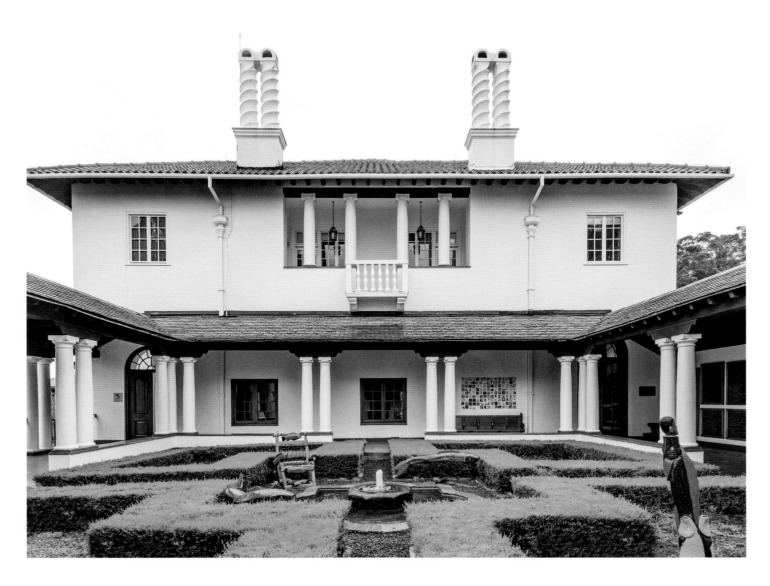

extraordinary moment of colonial splendour, with its attempts at the nurture of an artistic cultural identity, today fully revived and restored by the current owner and occupant, Hollard Insurance Group, which bought the property in 2003.

The Phillipses only lived at Villa Arcadia for about 13 years. In 1917, they bought the Cape Dutch homestead Vergelegen, in Somerset West in the Cape, as their new home into which they moved in 1922. Many of the contents of Villa Arcadia went there, including Sir Lionel's precious library, where mementos remain to this day. In 1922, the South African Jewish Orphanage bought Villa Arcadia and it became home to some 400 children. When she moved out, Lady Phillips fully intended on removing all of Villa Arcadia's fixtures and fittings to Vergelegen, including all the work done by Ness and van Wouw. Only a court judgment prevented that, which is why the house is nearly as richly kitted out today as it was then. When it was no longer sustainable as an orphanage, Villa Arcadia was sold to Hollard and today it houses, appropriately, the company's considerable collection of contemporary South African art.

THIS PAGE The cloistered courtyard. The surrounding colonnade is of simple, white double columns of the Tuscan order. At the centre, a fountain. From this vantage point, the Italianate look of the building, with its low-pitched roof and terracotta tiles, is clear to see.
OPPOSITE The entrance hall today houses part of Hollard's collection of contemporary South African art. The barrel-vaulted ceiling and black and white marble floor lend an air of majesty – as if this is the vestibule of a Renaissance palace.

LEFT The loggia now, as in the Phillipses' time, is set with comfortable stoep furniture.

PAGE 186 The upper landing at the top of the stairs. Here a barrel-vaulted gallery gave access to the bedroom suites. In the foreground is Egon Tania's *Girl and Man on a Chair* (2002) in jacaranda wood and paint.

PAGE 187 The main staircase, with its bold, sculptural form, is reminiscent of one you might encounter in a Renaissance palazzo in Italy. The wrought-iron balustrade is the work of master metalworker George Ness.

PAGE 188 The garden in front of Villa Arcadia looks out over Saxonwold and Forest Town to the distant Magaliesberg. Here once again, Herbert Baker proves his genius at siting a great house.

PAGE 189 Today the house is occupied by Hollard Insurance Group and, while it retains a great many of its period fixtures and fittings, the furniture and artworks are not original.

185

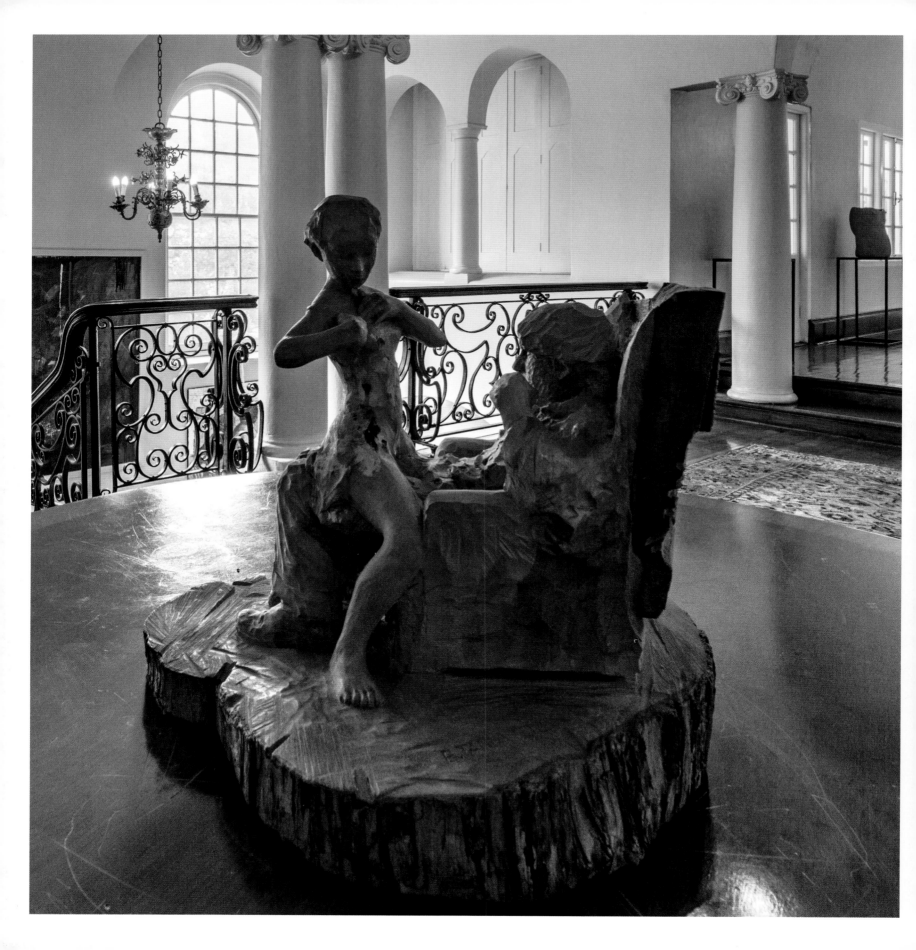

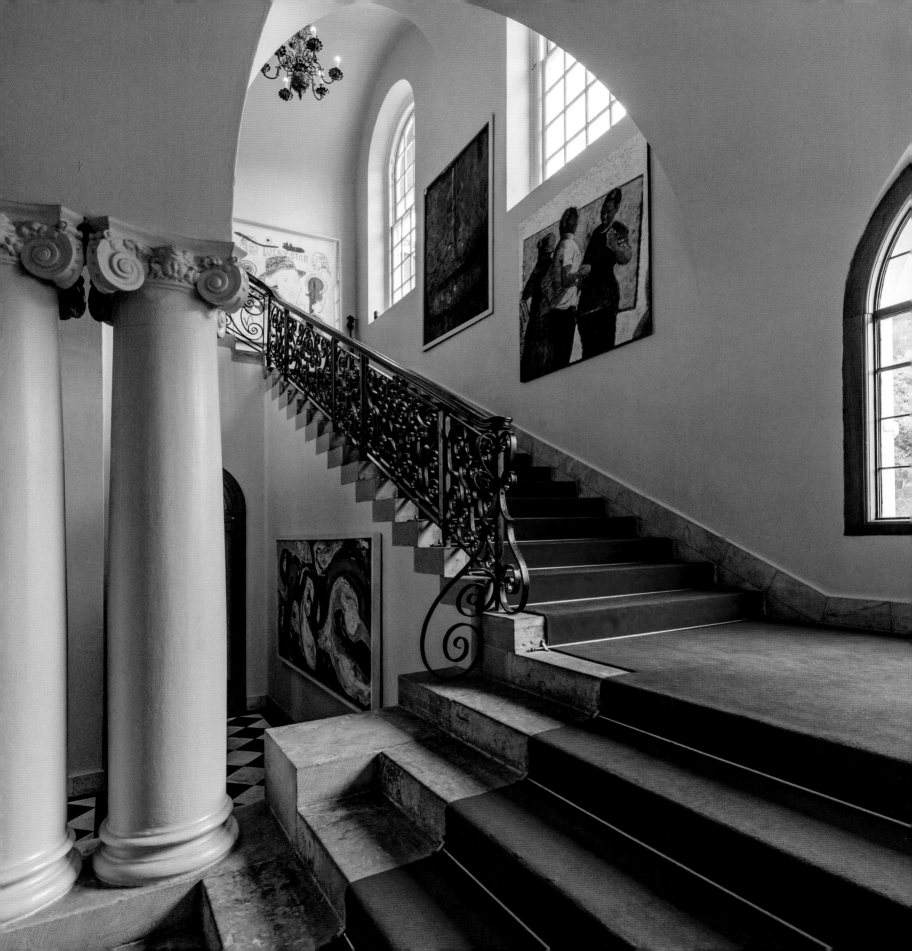

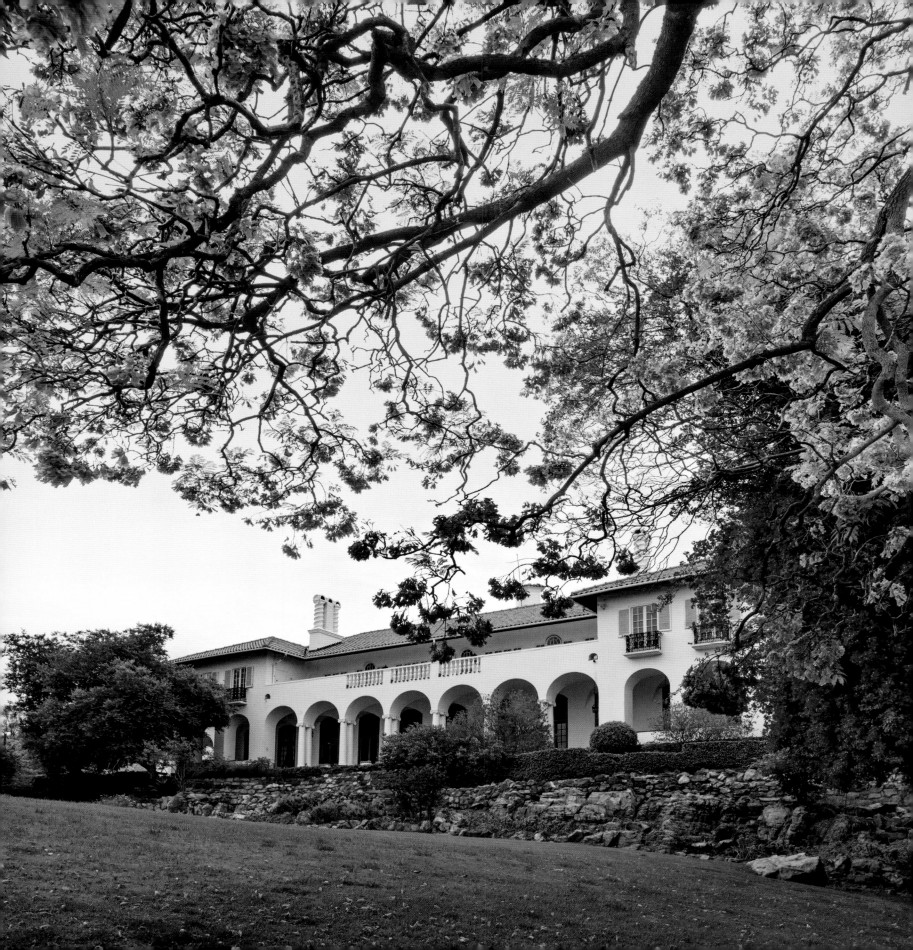

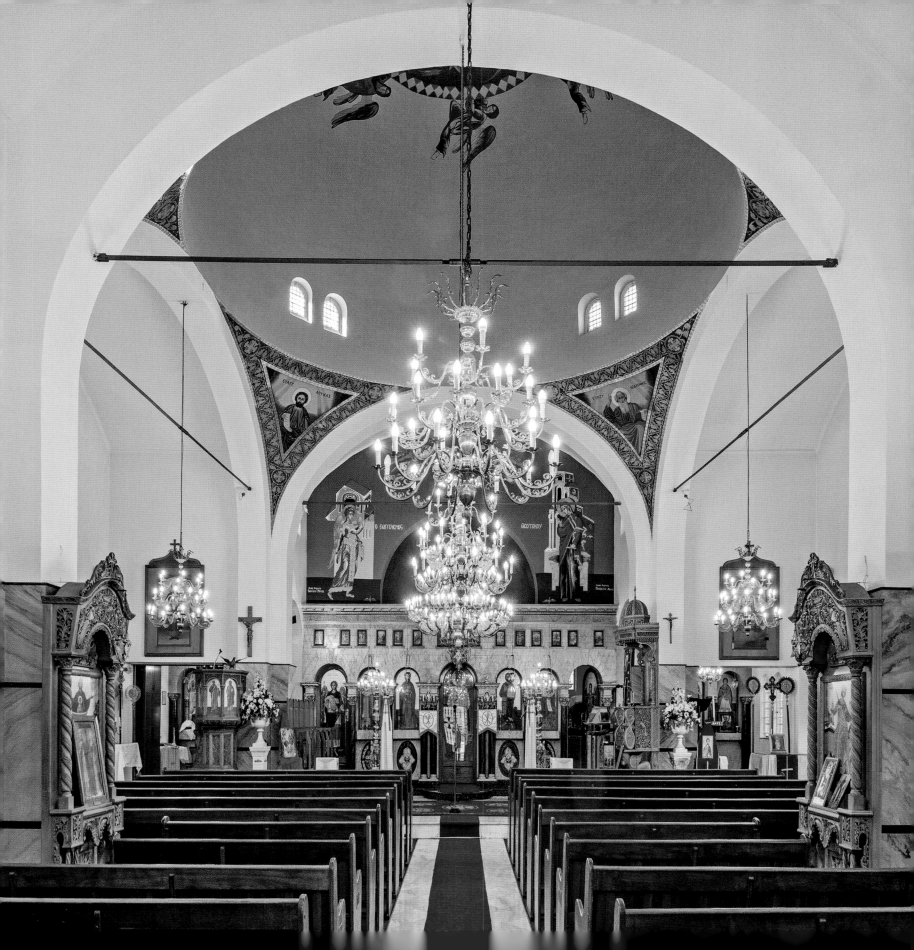

HOLY CATHEDRAL OF SAINTS CONSTANTINE AND HELEN

Wolmarans Street, Hillbrow

I n 1912, Hermann Kallenbach's practice, Kallenbach & Kennedy, won the commission to design Johannesburg's Greek Orthodox Cathedral. This was just 26 years after the founding of the city, and it was immediately after the practice was unsuccessful in the competition to design the new Great Synagogue, just up the road. Theophile Schaerer got that commission, but interestingly, the designs of both buildings rely on the Byzantine tradition of using domes to orchestrate the space within.

Until Saints Constantine and Helen came into being, the community of the Greek diaspora mostly attended religious services held in Anglican churches. Only in 1907 was a campaign of fundraising launched for the construction of a new church that reflected their own liturgical practice. At the highest end of the scale its model is, of course, Hagia Sophia (originally in Byzantium, then Christian Constantinople, now Istanbul), built in 537 and, until 1453, in use as the Cathedral of the Orthodox Greek Christians and seat of the Patriarch of Constantinople. It was designed by the Greek scientists Isidore of Miletus and Anthemius of Tralles and has been the official model for Greek churches ever since. The Holy Cathedral of Saints Constantine and Helen in Hillbrow is just another of these, a throwback even beyond Hagia Sophia to the very earliest Christian churches that had their origins in the Roman Empire. Kallenbach's building is a valiant attempt at recalling for the Greek diaspora, living then in Yeoville, Berea and Hillbrow, the old, sometimes ancient churches of home. Its iconography and design, here behind a high wall on a dusty corner of rundown Wolmarans Street in Hillbrow, reach way back into the distant past when Constantine was establishing Christianity as the state religion of the Roman Empire. It's quite something to have to live up to, but the Cathedral is still very much in use today.

There's a central dome, to symbolize the Heavens, with its image of Christ the Almighty. Four pendentives, supporting the dome, house images of the four Evangelists. There's the iconostasis, or screen, separating the nave from the sanctuary, and there's the sanctuary itself, the most sacred part of the church and home of the Holy Altar. Much of Saints Constantine and Helen's decoration came later; for example, funds for the iconostasis were only raised in 1919 by the Philiptokos Ladies Society. Completed in 1923, it's one of the gems of an interior whose magnificence is unheralded by a rather unprepossessing exterior, marooned now on a corner site where Nugget and Wolmarans Streets meet.

OPPOSITE Designed by Hermann Kallenbach, the Cathedral is built in traditional Byzantine style with an iconostasis, or screen, at the far end to separate the nave from the sanctuary. A central dome, the prevailing motif of Byzantine architecture, soars overhead, supported by four decorated pendentives.

PAGE 192 The iconostasis is richly decorated with icons and religious paintings in the traditional manner. Set into it are doors to the sanctuary. In Orthodox churches, these mark the boundary between Heaven and Earth.

PAGE 193 The dome, painted to represent Heaven with, at its pinnacle, Christ Pantocrator, Christ the Almighty.

PAGE 194 Image veneration is one of the focuses of the Orthodox faith; in general, images depicted are those of Christ, Mary and the saints and angels. Filled with symbolism, their facial appearances consistent, they use few conventional poses and often feature gold leaf, beaten silver, cast metal or precious stones.

PAGE 195 A view from the altar down the south aisle.

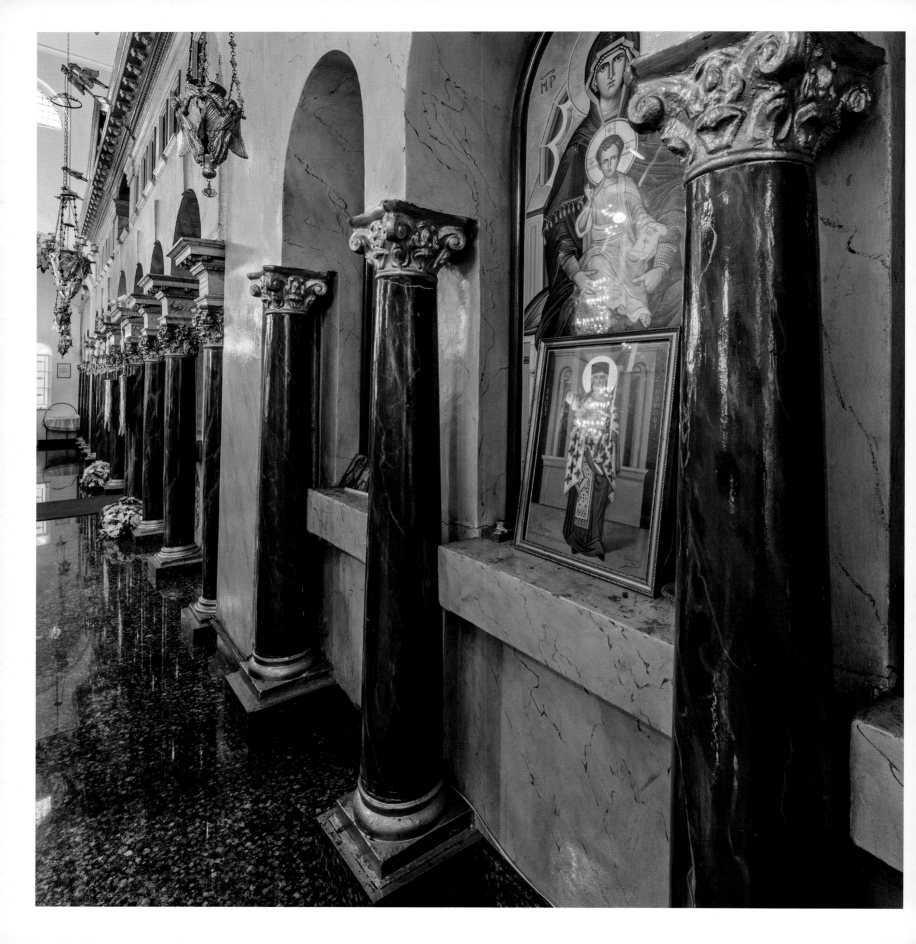

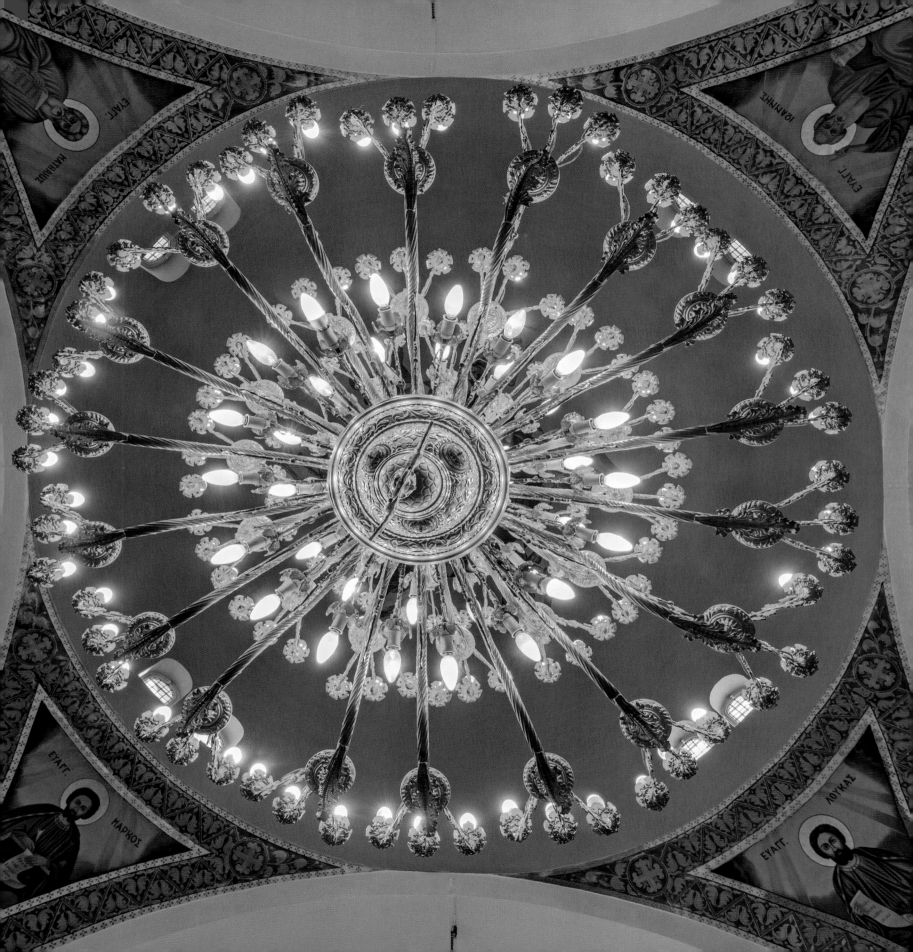

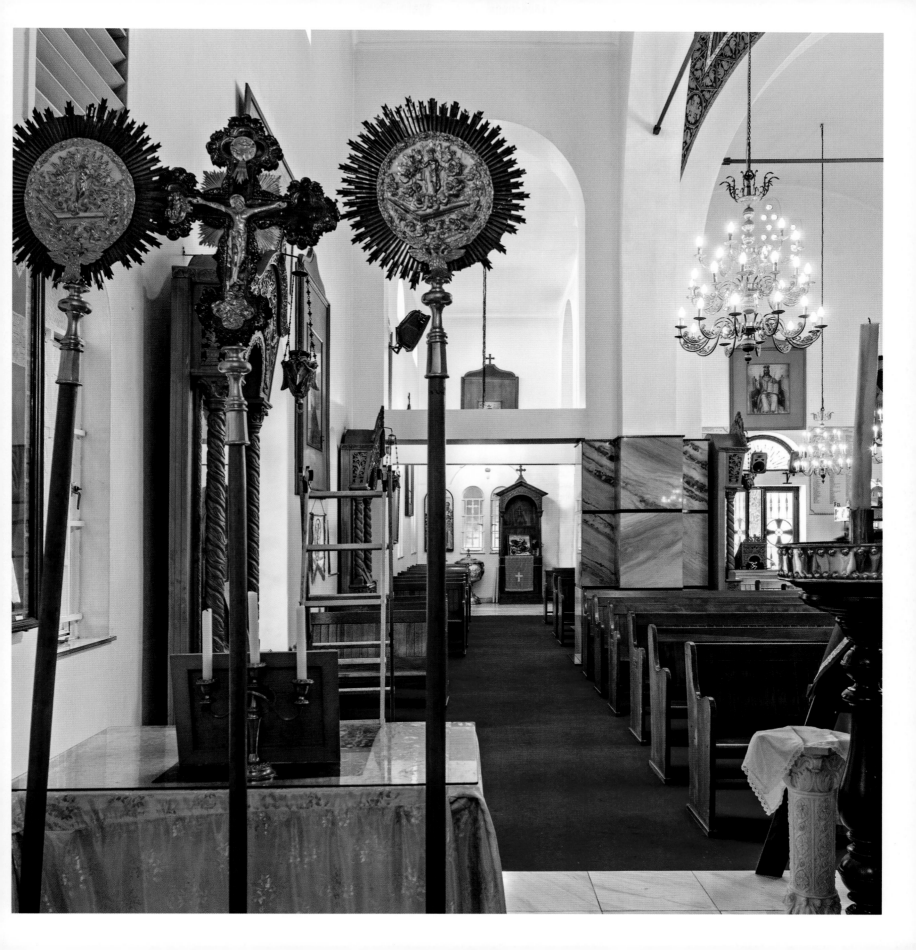

THE RAND CLUB
Corner of Fox and Loveday Streets, Marshalltown

The Rand Club is one of the great historical landmarks of old Johannesburg. Episodes in its history were at the centre of events that rocked the nascent city. Here, in the bar of the earliest clubhouse on this site, the Jameson Raid was plotted, while in 1913, striking miners tried to storm the club building – many of whose members owned the mines at the centre of their grievances. And during the 1922 Rand Revolt, the club was where the defence committee of mining magnates met with the government to discuss the implications of the mineworkers' strike, and to mull over Smuts's brutal handling of it.

Today the Rand Club is like a pensioner trying to cobble together a means of staying alive. On the one hand it's a patriotic symbol of allegiance to a vanished empire; on the landing, there are pictures of Lord Nelson and the Battle of Trafalgar, and there's a replica of Annigoni's portrait of Queen Elizabeth II, an earlier version of which was destroyed in the fire of 2005. On the other hand it's trying to court the plutocrats of the new South Africa, for whom Nelson is somebody quite different, the hero of Trafalgar an unfamiliar blast from the past. Can this colonial throwback, which until 1993 excluded everybody who wasn't a white, non-Jewish male, find its place in the twenty-first century? Women were only allowed to become members in 1993, and until the 1980s couldn't enter by the front door, even as guests. Admittance of black members, too, is a recent development. Business has moved to another part of town and today, perhaps for the first time since its founding, the Rand Club is on the sidelines of history.

The Rand Club began life in 1887, a year after Johannesburg was founded. Its first incarnation – a small brick structure with a wide, deep stoep and an iron roof – was on a site chosen, it's said, by Rhodes one dusty day. It housed the all-important bar and a billiards room along with various rooms to meet in. Two rebuilds later, in 1904, the club was transformed into a handsome, four storey, beaux-arts edifice designed for the committee by Frank Emley and William Leck who, as Leck & Emley, also designed the Corner House (1903) and the third Stock Exchange (1904). A steel frame, made in Glasgow and transported to Loveday Street, via Durban, on ox wagons, is at the core of the brick and stone-clad building.

Its male, socially exclusive membership was comprised of Johannesburg's most prominent men of influence – politicians, plutocrats, entrepreneurs, people shaping national affairs – who sought refuge here to socialize, debate and connive. It was a retreat for gentlemen, such as Rudyard Kipling and a young journalist called Winston Churchill, who represented the essence of the quintessential English gentlemen's club on which this one is based. The difference between a venerable London club like, say, White's, in St James's, and this one built on a dusty corner of a mining town halfway around the world, was that this club was at the centre of the world's greatest goldfield. In those days, the Rand Club was a real focus of power.

These days, to get inside you have to be let in by the porter lurking in the lobby. If suitably dressed, you're allowed to enter the entrance hall with its odd little collection of artefacts which include a bust of Chief Albert Luthuli, former president of the ANC, a bronze statue by Anton van Wouw of a top-hatted Paul Kruger, former president of the South African Republic,

OPPOSITE One of the most handsome of grand staircases in Johannesburg; a suitable stage from which the colonial elite – prominent citizens, political players and entrepreneurs of finance, property and business – once influenced the course of national affairs. Luckily much of it survived the 2005 fire and it is hoped it will live out at least another century.

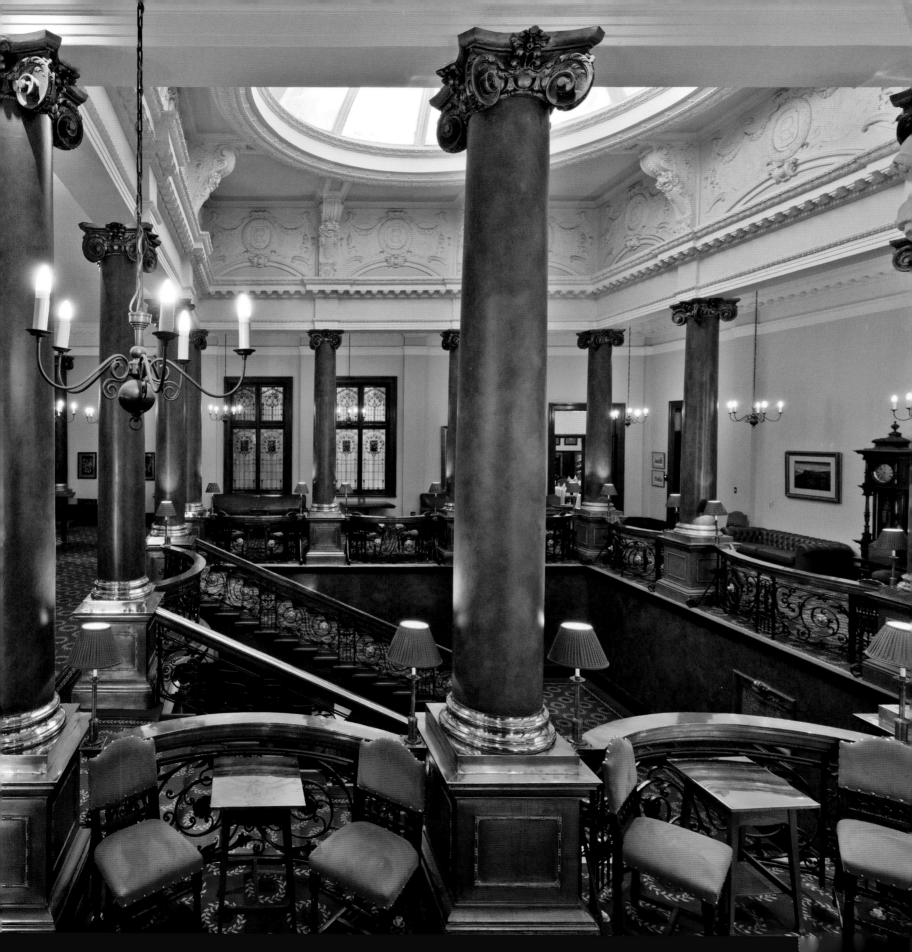

and Rhodes again, this time in bronze. From the hall, a short walk away is the Main Bar with a teak bar counter that's 103 feet long, a tin tray filled with sand skirting its feet for cigar butts and for drinkers to spit into. But best of all is the spectacular wooden staircase that rises up past towering, faux Ionic porphyry columns to a colonnaded *piano nobile*, the so-called 'Surrounds', dominated now by a large portrait of Nelson Mandela which deposed that of Her Majesty. Soaring overhead is the stained-glass dome that lights the interior of the building. This is an extraordinarily handsome space and dotted about are old seats and little side tables, lit by shaded table lamps, for covert meetings and the plotting of business subterfuge.

The main dining room doubles, when needed, as the ballroom, and there's the library with its collection of Africana and a row of leather armchairs which, facing the stacks, permit its members to contemplate the silence in peace. On the floor above are various meeting rooms that, along with the Rhodes Room with its spectacular full-length portrait of Rhodes, are adorned with all kinds of memorabilia – trophies from fishing trips and hunting excursions, old photographs, portraits of former British kings and queens, and cartoons lampooning the luminaries of the colonial era at home and abroad. And there's a whole corridor lined with works by Thomas Baines. In the basement is the billiards room, its walls and dark corners adorned with a menagerie of stuffed wildlife.

THIS PAGE The library, with its comfortable armchairs facing the stacks, all the better to enhance the quiet contemplation of members retiring there following a boozy lunch.

OPPOSITE The gallery, known as the 'Surrounds', is dominated by a colonnade of faux porphyry columns. Its walls are lined with portraits past and present of presidents, politicians, magnates and city bosses. Annigoni's portrait of the Queen was here too, until consumed by the flames of the 2005 fire.

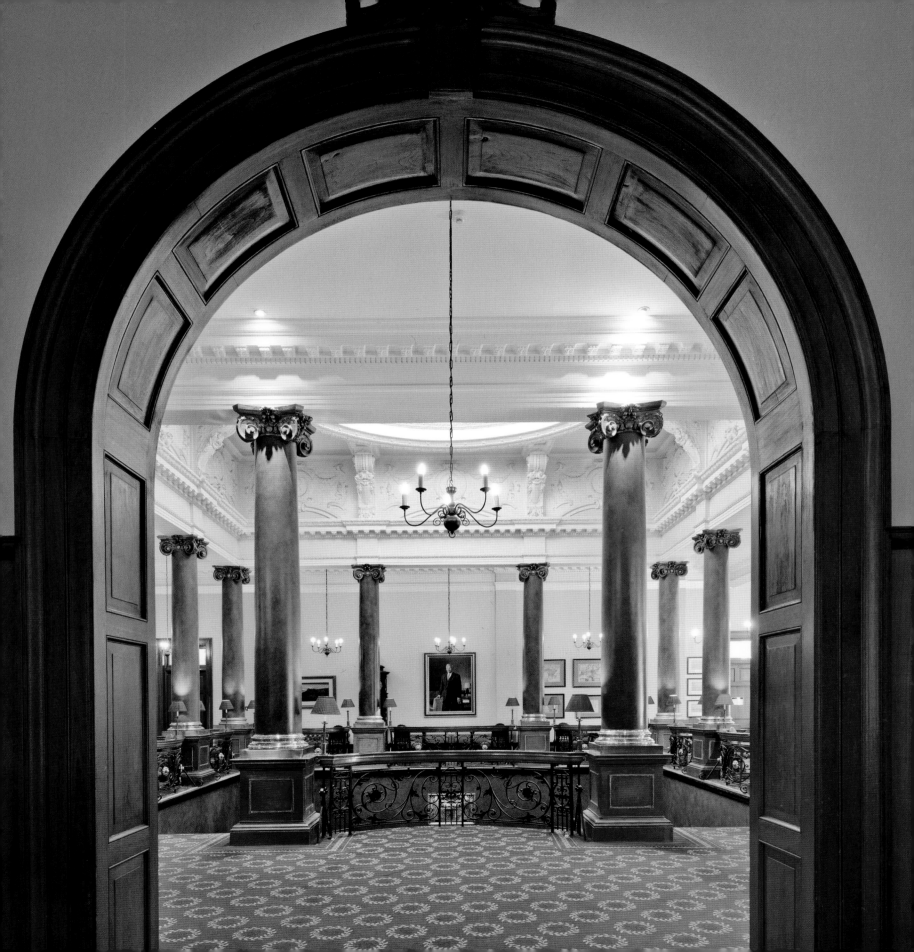

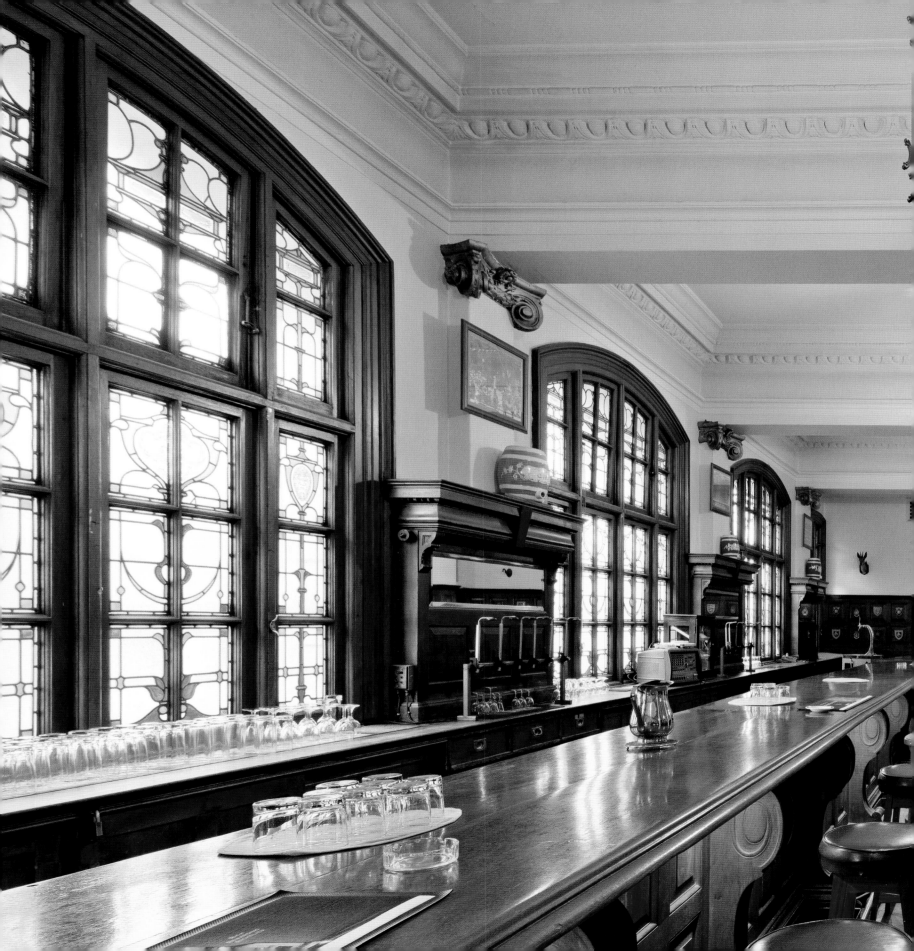

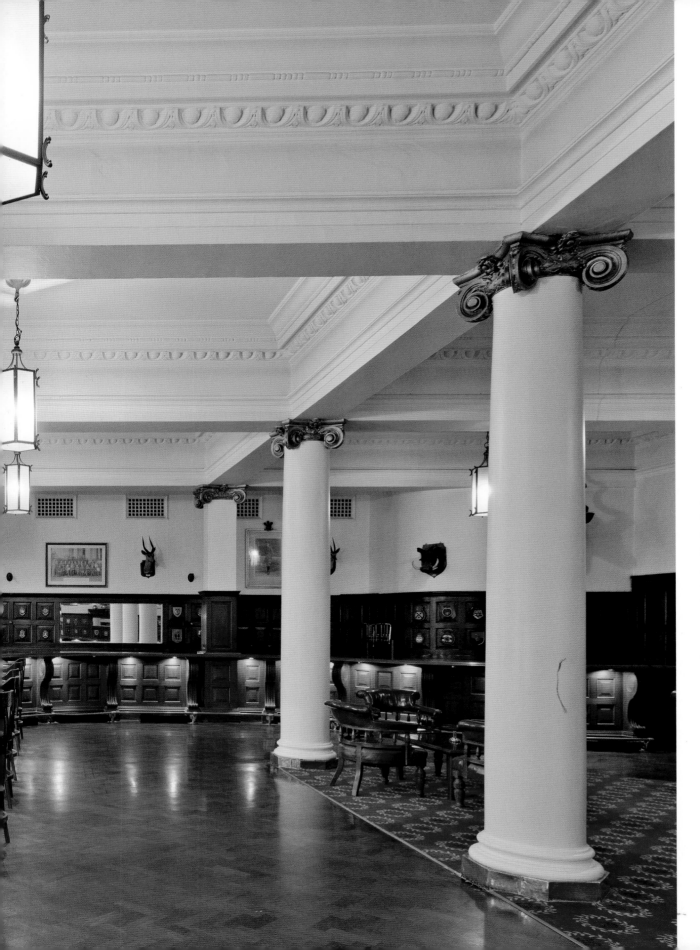

LEFT The Main Bar. The bar counter is famously heralded as the longest in all Africa. The movers and shakers of early Johannesburg would have congregated here, capitalizing on their membership of this most prestigious of the gentlemen's clubs in their developing city.

PAGE 202 The basement Billiards Room, with three billiard tables and their attendant banquette seating. The menagerie of stuffed animals was the gift of a member.

PAGE 203 The grand staircase ascends from the entrance lobby to the 'Surrounds'. In it is a range of unfashionable statuary including a bronze of Rhodes himself and one of Paul Kruger by Anton van Wouw.

201

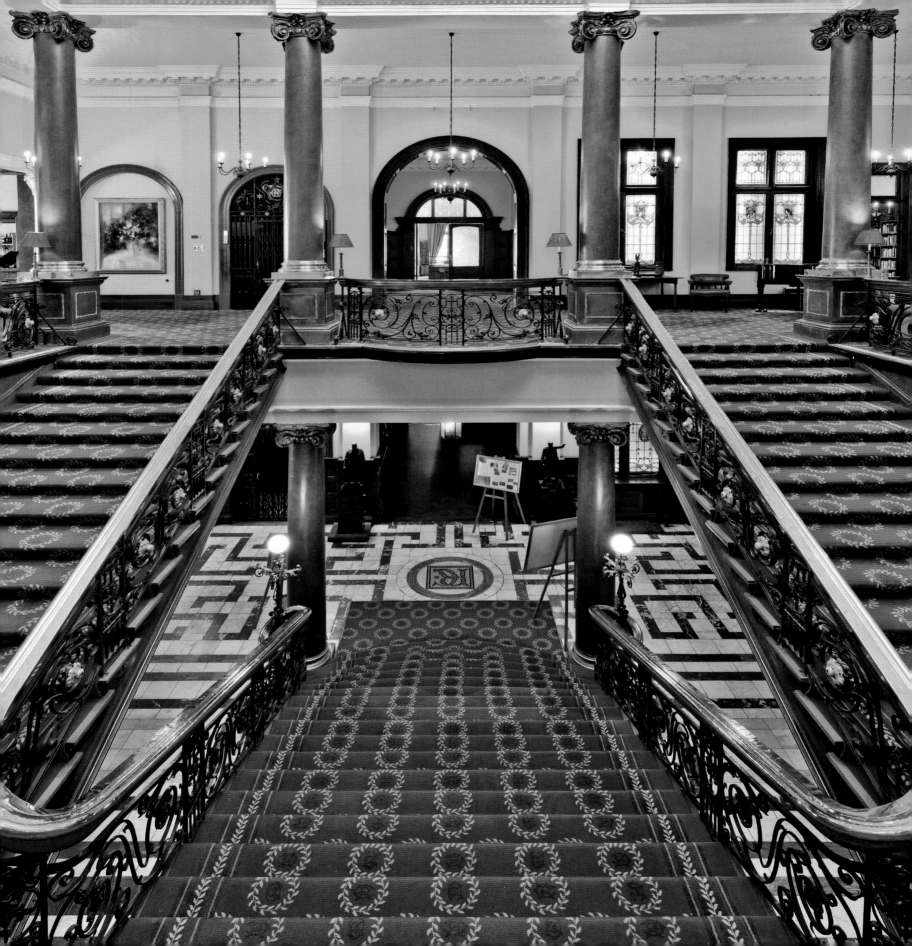

ANSTEY'S BUILDING
Corner of Jeppe and Joubert Streets, Johannesburg

An advertisement in *Homes of the Golden City* proclaimed that Anstey's was where 'the modern woman shopped', its 'well-lit fashion salon… the answer to every modern woman's prayer'. Here, when it opened, you could buy under one roof 'a needle, a can of asparagus, lingerie, Continental fashion in footwear, or a London dress fashion…'

'Anstey's' referred to Norman Anstey's glamorous department store which once occupied the four-storey podium on which sat a much taller building on a considerable portion of land on the corner of Jeppe and Joubert Streets in what had become a preening shopping mecca. When it was built, its soaring upper reaches scaled 17 storeys, ensuring that it was, for a limited time, the tallest of modern Johannesburg's new skyscrapers – making it, in fact, one of the tallest buildings in Africa. Designed by Emley & Williamson – although probably more by the young Frederick Williamson than the older Frank Emley, who designed the Rand Club and who died in 1938 – when it was completed in 1936 it was one of the city's more spectacular Art Deco buildings, its up-to-the-minute modernity expressed through the bold use of its zigzag profile and stepped silhouette, not to mention the sweeping curve of the podium section and the use of glass and metal. It's still one of the icons of 1930s Johannesburg and, along with Astor Mansions (1932), a symbol of the optimism of the period.

A ziggurat, comprising two 'stepped towers' of apartments set at right angles to one another and with inset windows at the outer corners, rises 12 storeys above a Bauhaus-looking podium that housed the department store over four floors. The two sections of the building are curiously at odds with one another in both function and design. The former curves around the corner from Jeppe Street to Joubert Street, with continuous strips of window to lighten the way. The upper reaches are stepped so that, halfway up, each of the two towers has a series of terraces that culminate in a kind of blockhouse at the building's highest point. Chromium-clad windows at pavement level exhibited the merchandise in a famous array of gorgeous displays, screened from the sun by awnings displaying the Anstey's logo.

Behind the windows was a 'shopper's paradise' of displayed merchandise that was 'an invitation to spend your money wisely'. Old photographs feature cars parked along the kerb, and hatted and gloved shoppers doing their best to keep out of the sun beneath the jutting roof that protected the pavement from the elements. Jean Feldt remembers Anstey's in the late 1940s: 'If you could afford it, you shopped at Anstey's. It was *such* a prestige store – like a Harrods of the south. We spent a lot of time there choosing dress fabrics. And the underwear! They had the best. And you were always assisted by well-spoken, well turned out, white attendants'. The basement tearoom featured live mannequins 'who'd hover by your table just as you were about to bite into your Victoria sponge', remembers Gail Behr, whose grandmother took her there for treats in the 1960s. 'They'd stare impassively into the middle distance expecting you to admire the American ensembles they were modelling. To be honest, the three-tiered sandwich platter was more fascinating than the shirt-dresses and matching hats. My sister and I used to love the toasted anchovy fingers and the egg mayonnaise triangles which arrived sprinkled with shredded iceberg lettuce … oh, and the strawberry milkshakes in those ribbed glasses…' But that's all gone now.

OPPOSITE Not much of the old Anstey's survives, but there's enough of it left to conjure up a picture of stripped-down modernity.

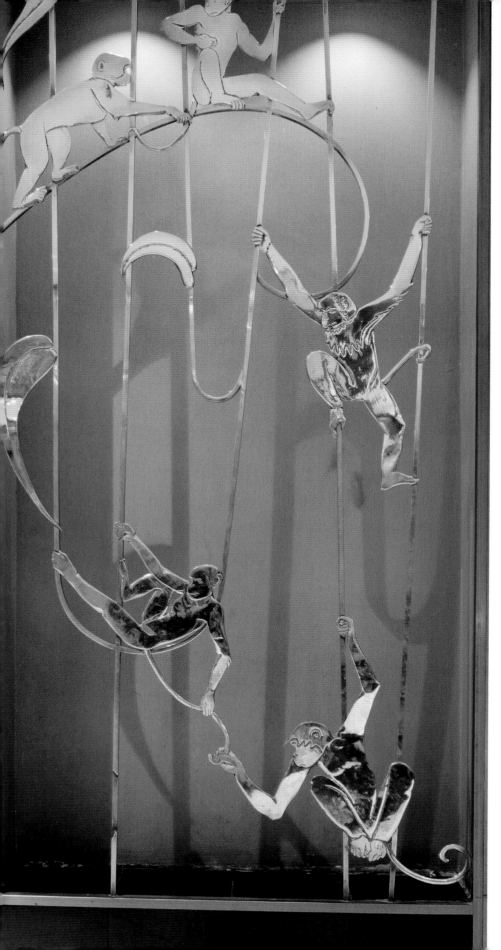

The way to the apartments above was — and still is — via a lift lobby where the decorative brass monkeys clambering up and down are fabulous survivors of the period. The chairman of the Johannesburg Stock Exchange once kept a penthouse here, and it was also home to gay theatre director, political activist and Umkhonto we Sizwe member, Cecil Williams, who in 1959 was tried for treason but acquitted. Sir Laurence Olivier and Danny Kaye were frequent guests at his parties. When Nelson Mandela was arrested in 1962, he was disguised as Williams's driver. One of the unsung heroes of the Struggle, Williams was the subject of a film shown at Cannes in 1999 called *The Man who Drove Mandela*. Said a headline in *The Independent* in May of that year: 'Film celebrates gay hero who drove with Mandela', continuing '… his opposition to apartheid inspired some of the world's most liberal laws on homosexuality, introduced when Mr Mandela came to power…' But Cecil Williams is virtually unknown now. He left South Africa and died in Britain in 1979.

'Today Anstey's is home to offbeat city artists and urban pioneers, people keen to secure their own stake in Johannesburg's rebirth' writes architect and blogger Brian McKechnie, who now lives in that penthouse once occupied by the chairman of the Stock Exchange.

LEFT The way to the apartments above the deparment store was via a lift lobby decorated with cavorting brass monkeys.
OPPOSITE The ziggurat-shaped apartment building above the store was once home to a cross section of Johannesburg society. Today, it houses a new breed of 'urban pioneers' who are bent on breathing life back into downtown Johannesburg.

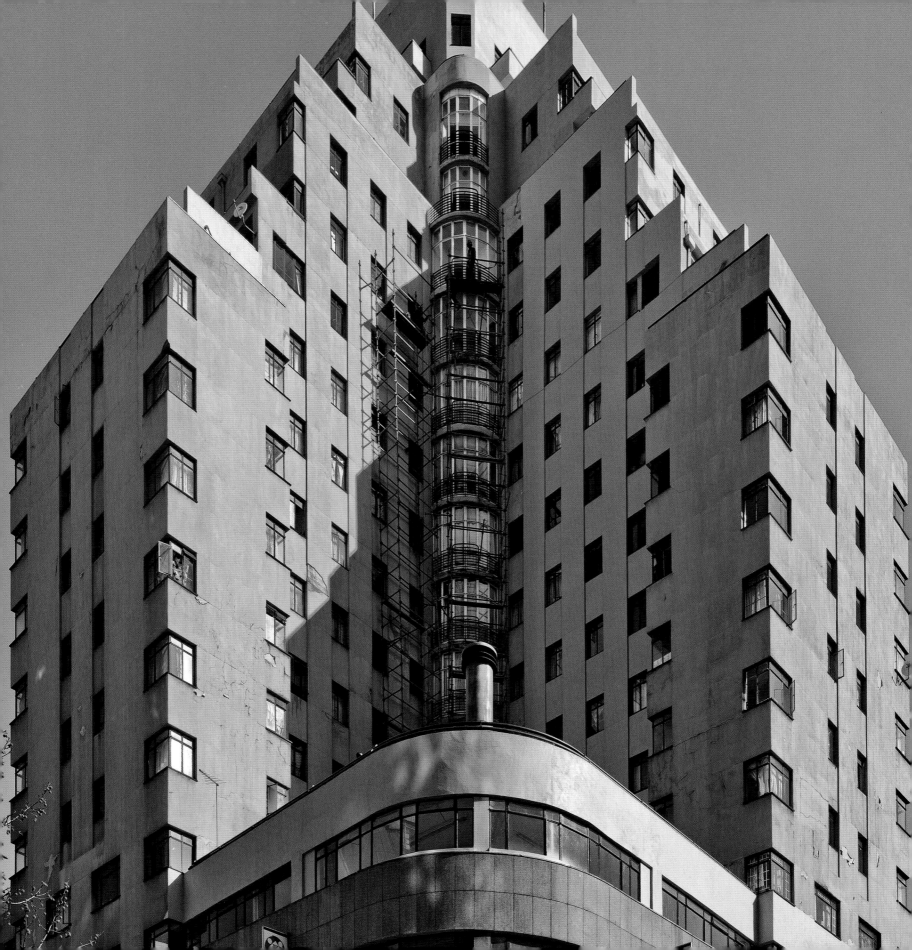

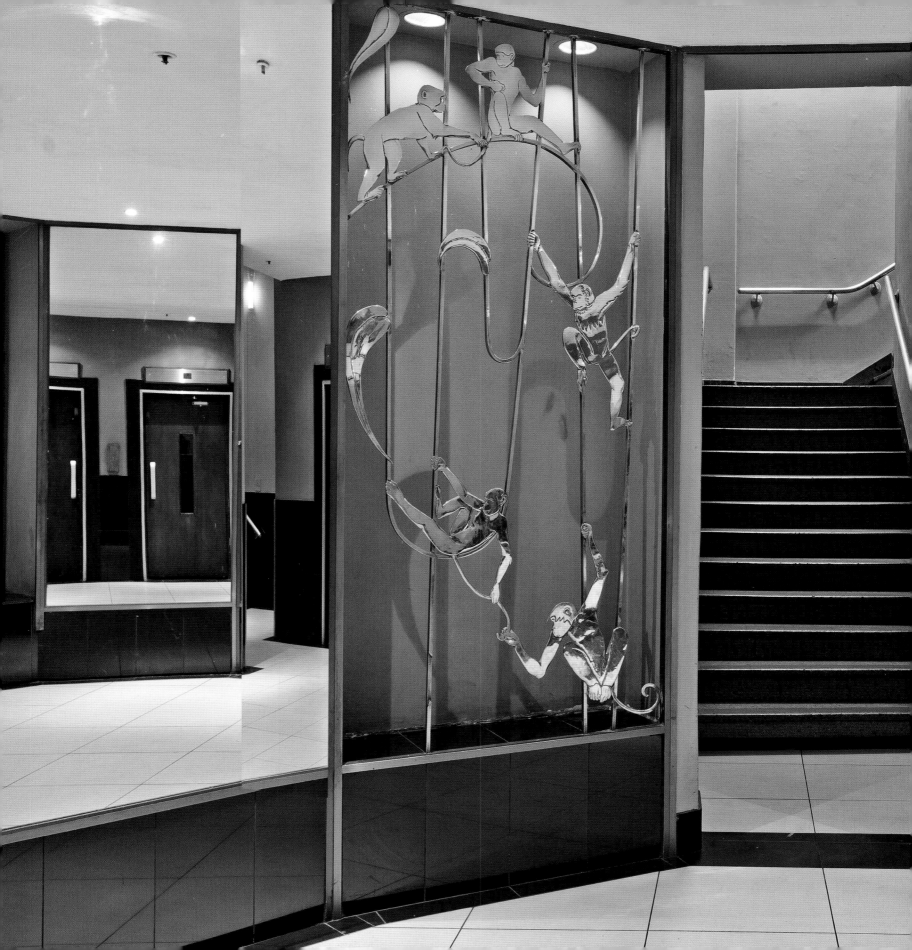

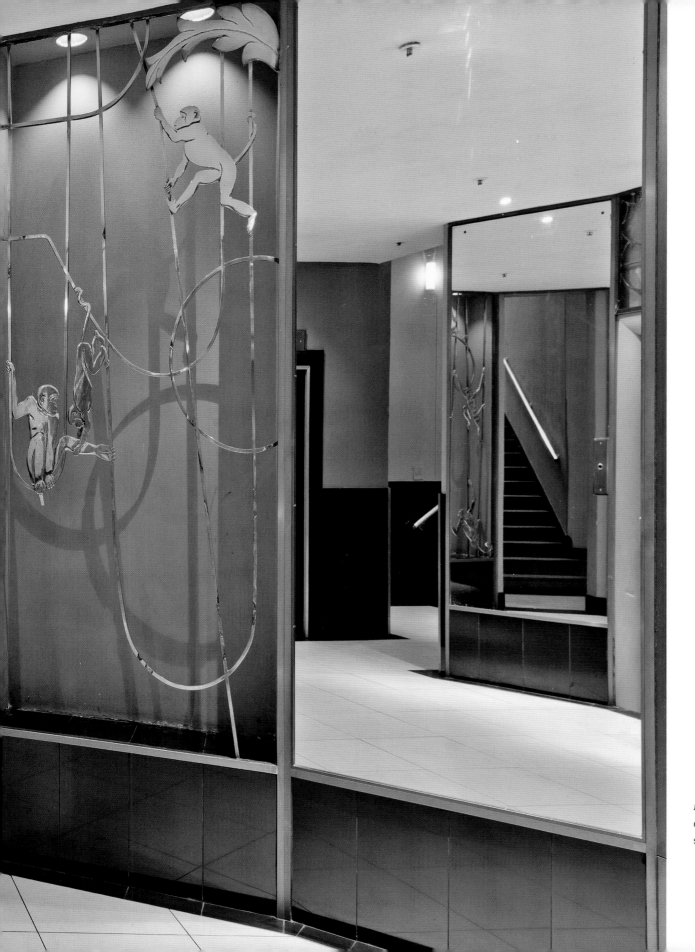

LEFT The lift lobby, with its curious decoration, is a remarkable survivor of a bygone era.

CATHEDRAL OF CHRIST THE KING

Nugget Street, Doornfontein

From outside it's nothing remarkable, a Modernist basilica in granite with transepts fronted by a prominent narthex or porch. The most striking thing about the plain, even austere, Cathedral of Christ the King at the heart of Doornfontein, consecrated in 1960, is the riot of coloured light thrown across its interior and over the altar by the huge, glorious stained-glass windows set high up in the walls of the otherwise rather bleak nave. These are the work of Modernist stained-glass artist Patrick Pollen (1928–2010) who developed the principles and colouring of Evie Hone, a Roman Catholic convert and an artist who had studied with the Impressionist painter Walter Sickert. She became influential in the Modern Movement in Ireland with her own work in stained glass and with her Cubist paintings, following the work of Braque, Picasso and Gris.

Pollen's work is found mostly in the UK, in particular in London's Brompton Oratory, in the crypt of Rosslyn Chapel in Scotland, and in the Irish Republic, including Galway Cathedral. Thirty-two of the windows at the Cathedral of Christ the King are Pollen's – eight in the sanctuary and 24 on the clerestory. All were made in his studio in Dublin and then shipped in 39 boxes to be assembled in Doornfontein, in 1957, in the new cathedral designed for the Bishop of Johannesburg, Hugh Boyle, and the Diocese of Johannesburg, by the Belfast father-and-son practice, P & B Gregory.

Situated directly across the road from the gaudy Greek Orthodox Cathedral and a block or two from the Byzantine-like Great Synagogue in Wolmarans Street, the Cathedral of Christ the King is massive and barnlike and thoroughly North European. Architect Brian Gregory's rationale for the choice of building design and materials couldn't be more prosaic: 'The structure has been treated simply and in such a way that throughout the coming years there shall be a minimum of maintenance necessary. Though marbles from Italy have been used, these have been limited to the sanctuary, altars and aisles, but the general decorative effect has been achieved with untreated natural materials such as the glass and granite-faced concrete, the brick of the walls and the natural wood finishes of the seats and ceilings'.

Although built to a traditional plan, the Gregorys' work nonetheless reflects the more tolerant Modernist ideals of Pope Pius XII who encouraged buildings of this kind. The cathedral is also influenced by Dutch neo-Expressionism and the work of Francis Velarde, an important English architect known for his Roman Catholic churches mostly in the stripped-down Modern Movement style. That it also, and conspicuously, owes the kernel of something to the same Modernist preoccupations as Basil Spence's Coventry Cathedral, consecrated in 1962, can't go unremarked upon since both are monumental buildings that their architects have attempted to design and detail in an abstracted Gothic manner. Spence was more successful than the Gregorys, but it does explain the uncomfortable insistence at the Cathedral of Christ the King on soaring straight lines, the angles, the roof structure and the flat-pointed arches that articulate its otherwise ornamentless features. Only Pollen's stained-glass windows, it seems, relieve the bleakness within – and they herald by a couple of years John Piper's rich array of contemporary stained glass inside Coventry Cathedral.

OPPOSITE This massive, barnlike cathedral is surely one of the unsung heroes of downtown Johannesburg – in spite of its austere, crisp design.

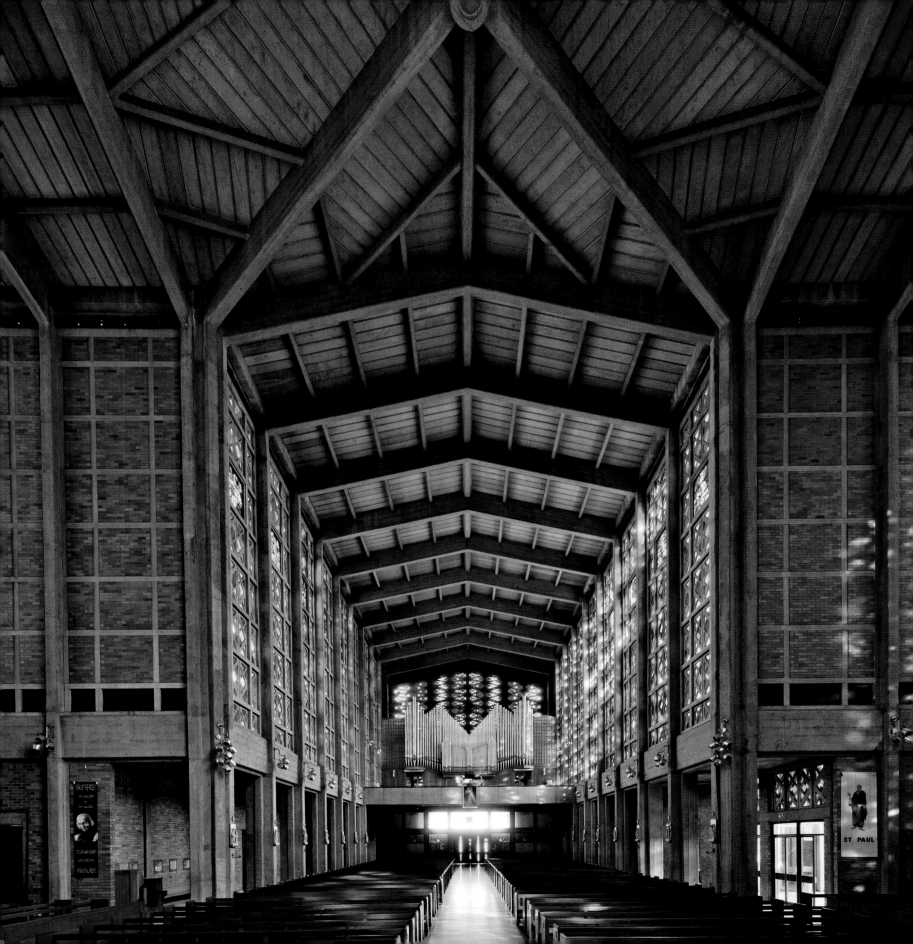

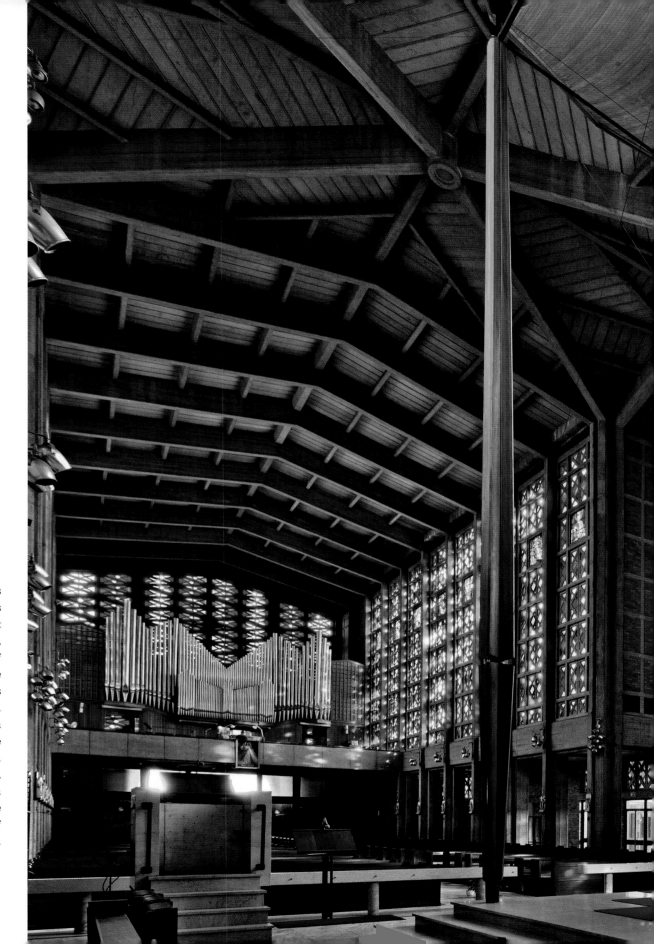

RIGHT The real treasure of this Catholic cathedral is Patrick Pollen's stained glass. It breathes life into the building, animating it in the manner of Braque, Picasso and Gris, whose work Pollen followed via his mentor, Evie Hone.

PAGE 214 In a side chapel, a marble pietà is supported above an altar of solid Botticino marble.

PAGE 215 The organ is lit by blue, red, orange, yellow and green glass, transforming the sunshine outside into rich patterns of coloured light.

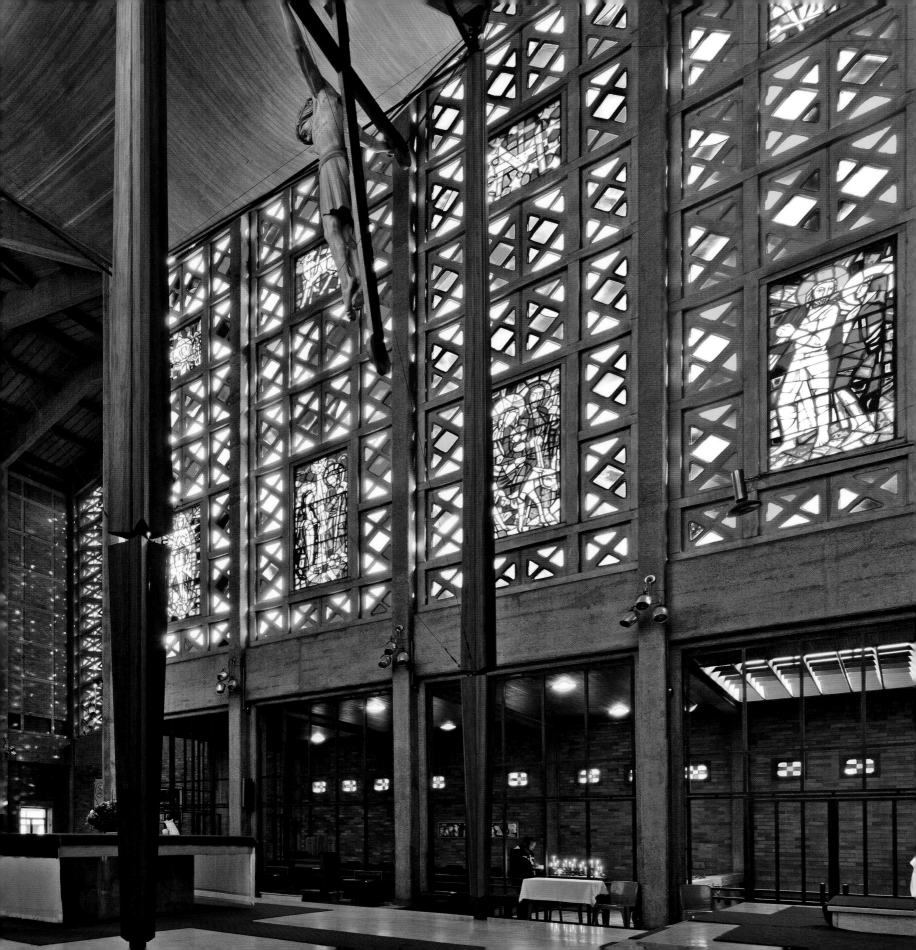

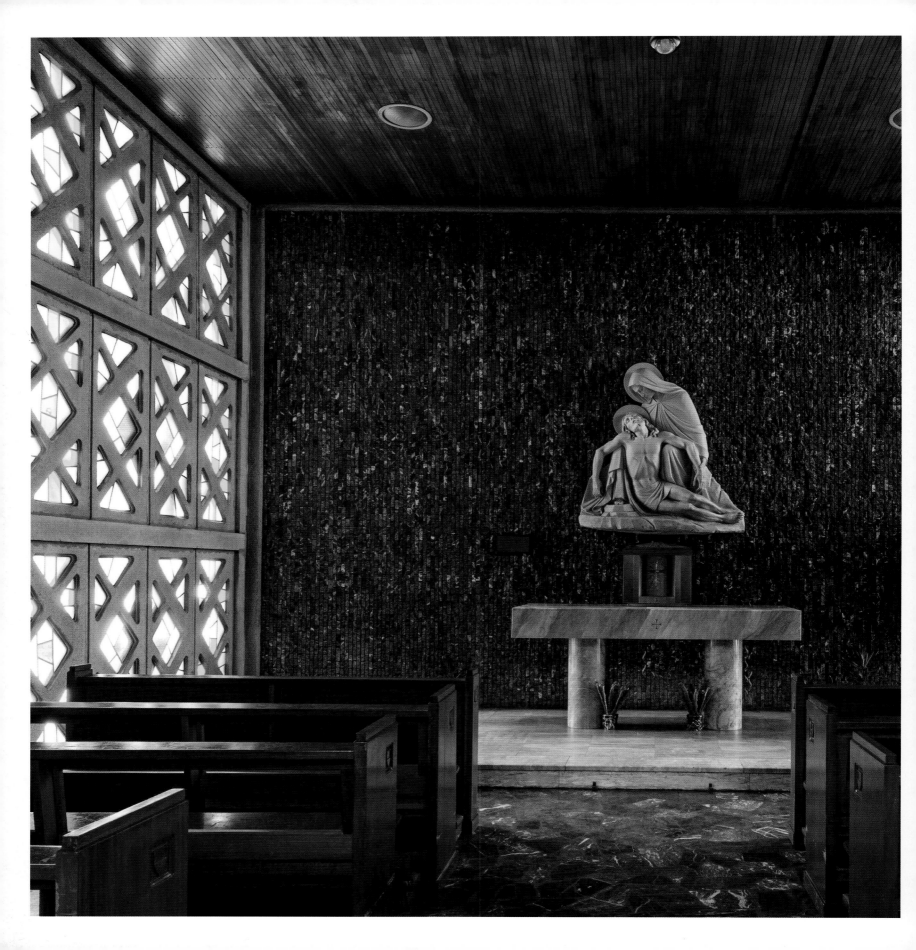

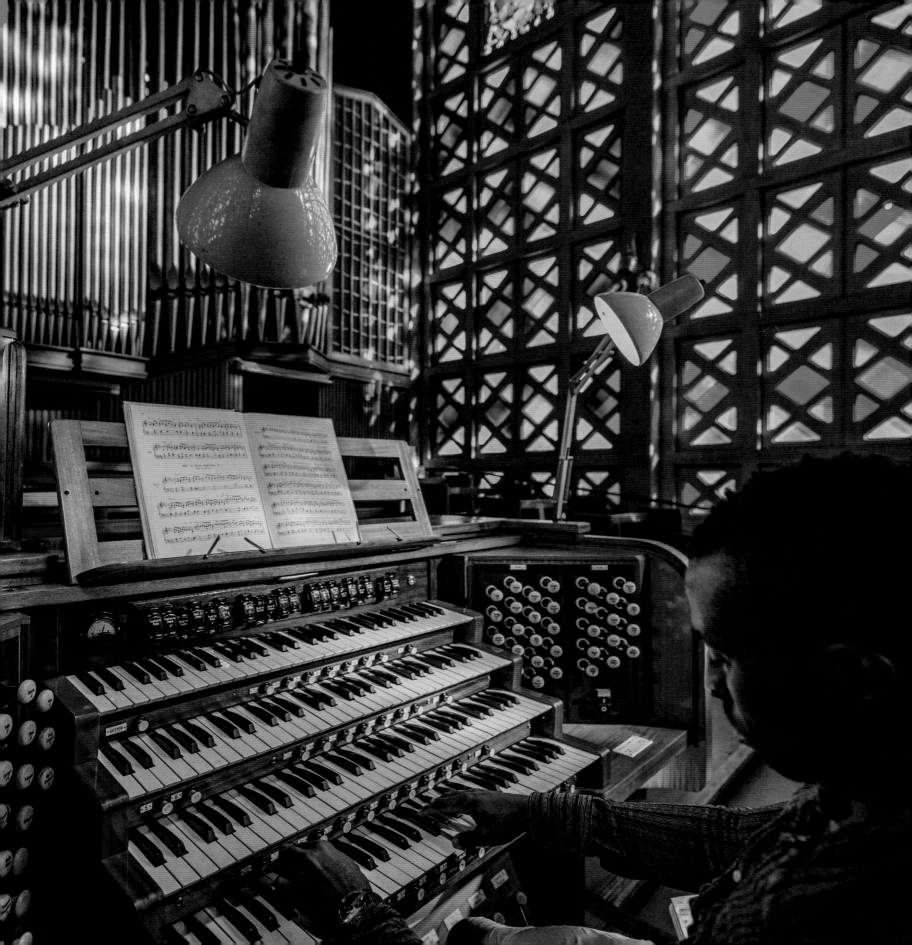

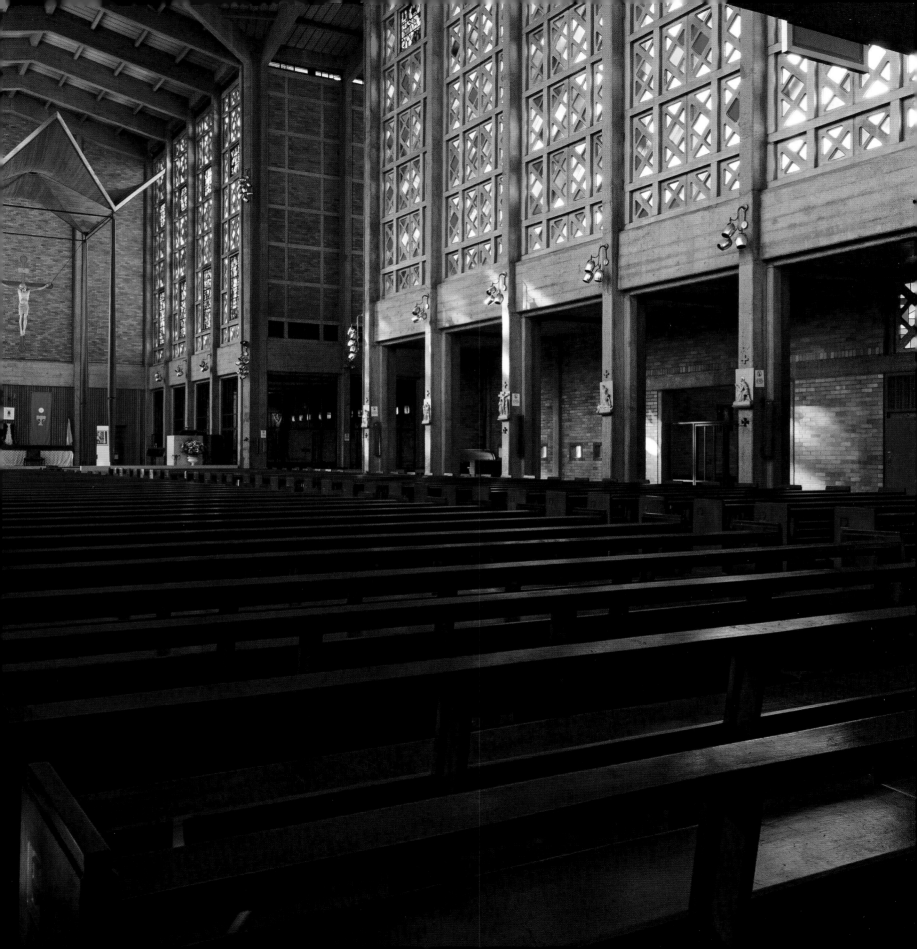

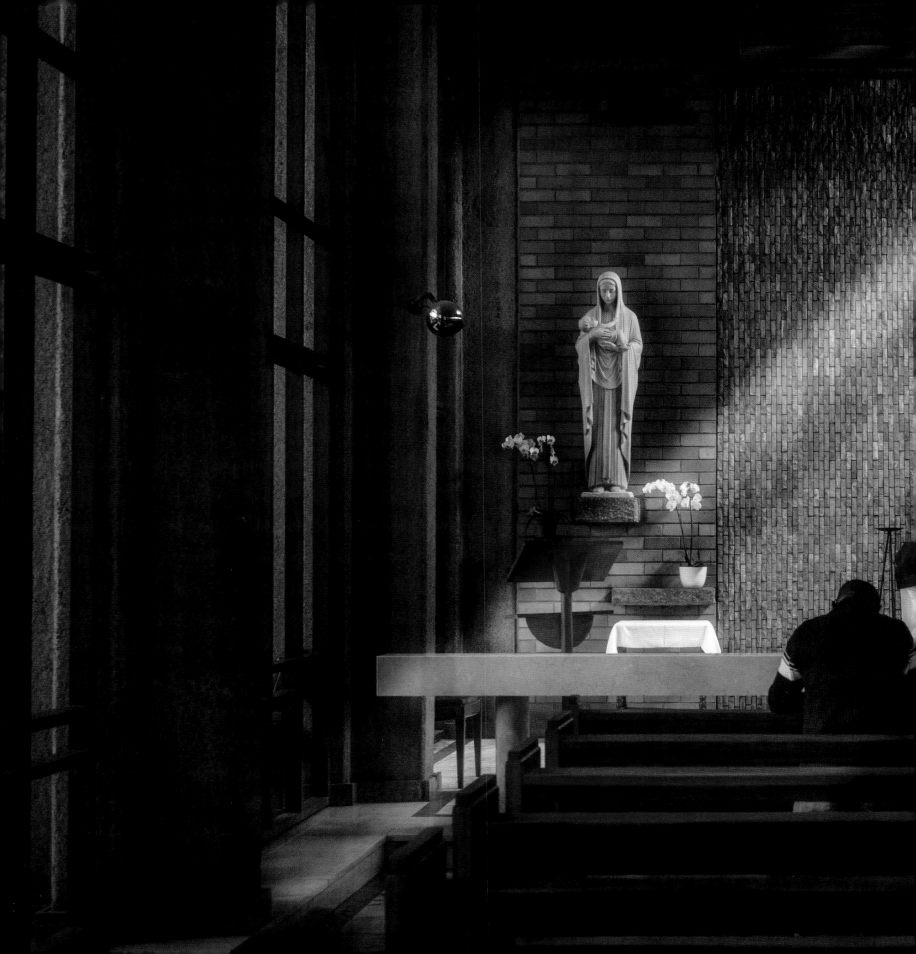

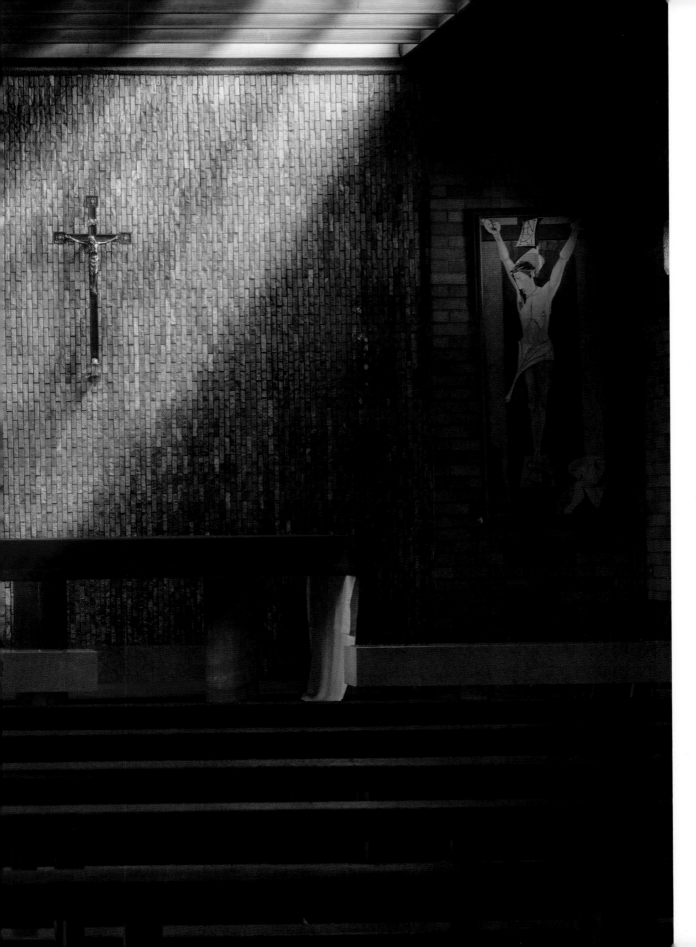

LEFT A side chapel, finished using facebrick, red granite aggregate, marble, terrazzo and linoleum, is the focus for a period of quiet contemplation.

PAGE 216 Above the high altar, the canopy, constructed of edge-grained Oregon pine, is a hyperbolic paraboloid supported on mahogany columns.

PAGE 217 The cathedral, which can seat about 1500 people, has a traditional Latin cross plan with a high nave and transepts. The building's structural frame is reinforced concrete, while reconstituted stone panels form the open lattice-work patterns that house the stained-glass windows.

219

GLENSHIEL
Woolston Road, Westcliff

Glenshiel, on the Westcliff ridge, is another perfect embodiment of the extraordinary sense Herbert Baker had for placing a building where it commanded not only the best views but was dramatically picturesque in return. Designed in 1908 for the mining magnate Colonel (later Sir) William Dalrymple and his wife Isabel, it lent its owners a certain status, and was for years a centre of Johannesburg's social and charitable life. 'Glenshiel, her beautiful home in Parktown,' said Lady Dalrymple's obituary in *The Star* on 31 December 1938, 'has become one of the historic houses of the Transvaal, for here she and Sir William entertained many distinguished visitors. The Earl of Athlone during his term of office, and Princess Alice were frequent visitors, and there was hardly a person of note visiting the country who was not entertained by them'.

It was the last of Baker and Fleming's big Johannesburg mansions and it's another of those English-looking Arts and Crafts 'country mansions' that chases after the rural vernacular of an ancient island many thousands of miles away. It was built using stone quarried from the ground around it and, consequently, appears to rise out of the rock on which it stands. In fact, it's almost completely at one with its context. It sits on a sort of peak of the ridge, its plan a rather idiosyncratic 'butterfly' that appears to take its cue from Papillon Hall, designed by Edwin Lutyens in Leicestershire in 1902 for a French family known as Papillon (in French *papillon* means butterfly). The butterfly typology and shape of the house plan has a long provenance however, reaching back to seventeenth-century England. It may seem an odd choice for the layout of a house until it becomes clear that, with four full-height wings added at 45 degrees to the main block, two on either side of it, it's possible to increase the number of rooms oriented towards the sun. Not only that, but the butterfly shape increases the number of rooms with views – a dramatic advantage for a house built on the very edge of the Westcliff ridge which has some of the best outlooks on offer in Johannesburg. The butterfly plan fits well with Baker's preoccupation with the Arts and Crafts style of building: it's a design which found its best expression at the hands of Arts and Crafts designers whose love of natural forms gave them a greater sensitivity to the opportunities they offered – oddly, even butterflies.

Today, Glenshiel houses the offices of the Order of St John. When Sir William and Lady Dalrymple lived there it was one of the first Johannesburg houses to have a swimming pool and tennis courts. It was the kind of place that, had you been invited to tea, you might have bumped into a visiting royal personage, or perhaps a troupe of orphans from Nazareth House. Isabel Dalrymple, a former prima donna of the famous London Gaiety Company, arrived in Johannesburg in 1895 on a South African Tour, having made a name 'on the stage and off it…' said her obituary. The main attraction of musical comedies at London's Gaiety and Daly's Theatres were the Gaiety Girls who formed the chorus. Some of these young women, fashionably dressed, well-spoken dancers and singers, went on to become serious actresses, or moved to Hollywood in the 1920s. Others attracted male admirers who never missed a performance and queued up afterwards to give them flowers and chocolates. These 'stage-door Johnnies' included members of the aristocracy and self-made millionaires. After Gaiety Girl Rosie Boote married the Marquess of Headfort, and her friend Connie Gilchrist had a society wedding to the Earl of Orkney, it was joked that the Gaiety Girl chorus was a matrimonial agency. The 1894–95 South African Tour was a huge success, and in 1896, Isabel married William Dalrymple and stayed on in South Africa's mining boomtown. Glenshiel became the location of their entertaining, music and tennis parties.

OPPOSITE The peculiar butterfly shape of Glenshiel, designed by Herbert Baker, is mirrored in the layout of the interior.

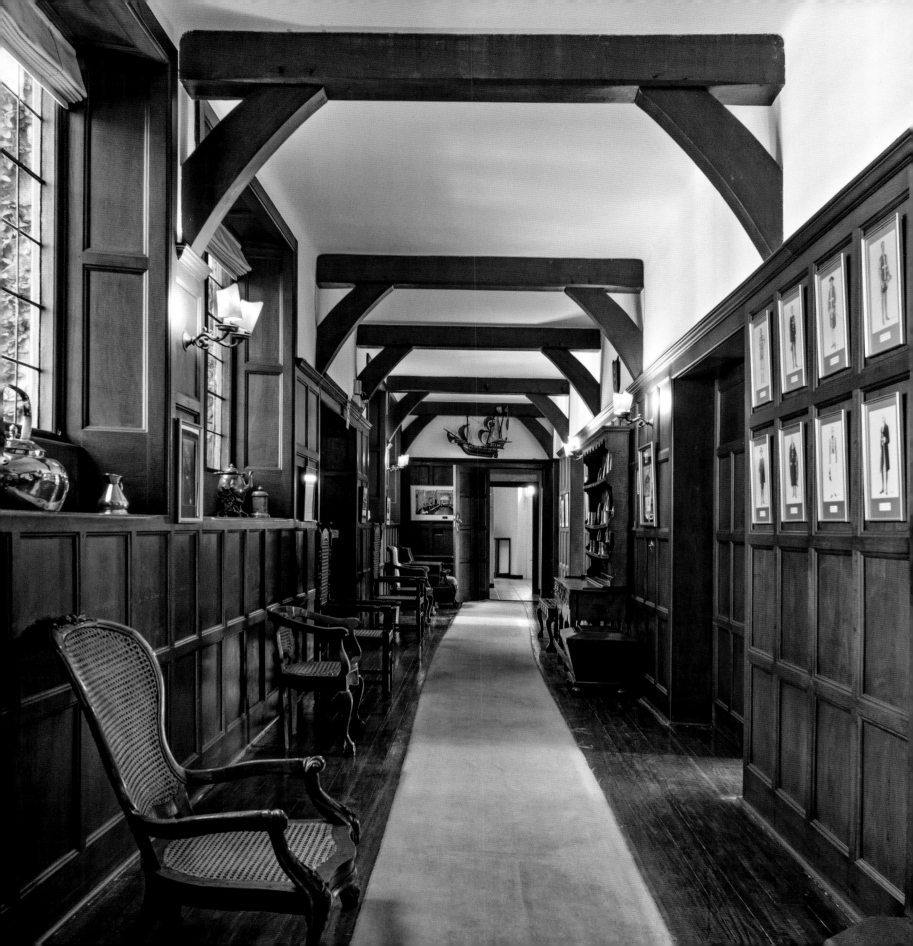

RIGHT The brass, mullioned windows and wood panelling are hallmarks of a Baker Arts and Crafts interior. All it needs are chintz-covered sofas and, because this is Africa, a few mounted animal-head trophies.

PAGES *222–223* On Sir William Dalrymple's death in 1941, the 27-acre property was divided in two. The seven-acre portion on which stand the house and stables was bought by Gordon Haggie who passed the house on to the Order of St John, reviving an old connection with the Order.

PAGE *224* The Gallery could be part of the quintessential English country house with its beamed ceiling, row of mullioned windows and procession of English and colonial furniture.

PAGE *225* During World War II, Gordon Haggie lent Glenshiel to the Order of St John as a place where wounded soldiers could recuperate. In 1949, he handed the building over for them to hold in perpetuity. His descendants, however, continue to live in the converted stables.

226

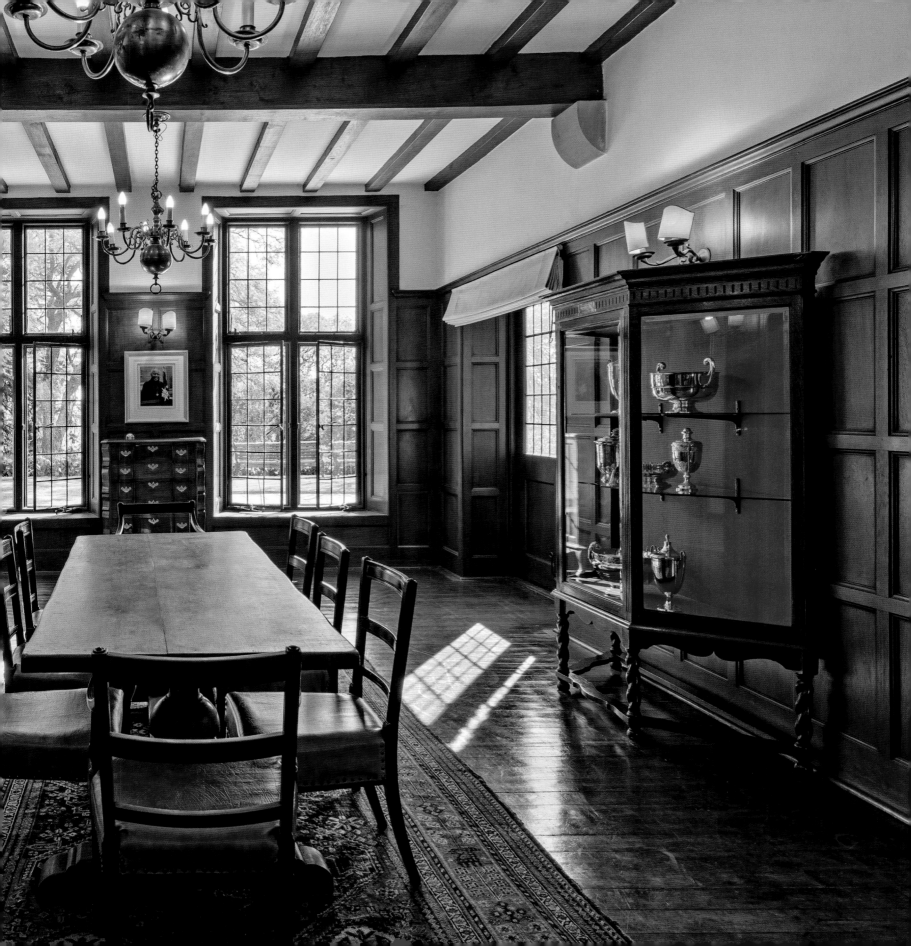

CITY HALL
Rissik Street, Johannesburg

Johannesburg's City Hall, defined by a pillared portico and a domed clock tower, is one of those massive late Edwardian compilations that, part neoclassical, part beaux arts, gave many cities of the British Empire their silhouette if not their gravitas as the twilight hour of imperialism approached. Exaggerated, even ungainly, it's the awkward precursor of a building style that culminated in Herbert Baker's handsome Union Buildings in Pretoria. It was brought to life by competition in 1909 and completed in 1914.

Designed by William Hawke and William McKinlay, its foundation stone laid by the Duke of Connaught in 1910, it is still the grandest feature on a list of diverse buildings by the Cape Town architectural practice Hawke & McKinlay that includes the domed senate house of the former University of the Cape of Good Hope, in Cape Town's Queen Victoria Street, now known as the Centre for the Book. William Hawke was trained in part in the offices of Sir Aston Webb who later designed not only the principal façade of Buckingham Palace, but the Mall and Admiralty Arch as well. Here he met William McKinlay, and together they became a prolific team responsible for, amongst other buildings, the winning designs for the Supreme Court Buildings, also in Queen Victoria Street, as well as the Law Courts and Museum in Bloemfontein. They did stately handsomely and monumental magnificently, but the overall quality of their designs indicates a sober, even humourless, rather plodding solidity. The Johannesburg City Hall 'is all that a municipal palace should be,' writes Désirée Picton-Seymour rather damningly in her book, *Historical Buildings in South Afric*a. But perhaps it is apt for a team whose principal was trained by Sir Aston Webb, whose obituary in *The Spectator* described a man who 'left his mark all over the country… in large buildings which reach a general standard of impressiveness…' So, in other words, nothing special.

The most interesting thing about the Johannesburg City Hall – apart from the elliptical vestibules with their *boisserie* and mirrored panels on either side of the main entrance, and the various panelled meeting rooms and stained-glass windows about the place – is that the maverick master builder, Mattheus Meischke, was responsible for its construction. He pioneered the building industry in the Transvaal and you find his buildings all over the old city centre. In fact, the first significant Republican government building in Johannesburg, the General Post Office, also in Rissik Street, was one of his, and so was his own Meischke Building on the corner of Market and Rissik Streets. In Pretoria, he was responsible for erecting the two wings of the Union Buildings (1910–13). He and AB Reid, another master builder, this time from Cape Town, worked together on a wide range of projects both before and after the Anglo-Boer War. The City Hall was one of the latter. Juxtapose the General Post Office with the City Hall and you have a telling view of the old and new worlds, representing two different eras: the former, utilitarian, provincial and, with its filigree and ornament, proudly Netherlandish for President Paul Kruger; and the latter a bombastic manifestation of British imperial ambition.

OPPOSITE The handsome staircase vestibule inside the City Hall is just one aspect of a compilation of stylistic features that characterize buildings of the British Empire just as the sun was beginning to set over it.

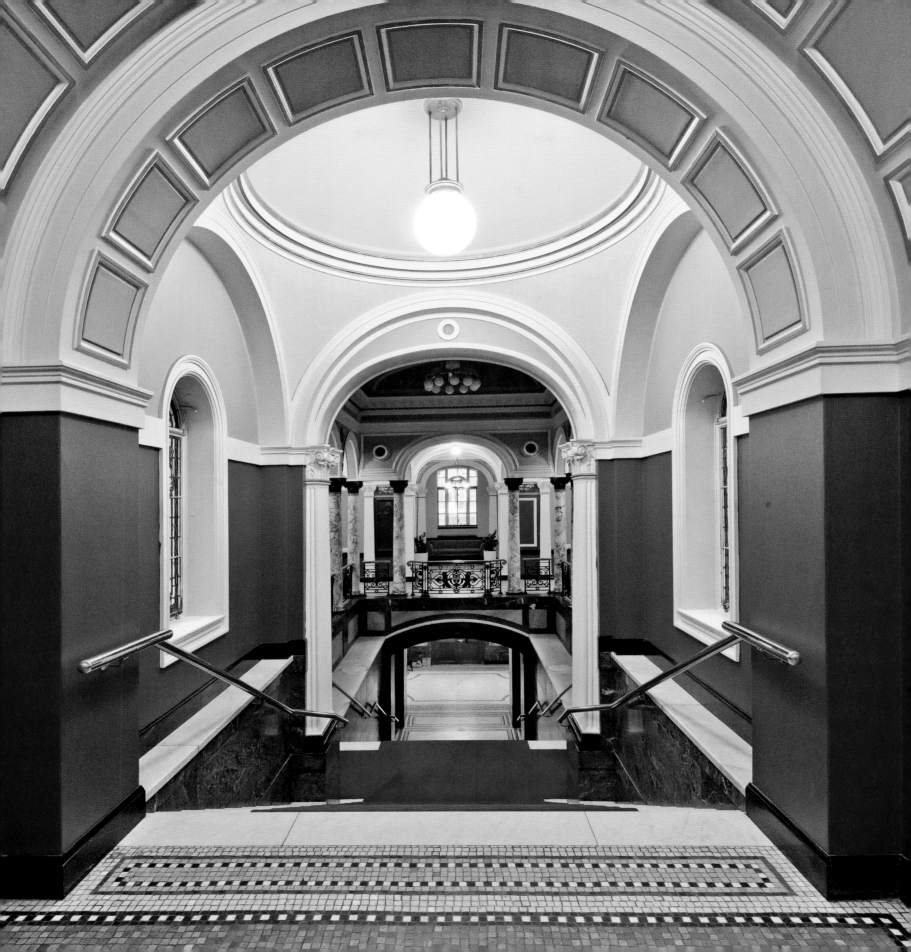

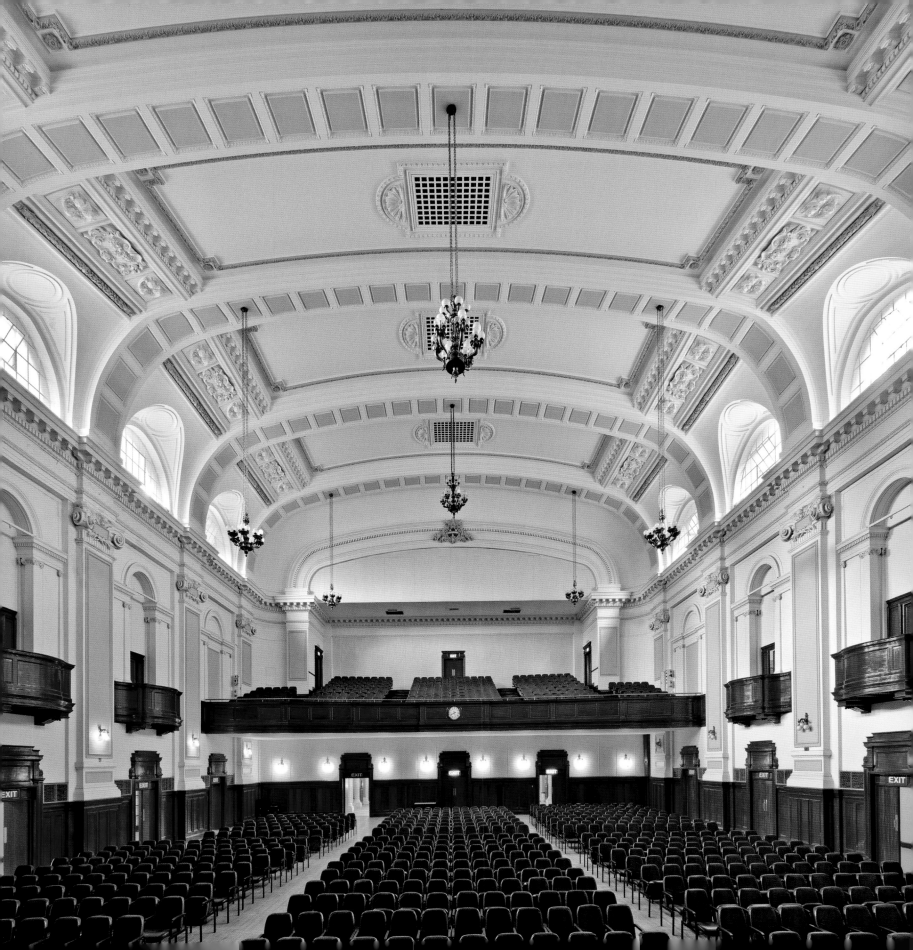

ABOVE Plaster detail of the pilasters lining the walls of the auditorium.

OPPOSITE The auditorium is still in use and houses what is claimed to be the biggest pipe organ in Africa which, gold trimmed (it is said), rises through three storeys. It was installed in the City Hall's West Wing in 1916 by Norman & Beard, a pipe organ manufacturer based in Norwich, England.

PAGE 232 In its time, City Hall has been witness to dramatic events in the country's history: protest meetings in the 1950s on its steps fronting Rissik Street (this picture); a bomb blast outside the main entrance in 1988; a voting station for FW de Klerk's national referendum to test the white electorate on his negotiations with unbanned black liberation parties in 1992; and a voter education centre in the run-up to democratic elections in 1994. Today a portion of it houses the Gauteng Legislature.

PAGE 233 Richly decorated with mosaics, gilding and moulded plasterwork, the beautiful elliptical vestibules lead to the foyer.

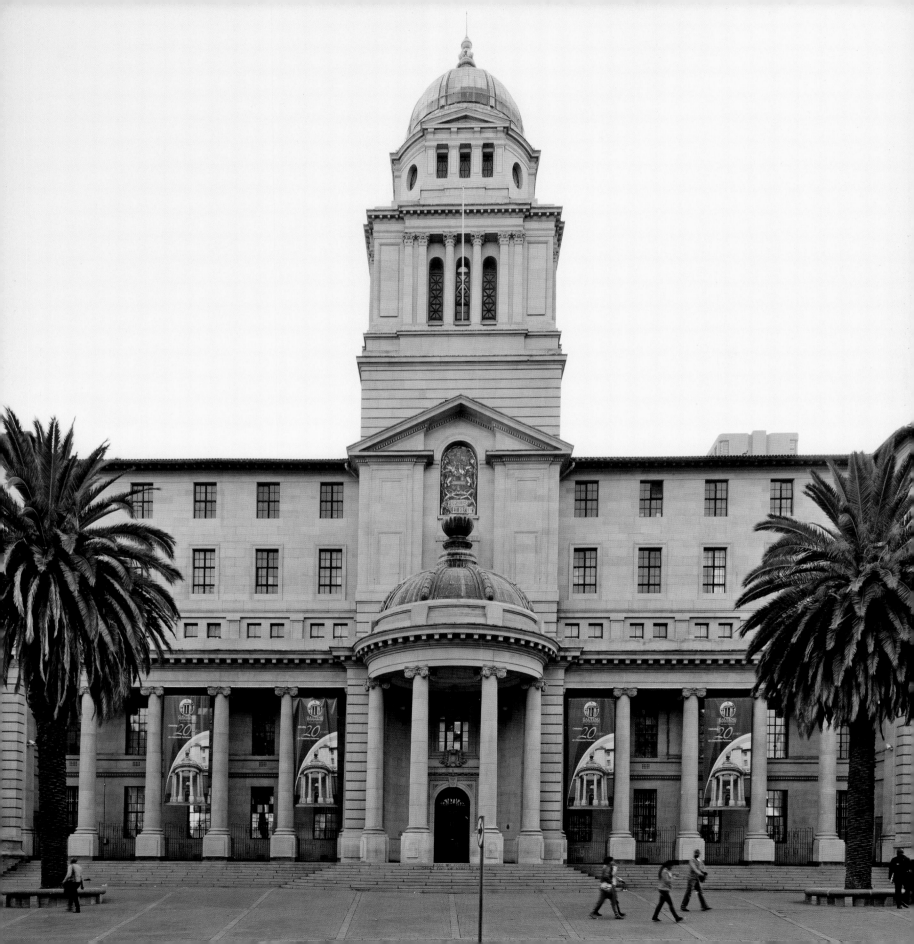

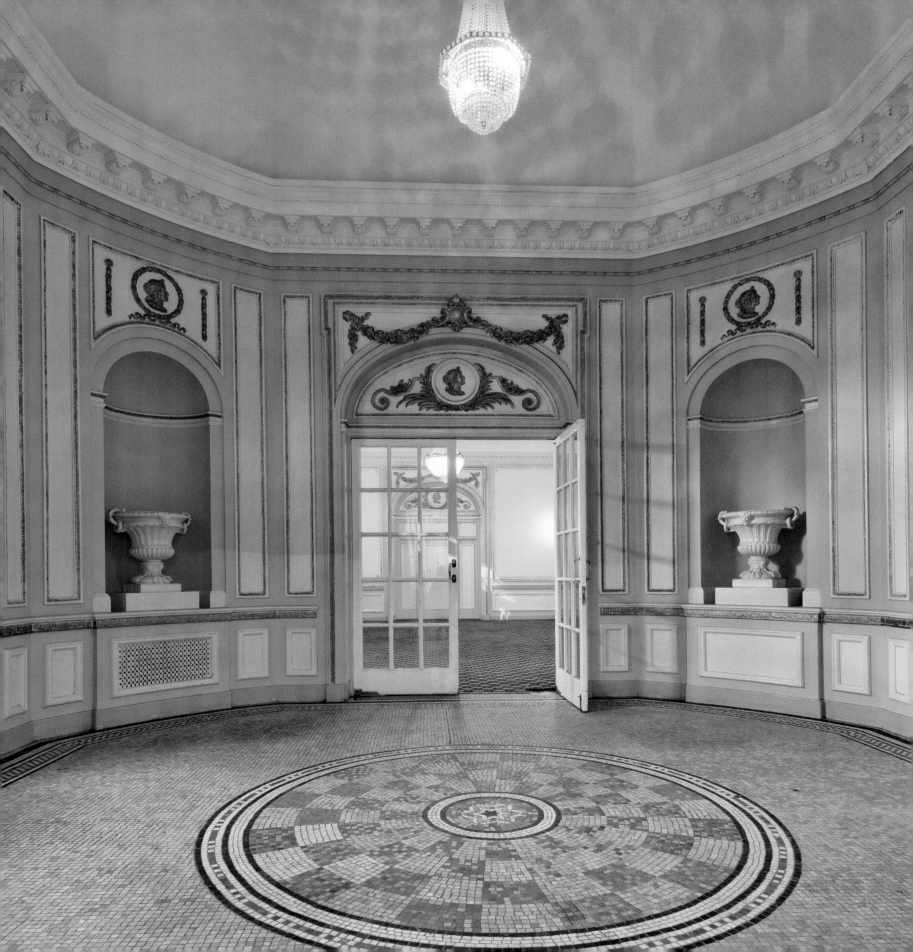

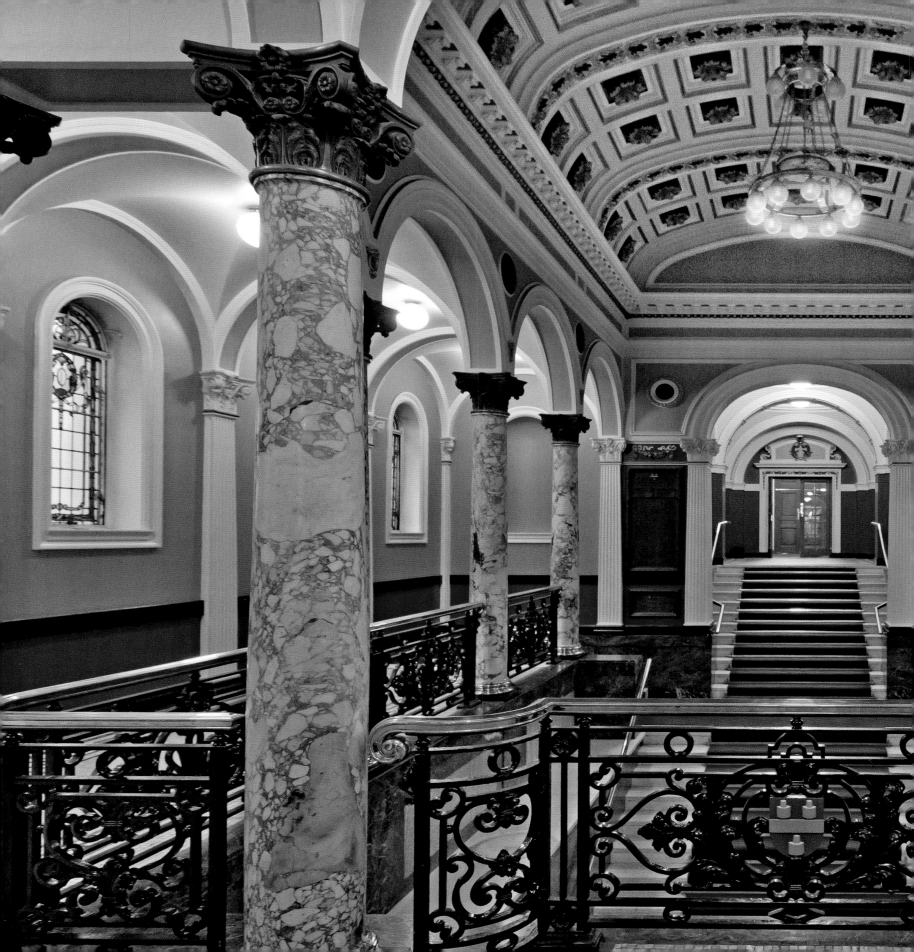

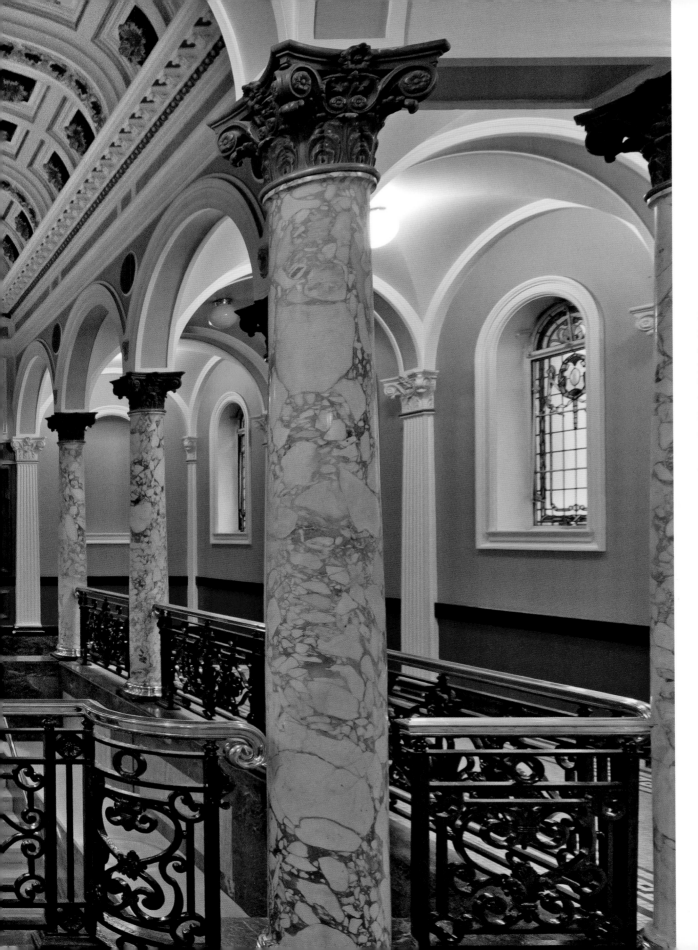

LEFT The variety of materials used in the fitting out of the City Hall's interior is diverse, ranging from plaster and mahogany to oak and teak, and from marble and mosaic to American cork and maple. Here, the gallery has, additionally, a bronze balustrade and stained-glass windows.

PAGE 236 This municipal palace has taken on, superficially at least, the hallmarks of an ancient Roman civic building – in particular, the richly decorated, coffered, barrel-vaulted ceiling and the various coloured marbles supporting the upper balconies with their entablatures and pediments.

PAGE 237 The pavement of the foyer is decorated with brightly coloured mosaic tesserae; its upper reaches adorned with painted and modelled stucco.

PAGE 238–239 Much of the interior has been altered, but what survives is extraordinary – if only because the architects made a virtue of the rather utilitarian materials they used. Here, a handsome staircase leads up from the lobby to the gallery.

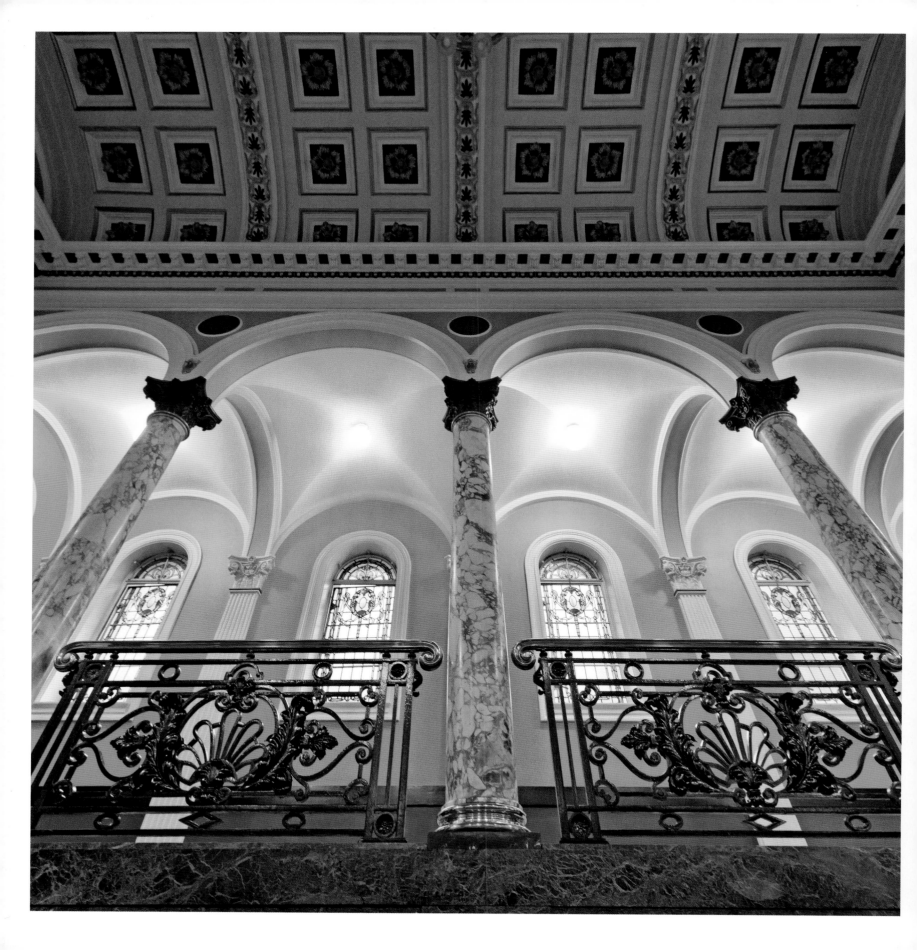

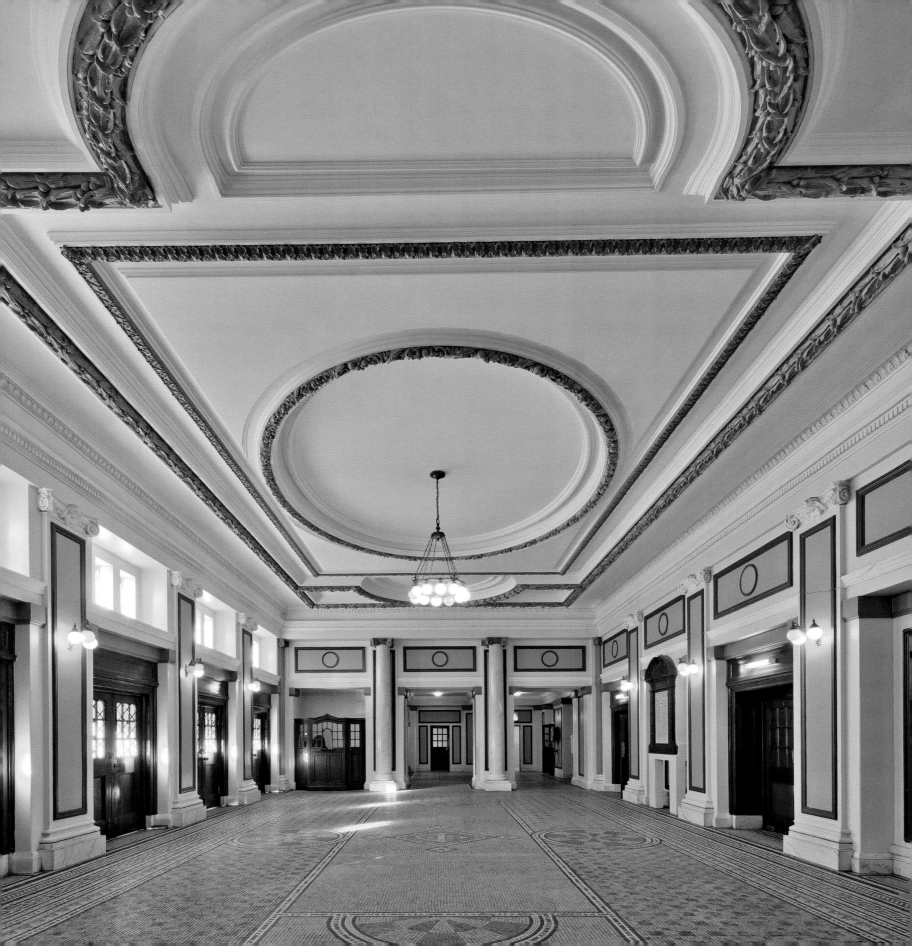

CONTACT INFORMATION

Bedford Court (St Andrew's School for Girls) *Beverley Smith*
 bsmith@standrews.co.za
Cathedral of Christ the King www.catholic-johannesburg.co.za
City Hall www.joburg.org.za
Freemason's Hall *General Secretary, David Pickard*
 dgsec@freemason-jhb.org.za
Glenshiel www.orderofstjohn.org.za
Greek Orthodox Cathedral www.orthodoxjhb.co.za
House Edoardo Villa *Warren Siebrits* enquiries@warrensiebrits.co.za
Lion's Shul *Rabbi Ilan Herrmann* soulworkout@gmail.com
L Ron Hubbard House www.lronhubbard.org
Nelson Mandela House www.nelsonmandelahouse.co.za

Nizamiye Mosque *Imam Ibrahim Atasoy* iatasoy@gmail.com
Northwards www.parktownheritage.co.za
Radium Beer Hall www.theradium.co.za
Rand Club www.randclub.co.za
Satyagraha House www.satyagrahahouse.com
St Charles Borromeo www.saintcharles.co.za
St George's Anglican Church www.stgeorgesparktown.org
St John's College www.stjohnscollege.co.za
St Michael & All Angels www.anglicanboksburg.co.za
The Old Fort www.constitutionhill.org.za
The View www.jocks.co.za
Villa Arcadia www.hollard.co.za

BIBLIOGRAPHY

Architecture in South Africa, Volumes 1 & 2, edited by L Cumming-George. The Specialty Press, 1933.

Bird of Paradise, Daphne Saul. Parktown & Westcliff Heritage Trust, 1986.

City of Extremes. The Spatial Politics of Johannesburg, Martin Murray. Duke University Press, 2011.

Gandhi Before India, Ramachandra Guha. Penguin Books, 2014.

Colonial Houses of South Africa, Graham Viney. Struik Winchester, 1987.

Herbert Baker in South Africa, Doreen Greig. Purnell 1970.

Historical Buildings in South Africa, Désirée Picton-Seymour. Struikhof Publishers, 1989.

Homes of the Golden City, compiled by Allister MacMillan and Eric Rosenthal. 1948.

Johannesburg Style. Architecture & Society 1880s-1960s, Clive Chipkin. David Philip Publishers, 1993.

Johannesburg Transition. Architecture & Society from 1950, Clive Chipkin. STE Publishers, 2008.

John Betjeman's Guide to English Parish Churches, revised and updated by Nigel Kerr. Harper Collins Publishers, 1993.

L. Ron Hubbard, A Profile, The L Ron Hubbard Series. Bridge Publications Inc, 1995.

Lost and Found in Johannesburg, Mark Gevisser. Jonathan Ball Publishers, 2014.

Modern Architecture since 1900, William JR Curtis. Phaidon Press Ltd, 1991.

No Ordinary Woman, Thelma Gutsche. Howard Timmins, 1966.

The Joburg Book, A guide to the city's history, people & places, edited by Nechama Brodie. Pan Macmillan, 2014.

The Parktown Collection, various authors. Parktown Heritage Foundation.

The World that made Mandela, Luli Callinicos. STE Publishers, 2000.

Victorian Buildings in South Africa, Désirée Picton-Seymour. A.A.Balkema, 1977.

Villa at 90, various contributors. Jonathan Ball Publishers, 2005.

Walk in Ron's Footsteps, www.lronhubbard.org

Who Built Jozi? Discovering memory at Wits Junction, Luli Callinicos. Wits University Press, 2012.